FASHIONED by SARGENT

Erica E. Hirshler

WITH CAROLINE CORBEAU-PARSONS,
JAMES FINCH, AND PAMELA A. PARMAL

CONTRIBUTIONS BY
PAUL FISHER, FRANCES FOWLE,
DOMINIC GREEN, REBECCA HELLEN,
STEPHANIE L. HERDRICH,
ELAINE KILMURRAY,
RICHARD ORMOND,
ELIZABETH PRETTEJOHN,
ANNA REYNOLDS,
AND ANDREW STEPHENSON

Contents

Directors' Foreword

THIS BOOK AND THE EXHIBITION IT ACCOMPANIES INVITE US into the studio of the turn-of-the-twentieth century's best-known portraitist and encourage us to reconsider him as an artistic director of public performances. Through the lens of dress and fashion, we can see John Singer Sargent's power over his images. Clear are the liberties he took with his sitters' sartorial choices to express their distinctive personalities, social positions, professions, gender identities, and nationalities. As Sargent brought his subjects to life, he did much more than simply record what appeared before him. He used his sitters' clothing to proclaim his own aesthetic agenda. From the sensuous sheen of silks and satins, laid on canvas with thick strokes of liquid paint, to the time-honored exercise of painting black-on-black or white-on-white, he reveled in the possibilities for depicting fabric. By placing major paintings alongside some dozen dresses and other clothing items (among them several pieces worn by his sitters), we can explore the complex relationship between painting and fashion in Sargent's art.

The Museum of Fine Arts, Boston, and Tate Britain are uniquely placed to offer new perspectives on a cosmopolitan artist who would come to claim both Boston and London as home. Our institutions committed themselves to Sargent during his lifetime, and the MFA's collection now numbers almost 600 works by him in all media, the most comprehensive assemblage of his art in a public institution. The artist's work has been present at Tate from soon after its founding in 1897. Sargent advised both museums on acquisitions, and he was commissioned by the MFA in 1916 to reconfigure and decorate the museum's main rotunda, a project that engaged him for the rest of his life. At his death in 1925, the MFA honored him with a memorial exhibition, and the next year Tate dedicated an entire gallery to his work, strategically located adjacent to spaces for "modern foreign art." Together, the MFA and Tate Britain have served as guardians of the artist's legacy, and we are proud to offer the opportunity to consider his work in new ways.

This project, co-organized by our two museums, was envisioned in 2017 by Erica Hirshler, Croll Senior Curator of American Paintings at the MFA, working first in partnership with Pamela Parmal, Chair and David and Roberta Logie Curator of Textile and Fashion Arts (now Emerita) at the MFA, and Caroline Corbeau-Parsons, formerly Curator, British Art,

Lady Agnew of Lochnaw (**12**), detail

7

1850–1915, at Tate Britain (now at the Musée d'Orsay); and since 2020 with Tate's James Finch, Assistant Curator, 19th Century British Art, and Chiedza Mhondoro, Assistant Curator, British Art. Our MFA colleague theo tyson, Penny Vinik Curator of Fashion Arts, has brought fresh eyes to our narrative. The 2020 pandemic and many related and unrelated global difficulties have changed our project, in ways that we truly believe make it even more relevant to a world that has become increasingly reliant upon image-making. Indeed we are more cognizant than ever that those images often mask reality and create subjective narratives. We are indebted to all of the scholars who contributed to this publication with their insightful thoughts about Sargent's continuing relevance. We also gratefully recognize the generous spirit of our lenders, both institutions and private collectors, who have parted with some of their most celebrated treasures to bring our exhibition to fruition.

The exhibition at the MFA is sponsored by Bank of America, with additional support from the Barbara M. Eagle Exhibition Fund, the MFA Associates/MFA Senior Associates Exhibition Endowment Fund, the Dr. Lawrence H. and Roberta Cohn Fund for Exhibitions, and the Alexander M. Levine and Dr. Rosemarie D. Bria-Levine Exhibition Fund. The exhibition at Tate Britain is supported by the Blavatnik Family Foundation with additional support from the Sargent and Fashion Exhibition Supporters Circle, and has been made possible as a result of the Government Indemnity Scheme, and we thank HM Government for providing Government Indemnity and the Department for Digital, Culture, Media and Sport and Arts Council England for arranging the indemnity. Both institutions received generous support for international scholarly convenings and for the exhibition from the Terra Foundation for American Art. Generous support for this publication was provided by the Vance Wall Foundation and the Andrew W. Mellon Publications Fund.

This exhibition and publication encourage us to think about portraits and how they are created, as well as their social function. Sargent's work eloquently expressed the desires and anxieties of the society to which his sitters belonged. They were often (but not always) wealthy, and their clothes frequently costly, but the manufacture of public identity is an issue that affects us all. Our ability to comprehend the artistry involved in these decisions, and to ascertain the fictions or truths they declare, affects how we see others, and how the world sees us.

MATTHEW TEITELBAUM
Ann and Graham Gund Director
Museum of Fine Arts, Boston

ALEX FARQUHARSON
Director
Tate Britain

Curators' Preface

WHAT HAPPENS WHEN YOU TURN YOURSELF OVER TO THE HANDS of an artist? Who decides what you wear when your portrait is crafted, and what message will it send when your image goes out into the world? This book, and the exhibition it accompanies, explore these questions in John Singer Sargent's portrait practice from his early career in Paris to his late studies of figures in the landscape. Through the dynamics of dress, we can see that Sargent did not pander to his clients — his art always came first. Paying particular attention to the choices he made, we can contrast his depictions with the types of garments his sitters wore, illuminating the liberties and elisions Sargent permitted himself in painting them. He clearly took the lead in creating his likenesses, sometimes entirely ignoring his sitter's preferences to fulfill his own aesthetic vision. Like the tailor in Thomas Carlyle's *Sartor Resartus* (The Tailor Re-tailored, 1836), Sargent was "not only a Man, but something of a Creator or Divinity." The painter confessed that he "immensely" admired Carlyle's novel, in which a fictional philosopher proposes that it was through clothing that an entire person was built.[1]

Society portraits do not always endure. Paintings commissioned to meet the self-conscious requirements of patrons often fatigue by their sheer quantity, and over time may begin to look alike, representing individual personalities and preferences far removed from our contemporary concerns. That is, unless the sitters are of particular interest, or the artist is exceptionally talented; in the case of Sargent's work, both have been true. But Sargent was an unusual portrait painter. His own biography played a part: the child of an itinerant expatriate American family, raised and trained in Europe and maintaining a lifelong passion for travel, there is nothing parochial or local in his practice. His subversion of gender codes and conventions is related both to his perspicacity of vision and to the deliberate ambiguity of his sexuality and the homosexual and homosocial circles in which he often moved. Sargent's clientele included wealthy aristocrats, industrialists, arrivistes, and politicians, as well as artists, writers, and performers. Some of his sitters, like Madame Gautreau and Lord Ribblesdale, did not commission Sargent but were pursued by him. And once sittings for a portrait began, Sargent would not necessarily paint his subjects as they chose to present themselves, but rather took an interventionist approach, recommending or vetoing choices of dress, selecting accessories, and pinning or draping fabric. Like Poussin with his models,

or Monet with his garden, the selection and manipulation of clothing was most often the way Sargent controlled the compositions he wished to paint.

Sargent and his patrons were acutely aware of the power of the image as a form of projection into the world. They weighed the various factors that constituted a picture's success — to be of the moment without being ephemeral, to be striking without being vulgar — in anticipation of the critical scrutiny that accompanied showing at the Royal Academy or the Salon. Fashion played a critical role. Brand-consciousness led many women from around the world to buy their gowns in Paris, where they could engage the leading designers of the burgeoning couture industry. Their portraits, and thus their public images, were judged not only upon the painter's skill, but also on the clothes they wore, whether the sitter chose them or not. Name brands — Worth, Paquin, Doucet — bought confidence, supplying women with, as the novelist Edith Wharton described it, social armor.[2]

The physical production of paintings and garments, both beginning with cloth, whether canvas or silk, makes for an interesting comparison. Sargent worked alone, employing his valet Nicola d'Inverno to serve as a studio assistant. The fashion houses of Paris were large companies with sizeable staffs: sales assistants, models, fitters, cutters, seamstresses, flower makers, beading specialists, and so on; by the 1870s the House of Worth, for example, employed some 1,200 people.[3] Painting and fashion both relied upon history for inspiration — the portraiture of Frans Hals, Anthony van Dyck, and Joshua Reynolds for Sargent; the laces and stand-up collars of the Renaissance or the panniered skirts of the eighteenth century at the couturiers. Clear parallels can also be drawn between sittings and fittings, each one involving assessment by another, of having one's measure, or measurements, taken. Both products were luxury goods, and their creation became a rite of passage for certain social classes. At the height of his career, Sargent charged 1,000 guineas for a full-length portrait (around $120,000 today). A Worth gown could cost between $10,000 and $30,000 in today's dollars, and many women bought more than one at a time and returned year after year. But unlike bespoke dresses that were put aside as styles changed, significantly altered to reflect new silhouettes, or remade for fancy costume parties, Sargent's paintings were meant to last beyond a single season, to withstand the vagaries of fashion and to become timeless. As one critic remarked, they were "heirloom[s] to pass down."[4]

Then as now, social concerns were raised about the role of fashion in women's self-esteem and about the economics of the fashion industry itself. "Style is a luxury, not a necessity," wrote the wage reformer Mary Dodge in her 1872 book *Women's Worth and Worthlessness*. "A woman is under no obligation to wear a Worth gown, nor is there real bitterness to the pain of going through life without it." Dodge proselytized on behalf of fair wages for women; many others campaigned specifically for fair treatment of textile workers, among them Adèle Meyer, who wears a luscious gown of apricot silk satin in her 1896 portrait by Sargent, and who co-authored a 1909 study about garment workers in London that called for an equitable minimum wage.[5]

House of Worth, evening dress (**105**),
detail

And what of the chief designers themselves? The costumed perfor-
mance of "the *artiste*" was something that Charles Frederick Worth, among
others, deliberately employed: velvet caps and capes raised the couturier's
social profile from mere craftsman to creative genius, a "King of Dress,"
as one writer dubbed Worth.[6] In contrast, Sargent dressed like a banker,
favoring conservative woolen suits or summer whites as the seasons
dictated, adopting formal wear when required. While early photographs
hint at a reserved Parisian bohemian style, there is no record of Sargent's
adopting the sort of aesthetic persona that many of his artistic colleagues
or clients favored; he was never known around town as a flaneur or a
dandy. Shy in public settings, he came alive in small groups of friends
and in the studio.

Sargent the man may remain elusive, but his art has continued to
fascinate artists up to the present day. His work has served as a source for
painters from Robert Colescott (who based a 1962 painting on Sargent's
The Daughters of Edward Darley Boit) to Kehinde Wiley (who painted
the rapper LL Cool J in 2005 in the pose of Sargent's portrait of John D.
Rockefeller). His influence extends beyond painters, however. Sargent
also played a role akin to a combination of stylist and director in creating
the situations that he depicted. This aspect of his practice can be related
to more recent artistic developments in photography, moving image, and
performance. Sargent is acknowledged as an influence, for instance, by the

Icelandic artist Ragnar Kjartansson, whose performances and film installations such as *The Visitors* (2012) sometimes evoke the atmosphere, as well as the composition, of Sargent's world.

In our own lives and times, especially since the dawn of the twenty-first century, we have been increasingly called upon to craft our appearances for projection to the world (or the internet). Today our brands might be Yves Saint-Laurent, Chanel, or Tinker Hatfield for Nike, but the right label still offers assurance for many on the public stage, both in person and in virtual realms. Instagram posts, Zoom calls, and numerous other situations provide opportunities for carefully mediated self-presentation. The relevance of Sargent's work to the present day may lie less in its power to evoke a specific historic moment, potent as that is, than in showing an unrivalled mastery of the portrait as something *created*, in collaboration (or not) with the sitter and making the most imaginative use of the resources at hand. This exhibition and book seek to return us to the moment of that creation and encourage us to view the portrait less as immutable fact and more as something constructed, a fabrication reflecting the unique relationship between the artist and each of his sitters.

Sargent worked in a reputation-conscious, information-saturated economy of images in which an unflattering likeness or ill-chosen ensemble could signal social disaster. In other words, a time like the present. The outfits Sargent's sitters (both men and women) wore revealed much, not necessarily their flesh but certainly their characters, sometimes in unexpected ways. Sargent and his sitters experienced their share of critical drubbings, and the painter's productions were often dismissed as insufficiently decorous, or mere reflections of passing trends. Nearly a hundred years after his death, however, his art remains astonishing for its combination of immediacy and grandeur. Sargent didn't paint fashion but, rather, made fashion a part of his painting.

JAMES FINCH
Assistant Curator
19th Century British Art
Tate Britain

ERICA E. HIRSHLER
Croll Senior Curator
of American Paintings
Museum of Fine Arts, Boston

The Black Brook (**120**), detail

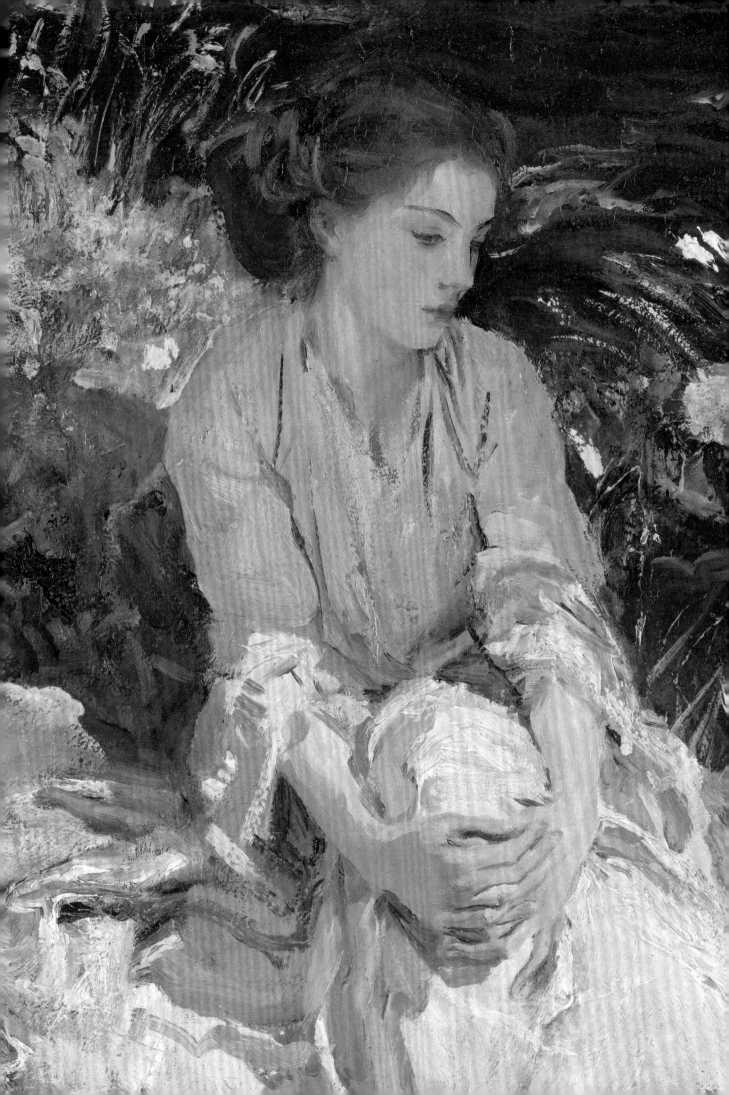

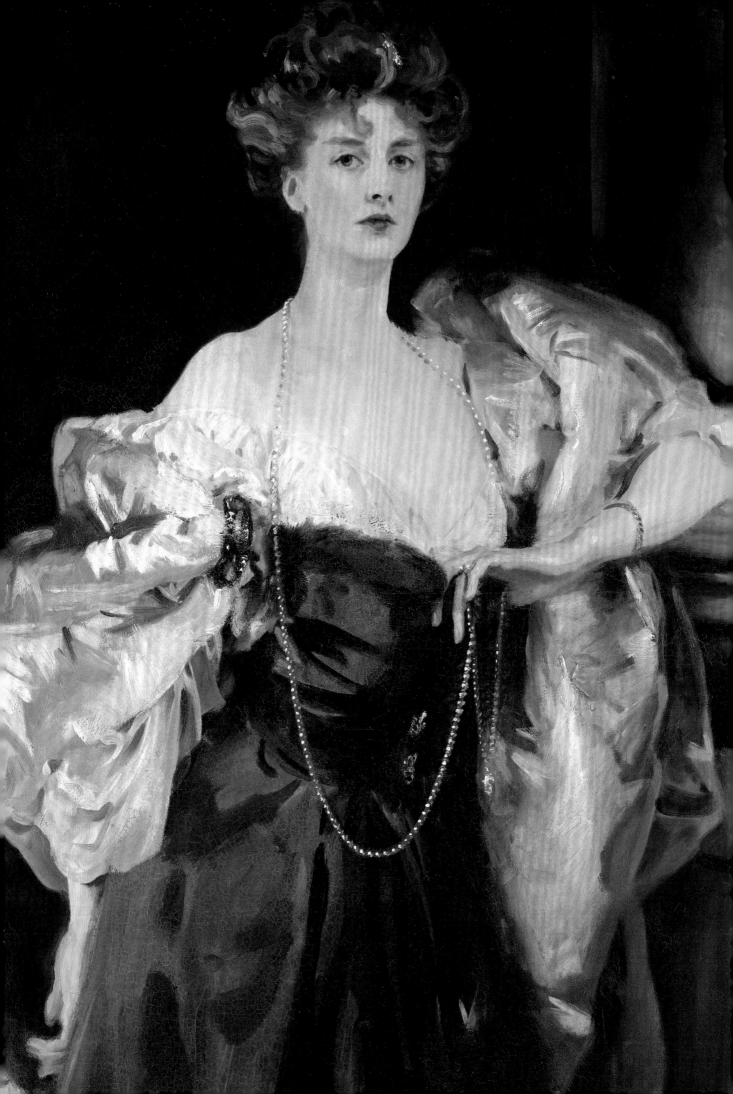

Sitting for Sargent | RICHARD ORMOND

 NYONE WHO HAS SAT FOR A PORTRAIT
knows the hazards involved: the self-consciousness of being stared at and
exposed; holding the pose and remaining still; the ensuing boredom; and
then dissatisfaction with the finished result: "Do I really look like that?"
Sargent's sitters endured all that, and something more. He brought to the
task of portraiture an unusual energy and intensity that were stimulating
and liberating for some sitters while unnerving others. It was not calm-
ing to see him dancing back and forth, viewing the portrait at a distance
before rushing forward to plant a brushstroke or two, while muttering
imprecations to himself: "Demons! demons!" "pish-tash; pish-tash!" or a
mixture of Spanish oaths.[1] He expected his sitters to play their part in the
business, projecting attitude, style, and personality so that he might catch
the essence of who they were. You can usually detect those sitters who,
through nervousness or inhibition, froze in the searchlight of Sargent's
relentless gaze. He described the painting of portraits as a battleground,
"very close quarters — a dangerous thing," as he crossed swords with his
sitters, challenging them as well as himself to deliver the proverbial rabbit
from a hat — a living, breathing likeness and a work of art.[2] The states-
man John Hay wrote of him in 1903 while sitting for a portrait: "He is
awfully nervous — with the nervousness of tremendous strength and size
rather than weakness. He stands off from his picture looking you through
and through — then jumps at the canvas and whacks it left and right
with his brush."[3]

As portrait creator, or stage director if you like, Sargent jealously
guarded his rights to determine how his sitters would be represented
and interrogated, what they would wear, how they would be posed, the
conditions of light, the color scheme, the style of setting, and the choice of
accessories. He did not take kindly to interference, and he resisted most
requests for changes unless he felt himself that improvements needed

Lady Helen Vincent (**82**), detail

15

to be made. While a full-length portrait or a group offered him the best opportunity for creating a memorable work of art, he was in the hands of his clients in terms of the size of portrait requested and what they were prepared to pay. His prices were in line with those of other successful portraitists, a thousand guineas for a full-length portrait in the early 1900s, five hundred for a three-quarter-length, and proportionally less for a head-and-shoulders.

The artist preferred to paint his sitters in the comfort of his own studio, where he could control the light and deploy familiar furnishings (**2**). In America he had to rely on makeshift or borrowed studios and private homes (**3, 4**). He normally required a minimum of six or seven sittings each lasting two hours, though there are accounts of much longer sessions, often running into months. With pardonable exaggeration Marie-Louise Pailleron claimed to have sat eighty-three times for the childhood portrait of herself and her brother, but she admitted to being a difficult and recalcitrant subject at war with the artist.[4] After posing for hours at Welbeck Abbey, the beautiful Duchess of Portland burst into tears on coming down to breakfast to find a new canvas on the easel: "I know you so well now," said Sargent, "that, if you will let me try again, I am quite sure I can paint something 'alive,'" and he did (see **62**).[5]

The artist's choice of pose was generally determined at the first sitting, though there are instances of poses being altered later on. Surviving pencil studies for a number of portraits reveal Sargent playing with compositional ideas before finalizing his design and setting to work. Most older women are shown seated, men generally stand. The artist was adept at revealing all the different ways in which people hold and present themselves, whether sitting, standing, or leaning. In a rare admission he did once acknowledge a reliance on formulas when painting portraits: "one gets into a sort of way — like hand-writing you know — capital letters and that sort of thing." He praised Whistler "for being remarkably free from anything like that."[6]

Keeping his sitters lively and alert was a perennial problem. Not naturally communicative, he resorted to having friends and companions to sittings, arranging book readings and playing records of Spanish music; Max Beerbohm drew him dashing about to the accompaniment of a string trio (**1**). He bribed young Frances Hill by giving her oranges and letting her play with tubes of paint, and he whistled and sang to amuse Cara Burch.[7] Needing breaks from the struggle to record his sitters, Sargent would rush to the piano and hammer out music to break the tension. For all their appearance of fluency, portraits did not come easily to him. He smoked incessantly, another sign of his nervousness and the strain he was under.

What women were to wear in his portraits was a matter of keen concern to the artist and his sitters. He knew that the younger ones invariably wished to be represented as icons of fashion, and he owed it to them as society figures to show them at their best. Yet dresses occupied so much of the space in a portrait that their shape, color, and texture determined its character as a work of art. Hence the tension between fashion and art. Ball gowns and evening dresses proliferate in his work, but he could conjure

1 | Max Beerbohm (English, 1872–1956), *Sargent at Work*, 1907

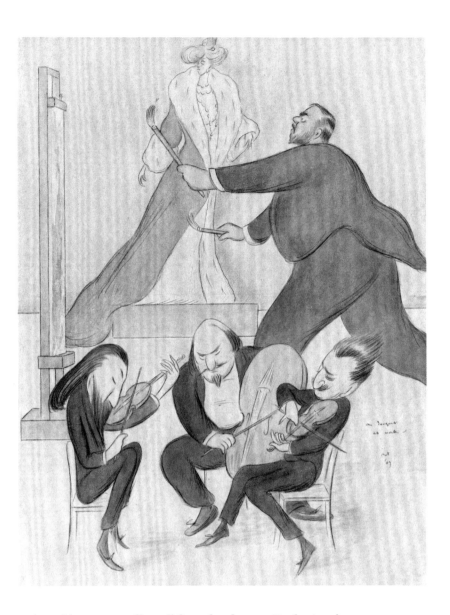

style and beauty equally well from day dresses. Professional women are frequently depicted in workaday clothes — Elizabeth Garrett Anderson, for example, one of the first women to practice as a doctor; and Jane Evans, last of the Eton dames (see **87**).

The artist told Mrs. Cazalet that he preferred to use dresses already in existence.[8] He asked Jack Morgan if his wife could bring a box with different dresses that could then be tested against the light of the studio.[9] The Worth dress commissioned for her portrait by Mrs. Endicott, Jr., was rejected out of hand, and so was every recent Paris model in Mrs. Widener's wardrobe. Her son records that the artist chose for her a dress of "Nattier blue velvet, old and torn now, its ball days over. Mother held on to it because she wanted the velvet to make sofa cushions for her chaise longue" (**5**).[10] Mrs. Fiske Warren's dress is said to have been borrowed from her sister-in-law, who was several sizes larger, while her daughter was simply draped in a length of material of the desired color and texture.[11] Having rejected an array of Mrs. Huntington's fine dresses, Sargent came upon her in a simple black dress: "I see you! I see you!" he exclaimed, and duly painted her in it.[12]

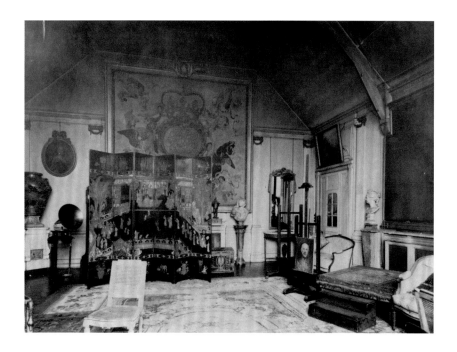

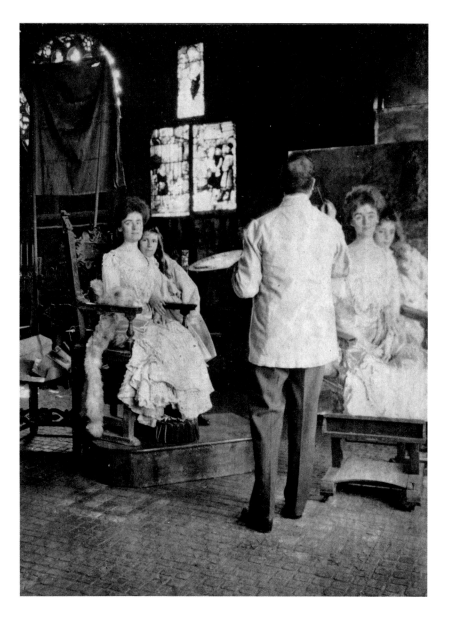

2 | John Singer Sargent's studio
at 31 Tite Street, Chelsea, London,
England, about 1920

3 | John Templeman Coolidge,
*John Singer Sargent Painting Mrs. Fiske
Warren and Her Daughter Rachel in the
Gothic Room at Fenway Court*, 1903

4 | *Mrs. Fiske Warren (Gretchen
Osgood) and Her Daughter Rachel*, 1903

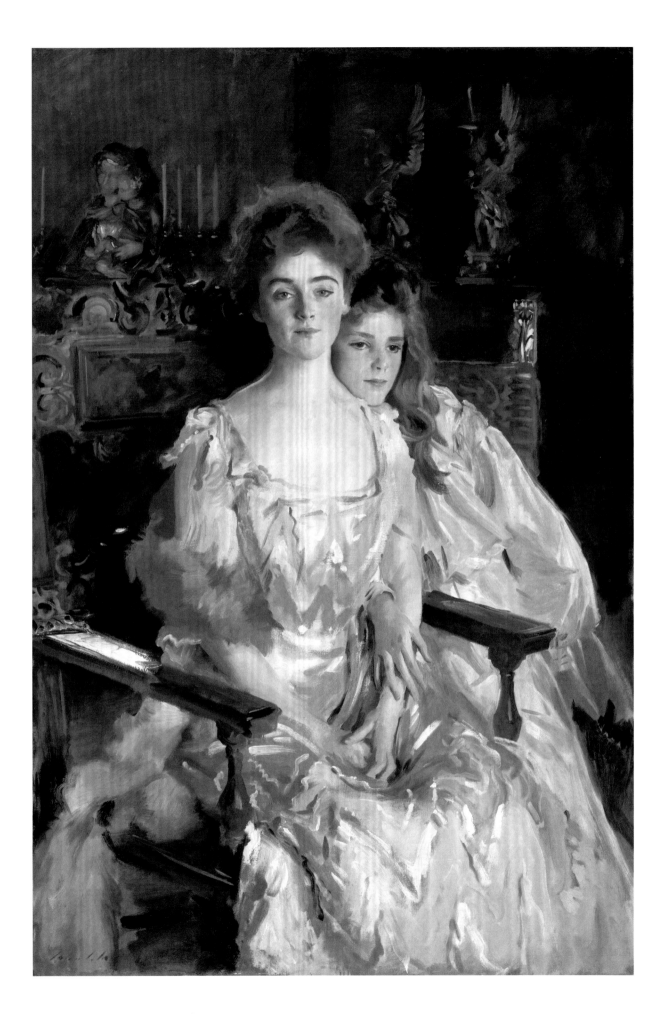

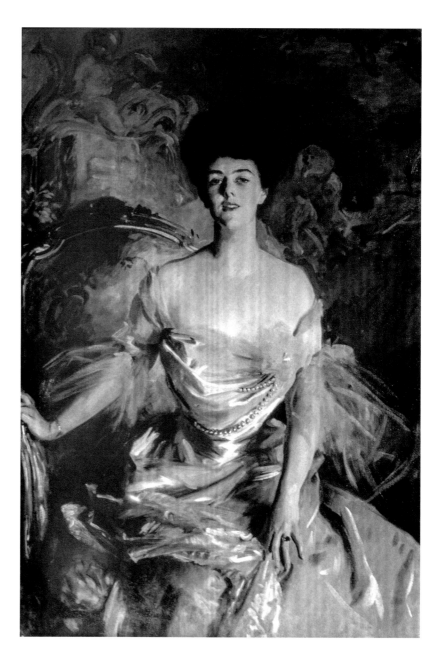

To the dresses that he selected Sargent added chiffon scarves, silk wraps, shawls, large hats occasionally, and other paraphernalia to animate his designs and to create sumptuous textures. He had no qualms about adding to or removing articles of dress, or pinning them up to achieve desired effects. A study of Lady Sassoon's surviving opera cloak reveals that the artist could have achieved the sinuous trail of pink lining, which is such a feature of the portrait, only by folding it back and pinning it up (see **38**). Izmé Vickers remembered pins when the artist was arranging her draperies "which often pricked."[13] The artist was equally free with jewelry, draping necklaces across corsages, placing brooches hither and thither, or removing jewels altogether. Sargent's outdoor figure subjects were no less carefully staged than those painted in the studio. In their billowing dresses and shawls his Alpine models seem to have migrated to the mountains from the fashionable beaches of the Mediterranean, or dressed as Turks from the harems of Constantinople (see for example, **45, 49**).

Male costume presented fewer problems than female dress. The ubiquitous frock coat limited the artist's field of action, master of black as he was. Deprived of color and decorative design he was dependent on force of characterization to make his mark. Exceptions include sitters in military uniform, Garter robes, judicial or academic gowns, hunting dress, tropical suits, and even one in a red dressing-gown (see **33**). William Cazalet stands beside his horse, resplendent in red, in Sargent's only equestrian portrait. The horse was added to fill out the composition for an overly wide canvas designed to fit the existing paneling of a period room. Arrayed in ceremonial robes, carrying the sword of state and attended by his page, Lord Londonderry captures the splendor of King Edward VII's coronation (see **28**). To Graham Robertson, who objected to wearing a long Chesterfield coat during the heat of summer, the artist expostulated: "But the coat is the picture. . . . You must wear it" (see **73**).[14]

Sargent used the props in his studio to evoke the elegant lifestyle of his sitters. French eighteenth-century-style bergère chairs, Aubusson carpets, pilasters, pillars, balustrades and panels of boiserie on wheels, and elegant tables with assorted sculptures and antiques create an atmosphere of luxury and cultured good taste.[15] Backgrounds tend to be downplayed, but not always. Isabella Stewart Gardner, full face and dressed in black, is highlighted against a panel of Venetian brocade so that she has the appearance of an Asian religious statue (see **34**). The actress Ada Rehan is matched to an exuberant Rubensian tapestry to suggest her theatricality. In a nod to the conventions of eighteenth-century portraiture, Sargent began to deploy painted landscape backdrops in his portraits from the later 1890s onward, as he joined reality to artifice. The pinnacle of Grand Manner portraiture is reached in his group of the 9th Duke of Marlborough and his family at Blenheim Palace; the duke in Garter robes, with his wife and children in period-style costumes, pose below a grandiose Baroque staircase.

The time of reckoning for the artist came when a completed portrait was unveiled and presented to the patron. Cara Burch's portrait, for example, was received in total silence by her family.[16] Likeness or lack of it was the critical issue. Sargent himself defined a portrait as "a painting with something a little wrong about the mouth," and he complained bitterly about "anxious relatives hanging on his brush" when painting Mrs. Hammersley (see **21**).[17] To one lady who complained about the rendering of her nose, he replied: "Oh, you can alter a little thing like that when you get it home."[18] The issue of likeness extended further than faces. Although such trials are the territory of the portrait painter, adding to Sargent's disenchantment with his profession, the majority of his patrons were appreciative of what he did and admiring of his genius.

Portraits as Fashion

CAROLINE CORBEAU-PARSONS

There is now a class who dress after pictures, and when they buy a gown ask 'will it paint?'"[1] This observation was made in 1878, only a year after Sargent made his successful début at the Paris Salon with the portrait of his childhood friend Fanny Watts (**7**). The author was referring to London, but her comment applied even more so to portraiture in the French capital. Paris was unequivocally the place to be for aspiring artists like the young Sargent. Although he exhibited strategically outside France, even the Royal Academy in London did not have the "international clout" of the Paris Salon.[2] That remained the unrivaled arena where reputations were made and unmade, and also where visitors could see and be seen. And within the Salon itself, the portraiture section had become the main event for artists, overtaking history painting in popularity if not in prestige. It was there that would-be patrons debated about who might paint their fashionable selves.[3] With up to twenty-five hundred portraits competing to catch the attention of patrons, it was essential for artists to make their sitters look fashionable and glamorous, in order to stand out and to attract a desirable clientele.

Dress, as a social marker of status and wealth, had always been an essential component of portraiture. The elegance of *Lady with the Glove* by Sargent's master Carolus-Duran — a portrait that represents Carolus's young wife dressed in a black satin dress, taking off a stylish gray glove with the utmost grace, having just dropped the other one at her feet — had propelled him to the highest artistic spheres (**8**). However, the importance of fashion reached new heights during the Gilded Age and the Belle Époque (1870–1914), when a class "dressing after pictures" emerged and became a force to contend with. Wealth and leisure, no longer the prerogative of the aristocracy, were now also enjoyed by a new cosmopolitan elite. Thorstein Veblen's seminal study *The Theory of the Leisure Class* (1899), which introduced the concept of "conspicuous consumption," devoted an

6 | *Madame Ramón Subercaseaux (Amalia Errázuriz)*, 1880–81

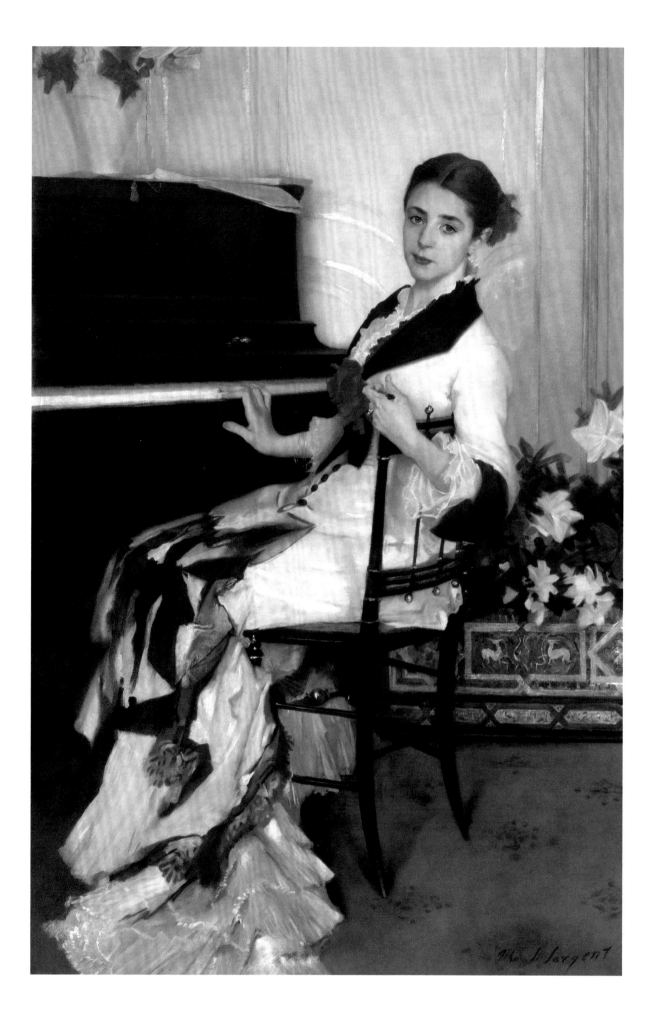

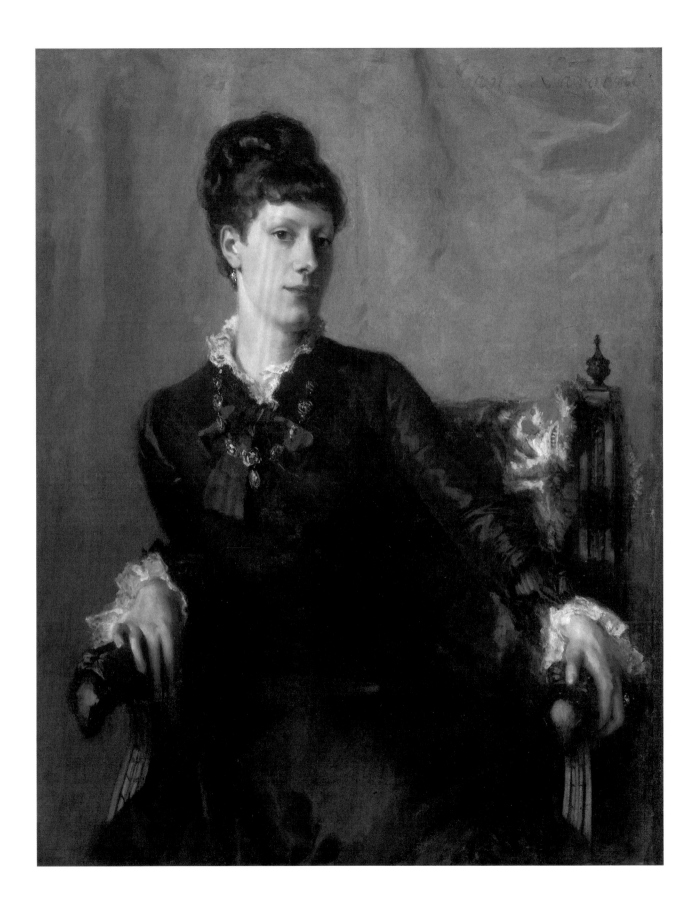

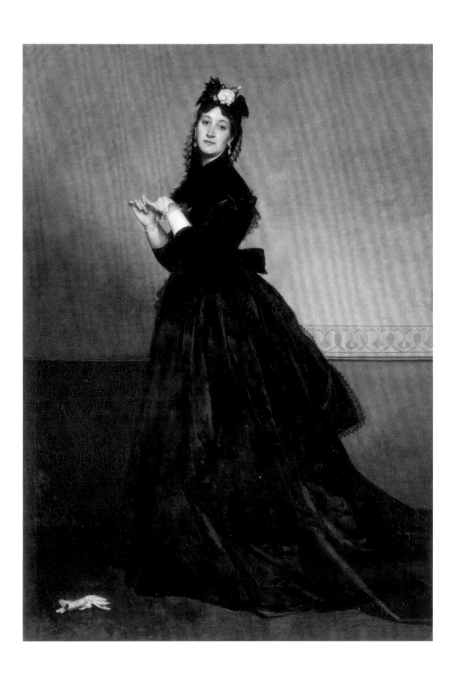

entire chapter to "Dress as an Expression of the Pecuniary Culture." The
rise of this new class in society coincided with the birth of haute couture.
As one of the main consumers of couture fashion, these clients did much
to make it into a thriving industry whose epicenter, once again, was Paris.
Fashion had become a commodity. The House of Worth and other haute
couturiers exhibited their designs at the 1878 Universal Exposition to
assert their international leadership, cohabiting with painters like Sargent,
who, after the success of his Fanny Watts portrait at the Salon in 1877,
showed it again at the fair the next year.[4] Members of the international
elite made their way to rue de la Paix or the Faubourg St-Honoré to get
their trousseaus made, and women of all nationalities aspired to encapsu-
late Parisian chic.[5]

It was therefore a great compliment to both Sargent and Madame
Ramón Subercaseaux when in 1881 the Chilean beauty was mistaken
for a Parisienne by a Salon critic (**6**).[6] Her portrait earned the artist a

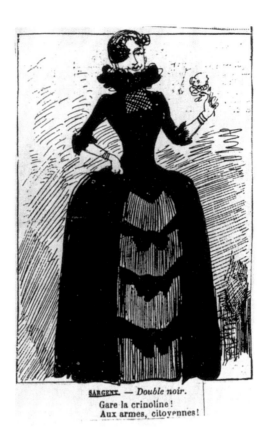

SARGENT. — *Double noir.*
Gare la crinoline!
Aux armes, citoyennes!

second-class medal and hors-concours status, which meant that works sent by Sargent to the Salon in future would be accepted without examination. The next year the artist demonstrated anew his understanding of fashion, and his ability to show a sitter to her best advantage, with the portrait of his friend Louise Burckhardt, *Lady with the Rose* (**10**). Critics immediately identified his ability to paint her black crinoline ensemble, the latest fashion, as one of the keys to his success as a portraitist. A critic for *Art Amateur* wrote, "The young girl in this year's picture was dressed in mourning in the very latest mode, with exactly the colossal bouffant tournure [bustle] that fashion put upon all lady visitors to the Salon of 1882."[7] The young artist's strategy in exhibiting Louise Burckhardt's picture paid off: "Mr Sargent will inevitably be the object of one of these *fashionable* trends that his portrait of a young lady is enough to justify. Any pretty woman dreams, at the moment, of being painted by him," noted the critic Paul Leroi.[8] This success also earned the portrait the honor of being caricatured, a sign of the notice it received during the show (**9**). After the Salon, Sargent endeavored to reach an international audience, exhibiting the painting at the Royal Academy, and then at the annual exhibition of the Society of American Artists in New York City, where it was very positively received.

Fashion and portraiture became mutually reinforcing. By wearing a gown of the latest fashion by a well-known couturier, a lady showed that she abided by the codes of the social group she belonged to, or aspired to be a part of. And to be immortalized in such a gown in a portrait singled out at the Paris Salon, the Royal Academy, the National Academy of Design, or the Society of American Artists, or any other prestigious exhibition venue,

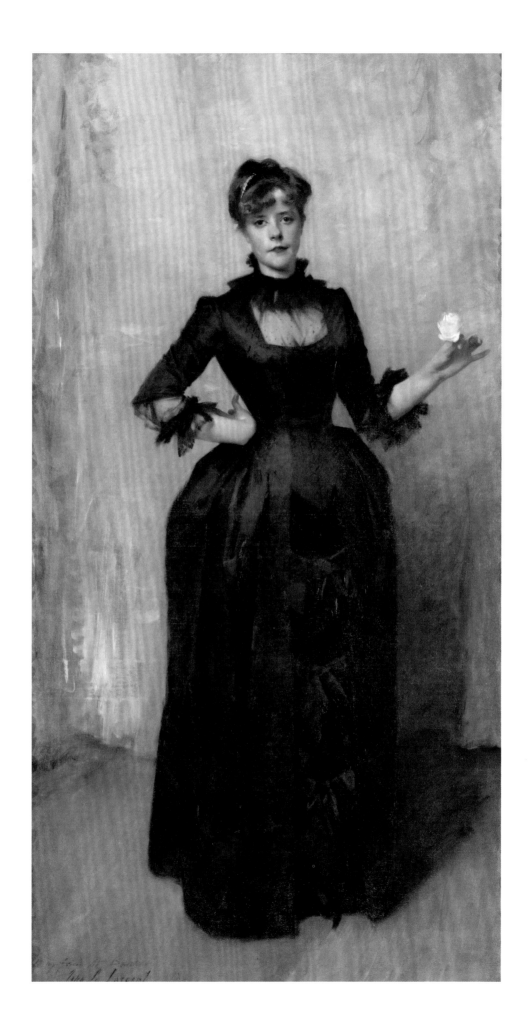

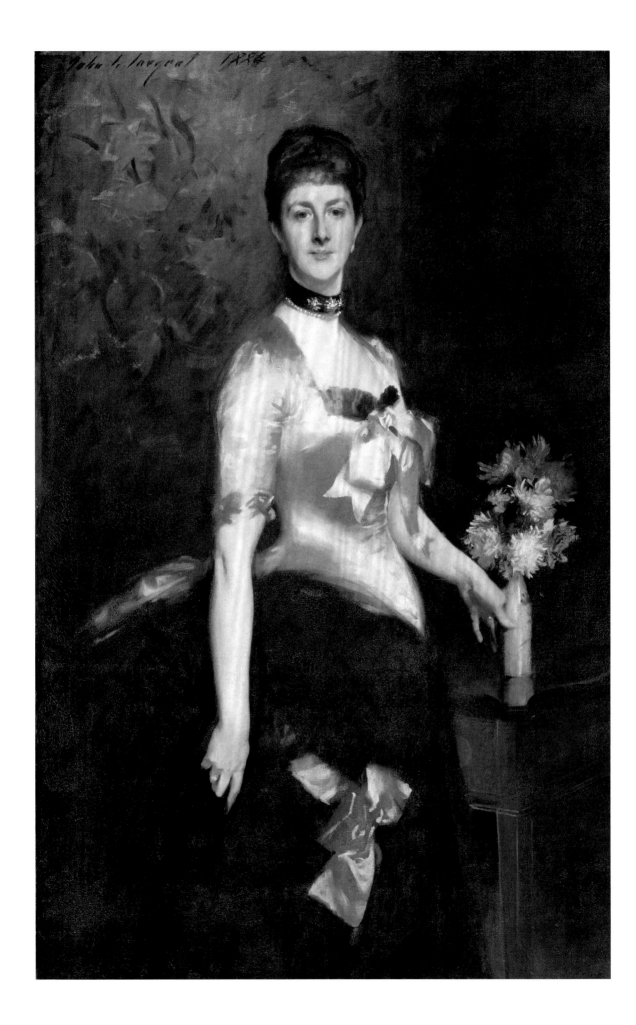

could help sitters gain or reassert their social status. As Henry James proclaimed, "If you are so to be represented, if you are to be perpetuated, in short, it is nothing that you be great or good — it is everything that you be dressed." [9] Such acts of conspicuous consumption had to be witnessed by peers where it mattered — in a capital city — in order to be validated and have the intended effect: social notice was of the essence. Portraits thus acted as interfaces between sitter, artist, and the public, becoming unparalleled platforms for self-presentation. [10] Fashion photography, which began in the 1850s, was still in its infancy, and while fashion plates were an important medium for diffusing trends in proliferating fashion and lifestyle magazines, print reproductions of portraits were key in showcasing both new vogues and sitters in all their glamour. They were also essential for keeping up with the main actors on the social scene, not least the "fashion-able" portrait painters, an epithet that cropped up in fashion magazines as well as art reviews.

Art critics were quick to exploit this interest in haute couture, to the point of mixing up art and fashion and analyzing the former using a vocabulary fit for the latter. George Moore's review of the "daring" portrait of Mrs. Hugh Hammersley (see **21**), used the lexicon of fashion to imply that Sargent was not a serious painter. While recognizing Sargent's phenomenal technical abilities, he negated his agency as an artist by insinuating that the image he had conjured up of Mrs. Hammersley was simply a transposition of her image onto the canvas, more like a photograph: "the dress is practically a huge splash transferred from nature to the canvas." Moore applied the lexical field of fashion to his critique of the portrait: "And when we ask ourselves if the picture has style, is not the answer: It is merely the apotheosis of fashionable painting? . . . He has revealed their souls' desire, and it is — *l'article de Paris* [a Paris novelty]." [11] Moore was not alone in drawing parallels between the realms of art and fashion; indeed, the comparison between society portraitists and costumiers almost became a cliché. D. H. Lawrence wrote more generally of Sargent's portraits that they were "nothing but yards and yards of satin from the most expensive shops, having some pretty head propped up on the top. The imagination is quite dead. The optical vision, a sort of flashy coloured photography of the eye, is rampant." [12] Such comments led to the conclusion that Sargent's art belonged to a subcategory of portraiture, subservient to fashion, one that the painter and art critic Walter Sickert would later call "the chiffon and wriggle school of portraiture." [13] In Sickert's view, Sargent (and also Jacques-Emile Blanche, Paul Helleu, and chief of all Giovanni Boldini) laid too much emphasis on dress and the sensual rendering of fabric. Such a reading of their art led to the conclusion that they were slaves of fashion, and that their portraits were themselves commodities. This is what a critic in the *Art Journal* in 1885 implied when he characterized Sargent's portrait of Lady Playfair, sporting a striking crinoline dress with a tangerine silk satin cuirass bodice and a voluminous black tulle skirt sprinkled with large matching silk bows, as "*tapageur* [gaudy] and neither graceful nor dignified" (**11**). [14]

11 | *Edith, Lady Playfair (Edith Russell)*, 1884

Sargent and his peers were on a tightrope: they had to manage their sitters' expectations and make them look fashionable enough to please them and get favorable notice at public exhibitions, but they also had to avoid the pitfall of having the fashion overpower considerations of their artistic approach, style, and creative powers. Moving critical discussions away from the portrait's depiction of the sitter's apparel could prove challenging. At the Salon of 1884, when *Madame X* (see **13**) was the center of all critical attention, the representation of her gown was reported to be the primary focus of female visitors at the Salon: "Women, be they models of virtue or renowned coquettes, elaborated on Mme ***'s dress and blamed her bodice's neckline."[15] In his own review of the portrait, the famous French critic Jules Claretie, having first discussed the likeness of Madame Gautreau, knew that the topic was unavoidable: "But the dress, will exclaim women, what about the dress? The dress is also alike. The beautiful Madame Gautreau was wearing a precisely comparable bodice . . . at Mme Aubernon's, held by similar curb chains."[16] More surprisingly perhaps, Sargent himself stayed on sartorial grounds when Madame Gautreau's mother accused him of having "lost" her daughter: he replied that he had painted her "just as she was dressed."[17] Yet, while working on the picture, Sargent had referred to Madame Gautreau as "Diana," suggesting that the diamond crescent on her headpiece was more than a fashionable accessory and had a symbolic value. An asymmetrical, one-shouldered tunic was a frequent element in the iconography of Diana the Huntress, and Sargent's suggestion that Madame Gautreau could be seen as a modern Diana was not lost on everyone. The critic of *Le Monde Illustré* applauded Sargent's savvy treatment and simplification of the gown's lines to make this classical reference more salient: "The dress has been changed into an undulating twirl recalling some goddess's tunic — Diana's, for instance — of whom Mr Sargent has placed the crescent in the hair of his graceful model."[18] Sargent had subordinated fashion to his own artistic goals. How to interpret his restoration of the fallen strap of Madame Gautreau's dress, as a couturier might remedy a wardrobe malfunction? Had art bent the knee to fashion to satisfy a philistine public?

A British art critic writing under the pseudonym of "The Tailor" cleverly based his review of the 1895 Royal Academy show on the premise that most members of the public engaged with portraiture in a very literal way, looking only at the fashion. Wittily playing devil's advocate, he appraised the portrait of Graham Robertson (see **73**) according to sartorial criteria: "It is described in our notes as 'a long frock coat put on a lamp post.' . . . The figure looks as if it would measure 28 in. breast and 26 in. waist, with no hips, and the long coat clinging close to the legs to the bottom. When we add to this that the details of coat are very poorly defined or rendered, some idea of this figure may be formed. Mr. Sargent, it is clear, will never receive a commission to execute one of our fashion plates."[19] The Tailor's reference to fashion plates highlights that at a time of mass print and visual culture, portraits were frequently encountered first in printed form by the public. And by the mid-1890s, artworks were

more often photographed (in black-and-white) than engraved. Apart from the overwhelming focus on fashion at exhibition venues, painters lost further agency when their works were represented on a small scale, flattened, and bereft of their color. Women's magazines such as *Les Modes* (1901–37) or *Femina* (1901–16), which reproduced some of Sargent's portraits on their front covers, occasionally cropped the compositions to show more of the gown and sitter, treating the image not like the photograph of a work of art, but like a photograph of a model.[20] By 1907, the year Sargent officially gave up portraiture, the names of Paquin and Doucet were recorded in captions in *Les Modes* alongside those of the painters Boldini and Antonio de la Gandara, who perhaps were more willing than he to collaborate with the fashion industry.[21]

The public occasionally had to be reminded of the mediation of portrait painters in presenting a successful image of their sitters. Gabriel Badea-Päun put forward the idea that titles using Madame or Miss *** at exhibition venues was not so much a way of preserving the anonymity of a sitter as an attempt to steer the attention of the viewer away from the sitter and her apparel and to bring back the focus on the artwork itself and the artist's role in creating it.[22] Painting a well-known "professional beauty," a *femme du monde* — some of whom had been painted dozens of times — or a famous performer such as Ellen Terry, was a way of showcasing one's talent and distinct style as a portrait painter. By the early 1890s, after the success of *Ellen Terry as Lady Macbeth* (see **50**) and the triumph of *Lady Agnew of Lochnaw* (**12**) at the Royal Academy, Sargent was crowned chief painter of the international elite. The public sought out his latest portraits, now consistently hung "on the line" (at eye level as opposed to "skied" higher on the wall) whether at the Royal Academy, the Salon, or the Society of American Artists, among other international venues. People also looked for reproductions in the press. Sargent's services were in such high demand that he could not paint all the people who wished to be painted by him, putting him in a position where he could choose whom to paint. To have one's portrait by Sargent was a sign that you belonged to the "Happy Few."

Beyond aiming to project a stylish image through the commission of a likeness, members of the new class analyzed by Veblen were also in search of something that money alone could not buy, and that blue bloods believed was still their prerogative: taste. If art was occasionally overshadowed by fashion in portraiture, it was understood that portrait painters of note were arbiters of taste, which made them superior to couturiers. Worth may have famously claimed that he was an artist, but a hierarchy in which fine arts came out on top still prevailed. The Belgian-French journalist Maurice de Waleffe asserted that both "couturiers and elegant women" visited the Salons in search of inspiration: "I am not referring to the hocus-pocus of the private view, where one looks at dresses and not paintings, but of visits one pays to the pictures later on, quietly. Many of these paintings are portraits of actresses, socialites, or of artists' 'models,' dressed according to their taste. And it is self-evident that artists have taste. When painting a fashionable dress, they correct it, they interpret it."[23] To the modern

eye, Madame X's dress, painted frontally with its flouncy crinoline bustle obscured, could almost pass for the prototype of a sheath dress.[24] Sargent simplified its lines with his brush, giving the impression of a more streamlined cut, revealing the hourglass curves of his sitter, but also minimizing distraction to showcase her now-famous profile.

As a rule Sargent favored white, black, or muted shades over vivid hues for dresses, and he tended to edit out potentially superfluous ornaments. He knew how to employ and subdue fashion to create a harmonious picture and show his sitters to their best advantage. As Henry James put it, as "it has mainly been his fortune . . . to commemorate the fair faces of women, there is no ground for surprise at this sort of success on the part of one who had given so signal a proof of possessing the secret of the particular aspect that the contemporary lady (of any period) likes to wear in the eyes of posterity."[25] Sargent's sitters expected him to save them from sartorial faux-pas, seeking validation from posterity, not just from their peers and all those they wished to impress in their lifetime. They expected the picture to be of their time, but also timeless.

For all the craze for fashion and haute couture, Sargent's sitters were acutely aware that trends superseded each other at a vertiginous speed, and that fashions could soon appear dated. By asserting that Sargent's portrait of Mrs. Hammersley belonged to the category of "fashionable painting" and that it was "*l'article de Paris*," George Moore implied that the picture did not rise above the realm of fashion into the sphere of high art: "It is essentially a picture of the hour," he wrote. "It fixes the idea of the moment and reminds one somewhat of a premiere at the Vaudeville with Sarah [Bernhardt] in a new part. . . . It is the joy of the passing hour, the delirium of the sensual present."[26] Moore would stand corrected if he could witness the admiration her portrait still elicits at the Metropolitan Museum of Art.

Other critics were quicker to perceive Sargent's talent at sublimating fashion to create a timeless work of art. Writing about *Lady with a Rose*, the critic of the *Art Amateur* noted: "Artists contend that Fashion is Philistine. . . . Yet the artist had managed to give it such an indescribable quaintness of air and pose, and had treated it so thoroughly in the artistic spirit, that [one] cannot but imagine how exquisitely quaint and strange it will seem to those who shall see it a hundred years hence."[27] It took Henry James a much shorter time to perceive what Sargent had achieved with this portrait and to see beyond the admirable likeness of a young lady sporting the latest fashion: "I well remember that, encountering the picture unexpectedly in New York a year or two after it had been exhibited in Paris, it seemed to me to have acquired an extraordinary general value, to stand for more artistic truth than I would be easy to declare, to be a masterpiece of color as well as of composition, to possess much in common with a Velasquez of the first order."[28] Sargent's portraits would stand the test of time. There was a class of painters who painted after dress. He was not one of them.

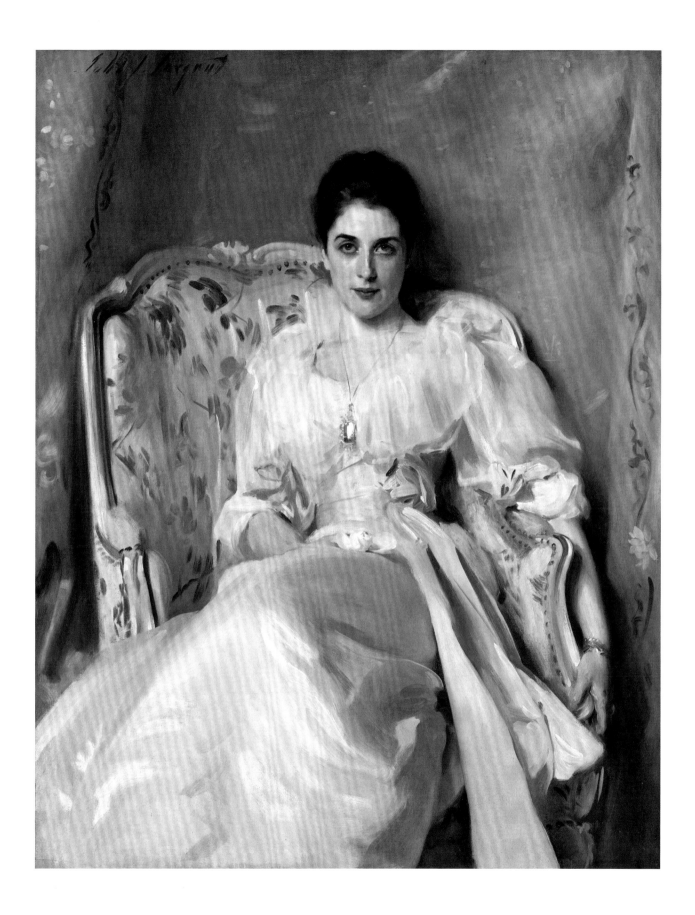

12 | *Lady Agnew of Lochnaw (Gertrude Vernon)*, 1892

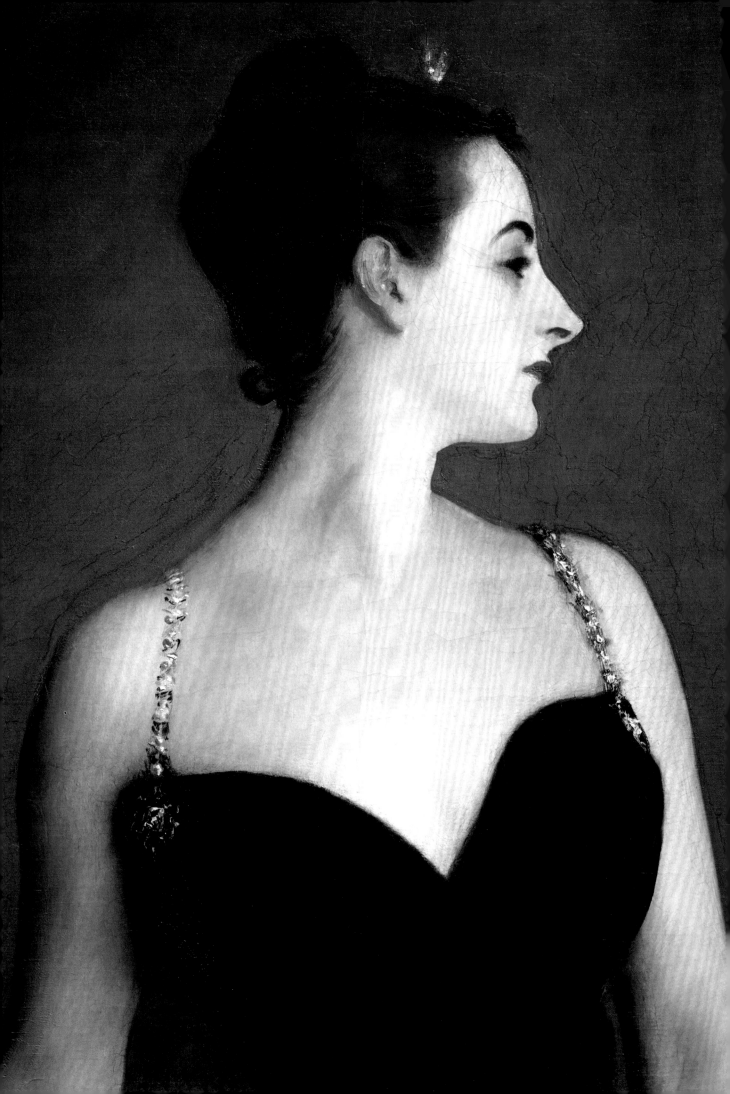

Madame X | STEPHANIE L. HERDRICH

*V*IRGINIE AMÉLIE AVEGNO GAUTREAU (1859–1915), the Louisiana-born wife of a French banker, was admired in Paris society for her arresting beauty, which she highlighted with an array of striking couture gowns and an elaborate cosmetic regimen. Newspapers raved about her appearance and often reported her among the "pretty women in delightful dresses" who were seen at receptions around the French capital.[1] Sargent, captivated by Gautreau's self-fashioning, contrived to paint her likeness as a "homage to her beauty."[2] In 1882 he convinced her to pose — without a commission — for a life-size portrait, which was destined for the most prestigious and public of venues, the Salon of 1884 (**13**).

Conceived with great ambition, the portrait, known since 1916 as *Madame X*, was a calculated collaboration between the rising painter and his increasingly well-known, aspiring bourgeois sitter: two young Americans seeking acclaim in the French capital.[3] Even before they met, a critic using the pseudonym Perdican linked Sargent and Gautreau as exemplars of a troubling trend of upstart Americans infiltrating Parisian society and usurping attention from their French counterparts. Writing in 1881, he chafed at their potential for social mobility, noting that Americans "have painters who take away our medals, like M. Sargent, and pretty women who eclipse ours, like Mme Gauthereau [*sic*]."[4] Perdican's assessment would prove remarkably prescient: the greatly anticipated portrait formalized their alliance and ensured their mutual ascendancy.[5]

Following her marriage to Pierre Gautreau in 1878, the young Virginie artfully exploited her appearance to increase her social status in Paris. Her fashion sense and self-fashioning were essential to her rise. In 1880 a writer for the *New York Herald* recognized her as a work of art come to life: "Mme. Gautherot [*sic*] is a statue of Canova transmitted into flesh and blood and bone and muscle, dressed by Félix [the couturier], and *coiffed* by his assistant Émile. All her contours are harmonious. . . . I know she is

Madame X (**13**), detail

the loveliest creature I ever beheld coming of the hands of a Paris dress-maker."[6] This "living statue," as another writer labeled her, was a creature invented by her French couturier (Maison Félix) and hairdresser.[7]

Sargent understood that Gautreau's *toilette* was a critical component of her constructed identity and therefore essential to the portrait. Shortly after sittings began in 1883, he described his admiration for her "beautiful lines" and "lavender" skin tone, referring to her unnatural cosmetic tint.[8] Always invested in his sitters' attire, Sargent would have certainly discussed dress options with Gautreau. One French critic noted that it was well known that "the woman in question was to be represented in *le costume* that she was particularly fond of."[9] Her black dress, with its plunging décolletage and bared arms and shoulders, affords ample exposure of her artificially pale skin and her form, which Sargent admired. Set against a monochromatic background, her contorted pose, likely contrived by the artist, emphasizes her "beautiful lines" and echoes antique and Mannerist statues. The deliberately severe profile of her face is in contrast to her body as it rotates toward the picture plane, thus obscuring her bustle, which would have destroyed the effect of her sculptural lines.

Gautreau, who was almost certainly complicit in all aspects of the portrait, was pleased with the likeness and wrote a friend shortly before the Salon opened that "Mr Sargent made a masterpiece of the portrait."[10] The artist was more hesitant and sought reassurance from his teacher Carolus-Duran, who told him that he could send the portrait to the Salon with confidence.[11] Sargent's misgivings were immediately validated when a great uproar surrounded the portrait on opening day. Many who saw the portrait found Sargent's depiction unflattering and eccentric. His focus on Gautreau's lavender skin tone highlighted the artificiality of her appearance. (Sargent's cousin Ralph Curtis remarked that she looked "decomposed.") Her profile pose and averted gaze made her appear haughty. Gautreau's dress, perceived as indecent by some, became a target of criticism. In society, people were fascinated by her — but on the wall of the Salon, she was jeered.

The most distinctive feature of the dress according to descriptions was the bodice, "made up of only two fins having no other attachment above the shoulders than a simple silver chain." While the dress was repeatedly discussed in reviews, its designer has not been identified.[12] Its style was bold but not outside the realm of current fashion.[13] Indeed, *The Illustrated Catalogue for the Salon of 1884* reveals many portraits of sitters in low-cut necklines, by artists of varying renown.[14] Among contemporary portraits showing similarly plunging necklines and bare arms is one of the opera singer Caroline Salla, by Collin Raphael, shown in the 1882 Salon. Yet what was considered acceptable for an actress or performer was deemed unsuitable for a woman in society. Of course, female nudity abounds in paintings of allegorical and mythological subjects.

For Sargent, Gautreau's dress signified modernity and he would have admired portraits of the chic Parisienne by his predecessors, including Carolus-Duran (*La Dame au gant*; see **8**) and Manet (**14**). In contrast to

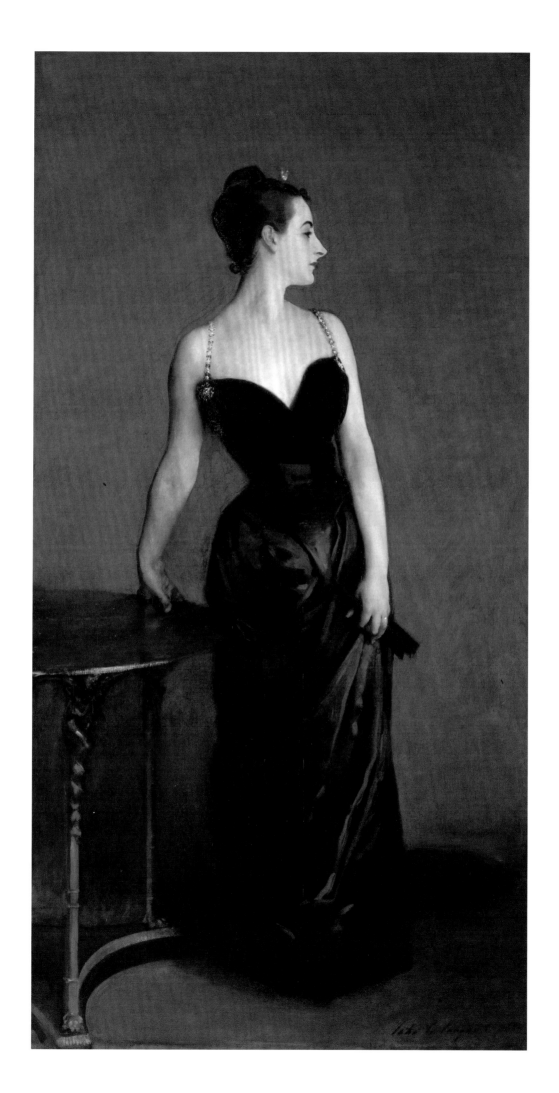

Manet's image of a modern woman on the go, Sargent's version of the theme highlighted Gautreau's self-conscious self-fashioning and pushed the boundaries of decorum by depicting the right jeweled strap of her evening gown sliding off her shoulder — a narrative detail that proved a grave miscalculation by the artist and the sitter. [15] One French critic wryly remarked, "Of all the undressed women [at the Salon], the only interesting one is from M. Sargent . . . interesting for its neckline with chains of silver, which is indecent and gives the impression of a dress that will fall." [16] The fugitive strap highlights another aspect of her dress: a lack of conventional undergarments. An American critic, writing with disdain on the "Eccentricities of French Art" at the Salon, devoted a lengthy diatribe to this lack of modesty:

Mais cette femme là ne porte pas de chemise!" [But this woman is not wearing a chemise!] has been heard half a dozen times within fifteen minutes before this "eccentric" object, and its immodesty is so conspicuous that groups of "gommeux" and "flaneurs" pose beside it to watch and grin at its first effect upon young girls as they unconsciously catch sight of it. The figure would better have been left uncovered, for modesty's sake as well as for art's. . . . The whole purpose of the picture being . . . a willful exaggeration of every one of his vicious eccentricities, simply for the purpose of being talked about and provoking argument.[17]

The fallen strap, perhaps meant to convey a fleeting instant, accentuated her bareness, and seemed vulgar and provocative, a sensational ploy to garner attention. Sargent defended the portrait, claiming that he had painted her "exactly as she was dressed," thus deflecting the criticism onto Gautreau for her choice of dress and questionable taste.[18] While the critic Jules Claretie noted that the portrait "caused such a stir . . . among socialites and among fashion designers," he absolved the artist and concluded that "Sargent's talent is intact."[19]

Upon seeing the portrait, the critic Louis de Fourcaud recognized that Sargent had transcended portraiture to create an iconic image of a new type in society, "the professional beauty," whom he described as "the Parisian woman of foreign origin, raised from her childhood to be an idol." He explained: "Know that in a person of this type, everything relates to the cult of the self and the increasing concern to captivate those around her. She ends by being more than a woman: she becomes a sort of canon of worldly beauty. Her sole purpose in life is to demonstrate her skills in contriving incredible outfits which shape her and exhibit her and which she can carry off with bravado and even a touch of innocence."[20]

If, as Arsène Houssaye, editor of the journal *L'Artiste*, had proposed in 1867, a woman could be Parisienne by birth or by dress, the American-born Gautreau had achieved that status by dress.[21] Fashion was an essential component of her transformation from arriviste American to Parisienne parvenu. In the portrait, Sargent deftly captured her performance as a professional beauty; his provocative depiction underscored her foreign origins and invited attention that threatened her status. The fallen shoulder strap revealed her poor taste — a mistake that would not have been made by a true Parisienne. Both artist and sitter were devastated by the response to the portrait. After the exhibition closed, Sargent repainted the fallen shoulder strap in the upright position. But the fashion faux pas had been documented for all to see on the walls of the Salon: a potent symbol of an upstart American who threatened to topple long-standing hierarchies in fashion, society, and national identity.

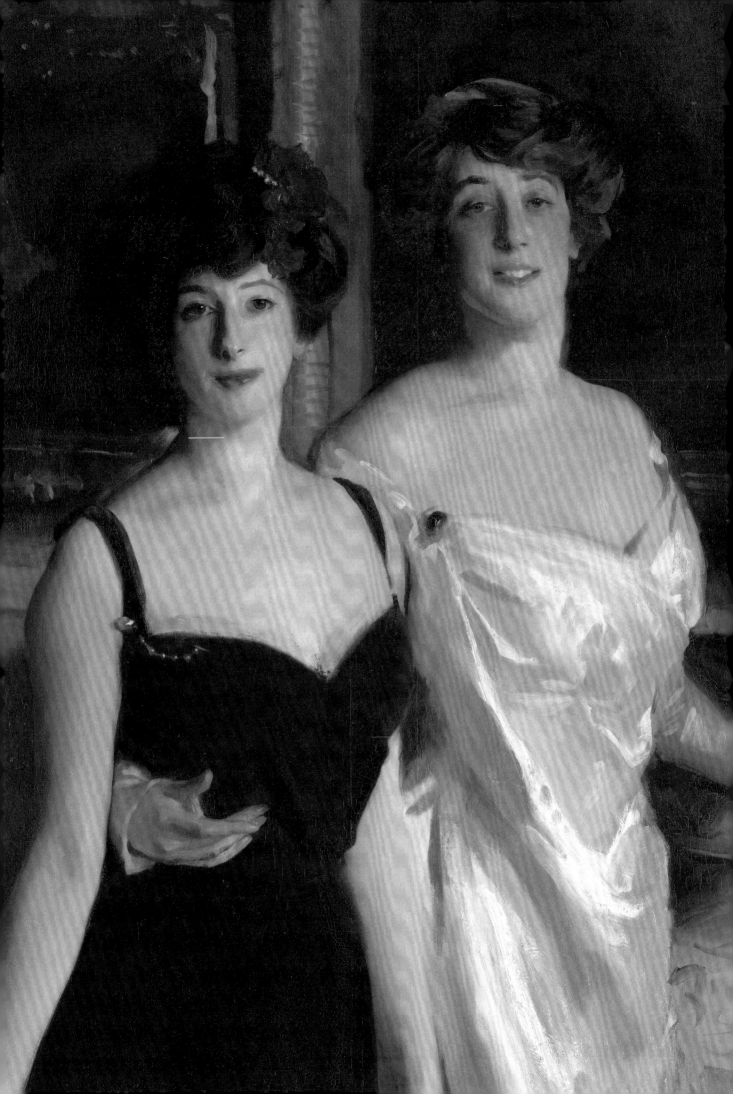

The New Woman FRANCES FOWLE

*I*N THE LATE NINETEENTH CENTURY, WHILE SARGENT'S
reputation as a portrait painter was at its height, there was a new aware-
ness, both in Britain and the United States, of women's position in society.
The campaign for women's rights had been gathering pace since before the
American Civil War, while in Britain the first female suffrage societies were
formed around 1865. Women in both countries played a prominent role in
moral reform, especially in the temperance movement, and in antislavery
organizations. As the century progressed, crucial changes were enacted in
laws concerning marriage and women's ownership of property. In 1894 the
term "New Woman" was coined to describe what was perceived to be a new
female type: independent, highly educated, career-oriented, and politically
engaged.[1] Such women were not universally celebrated, often caricatured
in the popular press for their appearance and manners.[2]

The New Woman had close parallels with the more generic "American
Girl," an ideal of womanhood that evolved at the end of the nineteenth
century. The American Girl represented the "best" type of woman, whose
pure white skin and middle-class ideals distinguished her from people of
the more diverse racial types that were then immigrating to the United
States.[3] She manifested as various types, from Harrison Fisher's "Beautiful
Charmer" to Robert Wildhack's "Outdoors Pal." She was more superficial
than the New Woman, and took no interest in political and social causes.[4]

In Britain, the New Woman was the natural descendant of the
eighteenth-century bluestocking. Intelligent and educated, associated with
sexual freedom and progressive reforms, she was lampooned for lacking
"natural" feminine qualities.[5] The New Woman was also satirized in the
pages of magazines like *Punch* for indulging in athletic activities such as
playing golf, shooting, or bicycling, for her "mannish" appearance, and
above all for wearing what was known as rational dress — that is, practical
clothes for walking, working, or sports.[6] In the 1880s and 1890s rational

*Ena and Betty, Daughters of Asher
and Mrs. Wertheimer* (**17**), detail

41

wear became a marker of female empowerment, as well as the height of fashion for much of the younger generation. Dress reformers approved of loose-fitting "Aesthetic" dress (popular in Britain) or comfortable daywear, such as paneled skirts whose buttons could be undone for walking and cycling. They objected to tight corsets, laced from the back, as detrimental to women's health, and promoted instead the "liberty bodice," a fitted sleeveless vest that buttoned up the front.

A type of American Girl who combined traditional feminine appeal with a veneer of modern style appeared in the United States in the mid-1890s in the form of the "Gibson Girl." She was the creation of Charles Dana Gibson, who was a leading illustrator for popular magazines.[7] The Gibson Girl was very different from the New Woman: her slender hourglass figure was achieved through wearing a corset, and she was not vulgar or opinionated. The New Woman was financially independent, politically engaged, and intellectual (she often wore glasses), and even smoked cigarettes (associated with both masculinity and bohemianism), while the Gibson Girl took no interest in politics or women's suffrage, wore the latest fashions, and arranged her hair in a fashionable chignon. Nevertheless, she was outgoing, athletic, and self-confident. In 1895 *Scribner's* magazine endorsed this new type of modern woman by advertising its June issue with a poster of a Gibson Girl riding a bicycle, dressed in a straw hat, white shirt with stiff collar and leg-of-mutton sleeves, and a divided skirt, drawn tightly in at the waist (**15**). Fashion designers began to produce "good sense" corset waists for such women's sporting activities. Shaped and adjustable, they permitted "full expansion of [the] lungs," while "giving the body healthful and graceful support."[8]

The portraits produced by Sargent in the 1880s and 1890s were created while images of the New Woman and the Gibson Girl, as well as illustrated articles with fashion tips for the modern woman, were being published in newspapers, journals, and women's magazines, and their subjects appear to be following these trends. His 1889 portrait of the Scottish writer on aesthetics Clementina ("Kit") Anstruther-Thomson, shows her in collar and tie, adopting a commanding, masculine pose (see **72**), while the corseted figure in *Mrs. George Batten Singing* of around 1897 (Glasgow Museums) is closer to that of the American Gibson Girl. Sargent even exaggerated Mrs. Batten's astonishing hourglass figure by cropping the canvas, creating an unusually narrow format.[9] In both paintings Sargent appears to draw attention to socially determined feminine types. The "mannish" New Woman is epitomized by Kit Anstruther-Thomson, who at the time was in a same-sex relationship with Sargent's good friend Vernon Lee. However, the more "feminine" Mabel Batten would also later fall in love with a woman, the writer Marguerite Radclyffe Hall.

Indeed, several of Sargent's female friends and sitters were sexually liberated, or had connections with progressive politics. An example is Mrs. Robert Harrison, whose portrait Sargent painted in 1886 (**16**). Helen Harrison was the daughter of the Liberal MP, ship owner, and art collector Thomas Eustace Smith.[10] Sargent chose to portray her in a virginal white

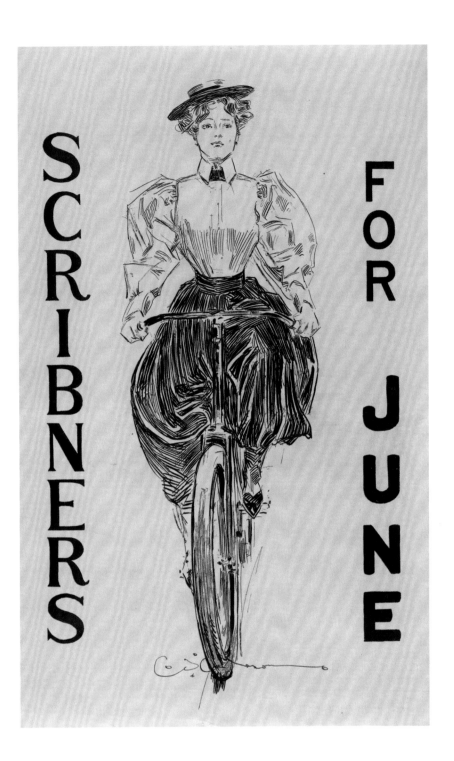

organza dress with puff sleeves, partially covered by a more severe, full-length, scarlet red overgarment fastened at the neck. A critic remarked that the costume gave her devilish "red wing-like appendages," which looked as though they were "about to expand and convey her to the regions of Mephistopheles."[11]

Such a characterization is explained by the context in which Sargent's portrait was created. Helen's reputation had been sullied by her sister Virginia's scandalous divorce trial the same year the painting was made. The case involved the radical Liberal politician Sir Charles Dilke, tipped to be the next Prime Minister, who was accused by Virginia of seducing not only her, but also one of her brothers.[12] However, during the proceedings

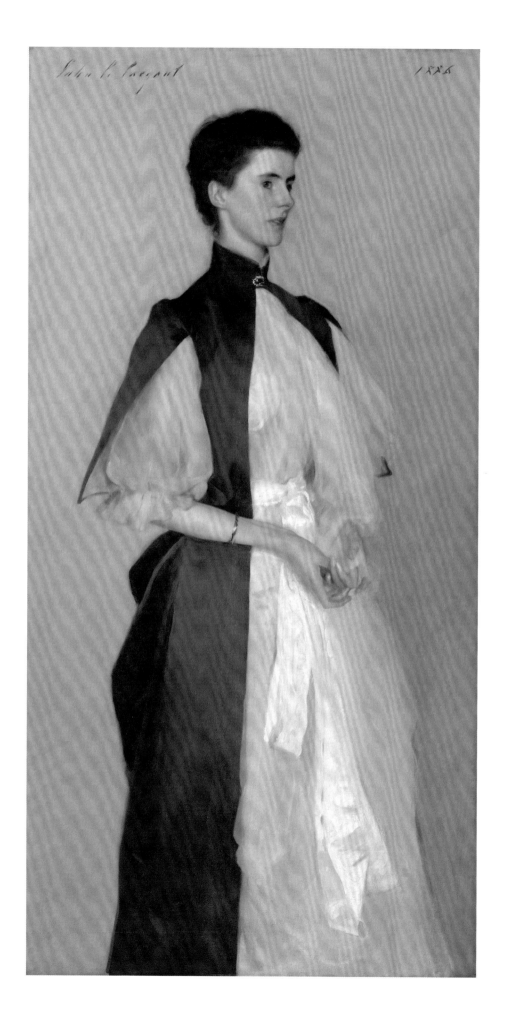

16 | *Mrs. Robert Harrison (Helen Smith), 1886*

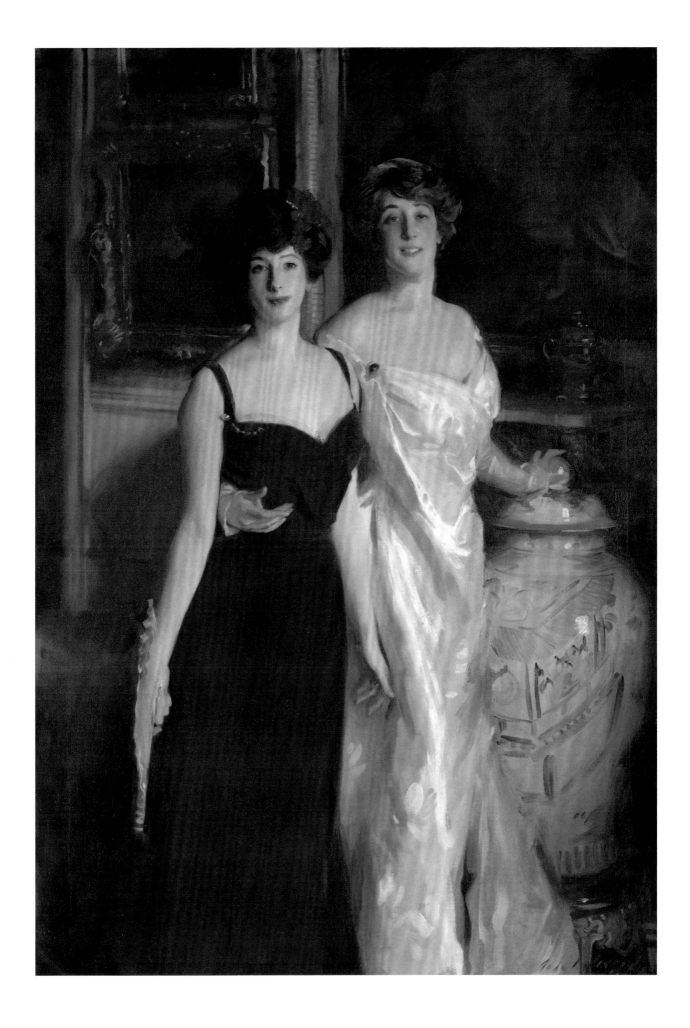

it was suggested that Virginia had implicated Dilke in order to protect her real lover, a Captain Forster, with whom she and Helen Harrison had allegedly had a three-way relationship. The case was extensively covered in the press, with rumors that Helen and Virginia had propositioned young medical students, and that Helen had been infected with syphilis.[13] There is no real evidence that Helen was involved in the affair, but her reputation was severely damaged. Sargent's portrayal of her in a pure white dress partially covered by a scarlet overgarment is fraught with symbolism. In the portrait, however, Helen comes across as demure, and even hesitant — perhaps a suggestion by Sargent that she was far from the licentious woman portrayed in the newspapers.

In 1901 Sargent used the same contrast of red and white to produce a very different image, a double portrait of the two elder daughters of the wealthy London-based art dealer Asher Wertheimer (**17**). Both girls trained at the Slade School of Fine Art and pursued independent careers as artists (Ena also as a gallerist). Coming from a German Jewish family that was quickly rising in social status, and unconstrained by the aristocratic British upbringing of many of Sargent's other sitters, Ena and Betty Wertheimer project personal and sexual confidence, enhanced by their self-assured stances and their décolleté evening dresses. The younger sister, Betty, then about twenty-four years old, is dressed in a rich ruby velvet gown, offsetting her ivory complexion; her hairstyle, pale makeup, and fan connect her with the "exotic" origins ascribed by the tacit antisemitism of the time. Her taller and more flamboyant sister wears a revealing, off-the-shoulder (albeit sleeved) white damask gown. At first sight it appears loose fitting, but it is gathered at the shoulders in order to reveal Ena's corseted waist. Her exuberance and energy are almost palpable as she reaches out to touch a large Chinese jar, denoting the source of the family's wealth through the art trade.

Sargent was often entreated by his female sitters to depict them in the most fashionable evening gowns, but sometimes he celebrated their role as modern women through showing them in more practical daywear. An example is his portrait of Alice Thursby, who, like Helen Harrison, came from a politically liberal family (**18**). Brought up in Paris, Alice was the daughter of the eminent New York socialist philosopher Albert Brisbane. She studied painting in Paris, prior to her marriage, in 1888, to Charles Radcliffe Thursby, an English engineer with landed estates.[14] Sargent rejected the initial proposal to show Alice in evening dress, preferring to present her as a dynamic modern woman, hand on hip, adopting an active pose as if she were about to rise from her chair. He depicted her in a fashionable black frogged jacket, whose greenish hues complement the mauve skirt and white high-necked shirt. The outfit is accessorized by a lilac-colored bow and a long silver necklace. The green, white, and violet touches suggest the suffragette acronym GWV or "Give Women the Vote," perhaps the artist's way of subtly alluding to Alice's belief in women's enfranchisement. Like many of Sargent's New Women, she was brought up in a family that believed passionately in social reform. Her father was

18 | *Mrs. Charles Thursby*
(Alice Brisbane), about 1897–98

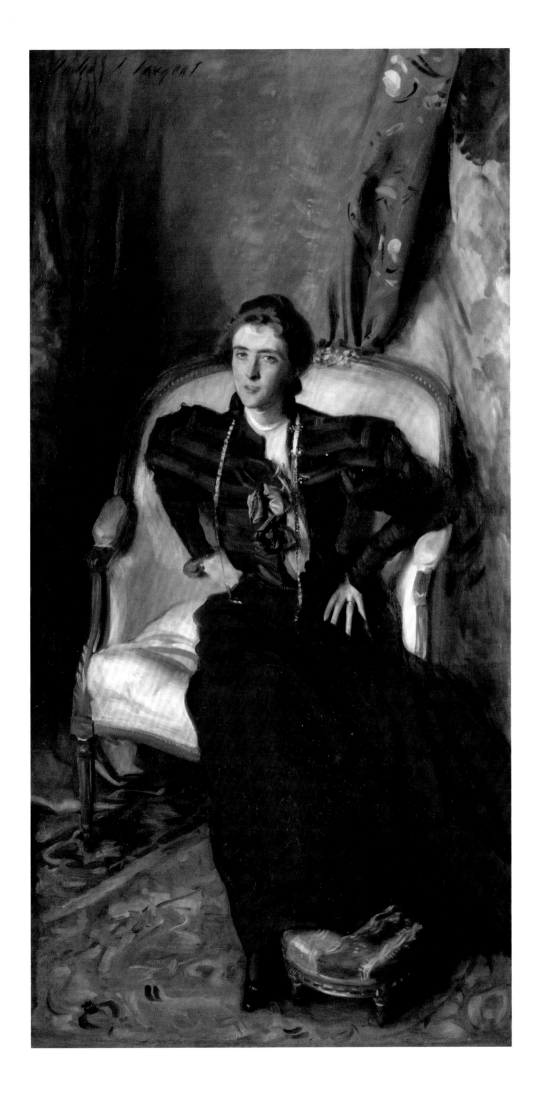

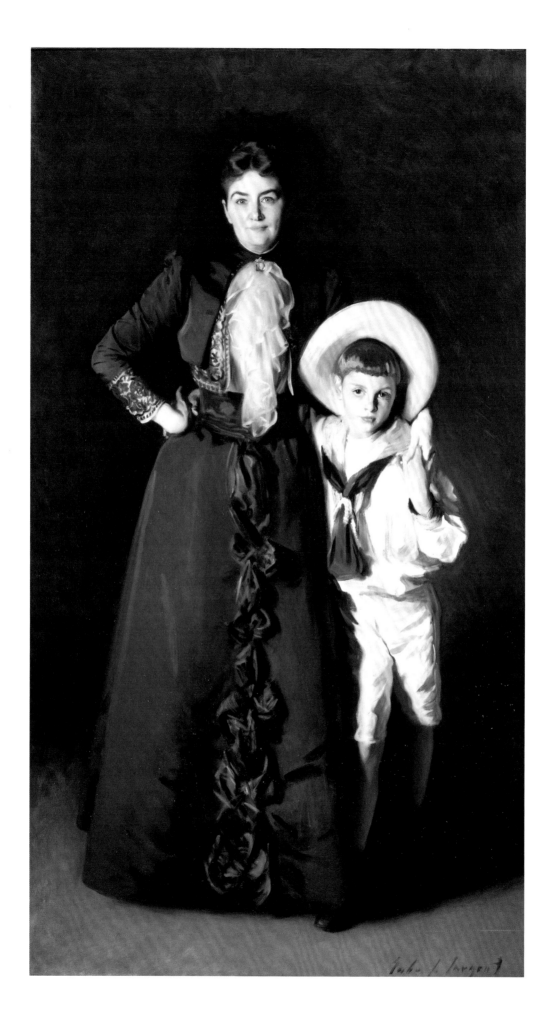

a Fourierist, while her younger brother Arthur, as editor of the *New York Times*, moved in circles that included Nellie Bly (Elizabeth Cochrane Seaman), who reported on issues of reform and taboo subjects such as divorce.

Like Alice Thursby, the New Woman, especially in satirical journals, was often shown assuming an assertive pose, with arms akimbo. Sargent introduced the hand-on-hip pose as early as 1882 in his full-length portrait of Louise Burckhardt, known as *Lady with the Rose* (see **10**). He revisited the idea eight years later in his portrait of Mrs. Edward Davis and her son (**19**). Maria Robbins Davis was the second wife of Edward L. Davis, a prominent Massachusetts investor and politician. Here Sargent pays homage to Velázquez's predilection for a dark background and dramatic lighting. As a result, the figures of Mrs. Davis and her son, both dressed in black and white, are like celebrities standing in the spotlight. Mrs. Davis is dressed for action in a long dark walking skirt decorated with ruffles or bows down the front and drawn in tightly at the waist to show off her figure. The jacket is trimmed with black-and-white embroidery, and she wears a white jabot pinned at the neck with a cameo brooch, an adaptation of eighteenth-century menswear. By contrast her son is dressed for play in a white sailor suit with black neckerchief and a wide-brimmed light-colored straw hat. As he worked on the painting, Sargent altered the position of Mrs. Davis's right hand, placing it on her hip, in order to give her a more assertive appearance. A self-assured American woman, she gazes directly out of the canvas, her eyebrows arched. She gives the impression of a strong woman who stands no nonsense. Her son leans in to her, but she does not obviously return his affection, even though she has her arm around his shoulders in a protective gesture.

The climax of Sargent's New Woman paintings is the double portrait of Mr. and Mrs. Phelps Stokes of 1897, where he again explored contrasts of light and dark (**20**). The portrait features a confident Edith Minturn Stokes dressed in daywear. The Stokeses initially expressed concern that their friends "might not altogether approve" of Sargent's decision to portray Edith in walking clothes, rather than in a fashionable gown.[15] The archetypal New Woman, she is wearing a light shirtwaist tucked into her starched white pique skirt, with a blue serge tailored jacket. Sargent even included her fashionable boater hat, added at a late stage in the composition. Her costume, down to the puffed sleeves of the jacket, represents the latest in ladies' daywear. Her functional shirtwaist, modeled on men's shirts, was a relatively new invention, replacing the more restricting bodice; practical and available ready-to-wear, it was initially popular with modern working women, and soon became a fashion item available in various colors, sometimes with added lace and frills. In 1906 the *Pittsburgh Press* reported that "a very fashionable woman with a half hundred waists boasts that there are no two alike."[16]

Edith Stokes was a woman of independent means, the daughter of Robert Brown Minturn Jr., heir to a New York shipping fortune. From 1912, as president of the New York Kindergarten Association, she would

19 | *Mrs. Edward L. Davis (Maria Robbins) and Her Son, Livingston Davis, 1890*

become a keen advocate for the improvement of elementary education.[17] Her husband, Isaac, was an architect and scholar from a wealthy and progressive New York family, yet in the portrait he is completely overshadowed by his confident, liberated wife.

When Sargent's portrait was exhibited at several venues in America, some critics objected to the emphasis on costume. Charles Caffin described the painting as "a brilliant interpretation of the lady's white starched skirt, blue jacket and gray shirt . . . but the superficiality of the conception makes itself felt with a suggestion almost of annoyance that so much cleverness should have been expended to such trivial purpose." James Montgomery Flagg produced a caricature of the painting showing the couple as a pair of tailor's dummies, bearing the inscription "These Stylish Suits, $49.98." Nevertheless, at least one critic approved of the female figure's confident demeanor, describing Edith as "The American Girl herself."[18]

In 1906 Howard Chandler Christy predicted that the American Girl would become "a veritable queen of the kingliest of races."[19] Although she may have embodied an essentially white, nationalist, bourgeois ideal, the American Girl and the more activist New Woman also represented the universal struggle for equality among women. As an American based in London, and as someone who was extremely private about his own sexuality, Sargent existed on the social periphery and naturally sought the company of those who flouted convention. He admired active and vivacious women, and in his art he celebrated those who forged an independent path — from writers and artists such as Kit Anstruther-Thomson or the Wertheimer girls, to feminists, liberal reformers, and career women such as Martha Carey Thomas or Elizabeth Garrett Anderson. Above all, however, it was through their dress that he expressed and celebrated the newfound confidence and sense of empowerment of the New Woman.

20 | *Mr. and Mrs. I. N. Phelps Stokes*
(Isaac Newton Phelps Stokes and
Edith Minturn), 1887

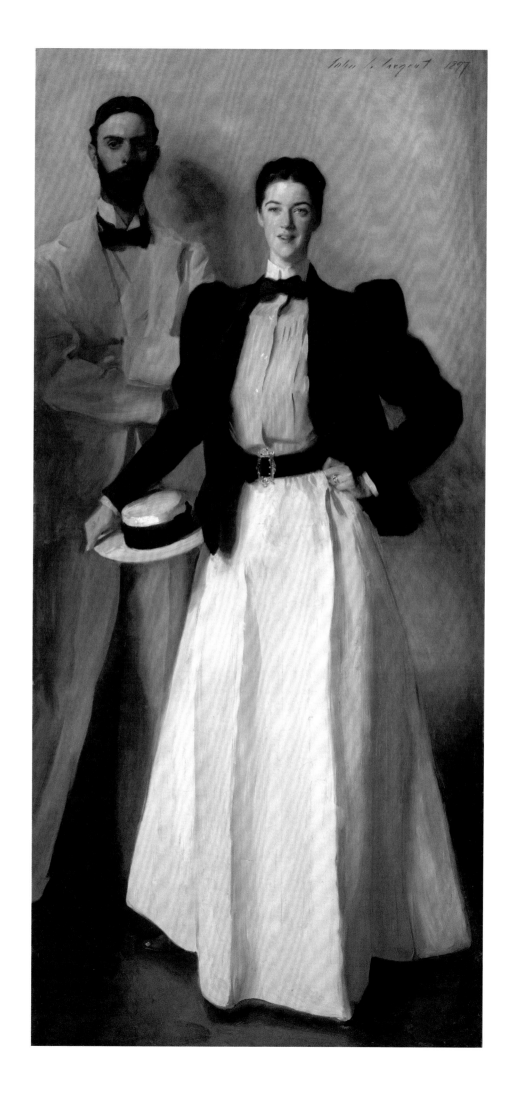

Mrs. Hugh Hammersley | James Finch

THINK OF A CHERRY-COLOURED VELVET FILLING HALF
the picture — the pale cherry pink known as cerise — with mauve lights,
and behind it pale yellowish draperies and an Aubasson [*sic*] carpet under
the lady's feet."[1] Thus the writer George Moore instructed his readers to
visualize Sargent's *Mrs. Hugh Hammersley (Mary Frances Grant)* (**21**). The
sitter wears a cherry silk velvet evening gown, its train carefully arranged
to spread across the bottom left corner of the canvas and spill beyond it.
The dress's complex network of creases is conveyed through the "mauve
lights" described by Moore, creating a structure of lines crisscrossing the
dress. In brilliant flickers of white, Sargent captures the light catching
on the metallic threads of the lace collar and hem embellishment. It is a
bravura performance.

When the painting was first exhibited at the New Gallery in 1893,
the sitter's dress was a lightning rod for opprobrium from art critics in
the British press, almost all male. They labeled it with adjectives such as
"decadent" and "violent," a language of threat and distaste that reflects
critical resistance to the presence of new fashions in portraiture.[2] The
unnamed reviewer of the *Times* described the dress as "red mauve, only
one shade removed from something aniline and terrible, but that shade
all-important."[3] These words convey discomfort with the colors produced
by synthetic dyes based on the chemical compound aniline, which by the
1890s had become highly popular but were often criticized as gaudy.

Technical analysis of the surviving fragment of the dress worn for the
painting shows that the color was created primarily through a mixture
of mauveine (one of the first aniline dyes) and cochineal (a natural dye
derived from insects), with the addition of other synthetic dyes (**22**).[4]
Sargent represented the color faithfully, painting it in a red lake pigment
over a light gray ground to imitate the velvet's brilliant saturated color and
shimmering weave.[5] For the *Times* reviewer to refer to an "all-important"
shade which distinguished the dress from "something aniline and terrible"
was therefore to compliment both the color of the dress and Sargent's

21 | *Mrs. Hugh Hammersley*
(Mary Frances Grant), 1892

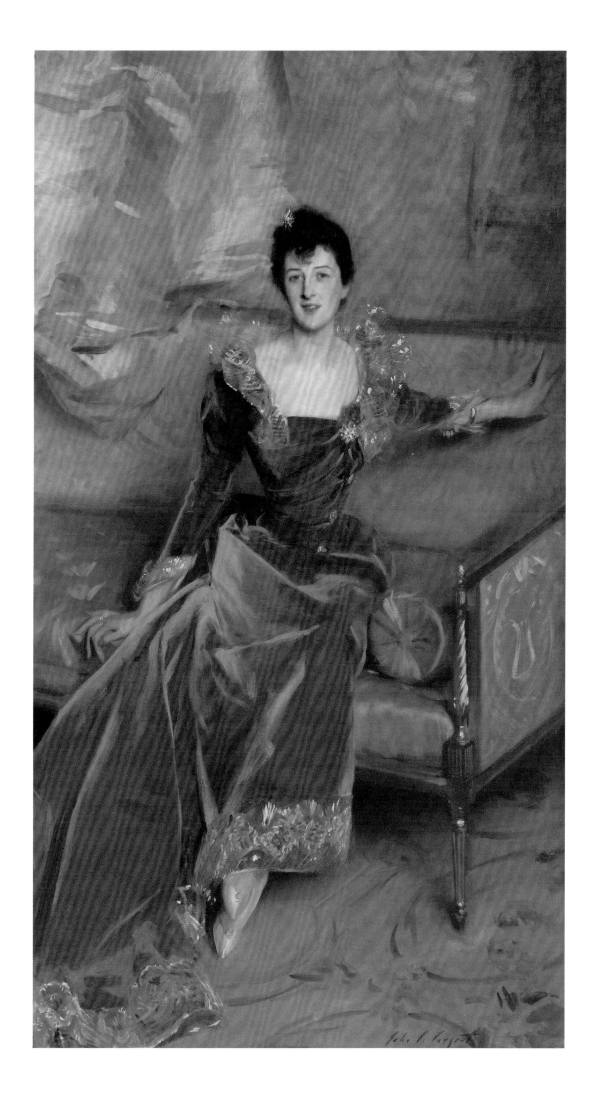

rendering of it. It was also an indication of the fine margins by which a dress was judged to have succeeded or failed.

When first exhibited, *Mrs. Hugh Hammersley* invited comparison with Sargent's other attention-grabbing exhibit in 1893, *Lady Agnew of Lochnaw*, which was displayed at the Royal Academy (see **12**). Elegant and restrained, *Lady Agnew* found favor with a London press that had previously been critical of Sargent.[6] The portrait, in which Lady Agnew wears a white silk gown with a lavender sash, was praised as a departure from Sargent's earlier work, as it was "finished to a degree hardly common" in his oeuvre and showed he had "abandoned his mannerisms."[7] However, if *Lady Agnew* (which continues to be among Sargent's best-loved portraits) was widely praised, *Mrs. Hugh Hammersley* was far more divisive. Even in the process of anointing it "picture of the year" in 1893, the *Times* critic noted that it was "a very apple of discord to the critics, so sharply does it divide opinions."[8]

This discord can be seen in the divergent responses to the lively, restless quality of the portrait, a characteristic of Sargent's work since his early portrait of Fanny Watts, and one that he would continue to display in subsequent works such as *Mrs. Carl Meyer and Her Children* (see **7, 65**).[9] Kit Anstruther-Thomson, writing to Vernon Lee about the "cracking success" of Sargent's 1893 exhibits, captured this impromptu quality most vividly: "Mrs Hammersley has just sat down on that peach coloured sofa for *one* minute — she will be up again fidgeting about the room the next moment, but *meanwhile* Mr Sargent has painted her!"[10] The critic of the *Times* focused on the painting of Mrs. Hammersley's head (which Sargent repainted sixteen times before he was satisfied), writing that it "vibrates with life; never has the spirit of conversation been more actually and vividly embodied."[11] However, G. F. Watts, one of the senior Academicians upstaged by Sargent at the Royal Academy in 1893, asserted that the vitality of the painting was more suited to humorous sketches than to a portrait, which was "something to be always before one & should be more or less monumental in character."[12]

Connected to Watts's contention that Sargent painted in a way more suited to caricature than portraiture was George Moore's view of the portrait as "the apotheosis of fashionable painting" rather than serious art.[13] Moore acknowledged the technical accomplishment of the picture, and its success in appealing to both audiences and artists, but considered the painting "essentially a picture of the hour" rather than an artwork that would retain its appeal as fashions changed. His review of the painting ended by forecasting a day when "many will turn with a shudder from its cold, material accomplishment."[14] The critic, who like Sargent studied painting in Paris, peppered his text with French words: the painting reminds him of "a *première* at the Vaudeville with Sarah [Bernhardt] in a new part. Every one is on the *qui vive*. The *salle* is alive with murmurs of approbation." Most tellingly, Moore describes Sargent's painting as "*l'article de Paris*"— a term referring to the newest Parisian fashion.

By incorporating references to French culture into his critique of Sargent's portraiture, Moore betrays the suspicion of Continental influences

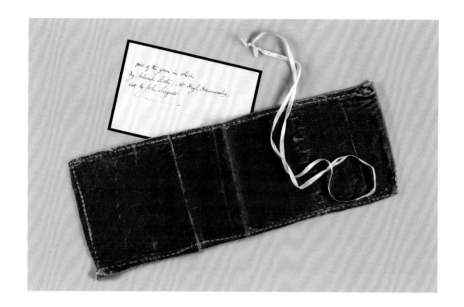

on the artist that continued even as he gained acceptance within the British art establishment. Following Sargent's election to the Royal Academy as an Associate Member in 1894 (paving the way to his election as a full Academician in 1897), the *Sunday Times* critic stated that *Lady Agnew* had made his election "practicable" by demonstrating to the Academy "evidence of solidity and seriousness of purpose." *Lady Agnew*, as a painting demonstrating the bona fides of an Academician, was pointedly contrasted with *Mrs. Hugh Hammersley*, which demonstrated (with reference to Sargent's teacher in Paris) "the Carolus Duran influence pure and simple," and, by implication, the lack of substance characteristic of French art.[15]

Mrs. Hammersley, who in 1889 had married the banker Hugh Greenwood Hammersley, took a keen interest in contemporary art. She regularly hosted artists such as Walter Sickert and Augustus John (in addition to Sargent) and promoted their careers, and there is no doubt that the Hammersleys desired a modern portrait. Mrs. Hammersley noted that Sargent was selected for the commission in preference to the Scottish painter John Pettie, whose portraits tended to present their subjects in period costume or in explicit homage to historic portraiture.[16] Perhaps to balance — or to set off — the boldness of Mrs. Hammersley's dress, Sargent took care to situate his sitter in a familiar (and also French) context, which is accorded more prominence here than is usual in his portraiture. In Sargent's studio, Mrs. Hammersley sat on a Louis XVI sofa placed on an Aubusson carpet and surrounded by golden drapery. With these furnishings Sargent evoked both the vogue for French eighteenth-century design in London at the time and Old Master painters such as Van Dyck and Gainsborough, in whose lineage he was so often placed. Even in the gown itself, the impact of the cherry velvet is tempered by the lace collar that frames the subject's face. If *Mrs. Hugh Hammersley* was guilty, in the eyes of its detractors, of jettisoning elegance and grandeur to accomplish "the apotheosis of fashionable painting," Sargent's choice of furnishings evokes the grand tradition. They provide the armature upon which the portrait is constructed, allowing it to transcend the fashion of the moment.

Transnational and Transatlantic

ANDREW STEPHENSON

*S*ARGENT'S SUCCESS BUILT ON DEMAND FOR HIS portraits from a growing cosmopolitan clientele primarily based in France, Britain, and the United States. The early reception of Sargent's work was complicated by his American nationality and his expatriate European existence. It was Sargent's Parisian training, from 1874 to 1877, that allowed French critics to claim him as one of their own, comparing Sargent's early works with paintings by leading French academic painters, notably his teacher, Émile-Auguste Carolus-Duran, and to Édouard Manet.[1] For their part, some English critics berated Sargent's Francophile technique as a sign of his disengaged cosmopolitanism — "the French method as learned by a clever foreigner"— while American critics positively evaluated his work as "French through and through," befitting an expatriate painter of the Franco-American school.[2] Sargent's artistic affiliations and his work's national identity became particularly contested in the late 1880s, as his career extended to the United States at a time when that nation was mounting an imperial challenge to Britain and France, with growing cultural aspirations. As portraiture was being updated to fit the contemporary tastes and fashion sense of plutocratic elites, Sargent's East Coast sitters were eager to be depicted as distinctively American, although captured in a sophisticated French manner that registered their individuality and modernity. At the 1900 Paris Universal Exposition, when Sargent was placed alongside James McNeill Whistler as the cofounder of a modern American school, his works' French styling was re-evaluated by American cultural nationalists as both the hallmark of a cosmopolitan luminary and the emergence of an eclectic and independent American art.[3]

Following his Parisian art training, Sargent exhibited a portrait of his teacher Carolus-Duran at the 1879 Salon to great success. He also cultivated the expatriate American community in Paris as patrons alongside a circle of leading French artists and writers such as Édouard Pailleron,

23 | *Pauline Astor, 1898–99*

57

whose portrait he painted in the same year (see **31**). The French poet and playwright is depicted with his head and hands dramatically illuminated in a manner reminiscent of Diego Velázquez or Frans Hals, both artists much admired by Carolus-Duran and Sargent.[4] Pailleron wears working-class garb, described by his daughter as "un veston de travail et chemise de soie ouverte"— a work jacket and a loose-fitting, crimson-edged, open silk shirt with sewn-in neck strings, in the Bohemian or Romanian style. Similar coats made of moleskin or velour were worn by country laborers, and the shirt, though made of silk, is reminiscent of a traditional agricultural worker's shirt or smock. Standing with his left hand on his hip and carrying a well-read book in his other hand, Pailleron's studied air reinforces his status as a member of the Parisian intelligentsia. The finely judged characterization is sharpened by the astute observations of an expatriate artist, of how claims to bohemianism by a middle-class Parisian writer could be reinforced through sartorial appropriation. The traditional rural worker's jacket and simple shirt not only signal the writer's claimed proletarian affiliations, but also function as key components in the construction of the modern bohemian look.

Following the bankruptcy of the leading French bank, the Union Générale, and the subsequent stock market collapse in February 1882, the decline of the French art market had dire consequences for artists. As Édouard Manet wrote to his fellow artist Berthe Morisot in March 1882, "Business is bad. All these financial events have almost cleaned everyone out and painting is feeling the effects."[5] Sargent was also affected by these events, lamenting in 1885, "since the last three or four years I have been more or less up and down of prosperity: just now I am rather out of favour as a portrait painter in Paris."[6] Prompted by the positive reception of his recent work in London and encouraged by Henry James to relocate to England, Sargent moved to the British capital in the summer of 1886. Having exhibited at the Royal Academy, the Grosvenor Gallery, the Fine Art Society, and the recently formed New English Art Club, Sargent calculated that with the success of some recent "portraits done in England . . . there is perhaps more chance for me there as a portrait painter." The artist was aware that his Parisian training and French style, and his selection of the French Salon as his principal exhibiting forum, inflamed the prejudices of English critics, and he recognized that "it will be a long struggle for my painting to be accepted."

Adapting Sargent's French painterly style to British aesthetic preferences was more than a matter of artistic technique. In 1885, Henry James had told Vernon Lee that Sargent knew that many of his English female sitters were worried lest he make them "too eccentric looking" by London standards.[7] The London *Art Journal* critic reviewing Sargent's work at the 1886 Royal Academy summer exhibition echoed this concern, stating that "his colouring and composition are both eccentric," resulting in "a certain *chic* about his portraits."[8] The elegant fashionability of Sargent's French portraits needed to be reconfigured for London patrons, who expected their portraits to demonstrate greater restraint. English taste in dress

24 | *Mrs. William Playfair*
(Emily Kitson), 1887

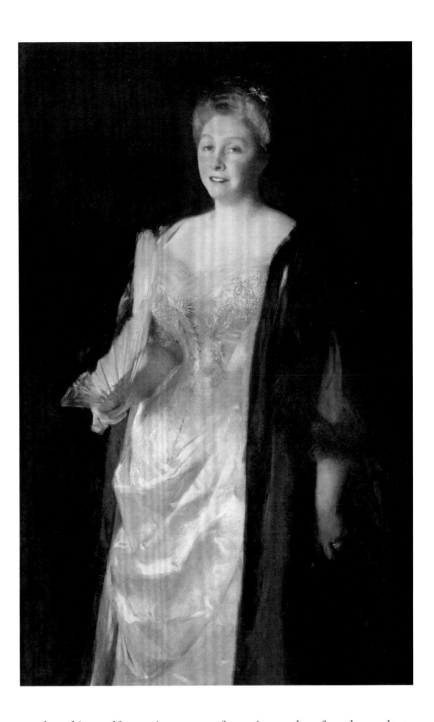

was based in a self-conscious sense of occasion, and preferred a modern, understated elegance to what could be perceived as the overly ostentatious and fussy chic of the Continent. Nevertheless, the internationalization of the high-class fashion market in the second half of the nineteenth century, with Paris at its center, granted wealthy elites in Britain and the United States familiarity with the latest fashions from leading couture houses such as Worth, Paquin, Doucet, Pingat, Callot, and Poiret.[9] Along with retail outlets in fashionable French resorts and on the Riviera, many Parisian couturiers also opened offices in London, while the London-based firms Lucile Ltd. and Redfern established branches in Paris.[10]

The English-born Charles Frederick Worth built his fashion house by courting aristocratic French, British, and Russian patrons and wealthy American buyers, tailoring the latest Parisian models to the varied tastes

of his exclusive cross-Channel and transatlantic clientele. These national preferences informed Worth's selection of materials, finishings, and accessories, as well as which historical designs and fabrics to use in the revival of seventeenth-century or eighteenth-century styles. For example, while Second Empire French courtiers favored Worth's *style tapissier* (upholstery style), with its profusion of fabrics and elaborate trimmings, flounces, and decorations, aristocratic English women found it too ostentatious and overblown for British court etiquette, where an elegant formality prevailed.[11] American patrons, by contrast, were sometimes more extravagant in accessories than their European counterparts, especially when sporting opulent jewelry as daywear rather than saving it for evening ensembles.[12]

When in 1887 Sargent exhibited *Mrs. William Playfair* at the Royal Academy Summer exhibition, the majority of English critics agreed that Sargent had successfully modulated his Continental portrait style and mitigated his "eccentric manner" (**24**). The *Saturday Review* critic praised the portrait for making "no resort to false, trickily-effective reliefs or mannered system of colouring."[13] R. A. M. Stevenson, in the *Art Journal*, commended Sargent for producing "a portrait [that] lays itself open to little adverse criticism, even from those who do not sympathise with the painter's style," and saw its positive reception as evidence that Sargent had "conquered the fresh country."[14] In this portrait, Sargent demonstrates his recognition of the English preference for a more reserved form of presentation, deportment, and dress. The wife of a famous British obstetrician, Emily Kitson Playfair is depicted in a bejeweled pale yellow silk satin evening dress worn under a dark green fur-trimmed opera jacket, as if about to embark on a night out. She wears understated jewelry comprising a dragonfly hair ornament and ring on her left hand, and carries a feathered fan in her right hand and an evening bag in the other. English critics particularly complimented the elegant choice of costume and they praised Sargent's skill in rendering its shimmering surfaces and subtle texture; in the periodical *Academy*, Claude Phillips applauded Sargent's treatment of its colors, noting the "peculiar juxtaposition of the dark green mantle which half-covers the yellow-white satin of the lady's dress, with the wine-colored background being something of a novelty."[15] And the *Saturday Review* critic concluded that it was "the finest piece of painting in the Academy," congratulating Sargent's portrait for its "quiet power of fascination," "the admirable relation of the figure to the background, [and] the finesse and brilliance of the flesh."[16]

Aware of expanding opportunities in the United States, especially for paintings in a modern French idiom, Sargent had already joined leading American art associations such as the Society of American Artists, whose membership comprised a rising generation of progressive American artists, many trained like Sargent in Paris in the 1870s. To advertise his French credentials, Sargent exhibited *Fishing for Oysters at Cancale* (1878, MFA) at their first show in 1878 after showing an almost identical version at the Paris Salon that year, and at the SAA's third annual exhibition in 1880 he showed his portrait of Carolus-Duran (**25**). The painting's cultural

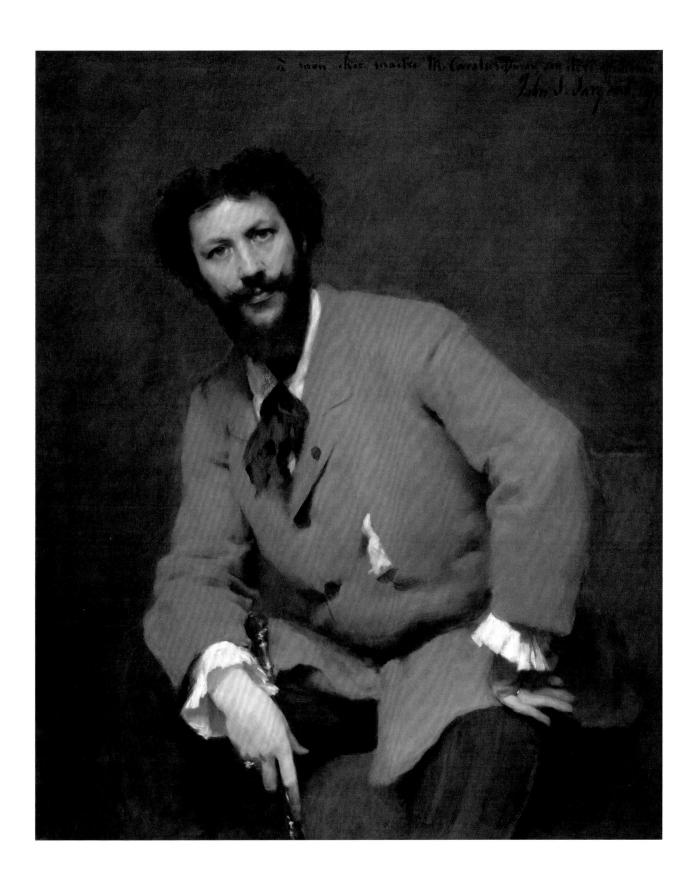

Carolus-Duran (Charles-Émile-Auguste Durand), 1879

affiliation registered with the American critic Mariana Griswold van Rensselaer, who declared that the Sargent portrait "is French work through and through."[17] Once again, differences in European and American dress conventions, this time for men, emerged in the portrait's transatlantic reception. While the painting was celebrated for its daring stylishness in Paris, the *New York Times* writer found that Carolus-Duran's fancy lace cuffs, striped trousers, "jaunty cravat," and decorative handkerchief registered to "sober Americans" a distinct "lack of manliness" resulting in an "effeminate effect . . . a little on the order of the fops."[18]

To capitalize on the growing American demand for modern European art, alert European dealers negotiated informal trading arrangements or formal collaborative alliances with American dealers.[19] One of the first transatlantic dealerships was Goupil & Cie, of Paris and London, which opened a New York branch, Goupil, Vibert & Co., in 1848. Sold to Michael Knoedler in 1857 and renamed the Knoedler Gallery, by the late 1870s the firm conducted a significant transnational business. With branches in Paris, London, New York (and, from 1897 to 1907, Pittsburgh), M. Knoedler & Co. would become Sargent's main dealer.[20] Paul Durand-Ruel, another Paris dealer, operated a Manhattan gallery and auction house in conjunction with the American Art Association from 1886, and in April 1887 opened his own New York gallery.[21] By 1889 Durand-Ruel was catering to a wealthy American clientele from a Fifth Avenue showroom, with Sargent facilitating introductions to American collectors eager to purchase works by Monet and other modern French artists, and both dealer and artist advising American buyers and museums on potential Old Master purchases. For example, in 1904 Sargent liaised with the Spanish painter Ricardo de Madrazo on the purchase of El Greco's portrait *Fray Hortensio Félix Paravicino* (1609) for the Museum of Fine Arts, Boston.

The Duveen Brothers, dealers in Paris and London, also shipped European fine and decorative arts across the Atlantic to wealthy American collectors eager to remodel their modern interiors with period fittings, European antiques, and *objets d'art*.[22] Their first New York gallery was established in 1877, a second gallery opened in 1886, and by 1912 they had relocated to 720 Fifth Avenue, close to the Metropolitan Museum of Art.[23] British dealers particularly targeted American buyers after 1892, when the London art market contracted because of financial and banking scandals.[24] By March 1893, as the dealer David Croal Thomson recognized, "things [were] very bad in London & they will not be better for some time yet."[25]

The challenging conditions of the London and Paris art markets contrasted with the surging demand from wealthy American buyers for modern art painted by leading European-educated artists.[26] Expanding transatlantic passenger and freight shipping in the late nineteenth century increased the traffic of art between Europe and North America, and increased opportunities for wealthy American elites to travel, encountering the latest European styles in art and fashion. In September 1887, Sargent arrived in Boston for his first professional visit to the United States, also staying in Newport, Rhode Island, and later New York. Sargent's arrival

boosted his reputation as America's leading portraitist: the *Boston Evening Transcript* called him "one of the most famous of living American artists," even though Sargent was not native-born, and asserted that "his unusual success as a portrait painter in Paris and London has been fully merited."[27] Sargent's presence increased demand for American portraits executed by an American painter, resulting in commissions from East Coast patrons, many of whom were family members or close friends, along with expatriate Americans the artist had met in Europe. Even though Sargent had spent little time in the United States, he benefited from the belief that American artists were naturally better equipped to capture the social distinctions and cultural nuances of the Boston and New York Gilded Age elites. His first solo Boston exhibition, at the prestigious private-members St. Botolph Club from January 28 to February 11, 1888, marked what the artist recognized as "a turning point in my fortunes."[28]

Yet American critics still remained uncertain about how distinctively "American" Sargent's portraits were. One saw his "irreverently rapid, off-hand, dashing manner of clever brushwork" as overly expressive and derived from his French training, and reminded the artist that Boston "prides itself on an art culture very different from that of the contemporary Salon."[29] Others detected in Sargent's American portraits an over-sophisticated presentation indebted to eighteenth-century English prototypes. This courtly style was deemed distinctly un-American, even disrespectful to the colonial heritage of his American sitters: "There is an indefinite, but palpable atmosphere of refinement, ease and — *tranchons le mot* [to put it bluntly] — aristocracy, or whatever stands for it these days."[30] In support of Sargent, some American critics detected a direct lineage back from Sargent's work to the celebrated Boston portraitist John Singleton Copley, "the country's first 'old master.'"[31] Many of his Boston sitters were descendants of Copley's sitters, as indeed was Sargent himself, and such a connection reinforced their distinctive New England ancestry.

Sargent sailed from New York for England on May 19, 1888, and returned to the United States in December of the following year, renting a shared studio in Manhattan. By the time he left for England in November 1890, Sargent had painted nearly forty portraits of American sitters in New York and Massachusetts, and discussions about a major mural commission at the Boston Public Library were well advanced.[32] Between 1890 and 1910, as demand for Sargent's work soared, he produced 498 portraits of British and American sitters. He showed important works at multiple venues, including the Society of American Artists and the National Academy of Design in New York; the Royal Academy, the New Gallery, and occasionally the New English Art Club in London; and at the Salon and the Société Nationale des Beaux-Arts in Paris.[33] Working at such prodigious scale required Sargent to be especially sensitive to the differing national protocols for presentation, pose, and costume when showing British and French portraits employing elegant European aristocratic or Old Master conventions to nouveau-riche American East Coast audiences. Similarly, when portraits of plutocratic Americans were displayed in London and Paris,

the assured, self-confident presentation favored by many American sitters was viewed as demonstrating a boldness and singularity at odds with the historic portrait conventions and reserved manner preferred by his European aristocratic patrons.[34]

Sargent's double portraits involving mothers and children, for example, show contrasting British and American attitudes toward intergenerational lineages and dynastic formations of family. In *Mrs. Edward L. Davis and Her Son, Livingston*, the subjects' clothing is both informal and distinctive (see **19**).[35] Their poses convey the easy confidence of a well-bred New England family: American critics hailed the painting as "a model of refinement and good taste."[36] By contrast, a work such as Sargent's *The Countess of Warwick and Her Son* (1904–5, Worcester Art Museum), exhibited at the Royal Academy in 1905, employs the compositional formality, elaborate theatricality, and complex historical allusion required by a portrait of English nobility. Sargent shows Frances Evelyn Maynard and her son in a wooded setting; the composition, with the boy seated on a pedestal with pilasters terminating in lion's heads, alludes to eighteenth-century grand-manner portraiture. Their clothing, particularly that of the countess, clad in an evening gown and cloak and wearing jewels, and their poses are correspondingly formal. These two double portraits demonstrate Sargent's attentiveness to the different styling of mother-son relationships in Britain and in the United States and his choice of artistic references to underline such distinctions. For American audiences, Sargent's confident image of a respectable New England family is achieved through the painting's relaxed manner and the mother's self-assured pose and understated informal dress. By contrast, aristocratic British subjects expected a formal image of confident dynastic reproduction, befitting the depiction of a countess and her son and registering their pedigree.

In his portrait of Pauline Astor, Sargent took on the challenge of how to represent a glamorous female type that had only recently emerged on the social scene (**23**).[37] Beginning in the 1870s, male British aristocrats began to seek out wealthy American heiresses as brides. Creating portraits of these "dollar princesses," as they were known, required attention to differences in self-presentation in Britain and the United States.[38] It was important to avoid depicting these American women in an overly self-assured or flamboyant manner in which artfulness and artifice would register as a charade of elegant restraint and refined taste — features that the writer Roger Fry derided as "the effrontery of the arriviste."[39] Consequently, Sargent was careful not to paint them wearing ultra-fashionable, chic attire that conveyed risqué stylishness. He also avoided exaggerated make-up, overly tight corsetry, or a revealing décolletage that could suggest an eroticized artfulness rather than beauty naturally enhanced. Sargent preferred his sitters in monochrome fabric, often black, gray, or white, and left off "hard-glittering jewelry" that could be taken as a brazen and gauche display of nouveau-riche wealth.[40]

Sargent's choice of English art-historical precedents underscored the Astors' Anglophile aspirations and mitigated against the prevailing English

stereotypes of the dollar princess as a nouveau-riche social climber, gauche intruder, or outspoken New Woman. He depicts Pauline in a white silk evening gown with accessories for outdoor wear, a lilac silk shawl trimmed in fur and an ermine muff. The ensemble is completed by a lilac and white *bouquet de corsage*, triple strands of pearls, and a flower spray in her hair. She is accompanied by the family pet, a King Charles spaniel, who playfully tugs at her shawl. The portrait was finished after her father, the New York financier William Waldorf Astor, had inherited a vast fortune in 1890 and relocated his family to England; he became a British subject in 1899 and a peer in 1916. Sargent places Pauline in a picturesque, wooded setting reminiscent of the Astors' palatial country estate at Cliveden Place in Buckinghamshire, situated just above the River Thames.[41] The autumnal landscape refers to Thomas Gainsborough's Grand Manner portraits, such as *Sophia Charlotte, Lady Sheffield* (about 1785, National Trust).[42]

However, Pauline Astor was not your typical dollar princess. An article entitled "A Prince, 2 Dukes, 2 Girls and $40,000,000" in the *New York Journal* in October 1897 reported on the pursuit of two of the richest American heiresses, Pauline Astor and May (Mary) Goelet, by aristocratic

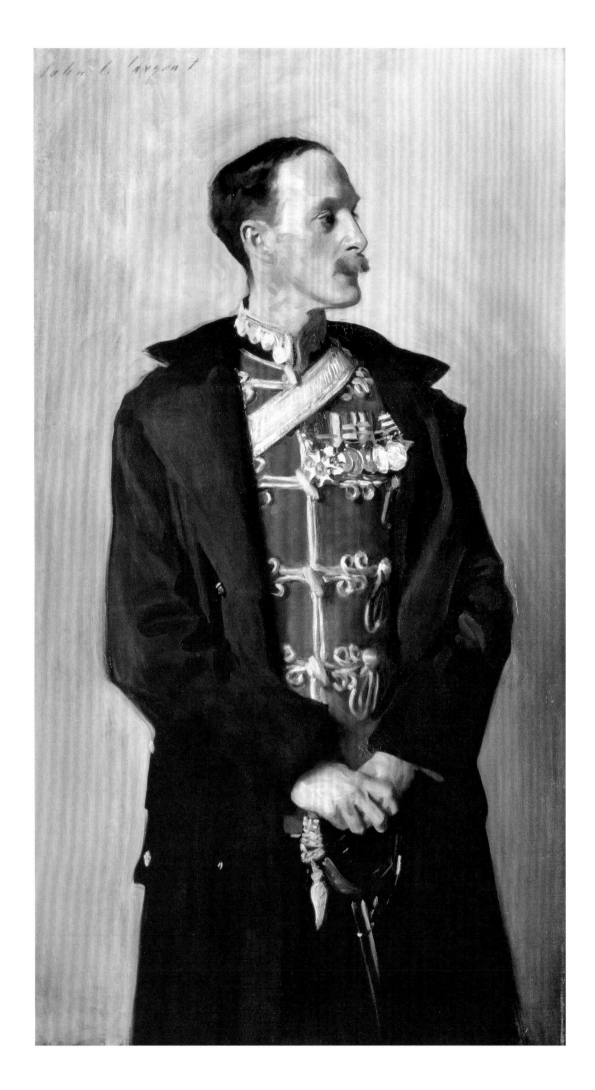

British suitors (**26**).[43] While May's family were cosmopolitan expatriates, Pauline had been brought up in the United States. Her Anglophile father had employed English tutors who groomed Pauline practically from birth in upper-class English etiquette and taste. Consequently, the newspaper article states that in American eyes the heiress had "none of the ways that are conventionally attributed to Americans by ordinary English people. You could not tell she was not English." Yet Pauline was decidedly not Anglo-English in looks, as the writer observed: "Her complexion is olive and her eyes large, dark and lustrous. She promises to be a very fine type of what is generally called Spanish beauty." Sargent's portrait, with its English aristocratic styling, carefully underplays these features.

Sargent's choice of restrained self-presentational models for portraits of male British aristocrats led to criticism when they were exhibited in the United States. Unfamiliar with British class distinctions and courtly protocols, many American viewers found Sargent's patrician or military portraits either overly complicated in iconography or lacking in masculine authority. When Sargent's portrait of Colonel Ian Hamilton in full regimental dress uniform was exhibited in London in 1899 and in Philadelphia in 1901, differences in expectations for the presentational styling of military leaders were exposed (**27**). The British *Art Journal* applauded Hamilton's impressive manly bearing and refined physiognomy, epitomized by "the muscular jaw and throat" and the way "the chin shoots out in challenging disdain," seeing Sargent's characterization as personifying British imperial endeavor: "The pose is essentially dramatic, and the picture might be labelled 'Imperialism.'"[44] By contrast, the portrait's reception at the Pennsylvania Academy of the Fine Arts was less laudatory, with American critics deploring Hamilton's lack of masculine authority in the way the uniform overshadowed the individuality of its wearer, and deriding "the pathetic force of the gauntly, sick subject."[45]

Differences in appreciation re-emerged when the portrait of Charles Stewart, Sixth Marquess of Londonderry, was exhibited across the Atlantic. Sargent presented Londonderry in a mode befitting the ceremonial occasion, the coronation of Edward VII in Westminster Abbey in August 1902 (**28**). Londonderry's mantle of crimson velvet, edged with miniver, and his cape trimmed in ermine signaled his status as a marquis of the realm. The peer wears the Privy Councillor's full-dress uniform, with white breeches and stockings, bedecked with medals, the Bath star, the Garter collar and star, and the Garter below his left knee. Behind him, his page carries his train and coronet.[46]

For an American audience, the finer points of Londonderry's ceremonial costume and regalia would not be well understood, and the courtly protocols and strict codes of deportment that directed Londonderry's performance would have seemed odd and old-fashioned. When compared with Sargent's relaxed depiction of the American oil tycoon John D. Rockefeller, Sr., the Londonderry portrait registered as pretentious and academic, carrying outdated connotations of history painting.[47] Rockefeller, one of the "Trans-Atlantic Midases," as the most affluent self-made

27 | *Colonel Ian Hamilton, C.B., D.S.O.,* 1898

men in the United States were known, is seated in a simple wooden chair in a relaxed pose, with hands on his lap and legs crossed (**29**).[48] To English viewers, Sargent's casual styling of the modern American man of business in a blue serge coat, with light-colored vest and trousers, simple collar, and knotted tie, was too unstudied and easygoing.[49] Similar criticism would have been directed at Sargent's portrait of President Woodrow Wilson from the same year for its depiction of the president in casual dress and informal pose, attired in a black frock coat and gray trousers and seated in a simple chair set against a dark curtain (**30**). The portrait was denounced as "undistinguished" by the *Saturday Review* critic when shown at the RA Summer show in May 1919.[50] To English eyes, it failed to achieve the haughty demeanor, imposing presence, and formal gravitas that were deemed appropriate to the presentational styling of the twenty-eighth president of the United States.[51]

Following Sargent's death on April 15, 1925, French, British, and American art writers evaluating his legacy tried to position him in relation to their respective national schools. Not unsurprisingly, French commentators stressed his École des Beaux-Arts training and his works' indebtedness to modern French painting. British writers focused on his extended residence in London and his achievement as a successful Royal Academician. And American cultural nationalists, especially eager to assert Sargent's Americanness, sought to detect in his painting the signs of a distinctive American art worthy of the nation's exceptional status and imperial ambitions.[52] However, his portraits' French technical virtuosity, their sophisticated art-historical allusion to English prototypes, and their updated presentational models fashioned to suit plutocratic American tastes complicated any easy national classification. Critics wary of Sargent's genteel cosmopolitanism, unimpressed by his formulaic Grand Manner modeling, and put off by the opulent and now outdated foreign haute couture favored by so many of his transatlantic patrons, hastened the rapid decline in Sargent's reputation in the following decades. However, as the critical models of modernism and formalism were challenged beginning in the 1960s, Sargent's achievement was reassessed and his dazzling artistic skill, his bravura brushwork, and his portraits' suggestion of penetrating psychological insight were once again applauded. Sargent's transnational success demonstrated how he had astutely navigated the expanding worlds of art and fashion, producing daringly modern and glamorous portraits that deployed haute-couture fashion to update European Grand Manner portraiture in ways that captured and flattered his wealthy transatlantic patrons.

28 | *Charles Stewart, Sixth Marquess of Londonderry, Carrying the Great Sword of State at the Coronation of Edward VII,* 1904

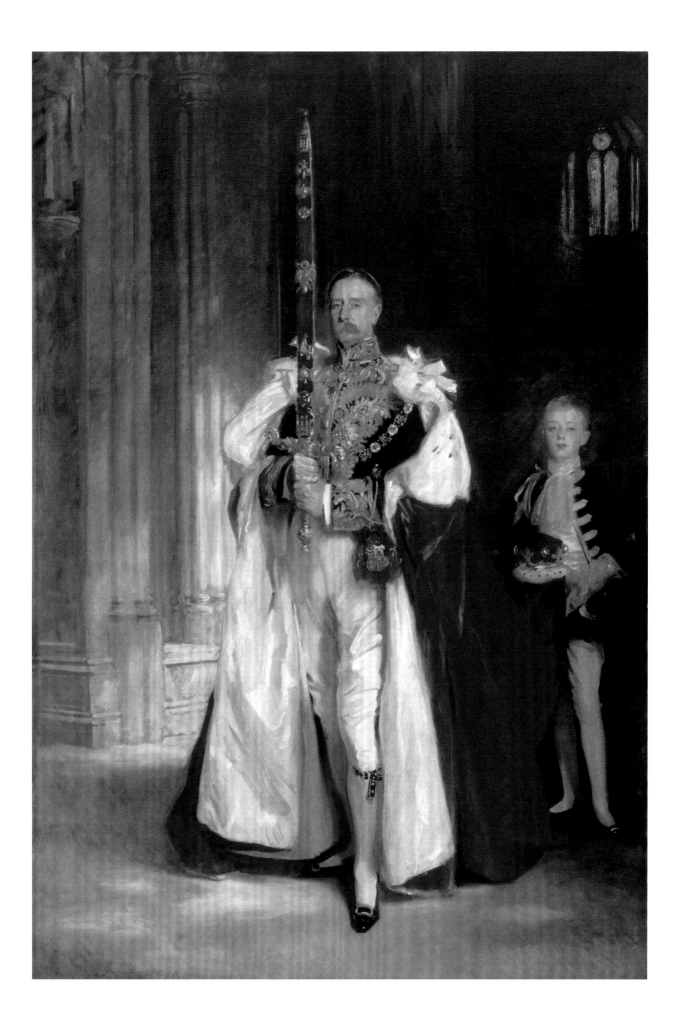

Portraits as Performance

ERICA E. HIRSHLER

ARGENT'S PORTRAITURE WAS A PERFORMANCE.
He crafted more than keepsakes and likenesses: he made his sitters fit to
be seen, styling them to make a public impression, on the walls of a presti-
gious art exhibition and in their own parlors, dining rooms, or (sometimes)
grand halls. Decisions about setting, pose, and costume were negotiated
between the artist's aesthetic desires and his sitters' expectations, and they
reveal much about the person depicted. But who made those final choices?
Who ultimately controlled the image? In most cases, and in his best work,
it was Sargent. He was the director; his sitters did what he asked, includ-
ing wearing clothes that he selected for them, sometimes not their own. He
held power over his subjects. "They're willing to let Sargent take liberties
with them," wrote Edith Wharton in her 1904 short story "The Pot-Boiler,"
"because it's like being punched in the ribs by a king."[1]

Some were afraid to pose for him. Others sought out his formidable
acumen, like the publisher Joseph Pulitzer, who, when warned about the
artist's incisive eye, declared, "I want to be remembered just as I really
am, with all my strain and suffering there." Another Wharton story, "The
Portrait" (1899), starts with several members of society discussing the
merits of a fictionalized Sargent, the painter George Lillo. "Don't let [him]
paint you if you don't want to be found out — or to find yourself out," one of
them remarks.[2] Like Lillo, Sargent had the last word. He acted not only for
his clients, but also for himself, constantly seeking to make the mundane
interesting, to turn a description into a work of art. Sometimes he was
daringly modern, at others he echoed the painters he most admired from
the past. His broad, liquid strokes of paint were especially suited to the
swathes of silk and satin that constituted many contemporary fashions,
but he also knew the aesthetic potential of a plain wool suit. He posed and
pinned, arranged and altered, acting as the director of a public display.

That presentation began in the artist's studio or occasionally the
client's home or garden, with sittings (so much more evocatively conveyed

La Carmencita (**36**), detail

in French, the *séance*) that would first establish and then carry out the performance. The process required a period of adjustment between maker and model, resulting in a significant self-consciousness on the part of the sitter. Portrait subjects, keenly aware of being examined, might alter their mood, position, or expression, feeling as if they were in the act of becoming the painting itself. This could create a distinct separation between their everyday identity and their public persona, as an actor metamorphosizes into character onstage.[3] Sargent's sitters — and sometimes even the artist himself — did not always anticipate what the public could (and would) apprehend. Audiences responded to this dramatic irony, grasping what the participants could not see. Critics, both professional writers and interested lay spectators, commented in print and in conversations that were meant to be overheard, sharing their opinions about both the painting and the person depicted. The portrait could serve as a displacement, giving viewers the opportunity to make comments about a person's appearance, character, and dress that perhaps they would not so freely express in the presence of the individual. They reacted as they might have done after seeing one of the modern French plays of the period that, after the manner of novelist Émile Zola, rejected artifice and dissimulation in favor of naturalism and realism, with contemporary plots that explored human behavior and emotion and viscerally engaged their audiences.[4]

Sargent's first stage was in Paris. His cast of characters for exhibition portraits there was dominated by figures in the arts and by Americans, sitters who (like Sargent himself) could be excused from strictly following convention by virtue of their aesthetic temperament or their position at the fringes of Parisian society. For several of them, Sargent created not only a portrait but a persona, capturing their vivacity and movement while also dressing and posing them to recall distinct types, two among them the bohemian and the Parisienne. Both were stock characters identified particularly with the French capital. The bohemian had been invented there in the 1840s, in Henri Murger's stories and play about aspiring artists, writers, and musicians (published as *Scènes de la vie de bohème* in 1851), narratives that inspired creative spirits to come to Paris from around the world. Similarly, the Parisienne embodied the height of French fashion, and her look was imitated everywhere. She had emerged as a type in the 1830s in the essays of Honoré de Balzac. She could even be foreign-born: The novelist and art critic Arsène Houssaye declared that a Parisienne could be created by an aspiring woman "at the first passion or the first trip to Paris, that land of metamorphoses and transfigurations." The prospect of transformation from provincial to Parisienne was magical, implying not only fashionableness but also sophistication, and women from many countries embraced the role. That tolerance was also deliberately useful to the burgeoning French fashion industry, which sought to expand its market globally by using the figure of the Parisienne to promote French design. In his best early portraits, Sargent layered his likenesses with references to these specific characters.[5]

Confidently posed hand-on-hip, Édouard Pailleron projects a studied bohemianism (**31**). He was Sargent's first major patron, commissioning

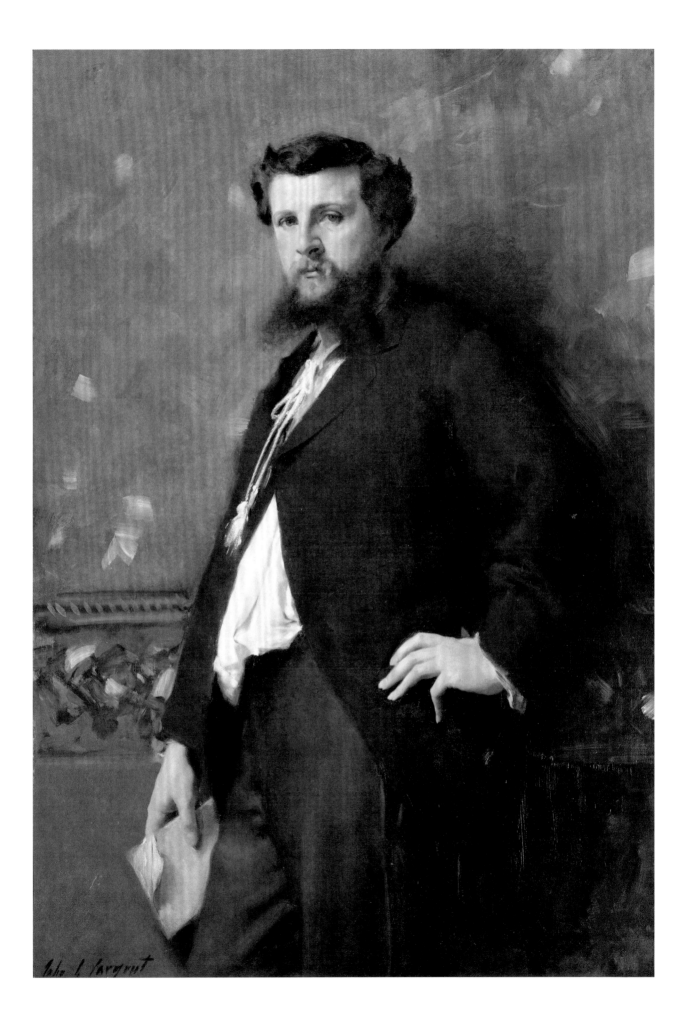

a portrait after seeing the painter's image of Carolus-Duran at the 1879 Salon (see **25**). A playwright, Pailleron was best known for his comedies of manners and marriages, clever satires of contemporary society. When Sargent depicted him, he had not yet achieved his greatest successes, but his entertaining *L'âge ingrat* (The Thankless Age) had just been staged, well received, and published. It centered on two couples and featured a mysterious foreign-born countess named Julia, whose free-spirited salon was a magnet for the husbands. The conceit was reminiscent of actual Parisian social hubs, particularly that of the American hostess Henrietta Reubell, who favored an international group of artists and writers, and where perhaps Sargent could have encountered Pailleron and where he would certainly meet Henry James, himself an occasional critic of Pailleron's plays.[6]

Sargent's portraits of Carolus and Pailleron share casual poses and informal dress, as well as a sly, cheeky elegance. Both convey the attitude of the artistic bohemian, although Pailleron's daughter Marie-Louise later declared that her father had not been "costumed," as Carolus-Duran had been. Pailleron is deliberately nonchalant, slouching against a wall, with his shirt partly untucked and a thin, well-thumbed volume (his play?) dangling from his right hand. Marie-Louise described her father's jacket as a "veston de travail," a work jacket, unstructured, informal, and "un peu débraillé," scruffy. She reported that he wore an "open silk shirt . . . without the ugly starched collar," but this garment seems not to be a conventional one; it has a corded, tasseled drawstring at the neck, and possibly red decorative embroidery. It bears a hint of mystery, perhaps appropriate to a man who had traveled in North Africa as a French dragoon and owned a portrait by Jean-Adolphe Beaucé of himself on horseback wearing a burnous. Marie-Louise recalled that Sargent's painting, "at a time of conformity, astonished . . . the Salon-going public, accustomed to the protocol of [the academic painter Léon] Bonnat, of black frock coats against a background of bitumen. Despite this infraction of the rules, the portrait pleased." Sargent was after a new look, something more modern, relaxed, and perhaps transgressive, but not disturbingly avant-garde. That he succeeded is clear from Jules Claretie's comparison of Pailleron's nonchalant grace to that much-admired master of stylish male portraiture, Anthony van Dyck.[7]

After Sargent captured the bohemian *artiste* in his image of Pailleron, he began his exploration of fashionable Parisian women with Pailleron's wife, Marie Buloz Pailleron, depicting her, as her daughter related, in an "astonishing" manner. Rather than showing her against the customary neutral background, Sargent silhouetted her in a garden setting wearing a stylishly slim dress of black satin (**32**). Although the juxtaposition of Madame Pailleron's dark afternoon dress against the bright green lawn startled many viewers — for, as her daughter admitted, a woman, even an elegant one, did not make a habit of promenading in Savoyard meadows wearing black satin — Sargent had made the unconventional choice because he was utterly focused on picture-making: "He was not concerned,

32 | *Marie Buloz Pailleron (Madame Édouard Pailleron)*, 1879

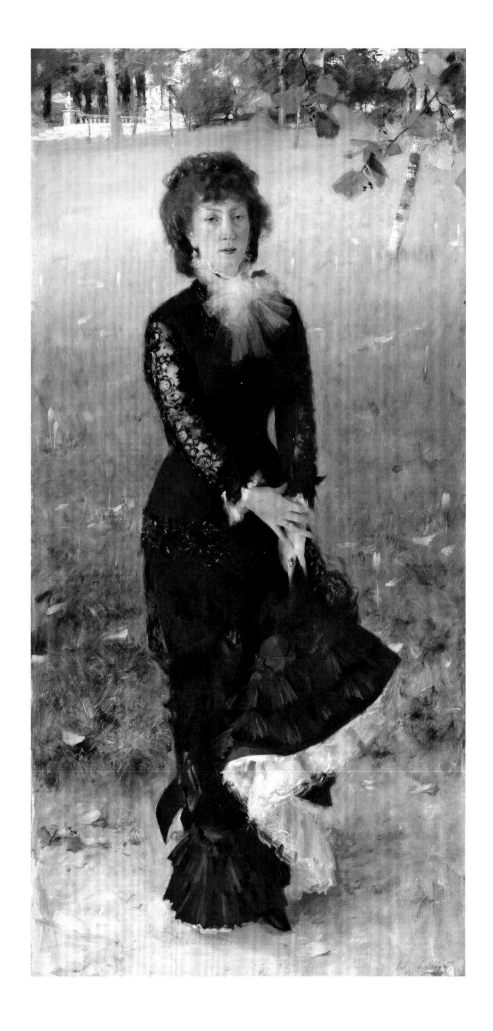

I am sure, with knowing if this dress was that of the hour, but if the tone of the dress emphasized the complexion and the hair of his model."[8] Critics were divided; some admired Sargent's novelty, others decried it. And several writers, both French and American, praised his handling of the dress, but could not help criticizing the woman. "The dress is a superb black, [but] the head and particularly the hair come from a less fortunate painting," remarked Philippe de Chennevières. The American critic Martha Bertha Wright was more caustic, stating that Madame Pailleron "looks as if her hair had not been touched for a week, and whose dim eyes are half closed, either from weakness or drowsiness, it matters not which."[9] Here the perils of the stage are made clear, for it was not only the painting that was under review, but also the performers.

Sargent's portrait of Carolus had attracted Édouard Pailleron, and his painting of Marie Pailleron led directly to a commission for another stylish lady, Amalia Errázuriz Subercaseaux (see **6**). Amalia, daughter of a wealthy and Eurocentric Chilean family, was the wife of Ramón Subercaseaux, a diplomat and aspiring painter. Already admirers of Sargent's work and soon to become personal friends, they were "induced" to commission a portrait after seeing his *Madame Édouard Pailleron* at the Salon. "He came to our apartment to arrange the setting, clothing, and other details," Amalia recalled; "he studied every single detail very carefully and was entirely free to arrange the composition of the portrait as he wished."[10] Sargent presented her as a woman at the height of fashion and staged the sittings in a room furnished in a modern Aesthetic Movement style, with ebonized furniture, blue-and-white tiles, and lilies. Amalia sits, turning away from the piano to engage the viewer, one hand still on the keys; she wears a smart white afternoon dress, its buttoned, long bodice and flounced skirt trimmed with black velvet, ribbon, and lace. Sargent posed her carefully, avoiding (as he so often did) the elaborate, sometimes padded, trimmings that defined the back of such ensembles and judiciously arranging her train to maximum decorative effect, creating a flowing cascade of blacks and whites that complement the setting — the black case and white keys of the piano, the black chair, the creamy white wall and flowers. She looks like a Parisienne, and Ramón noted that an (unidentified) French newspaper attributed the painting's "grace and good taste" to be the result "without a doubt" of the woman's identity as "a real Parisienne." He continued, "It delighted us to mingle with the viewers who were continually in the Salon in front of the portrait, saying amusing things about the painting and the model." However, the prominent critic Louis de Fourcaud, who admired and discussed the portrait at length when it was shown at the 1881 Salon, disagreed, remarking that the lady, chic as she was, appeared not to be French, describing her instead as a foreigner already disenchanted by society parties.[11] Once again, attention was drawn to the sitter.

Fourcaud's remark draws attention to Madame Subercaseaux's role in public Parisian circles. She is clearly *à la mode*, but perhaps not at center stage. She was not really a Parisienne, at least to her French audience. By the early 1880s, in the increasingly nationalist and imperialist period

following the Franco-Prussian War, general acceptance of foreigners into the ranks of Parisiennes had significantly diminished, and unmitigated praise for stylish, public figures would most often be reserved for French women.[12] Thus when Sargent's *Madame Subercaseaux* appeared at the Salon, the concept of a Parisienne who was not French was too much for some to accept, an omen of the reception his *Madame X* would receive three years later. Sargent won a medal for his portrait of Amalia, a great honor for the 25-year-old artist, but the prize was immediately transferred to his other submission, a double portrait of the Paillerons' two children (1881, Des Moines Art Center). The change came, according to Ramón Subercaseaux, at the instigation of an irate Édouard Pailleron, who felt that this foreign-born Parisienne, "a stranger and an unknown," could certainly not be honored over the portrait of his children. Eventually medals were bestowed on both paintings, but the nationalist view of the impossibility of a Parisienne *étrangère* remained. When a writer for *L'Illustration* complained in June 1881 that Americans were beginning to assert themselves too strongly, he remarked that "their painters, like Mr. Sargent, take away our medals," no doubt a reference to that year's Salon and *Madame Subercaseaux*.[13] A contract had been broken, the audience no longer accepting, as they might when attending the theater, a willing suspension of disbelief. The difference between native and foreign was not visible on the canvas, but here, insistence upon truth over fiction outweighed a successful performance.

Sargent staged Édouard Pailleron and Amalia Subercaseaux in natural settings and poses, wearing realistic garments; despite their roles, neither seems overly dramatic or mannered. Both were simple commissions. With Samuel Pozzi and Virginie Gautreau, sitters whom Sargent pursued for his own purposes, the painter unleashed his taste for the overtly theatrical. In both cases, the figures definitively pose, entirely aware of the characters they play. Pozzi, a surgeon who sometimes practiced in public (in the appropriately named operating theater), stands before a bundled red drape, the composition conflating public and private: the doctor simultaneously acknowledges his audience, hand on heart, upon a curtained stage, but he also stands guard before a shadowed entrance to invisible private quarters (**33**). An art collector and friend to writers, actresses, and poets, here he has gone beyond the casual, artistic nature of the bohemian into something akin to decadence. Gautreau, for her part, acts as the ultimate Parisienne. She tenses and torques in a pose evoking the purity of line in classical sculpture, as if she were performing in a tableau vivant (see **13**). According to Sargent's friend Judith Gautier, who recorded contemporary comments, she was called "a delicious arabesque," part of "a heraldic coat of arms," a sign conspicuously on display.[14]

Costume played a large part in Sargent's design for these portraits — Pozzi's flowing red dressing gown and Turkish slippers, Gautreau's décolleté evening gown of black satin and velvet. An audacious portrait of a daring man, *Dr. Pozzi at Home* depicted, in Sargent's words, "a brilliant creature"; his crimson garment may refer to the traditional red gown of his medical

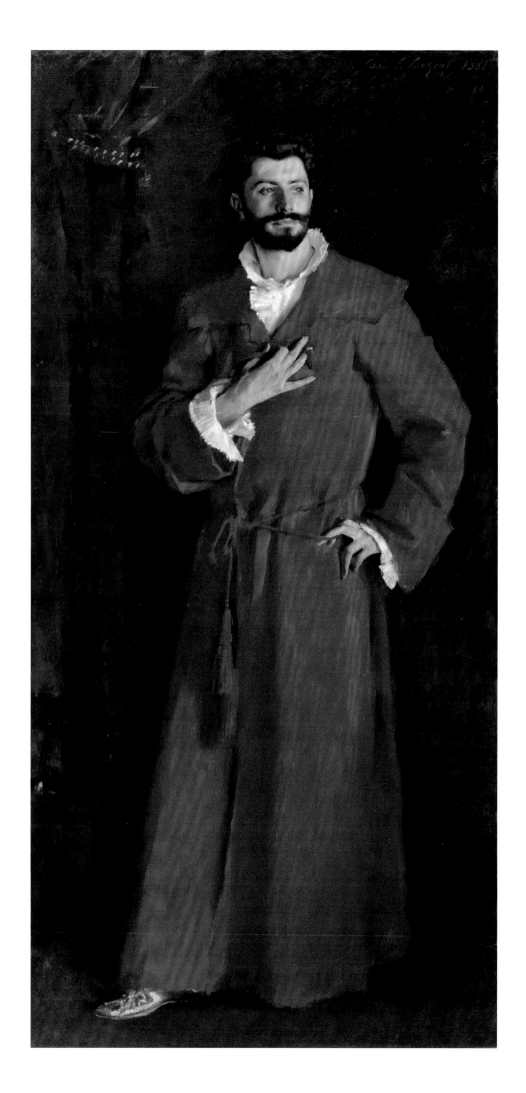

discipline. As one of Pozzi's students noted, he portrait looked like "the face of Cardinal Richelieu clad . . . in the costume of the Professor of the Faculty."[15] The robe and embroidered slippers combine to make a costume *à la turque* that recalls Jacques-Louis David's 1783 likeness of Alphonse LeRoy, also a prominent innovator in gynecology (Pozzi's specialty), who had been depicted in a red banyan and turban (Musée Fabre, Montpellier).[16] When exhibited — Pozzi at the Royal Academy in London and then in Brussels, Gautreau at the Salon in Paris — the paintings elicited comments directed toward both sitter and canvas, many of them occasioned by the clothes. Pozzi was described as "gaudy" and "decadent," while the vociferous responses to Gautreau have become legendary, none perhaps more cutting than the comments reported by Ralph Curtis of another artist, who called Sargent's painting a mere copy of a woman who painted herself, questioning Sargent's originality and casting aspersions on Gautreau's use of cosmetics. Writing in the *Gazette des Beaux-Arts*, Louis de Fourcaud (who also sat for Sargent in 1884) went beneath the surface, describing Sargent's portrait of Gautreau as accurately representing "the Parisian woman of foreign extraction, elevated from childhood to be an idol and to be constantly discussed in the fashionable journals." Fourcaud defined Gautreau as a "professional beauty," a woman whose sole function was to perform. She was not a real Parisienne, but an actress playing the role.[17]

One sitter, Isabella Stewart Gardner, stepped right into Sargent's theatricality and embraced the idea of becoming an idol. In October 1886, accompanied by Henry James, she went to see *Madame X* in Sargent's new London studio. The next year, when the painter made his first working trip to the United States, Gardner commissioned a portrait from him; she was among Sargent's earliest Boston clients and seemingly the only one who wanted something spectacularly out of the ordinary. Sargent depicted her standing with her hands clasped loosely before her, posed, perhaps nervously, as if she were ready to speak or sing onstage (**34**). Her black gown, with its low bodice, is much less revealing than Louise Inches's red velvet evening dress (see **83**), which Sargent was painting at the same time, but it was Gardner's that would generate punning and personal criticism. When the portrait was shown at the St. Botolph Club in 1888, many comments alluded specifically to rumors of an alleged affair between Mrs. Gardner and a younger Boston writer.[18]

Gossip was one thing, idolatry another. Gardner's severe frontal pose, the ropes of pearls festooned at her waist, and the patterned nimbus of the fabric radiating out from behind her head turned her into an emblem of worship. Her portrait embraced an iconography of power, encouraging the local audience to challenge her entitlement. "Mr. Sargent has had a profitable winter," opined *The Art Amateur*. "What does it matter if Mr. Sargent — who, above all his contemporaries, perhaps, has the gift of imparting distinction to his subject — makes a dowdy look like a queen, or to a little insignificant woman gives the air of a goddess, if no one can recognize in the picture the features of the original?" Sargent took it in stride: "The newspapers do not disturb me," he wrote to Gardner, "do you

33 | *Dr. Pozzi at Home*, 1881

bear up?" Throughout her husband's lifetime and her own, Mrs. Gardner kept the painting in private quarters, visible only by invitation until Isabella's death in 1924, but its authority was not forgotten and in time it came to be appreciated. In its "energy, at once delicate and invincible," according to the French writer Paul Bourget in 1895, the portrait represented the force that both inspired and drove American commerce and industry. The artist had captured on canvas a veritable Columbia, a distinctive American character. As Bourget saw it, Sargent's portrait was "the deification of woman . . . as a supreme glory of the national spirit."[19]

Sargent gave his early portraits a stage presence to match his spectacular paintings of actual performances, *Fumée d'ambre gris* (see **109**), described by Paul Mantz in *Le Temps* as an image of an idol, a priestess, engaged in a smoky rite, and the dramatic *El Jaleo* (1882, Isabella Stewart Gardner Museum), infused with the visceral sensuality of Spanish dance. For the rest of his career, Sargent continued to explore such subjects, both professional presentations, with likenesses of actors, musicians, dancers, and marionettes; and amateur, in the form of people dressing up. Ellen Terry, Carmencita, one of the celebrated Indonesian dancers at the 1889 world's fair — these were all women who made their living onstage, and Sargent depicted them in action.[20] He captured them while performing, but he often selected a dramatic moment of stasis. Ellen Terry, a statuesque Lady Macbeth, lifts the crown she covets for her husband, if not herself, in a scene that did not appear in the actual production (see **50**). Carmen Dauset Moreno, who performed as Carmencita, was a restless subject known for her energy and whirling movements; she stands completely still, before (or during) her dance in one of the tense pauses that characterize flamenco (**36**). Sargent's flicks and dabs of white paint capture the sparkle of her yellow silk satin costume, its heavy fabric overlaid with gauze net embroidered with beads, spangles, and sequins (**35**). One of the four young Javanese dancers (Seriem, Taminah, Soekia, and Wakiem) who dazzled Paris in 1889 with their precise percussive movements and hand gestures almost too fleeting to be captured on canvas is shown in a moment of "grace that has nothing to do with Raphael," according to Sargent's friend Alice Meynell (**37**).[21]

Along with these clearly theatrical portraits Sargent captured nonprofessional performances as well. If Édouard Pailleron played the role of the bohemian and Samuel Pozzi took on the fin-de-siècle decadent, Thomas Lister, Baron Ribblesdale, can be seen as a quintessential English aristocrat (see **107**). He was known to costume himself. Artist and sitter had first met at a fund-raiser, and Sargent pursued his subject. After "much heart-searching as to the composition . . . and the clothes that were to be worn," as Ribblesdale's daughter recalled, Sargent depicted him dressed for riding, crop in hand. His outfit was a carefully assembled, highly personal ensemble, not a standard riding or hunting habit. Ribblesdale was famously particular about his clothing, eschewing convention and favoring an old-fashioned elegance that recalled the gentlemanly perfectionism of Beau Brummell. He "always wore mufti when hunting," his daughter remembered, and

34 | *Isabella Stewart Gardner, 1888*

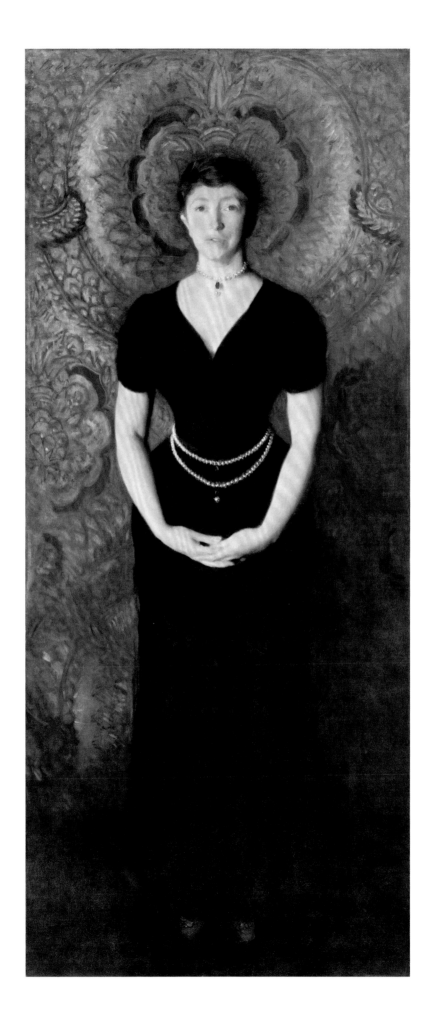

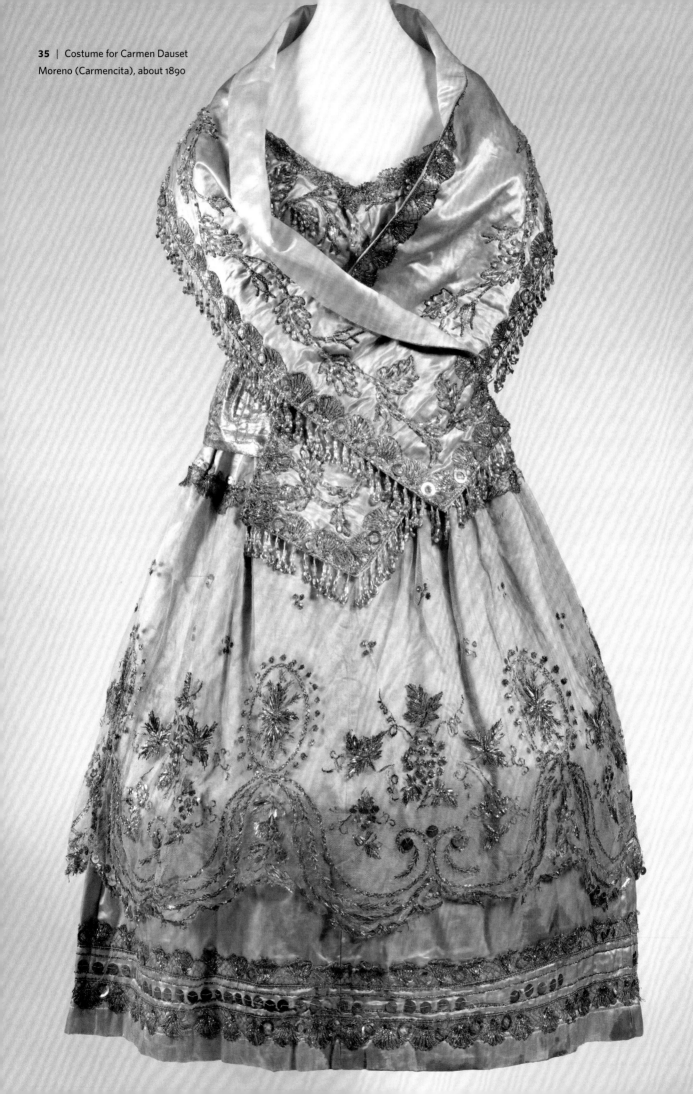

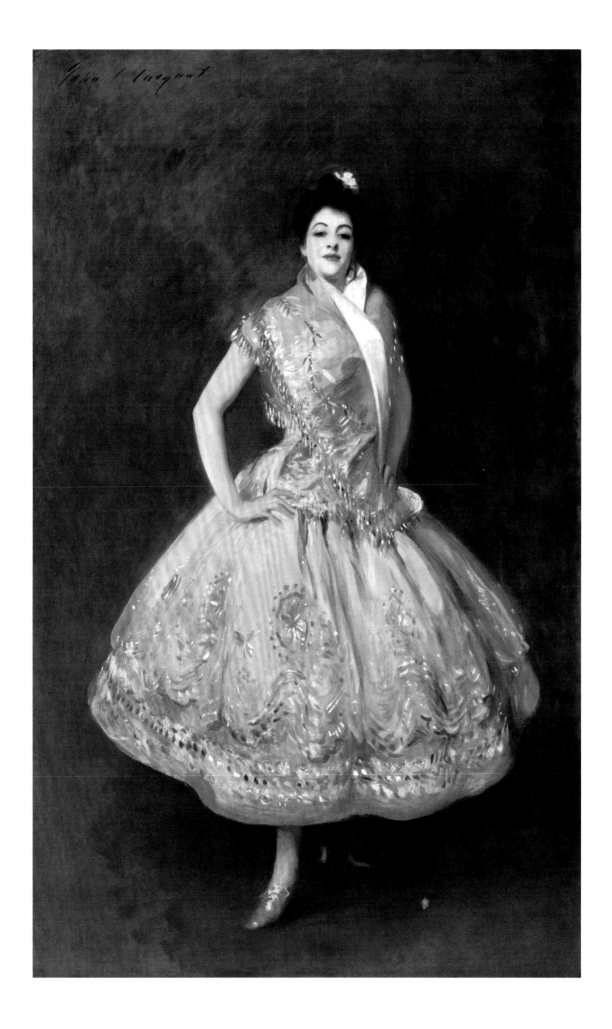

36 | *La Carmencita (Carmen Dauset Moreno)*, 1890

"possessed so strong a feeling for form in all things — in literature, in art, in dress and manners." The dandyism inherent in Sargent's image was satirized in a caricature in *Punch*, in which Ribblesdale's black silk tie and buff breeches balloon to enormous proportions. Sargent captured the persona of Ribblesdale so completely that when the baron went to see his portrait at the Salon in 1904, he was recognized and described in hushed whispers as if he were the stock character from central casting, "ce grand diable de milord anglais" (that great devil of an English lord).[22]

Ribblesdale dressed up for daily life; others dressed up for special occasions. Both men and women enjoyed transforming themselves with costume, choosing "fancy dress" for balls, tableau vivant entertainments, masquerades, parades, meetings of fraternal organizations, Oktoberfest, among many other festive events. Inspirations came from art, history, literature, mythology, folk traditions, and non-European cultures. Some looked to the past, others dressed themselves in the guise of contemporary affairs, including such imaginative ensembles as those representing "Electric Light" (a Worth gown worn by Alice Vanderbilt to her sister-in-law's fancy dress ball in 1883), or the "Suez Canal" (a gown of cloth-of-gold decorated with waves of blue satin proposed in Aldern Holt's helpful 1887 guide, *Fancy Dresses Described*). Unlike the deliberate mystery and concealment of eighteenth-century masquerades, these costume choices most often represented the personal attributes and interests of their wearers.[23] Such dressing-up has become more controversial in our own time, with more consideration given to the underlying political and social meanings, cultural appropriation, and racialized sense of superiority inherently (and deeply) embedded in decisions about what costumes to wear. In Sargent's day, however, it was simply regarded as a popular form of entertainment at all levels of society. For some intellectuals and artists of the period, Asian and Middle Eastern garb represented relief from the strictures of Victorian manners and morals; for them, wearing the clothing of North Africa, Turkey, or Japan was a symbol of their dissatisfaction with Western culture. Others simply admired the beautiful fabrics or enjoyed the lack of a corset.

Sybil Sassoon was an enthusiastic participant in costuming. She contacted her friend Sargent in about 1912 with regard to a Spanish-style outfit that she hoped to wear to an unidentified fancy-dress ball, charity event, or perhaps a tableau vivant: the spangled yellow silk dress that Carmencita had worn for her portrait. It may always have belonged to Sargent — or if it was Carmencita's, he never gave it back. Instead, it made its way from a public performance to a private one. "I have had every cupboard and box ransacked & the Carmencita dress is *found* – & I will send it to you tomorrow – it is very dirty besides being very tawdry & clinquant [flashy] – but such as it is you can at any rate make up your mind as to whether you like it," Sargent wrote. After the event, Sargent congratulated her: "I am so delighted that the reincarnation of the Carmencita was such a triumph . . . every body says you were divine – I am so sorry I did not see you. . . . Good oll' dress! I little thought it was destined to this apothéose!"[24]

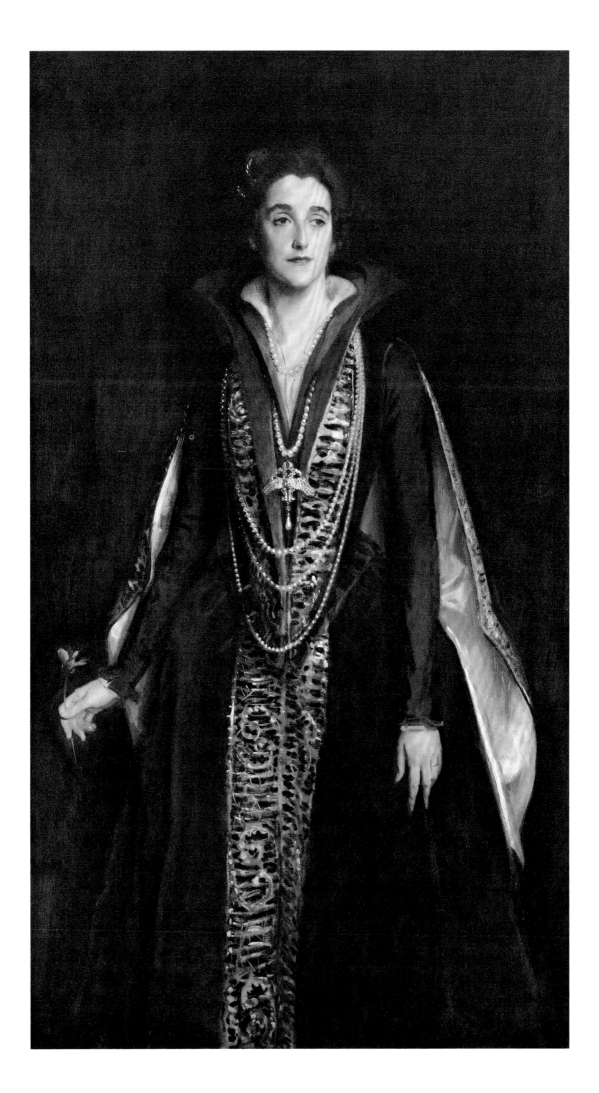

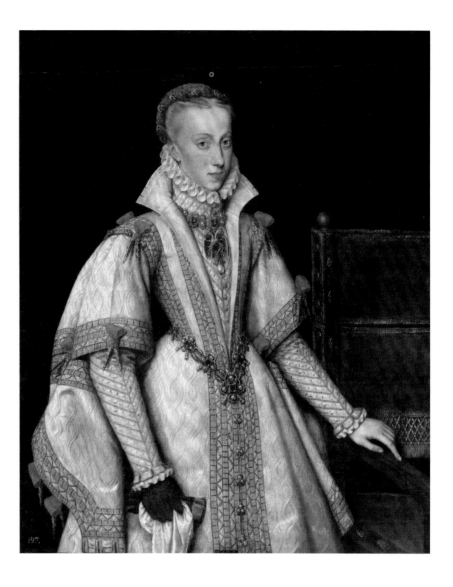

Sybil shared Sargent's taste for Spanish costume, and when he painted
her formal portrait late in his career, she wore a dramatic Renaissance-
inspired gown of ribbed black silk, relieved by a wide vertical band of gold
lace from shoulder to floor and a tall standing collar lined with magenta
satin (**38, 40**). The dress, apparently ordered from the House of Worth
by Sargent, not Sybil, at a cost to the artist of £200, seems to have been
loosely based on a portrait after Anthonis Mor of Anne of Austria, Queen
of Spain (**39**); both paintings feature the Hapsburg double-headed eagle
brooch that had passed down through the centuries from the Spanish court
into the Sassoon family.[25] Worth was famous for his fancy-dress costumes,
which the company provided both to actresses for stage performances and
to ladies of fashion for costume balls and charitable affairs. It was good
for business; the decision of a famous actress or society woman to wear a
Worth creation onstage or at a grand affair garnered notice in the press.

There was another place where one could play dress-up: the artist's
studio, long a site for imaginative transformations. In Sargent's portrait
practice, however, this sort of costuming was done more in jest than to play
a meaningful allegorical role. Although Sargent referred to past masters
in several of his portraits, he never directly imitated them, and he never

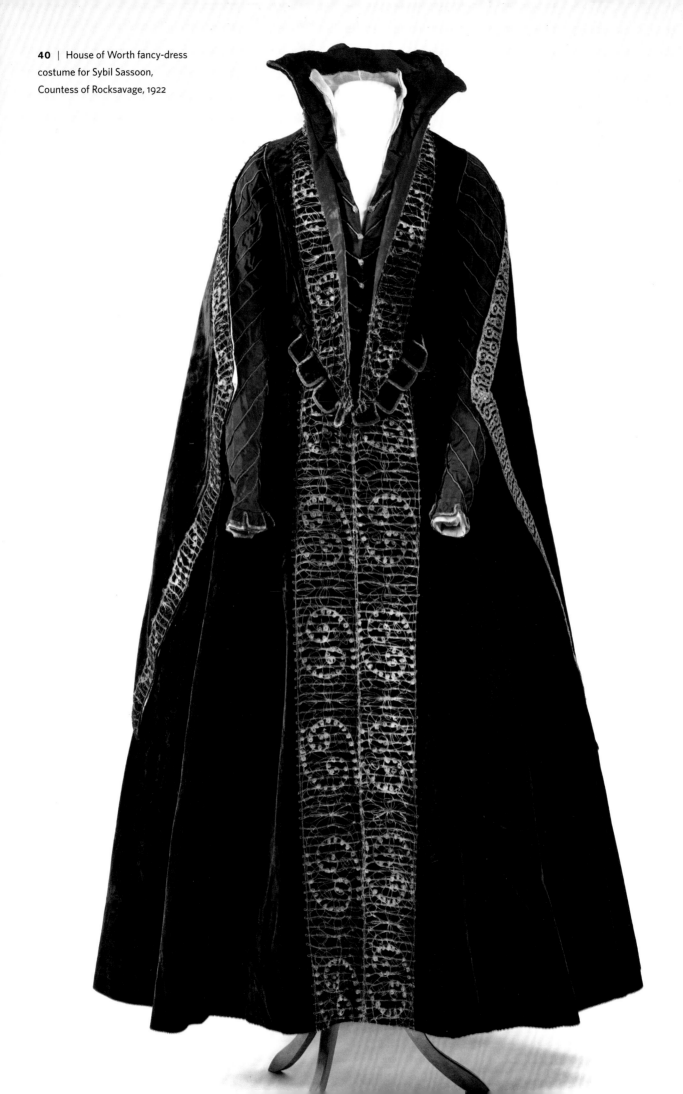

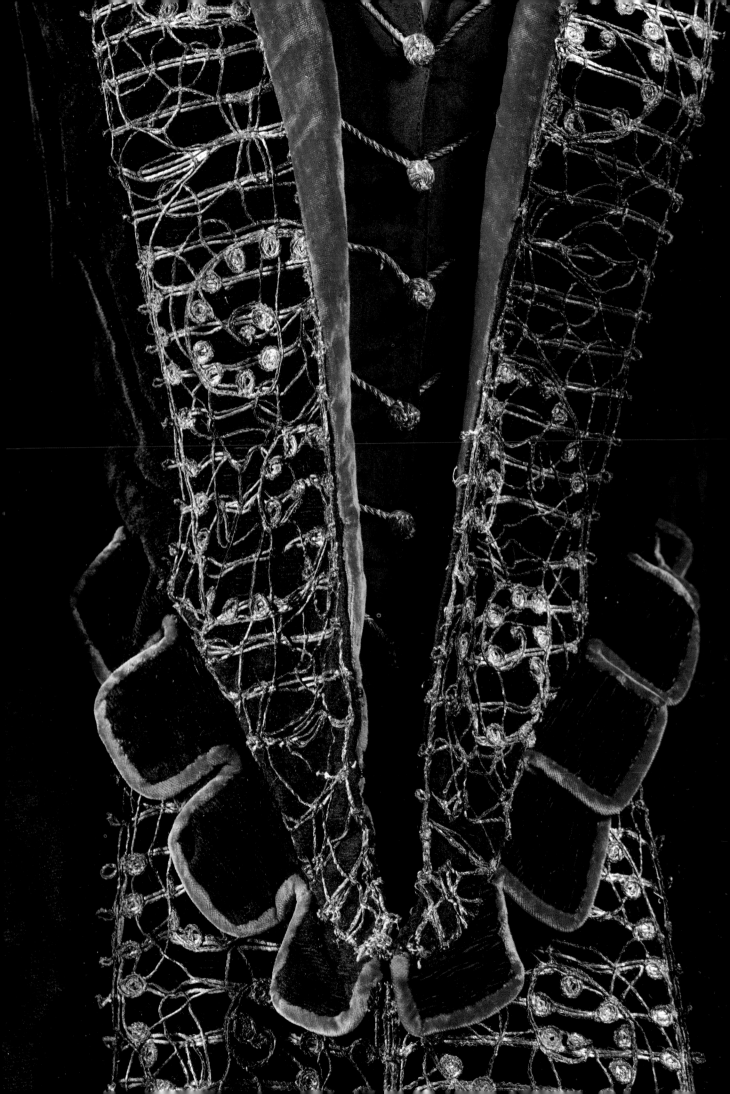

painted a sitter in masquerade as a shepherdess or tragic muse in the manner of the eighteenth-century artists he admired. Such make-believe was reserved for those in his circle rather than for formal sittings with clients: as early as 1882–83, he sketched his friend Albert de Belleroche both as a matador and as a Renaissance swordsman (see **75**). In *A Vele Gonfie*, Ena Wertheimer laughs as she takes on the role of a cavalier, her weapon a broomstick and her cloak a garment left behind from someone else's sitting (see **79**). She is clearly play-acting. The painting was "a cloak-and-sword portrait of a lady," according to one critic who saw it at the Royal Academy, simply "a fancy portrait" to another, and (later, at the Grafton) a "*gasconnade* [boastful swagger] . . . a romance of the seventeenth century almost," to a third.[26] Ena is not Diana the huntress, an allusion that helped to bring down Madame Gautreau, but instead someone completely aware of her own role in the fantasy.

This self-consciousness of performance was already evident in one of Sargent's most intriguing early portraits, his interior scene depicting the writers Robert Louis Stevenson and his wife Fanny Van de Grift Osbourne Stevenson (**41**). Both sitters described the painting and their clothing in detail. Louis (as he was called) recounted walking about the room in his "velveteen jacket," an artistic and aspirational literary choice for the young writer, for as the *New York Times* reported that year in a widely distributed article, "Men never see [the French novelist Émile] Zola without his black velvet jacket." In a letter to a friend, Fanny related lounging "in the robes (veritable) of an Indian princess, one blaze of gold and white lace. I had put on the dress to show it to [Sargent] and he could not resist putting it into the picture." The composition, with its flat backdrop and calculated view into a shadowed hallway, makes a distinctly theatrical impression, and Sargent himself jokingly described it as a "picture of the caged animal lecturing about the foreign specimen in the corner." It represents not just specific people, but also their world of the imagination — the fanciful realm conjured by these two writers of dramatic fiction — as well as Sargent's own acute abilities to costume and capture their creativity in paint.[27]

Fanny Stevenson was hardly the only one to collect and to wear non-European dress. Sargent himself owned a variety of garments that he occasionally used to costume his sitters — cashmere shawls, a robin's-egg-blue taffeta skirt, and (according to Jane de Glehn) "stacks of lovely oriental clothes."[28] One of these so-called "Oriental" garments (the term "Oriental," today considered offensive, betrays an indifference to the actual culture of origin) was Turkish, a white *entari* (robe) decorated with small green motifs and edged with gold trim, which Sargent bought either in London or on his travels.[29] Now lost, it is visible only in family photographs and in his paintings, but similar coats survive in numerous museum collections (**42**). Sargent's entari appears in one formal portrait, another invention for the Wertheimers, this time depicting Ena's younger sister Almina (see **67**). She too was complicit in the arrangement, donning the entari and a confection of draped and twisted fabrics that give the impression of pantaloons and a bejeweled turban. This imaginative ensemble

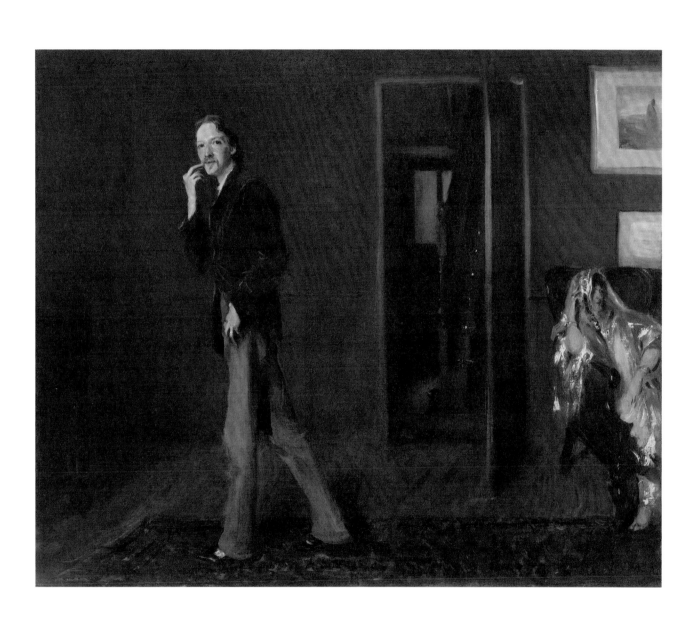

41 | *Robert Louis Stevenson and His Wife (Frances Van de Grift Osbourne)*, 1885

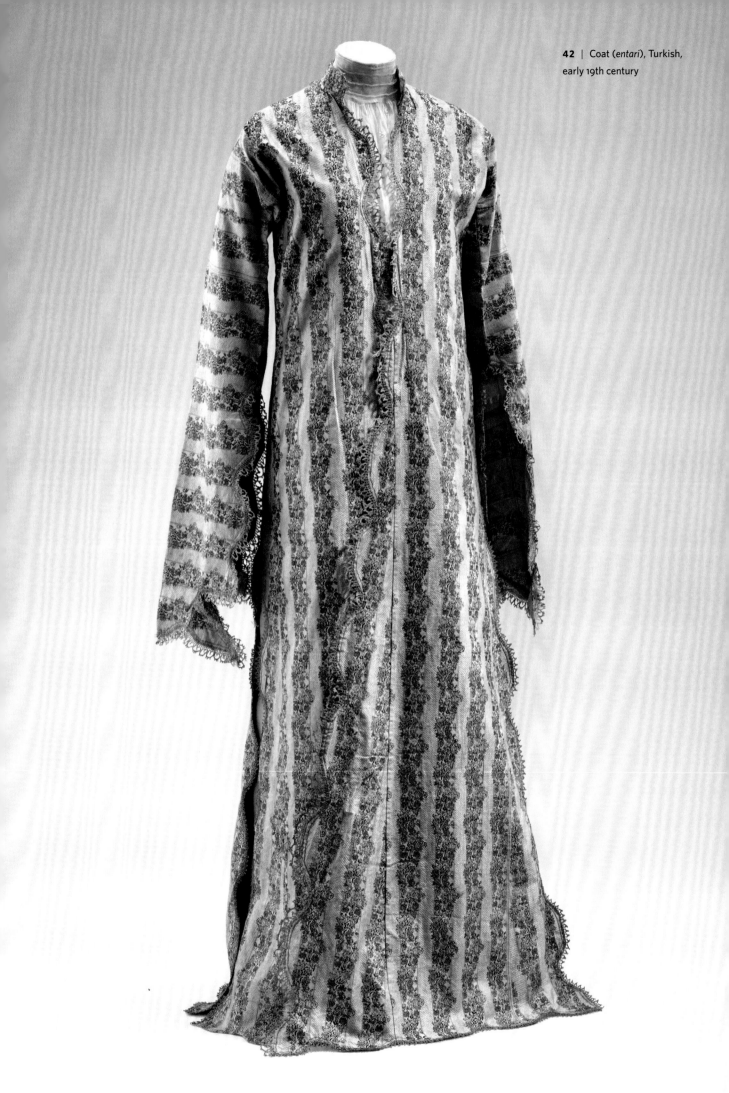

43 | Rose-Marie Ormond, Sargent's niece, in Turkish dress, Peuterey, about 1907

44 | Hiking party in the Simplon Pass, about 1911

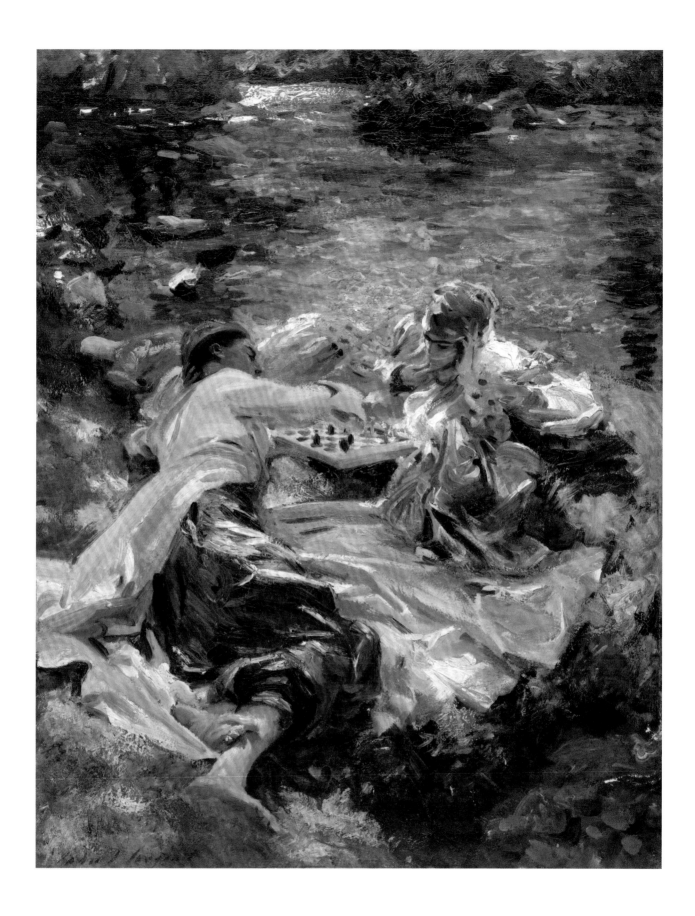

45 | *The Chess Game*, 1907

46 | Shawl belonging to Sargent, Indian (Kashmiri), about 1830

may well refer to a specific event involving a portrait by Reynolds, but the context also includes the stereotyping of Jewish women as "exotic" and "Oriental," originating in some unidentified "mysterious East" and thus definitively not British. The actual origins of both costumes and women were ignored, the Turkish robe and the pseudo-Indian headdress denote "otherness," just as did the non-Christian religion of Sargent's London-born sitter. Almina seems to have been entirely willing to play the role for Sargent, who was a family friend, even embracing two roles — her usual one of a Jewish woman navigating British society and here, unmistakably, the "Oriental princess" that society took her to be. When the portrait was displayed (together with four other Sargents, including *A Vele Gonfie*) at the International Society's 1910 exhibition "Fair Women," it was discussed in terms of "the realistic Eastern beauty of . . . another well-known lady, who is here Orientalized, and enriched by the painter's brush dipped in the colours and sentiment of a Persian poet."[30]

Sargent's entari appears most often in the paintings he made of friends and family (including his niece Rose-Marie Ormond) posing in the meadows of the Italian Alps (**43**). In these compositions, Sargent largely left portraiture behind him, but he did not abandon his position as director. Rather than hiking into the mountains in white skirts or cashmere shawls, his companions wore practical woolen sportswear and sturdy boots (**44**).

Once they arrived, the transformation began, and photographs document Sargent in control, arranging figures, clothing, and draperies. He dressed his cast variously, sometimes in Turkish garments, at others in voluminous, stiff white skirts; he frequently wrapped the women in long cashmere shawls (**45**; see **115**). Such shawls, originally imported from Kashmir, were no longer considered fashionable, nor were heavy white skirts, but Sargent found them both irresistible for picture-making. In the 1910s, when he eschewed most commissions, he used the shawls for portraits of his favorite people — his niece Rose-Marie, his friends Sylvia Harrison and Sybil Sassoon, and he gave one of his cashmere shawls to Sybil (**46, 47, 48**).[31]

In these late figure paintings, far from the routine of the studio portraits he had begun to abandon, Sargent made bodies and fabrics equally subject to his direction. These set pieces are evocative of escape from the ordinary, separated from place and time with their indefinite settings and independence from fashion. Meadows, rocks, and streams become vertical backdrops without horizon lines, figures are silhouetted against them in an indeterminate space (**49**). These paintings are as theatrical as anything Sargent ever made, although they tell no stories. They become participatory events, with viewers bringing their own experiences or imagination to Sargent's production. In *Cashmere*, for example, some see seven women, others a single figure repeated (**47**). The scenery is completely indistinct, "so slightly treated as scarcely to explain its character," as one writer commented. The draped figures could be contemporary or from the distant past, as they head toward an unknown destination, exiting stage left. "It is one of those rare triumphs of skill and feeling which, while so complex in their inner workings, appear simple as a result . . . it is the best picture of the year."[32]

Sargent has long been admired for his craft — for his visual acumen, the facility of his hand, his ability to capture people and things on canvas — but his talent went beyond painterly technique. Whether making a formal portrait of a prominent sitter or an informal study of friends resting in a field, Sargent directed the entire production, telling people how to dress, and where to sit, stand, or lie; he rearranged their garments, adjusted the lighting, and then painted what he wanted to see. His goal was always to make a great picture. As his friend Edwin Blashfield affirmed after his death, Sargent's talent was a "performance" and the artist himself was a "master enchanter."[33]

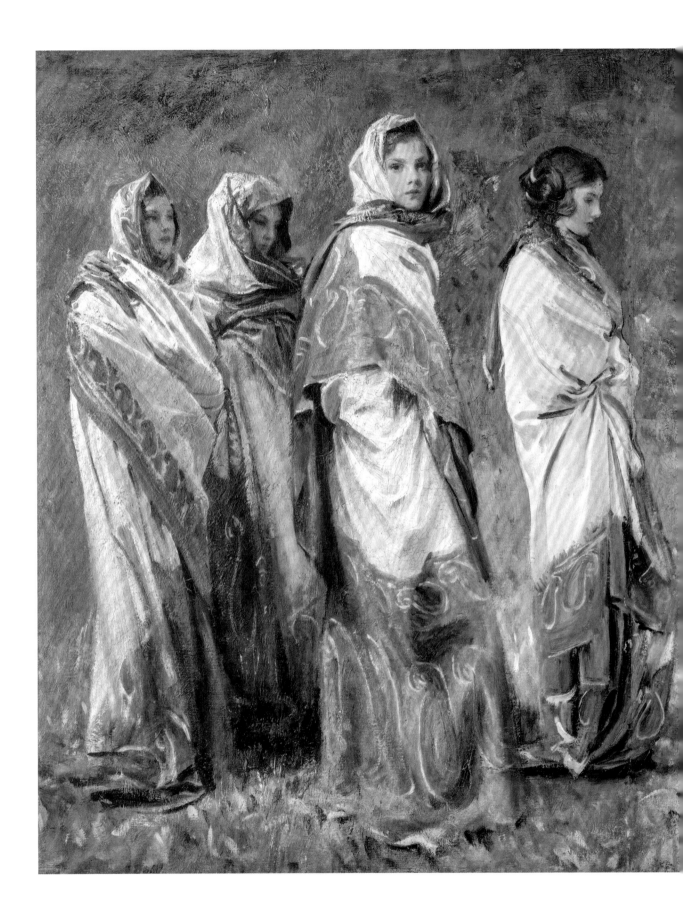

47 | *Cashmere*, 1908

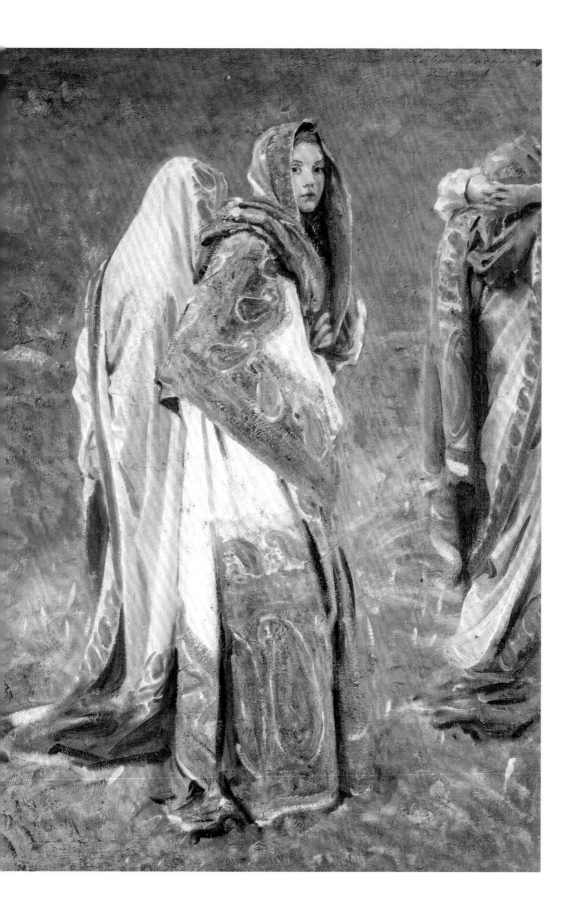

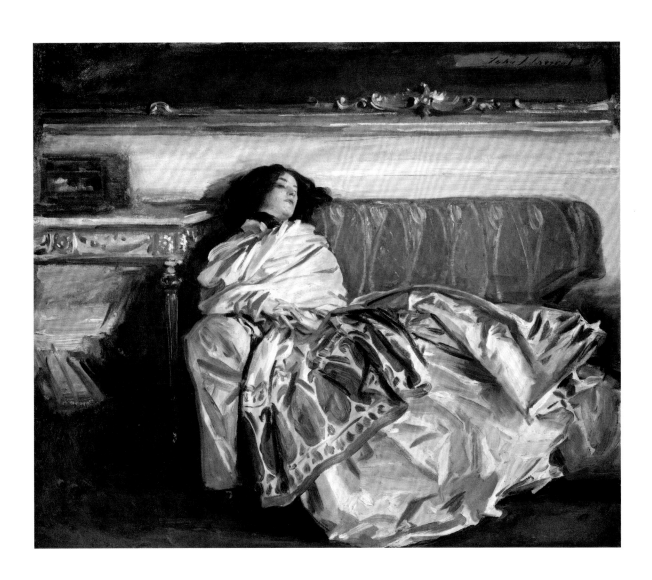

48 | *Nonchaloir (Repose)*, 1911

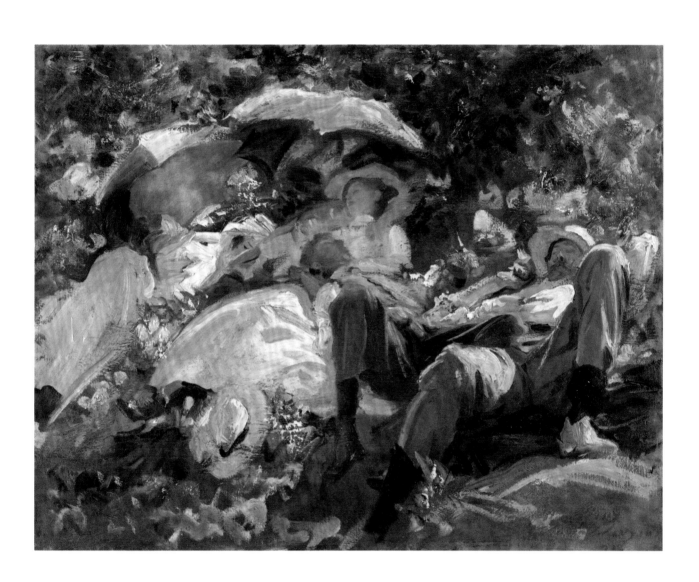

49 | *Group with Parasols (Siesta), 1904–5*

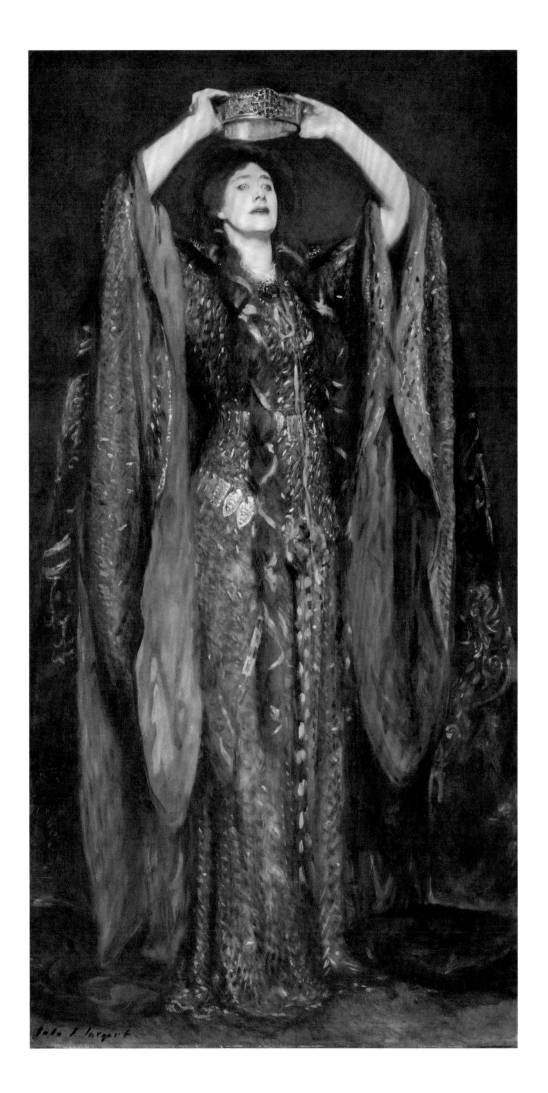

Ellen Terry as Lady Macbeth

CAROLINE CORBEAU-PARSONS AND REBECCA HELLEN

ISS TERRY'S LADY MACBETH . . . is the Lady Macbeth Shakespeare would have drawn had he had an Ellen Terry in his company. . . . In her strange and splendid robes she moves from grace to grace untiringly. I can remember no performance so full of plastic pictorial inspiration. It is an artistic, not a dramatic, triumph." So wrote a drama critic for the *Toronto Daily Mail* in January 1889, around the time that Sargent painted the celebrated British actor in the role (**50**).[1] According to a contemporary source, Terry's portrait was commissioned by her equally famous stage partner, Henry Irving: "Mr Irving stipulated that the lady was to be painted as she appears in private life, but the artist, while present at the first night of 'Macbeth' [December 27, 1888], was so enchanted with Miss Terry's appearance in the beetle-wing robes that he made a hasty sketch, and sent it to the actress as a suggestion for the portrait. Miss Terry was quite delighted with the idea, and promised to talk [it] over [with] Mr Irving."[2] According to Sargent's recollection, however, Terry herself needed some persuasion, as she first wanted some reassurance that her performance would be well received. Her restrained characterization took most critics by surprise, but so did her hypnotic charm in her scintillating costume, which won them over. The appeal was not lost on Sargent: "From a pictorial point of view there can be no doubt" about her success.[3]

The costume is now kept in Terry's cottage at Smallhythe, Kent (National Trust) (**51, 52**). It was inspired by designs of the French architect and medievalist Eugène Viollet-le-Duc and created by the costume designer Alice Comyns-Carr, with the input of Terry herself, using luxury materials reportedly supplied by the London draper Helbronner's (**53**).[4] Ada Nettleship was the dressmaker who carried out the design, probably before her own great success enabled her to hire a large team of seamstresses.[5] Both Comyns-Carr and Nettleship, who were part of Sargent's

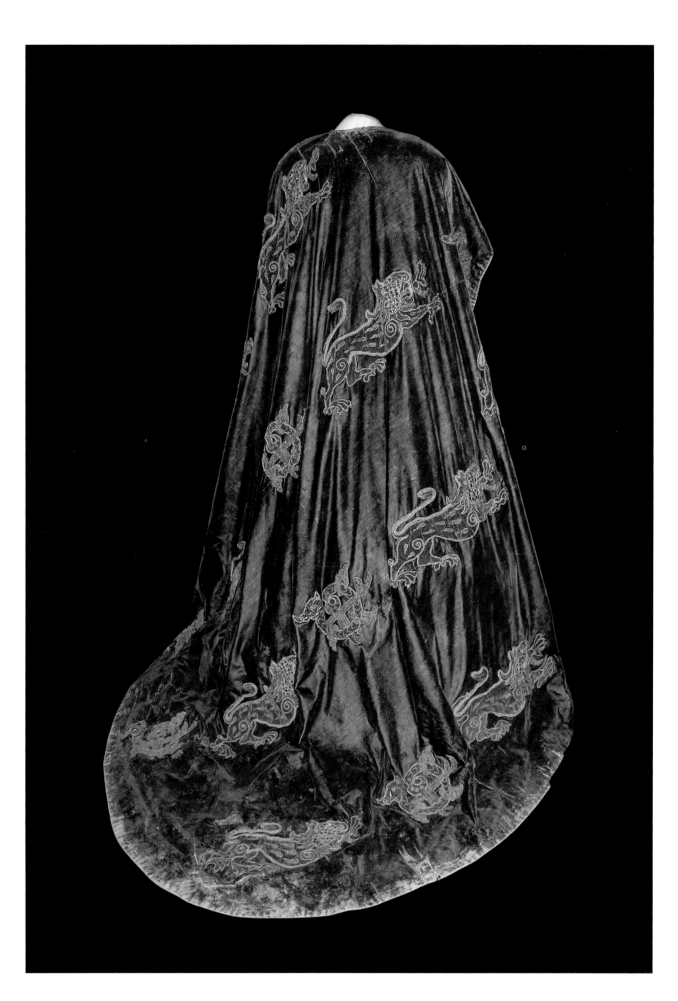

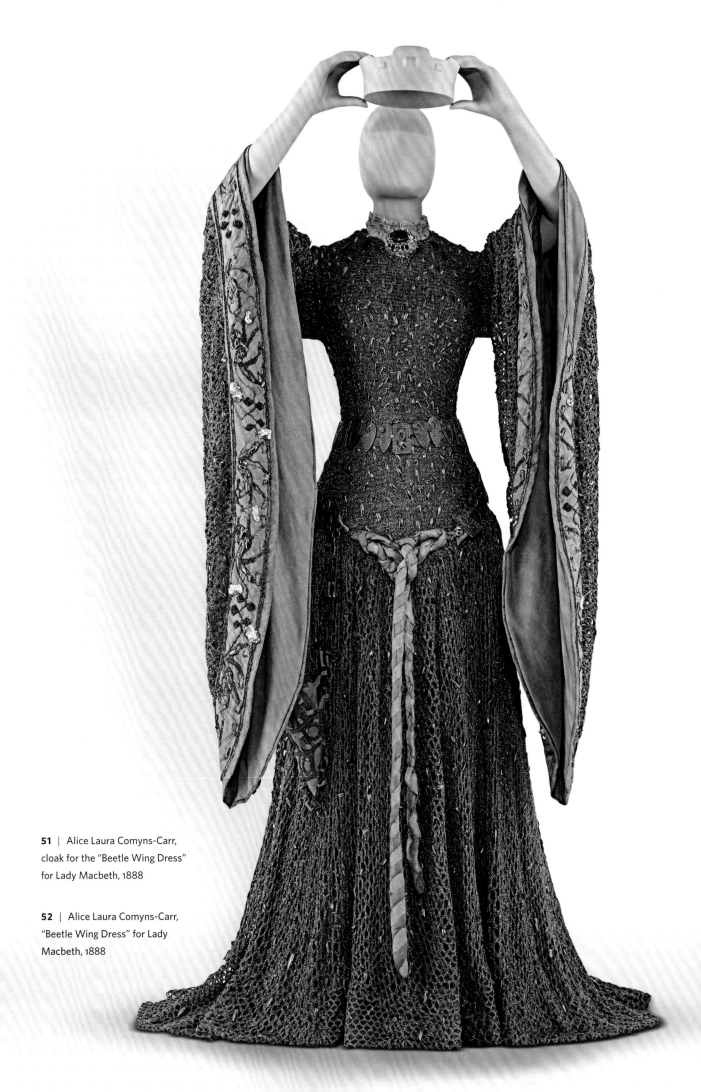

51 | Alice Laura Comyns-Carr, cloak for the "Beetle Wing Dress" for Lady Macbeth, 1888

52 | Alice Laura Comyns-Carr, "Beetle Wing Dress" for Lady Macbeth, 1888

social circle, were at the forefront of the Aesthetic dress movement in Britain, which favored natural dyes and garments that allowed freedom of movement. Terry, also a proponent, sported many of their costumes over the years and praised this one for its adherence to those principles: "Is it not a lovely robe? It is *so* easy, and one does not have to wear corsets."[6]

Comyns-Carr described the gown precisely: "It was cut from fine Bohemian yarn of soft green silk and blue tinsel . . . it was sewn all over with real green beetle wings and a narrow border of Celtic design worked out in [imitation] rubies and diamonds. To this was added a cloak of shot velvet in heather tones upon which griffins were embroidered in flame-colored tinsel. The wimple and veil was held in place by a circlet of [imitation] rubies and two long plaits twisted with gold hung to her knees" (**54**).[7]

Depicting a climactic moment of self-crowning that does not actually occur in the play, Sargent expressed the intensity of Lady Macbeth's emotions after the murder of Duncan. How many sittings the artist arranged to capture his interpretation of Terry's performance is not known. There must have been several, as his own bravura performance of painting developed through a number of stages. Visible on close inspection, the paint of her pale face and her startling gray-blue eyes has small wrinkles, testament to the number of sittings; the uppermost layers did not quite adhere fully to paint that had dried since the previous sitting. The portrait incorporates Sargent's impression of the actress posed, static, in his daylit Tite Street studio with his memory of her physical stage performance at the Lyceum Theatre, where the limelight on the dazzling cloak, dress, bejeweled crown, belt, and long gold-plaited hair must have been mesmerizing.

Paint on the edges of the canvas, now tucked behind the stretcher, indicates a possible earthier-toned background on which her face, figure, and costume were positioned with the crown above her head. Earlier colorways are also hinted at through cracks in the cloak's paint, where bright reds show through. In contrast to Comyns-Carr and Nettleship's Aesthetic principles, Sargent's palette included synthetic manufactured pigments, along with natural mineral and dye-based colors. Recent technical examination has revealed a brushy natural resin varnish layer, on top of which Sargent made later adjustments to the costume.[8] The decorative additions to her cloak and sleeve clasps, and daubs of cobalt for the iridescent beetle wings, can be seen as brighter areas in ultraviolet light (**55**).[9] As Sargent engaged with the visual message of Terry's performance, so he engaged with matte and gloss on his surface, the opacity and translucency of his paints, and the dazzling effects of wet-in-wet brushwork, positioning colors such as green and purple adjacent with each other and blending them at their borders on the canvas.

A shift in color is noted in Terry's autobiography, suggested by the senior artist Edward Burne-Jones — one of the leaders of Aestheticism — who visited during a sitting: "Sargent's picture is almost finished, and it is really splendid. Burne-Jones yesterday suggested two or more alternatives about the colour which Sargent immediately adopted, but Burne-Jones raves about the picture [which] is talked of everywhere and quarrelled about as

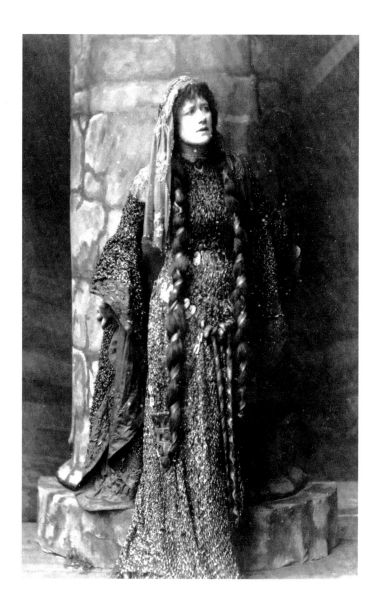

53 | Illustration from Eugène-Emmanuel Viollet-le-Duc, *Dictionnaire raisonné du mobilier français*, 1871

54 | *Ellen Terry as Lady Macbeth*, 1888

much as my way of playing the part."[10] A comparison between the dress and the portrait highlight how much more dazzling but also bluer Ellen Terry's costume is in the painting. The artist rendered the movement of her dress under the theatrical lights through a mesh of impressionistic blue strokes, with sparser, individual green highlights. The blue coloring may in part have been a dramatic impression of the dress under the limelight. A journalist noted that the "peacock blue tinsel . . . sparkles in the light."[11]

The blue of the background was technically achieved with glaze-like layers and possibly use of Megilp, a modifier that added body to oils and varnishes.[12] This medium may have also been applied around the head, unpigmented, to create a backlit effect.[13] Sargent added bright cobalt blue daubs across the costume to represent the beetle wings, using paint strokes similar in form and size to the wings themselves. The insect wings impart color by dispersing light, so the angle at which light hits them determines the color, and thus they may have appeared dominantly blue at some points while Terry moved around the stage, or posed in the studio (**56**).[14]

As we deliberate cause and effect between the performance and the sittings, the materials and techniques, and the brilliance of the costume

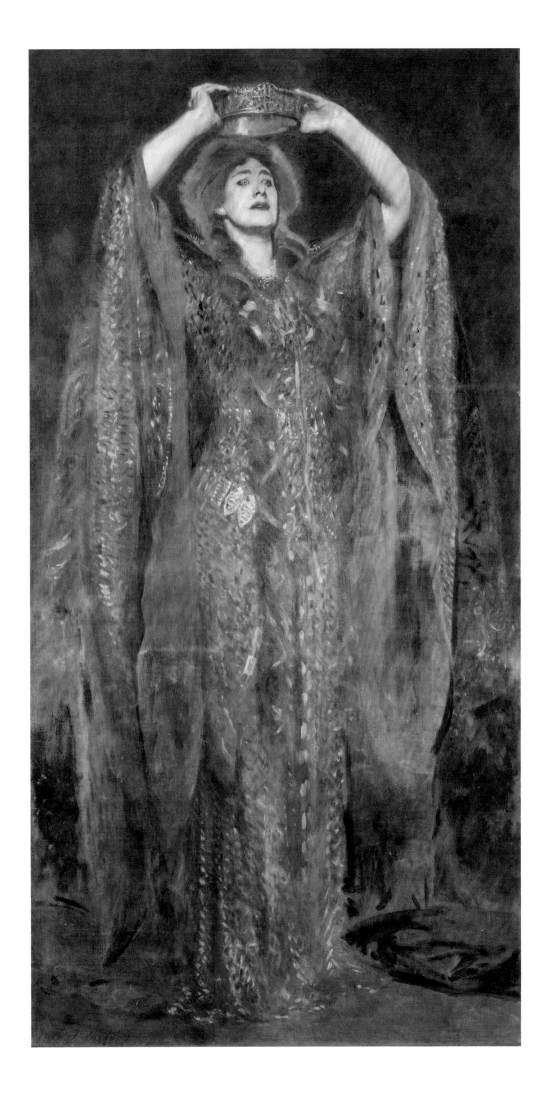

56 | Detail of sleeve, showing fabric with applied beetle wings and border

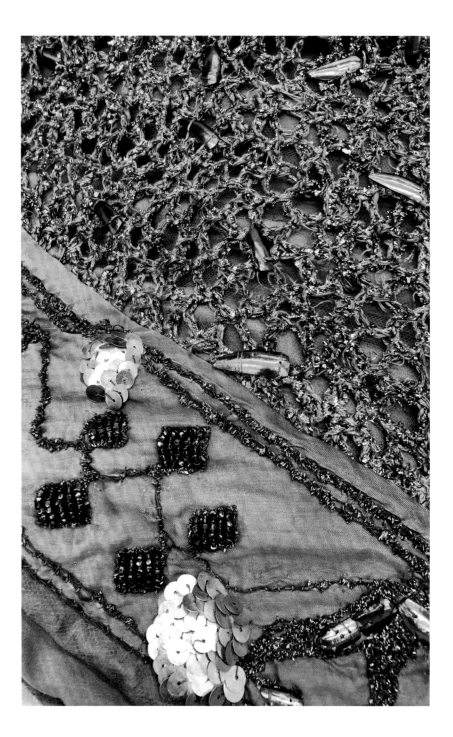

and the brilliance of Sargent's depiction of it, the legacy of the painting is clear: for many years the manikin dressed in the spectacular costume at Smallhythe has been displayed just as Sargent depicted the actress, arms raised in a dramatic crowning pose. In an essay on Terry, Virginia Woolf noted: "It is the fate of actors to leave only picture postcards behind them. Every night, when the curtain goes down, the beautiful coloured canvas is rubbed out."[15] Sargent's powers as an artist and director combined saved Terry's performance from this fate.

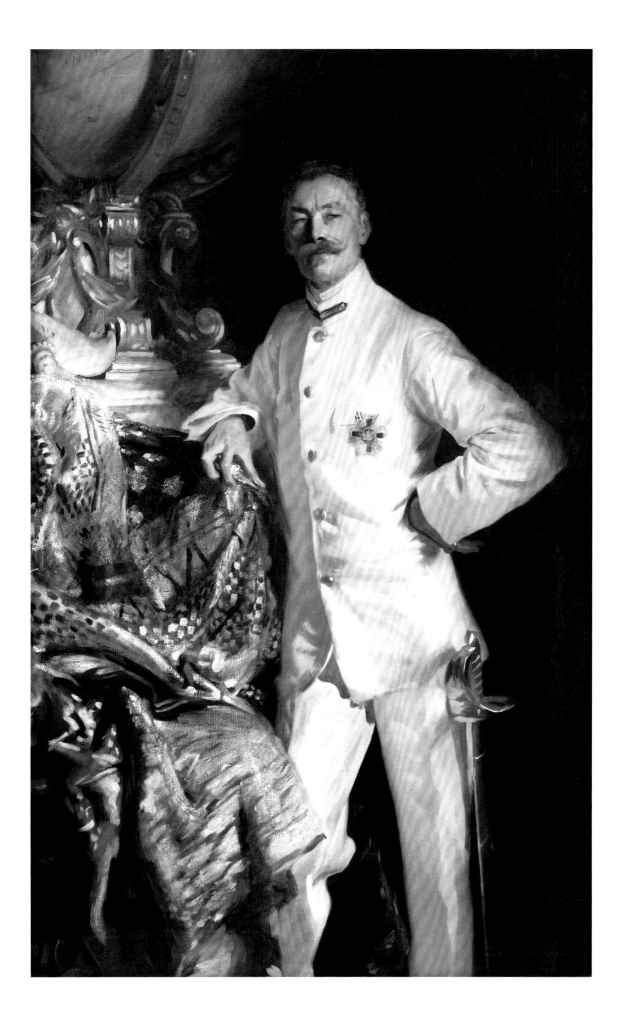

The Fashion in Old Masters

ELIZABETH PRETTEJOHN

*T*N SARGENT'S PORTRAIT OF 1904, SIR FRANK SWETTENHAM is surrounded by signs of his eminence as a British colonial administrator (**57**). The terrestrial globe, perched improbably on an elaborate gilded stand, displays the Malay Peninsula and Singapore, the part of the world in which Swettenham had made his career and won his fame. On the breast of his white tropical dress uniform is the sparkling decoration of Knight Commander of the Order of St. Michael and St. George, and his right arm rests on a sumptuous red-and-gold Malayan brocade from Swettenham's own collection. In every respect, Swettenham is the man of his moment. Yet the composition is orchestrated to give Swettenham his place in a long lineage of Old Master portraits. He stands with the confidence, and elbow akimbo, of Anthony van Dyck's portraits of Stuart courtiers (**58**). The brilliant white of his uniform is set off against curtains and draperies to give him a presence like that of King Louis XIV of France, in Hyacinthe Rigaud's famous portrait (1701; Louvre). The billowing red-and-gold folds of Swettenham's Malayan textile function, both visually and symbolically, like the French king's ermine-lined coronation robes adorned with the royal blue-and-gold fleur-de-lis. According to the writer Rebecca West, the portrait captures the distinctive mood of the years around 1900; at the same time it is "a splendid Titianesque work."[1] If there is a touch of humor, or even irony, about the presentation of the successful administrator in the guise of royalty or aristocracy, Sargent does his sitter, as well as himself, proud in the persuasiveness with which he invokes the traditions of the Old Masters.

Critics beginning with Sargent's friend Henry James have been fascinated by what the artist learned from the Old Masters in pose, gesture, and mise-en-scène: the Van Dyck swagger, the "Renaissance elbow" so jauntily angled, the Mannerist elongation of neck or hand, the urn or pilaster of a stately setting.[2] But what difference does this historical consciousness make to the ways in which Sargent's portrait sitters are clothed?

57 | *Sir Frank (Athelstane) Swettenham,* 1904

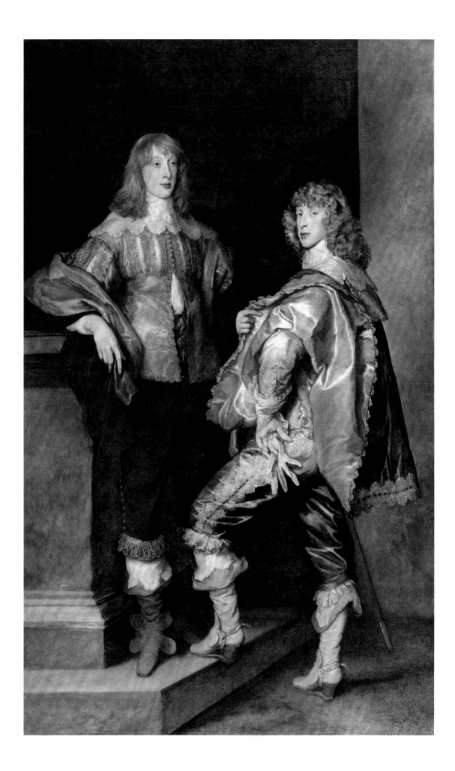

We might begin to answer that question by noting the ingenuity with
which Sargent accommodates the latest fashions in dress within the time-
honored conventions of Grand Manner portraiture. Swettenham's white
uniform is strictly accurate, down to minor details of the latest Colonial
Office regulations, and yet its luminosity permits Sargent to create a
genuinely Titianesque sumptuousness in the portrait as a whole.[3] Another
example might be the Earl of Dalhousie, whose loose-fitting white suit
displays the easy grace of fine tailoring at the turn of the twentieth century,
when London was the capital for menswear as well as for the British
Empire (**59**). Dalhousie strikes the pose of a seventeenth-century aristocrat

as he might have been portrayed by Van Dyck, one hand on hip to give the elbow a confident thrust, the other draped proprietorially on an array of stonework — molded pedestal, column, pilaster — that makes obvious reference to the apparatus of the country house or Grand Tour portrait. That the same architectural assemblage appears in other portraits by Sargent, and seems therefore to have been some kind of studio prop, does not lessen its efficacy as symbol of the ancestral estate.[4] The portrait also affords an opportunity for a bravura display of white-on-white — a traditional painter's tour de force — in play with the tropical suit. To be sure, the suit updates the Grand Manner portrait into modern fashionability, but that is only part of the story. Perfectly judged to carry the fashions of the metropolis into tropical climes, the suit remakes the Van Dyck aristocrat into an imperial adventurer of the new, twentieth century. In its white simplicity, however, it dispenses abruptly with the intricacies of lace, gold thread, brocade, and ruff that connoted opulence and power in the portrait tradition. If the suit retains the panache of Van Dyck costume, that is not to do with its design or decoration. It is a matter, instead, of how it is worn — and crucially, of how it is painted.

This suggests why our initial reply is not quite adequate. Sargent does not simply insert modern fashionable dress into a traditional portrait format. Conversely, he never paints an imitation or pastiche of a historical costume, as his contemporaries sometimes did in this age of the fancy-dress ball. Sargent has little interest in either modern or historical costume as an entity separate from the painting. Yet he is entirely captivated by what his sitter wears, inseparably from the way he will paint it.

Sargent had a more deeply embedded familiarity with the art of the past than any portrait painter before him, and perhaps since, for it was the result of a unique combination of circumstances. On the one hand was the intense art-historical consciousness of the age into which he was born — the great age of the public art museums, when scientific connoisseurship and style criticism created the canon of Western art much as we still know it today.[5] On the other hand was his peripatetic upbringing in a family constantly, even compulsively, on the move among the art centers of Europe. Letters between Sargent and his childhood friends show him already a seasoned, as well as avid, gallery-goer in his teens, and one who knew his art history: at age thirteen he is in raptures over ancient statues in Munich's Glyptothek; before he reaches twenty, he is recounting his recent enthusiasm for Tintoretto, alongside the other Venetians whom he has long admired.[6] In the Paris studio of his teacher Carolus-Duran, the oracle for the younger, progressive generation was the Spanish seventeenth-century painter: "Velasquez, Velasquez, Velasquez, étudiez sans relache Velasquez" (study Velázquez without respite).[7]

It was entirely in line with contemporary fashions in Old Master painting, then, that Sargent made the difficult journey to Spain in 1879.[8] His study of Diego Velázquez's masterwork in the Prado, *Las Meninas* (1656), is immediately evident in *The Daughters of Edward Darley Boit* (**60**). Sargent's response extends to the girls' dresses, their starched pinafores a

61 | *Sybil Sassoon, Countess of Rocksavage, 1913*

witty comment on the stiff formality of the Spanish court dress worn by the Infanta and her maids. The Louvre had its own portrait of the Infanta, highly regarded in Sargent's generation and generally considered to be an autograph Velázquez, although now considered a workshop piece. This version must be the principal point of reference for *Beatrice Goelet* (1890, private collection), which gives to the child subject's dress something of the pomp of Spanish court costume.[9] A similarly serious expression, together with a view from above, is seen in the portrait of young Helen Sears, whose unstructured white dress is more obviously modern; even here, the precise placement of the tiny feet, in their ribboned silk shoes, retains a hint of the formality of a historic child portrait (see **103**). The oversize hydrangeas in the portrait of Helen Sears, like the large caged parrot in the portrait of Beatrice Goelet and the enormous Japanese vases in *The Daughters of Edward Darley Boit*, play on the contrast in scale between the childish figures and the adult world they inhabit, a motif that goes all the way back to *Las Meninas*.

Sargent acknowledged the importance of Velázquez, but when advising a younger artist he recommended another seventeenth-century portraitist: "Begin with Franz Hals, copy and study Franz Hals, after that go to Madrid and copy Velasquez, leave Velasquez till you have got all you can out of Franz Hals."[10] The impact of Hals on Sargent's work may be less obvious than that of Velázquez or Van Dyck, but perhaps it is also more deeply absorbed. Again he traveled to see the artist's work, making the journey in 1880 to Holland, where he internalized the vivacity of the Dutch painter's brushwork. The striking contrast, characteristic of Hals, between dark male clothing and the snow-white linen of ruffs and lace cuffs may already be discerned in a male portrait of the year after Sargent's trip to Holland, *Dr. Pozzi at Home* (see **33**). Pozzi's flamboyantly red dressing gown has been compared, appropriately, to the robes in portraits of cardinals and popes, but the lesson of Hals may be more important to the bravura brushwork that conjures this meditative figure from the surrounding shadows.

"He is tending entirely towards a return to fifteenth-century ideas," reported Sargent's friend since childhood, Violet Paget (Vernon Lee), in 1884.[11] That was the year of *Madame X*, so often seen as the crystallization of a distinctively modern type, the "professional beauty" of Parisian high society (see **13**). But Vernon Lee may have been right: the incisive line of the profile can be compared with the female portraits of Antonio del Pollaiuolo or Piero della Francesca. The black evening dress seems to epitomize the haute couture of its date, and yet the stiff, body-molding bodice might also read as a simplified or abstract version of female costume in Florentine portraits of the 1470s. Sargent's move to London has often been attributed to chagrin or embarrassment at the controversy over *Madame X* at the Paris Salon. However, England was not merely a refuge, and its attractions included new opportunities to encounter the art of the past, and the present. The move coincided with Sargent's developing interest in the Pre-Raphaelites — both the Italian artists who predated Raphael and their self-appointed namesakes in nineteenth-century England.[12] Sargent's

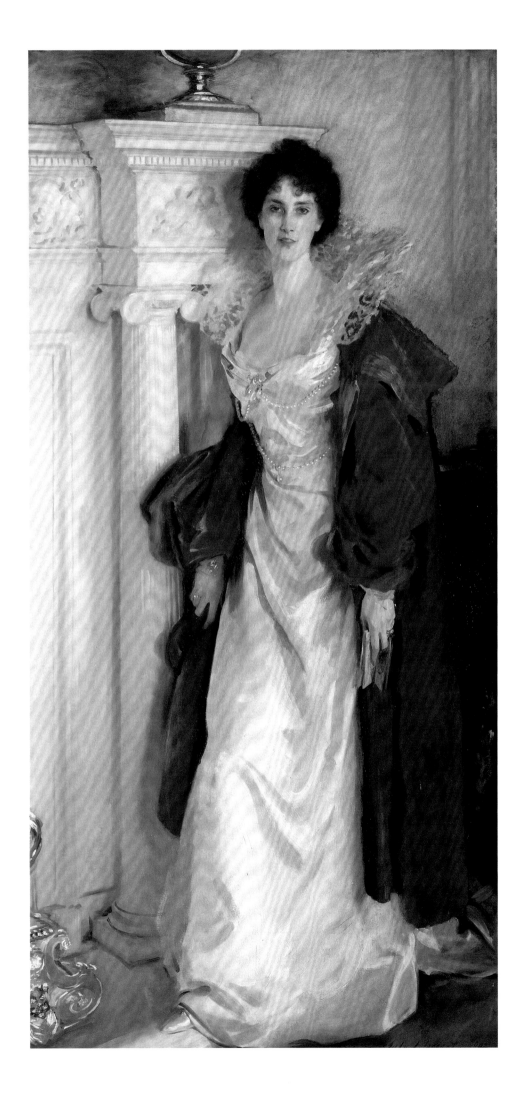

62 | *The Duchess of Portland
(Winifred Anna Cavendish-Bentinck,
née Dallas-Yorke)*, 1902

63 | Thomas Gainsborough
(British, 1727–1788), *The Honourable
Mrs. Graham*, 1775–77

social circle expanded to include artists of the later Pre-Raphaelite circle
along with the critics who were writing most compellingly about the Italian
Old Masters, Walter Pater as well as Vernon Lee.

Once in England, Sargent had ample opportunity to study the great
tradition of English portraiture, more conspicuous than ever before due
to the formation in 1856 of the National Portrait Gallery (the world's first
public portrait gallery), frequent London exhibitions of Old Masters, and
the dispersal of portraits from aristocratic collections following financial
perturbations in the later decades of the century. Auction prices soared for
portraits by such artists as Joshua Reynolds, Thomas Gainsborough, Henry
Raeburn, and Thomas Lawrence, alongside a conspicuous vogue for French
art of the same period, dubbed the "goût Rothschild" (Rothschild taste)

after the banking family, leaders of taste in this period of dramatic social change. Sargent's portrait sitters came to include prominent figures from both the old world of the British aristocracy and the new international plutocracy of Europe and America — that is, the classes who respectively sold and bought the Grand Manner portraits of the British tradition along with the fine and decorative art of the French Rococo. It was inevitable that the vogue for the eighteenth century should infiltrate the portrait styles, as well as the styles in fashion, of the later nineteenth century, just as the eighteenth-century portraitists themselves revived the fashions of their seventeenth-century predecessors, Rubens and Van Dyck.[13] In *Sybil Sassoon, Countess of Rocksavage*, Sargent alludes to the elegant déshabillé in female portraits by seventeenth-century court painters such as Peter Lely and Godfrey Kneller (**61**). It was Sargent's special skill not merely to present his art as the logical outcome of the entire tradition of Grand Manner portraiture, but also to position each portrait in precise relation to its most apposite precedents.

Among the grandest of Sargent's sitters was the Duchess of Portland, posed at Welbeck Abbey in Nottinghamshire, the family estate since the seventeenth century; this was unusual for Sargent, whose busy schedule ordinarily mandated sittings in his Tite Street studio (**62**). The tall Ionic columns of the white marble chimney-piece complement the duchess's elegant slenderness, and her costume captures the family's ancestry without the least hint of the antiquarian. At first glance she recalls a female portrait by Gainsborough, such as *The Honourable Mrs. Graham* (**63**). Yet Mrs. Graham's shimmering costume, with its pearls and lace collar, itself alludes to the seventeenth-century portrait tradition of Van Dyck. Sargent's dress is an early twentieth-century revival of an eighteenth-century revival of seventeenth-century costume, a play on the whirligig of fashion at the same time as it is a reminder of the duration of the Portland lineage. As conspicuously as the extravagant standing collar alludes to Van Dyck, or to the famous collar of Marie de' Medici as portrayed by Rubens, it also dissolves into an impressionistic flurry of brushstrokes that seem to propel it into modernity. How is it fastened to the dress? Like many of Sargent's most glamorous costumes, the dress seems to have liberated itself from all practical demands of tailoring, and the collar floats free, just as the red mantle slides from the shoulders without quite succumbing to mundane gravity. For all its scintillating improbability, however, the dress never lets the viewer forget the aristocratic traditions in which it is rooted. In a portrait of Mrs. Leopold Hirsch (**64**), herself a collector of antique clothes and textiles, a very different, though equally elegant, collar of silvery lace falls from the low neckline of a sumptuous Spanish brocade in rose and gray, the color scheme reminiscent of a portrait of Philip IV by Velázquez.

Sargent learned most from Old Masters who painted rapidly, from Tintoretto, Hals, and Velázquez to Gainsborough and Lawrence. This way of painting must partly have been temperamental, but it was also expedient. It was no longer acceptable to have a team of assistants paint the costumes, backgrounds, and accessories, as the eighteenth-century

64 | *Mrs. Leopold Hirsch (Frances Mathilde Seligman)*, 1902

65 | *Mrs. Carl Meyer (Adèle Levis)
and Her Children, Frank Cecil and
Elsie Charlotte,* 1896

66 | François Boucher (French, 1703–
1770), *The Marquise de Pompadour,* 1756

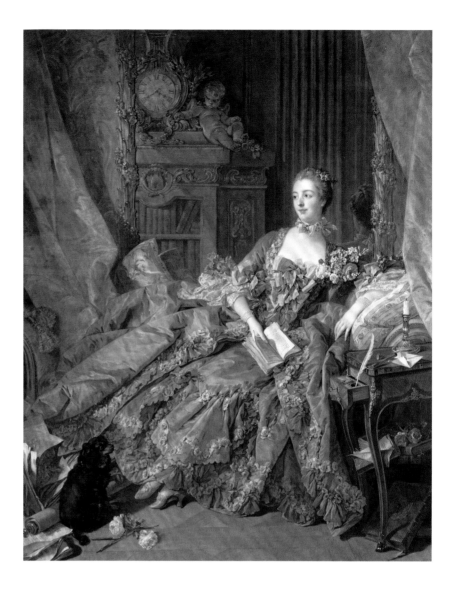

portraitists routinely did. Nor was it possible to obtain dozens of sittings
from busy celebrities, grandees, or plutocrats. Sargent was obliged to paint
fast, and the lessons of the Old Masters were crucial in forming his style.[14]
The need for rapidity also meant that the costume was not only conceived
but actually painted in one process, along with the likeness of the sitter.
That helps to account for the way the costumes seem somehow to be
imbued with the spirit of the historical precedent, even when they clearly
represent contemporary fashions in dress.

Mrs. Carl Meyer and Her Children is a striking example of the
daring that Sargent could exercise when a sitter was prepared to collabo-
rate (**65**).[15] Does it flatter Mrs. Meyer to cast her as that distinguished
eighteenth-century patron of the arts, Madame de Pompadour in her
portrait by François Boucher (**66**), or does it go a step too far, so as to verge
on satire? Sargent's portrait hovers on the very edge of that distinction.
Only the wealthiest of Mrs. Meyer's generation (she was the daughter of a
rubber manufacturer and wife of a banker, all of them Jewish) could afford
the French Rococo accessories: fan and pearls, gilded paneling in the style
of Louis XV, sofa and footstool adorned with Beauvais tapestry.[16] More

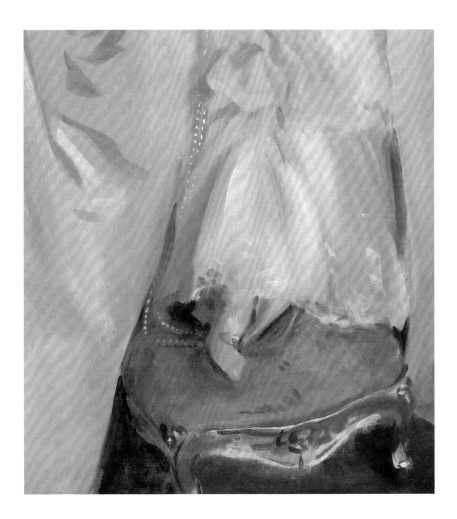

than historical allusions, the accessories represent the height of fashion at the end of the nineteenth century. The glamour is that of the "goût Roths-child" as much as the style of Boucher.

But what of Mrs. Meyer's dress? Sargent's imitation of the portrait by Boucher is unusually close, for him, and it captures the dynamism and verve of the prototype better than a more faithful rendering.[17] The dress, however, works differently: just as extravagant as Boucher's in sweep and volume, it has metamorphosed from a deeply opulent blue-green to the brightest peach-pink. All its historical detail has vanished, so the expanse of skirt is inflected only by painterly gestures broad and sketchy as Hals or Lawrence. Black cummerbund and frothy neckline give it a modern feeling. It might, for example, be compared with a pink ballgown with black details made in 1897 (the same year as the first exhibition of Sargent's portrait at the Royal Academy in London) by the Parisian couturier Jacques Doucet.[18] However, the dress as worn by Mrs. Meyer has not lost its historical connection. The pink slipper, for example, that just peeps from beneath the hemline reads as a direct quotation from the eighteenth-century portrait. It has become weightless, poised on the footstool, where the last loop of the pearls that fall five feet or more from a double circle at Mrs. Meyer's neck, over lacy frills, cummerbund, and skirts, finally meets the tiny slipper.

The loops of pearls are flagrantly impractical in comparison to the neat pearl bracelets of Boucher's Pompadour, yet just as much a sign of

conspicuous opulence. One critic of the Royal Academy exhibition of 1897 aptly termed them "ropes of pearls."[19] The phrase comes from a scene in Benjamin Disraeli's novel *Lothair* (1870), where the egregiously wealthy hero visits a jeweler and declares: "I want pearls, such as you see them in Italian pictures, Titians and Giorgiones, such as a Queen of Cyprus would wear. I want ropes of pearls." Lothair is referring to Venetian portraits of Caterina Cornaro, Queen of Cyprus, swathed in pearls. However, the "ropes of pearls" also call to mind another famous portrait with which *Mrs. Meyer* is surely in dialogue: Reynolds's *Mrs. Siddons as the Tragic Muse* (1783–84; Huntington Library). The two children in Sargent's portrait wittily play the roles of Pity and Terror (the Aristotelian attributes of tragic drama) behind the actress Mrs. Siddons's throne. Perhaps Mrs. Meyer's pearls also recall the long chain draped over the bodice in Rubens's *Helena Fourment* (about 1630–32, Calouste Gulbenkian Museum, Lisbon), whose costume might also have suggested the bows at the elbows. This Rubens was particularly famous at the time of Sargent's painting; in 1897, it inspired several dresses at the celebrated fancy-dress ball held by the Duchess of Devonshire on July 2 (to which Mrs. Meyer was not invited).[20]

Mrs. Meyer's dress stands in some kind of relationship to numerous prototypes and precedents in art and fashion alike — Franz Xaver Winterhalter and Tiepolo have been suggested as additional points of reference.[21] Yet the dress created in Sargent's portrait is not derived in any straightforward fashion from any one of these precedents, or even from a traceable or documentable combination of them. It does not appear historicizing, and if anything it looks fresher and more modern than the contemporary ballgown by Doucet. The precedents are not so much imitated as entirely transformed — or it might be better to say that they are entirely re-created in new terms. The result, which might be described as a co-creation by Sargent and Mrs. Meyer, is neither a fashionable nor a historical dress, and perhaps it is not even a possible dress: one struggles in vain to discern how the gauzy sleeves are attached, or where the billows of skirt could go, should Mrs. Meyer attempt to stand up on those tiny slippers. To that extent it is a dress of the pure imagination.

And yet it is also a dress fully realized in oil paint on canvas. That realization could never have taken place without the collusion of many creative minds — from Boucher, Rubens, and Reynolds to contemporary couturiers and Adèle Meyer herself. Nor could it have happened without Sargent's museum-going childhood and his exceptional openness to learning from the styles of other artists. Yet the result looks like nothing ever made before (or since). Suffused or saturated with the Grand Manner tradition in every one of its aspects, *Mrs. Carl Meyer and Her Children* nonetheless meets the gaze of today's viewers with the shock of the new.

Almina Wertheimer

CAROLINE CORBEAU-PARSONS

*A*LMINA WERTHEIMER WAS THE FIFTH surviving daughter of Sargent's greatest patron, the highly successful art dealer Asher Wertheimer, and his wife, Flora Joseph. The artist painted no fewer than twelve formal portraits of the couple and their children between 1898 and 1908, amounting to his largest private commission. A close friendship developed between him and the family, leading Asher to lament that "there were not more Wertheimers . . . to paint."[1] This portrait of Almina "à la turque" (in Turkish style) is the last of the Wertheimer pictures to have been painted (**67**). Almina had already featured in a 1905 group portrait alongside her siblings Hylda and Conway, in which she wore a riding habit, and three of her sisters were also portrayed twice by Sargent (**70**; see **17, 79**).

As a so-called Orientalist work, Almina's portrait stands out both in the Wertheimer series and as a formal portrait in Sargent's oeuvre, and it cannot help raising uncomfortable questions of cultural appropriation.[2] Critics have noted that the painting evokes — if not directly quotes — the figure of the slave in Jean-Auguste-Dominique Ingres's *Odalisque, Slave, Eunuch* (1839–40), formerly known as *Odalisque with a Slave* (**68**).[3] One of the greatest artists of the early nineteenth century, Ingres also was the epitome of the Orientalist painter: he never traveled farther from France than Naples, and his famous eroticized depictions of harems are the visual foundation of Eurocentric fantasies about the East.[4] His paintings have also been cited by art historians and feminists, alongside those of Jean-Léon Gérôme, as the embodiment of works produced by, and for, the male gaze.[5]

At first sight, Almina's portrait is in the lineage of such pictures, and the northern Indian *sarod* (lute) she is holding may have been included in the composition for its "exotic" effect. Unlike the women in Ingres's paintings, however, Almina was the artist's friend rather than an unidentified, sexually objectified model.[6] Not much of her anatomy is revealed, and

67 | *Almina, Daughter of Asher Wertheimer*, 1908

her expression and pose are devoid of the languid and lascivious attitudes associated with Orientalist paintings. Almina looks confidently and unprovocatively at the viewer with a smile on her face, projecting agency and collaboration. Without engaging in the much-debated and unresolved question of Sargent's (homo)sexuality, we can see that his gaze at Almina is a far cry from Ingres's at his models.

The robe she is wearing, a white silk Ottoman coat, or *entari*, with green cashmere patterns, was not just a prop, let alone the product of Sargent's imagination: it takes center stage in the picture. Together with his favorite white and blue-gray cashmere shawl (see **46**), this entari was the most prized possession in the artist's extensive textile collection. It made recurrent appearances in his more intimate figure paintings that staged members of his immediate circle relaxing or pursuing various leisure activities. Jane de Glehn, one of Sargent's traveling companions in the Italian Alps, recorded in her diary: "Yesterday I spent all day posing in the morning in Turkish costume for Sargent on the mossy banks of the brook. I and Rose-Marie, one of the little Ormonds. He is doing a harem disporting itself on the banks of the stream. He has stacks of lovely Oriental clothes and dresses anyone he can get in them."[7] His niece Rose-Marie Ormond was photographed at age thirteen sporting the entari, which supports the idea that he chose it for its decorative and picturesque qualities rather than for any erotic associations with harems (see **43**). That this garment was worn by both Rose-Marie and Jane de Glehn complicates the argument that Almina's portrait participates in the stereotype that grouped Jewish women with other "exotic" (and non-English) women, even though the painting could be — and was — read that way by some contemporary audiences, at a time of rising antisemitism in Britain.[8]

Just as he did with his other friends and relatives, Sargent dressed Almina in the entari, completing her costume with a turban made of an assemblage of linen-green shantung silk, pearls, and feathers. The choice

69 | Joshua Reynolds (British, 1723–1792),
Mrs. Charles Yorke, about 1763

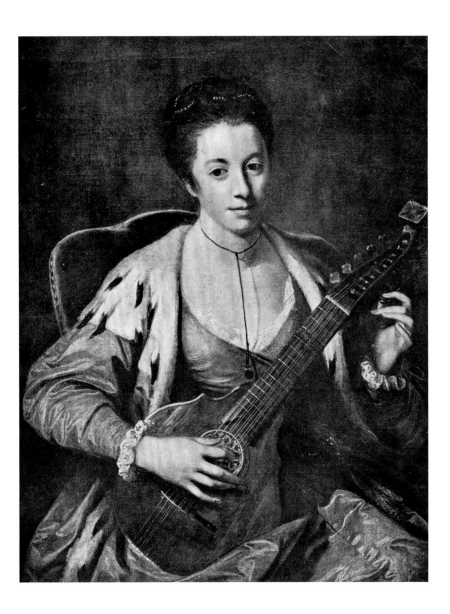

of dress places Almina's portrait at the crossroads between Sargent's formal portraiture and his more intimate, investigational works, usually painted on a small scale. The experimental nature of Almina's portrait was certainly facilitated by friendship and trust between artist and sitter — and at this point it's likely that Sargent virtually had carte blanche when portraying the Wertheimers.[9] Other portraits of the family count among his most celebrated and daring works, indicating that his intimacy with the sitters unlocked a greater freedom in his approach. This is the case with *Ena and Betty Wertheimer* and even more so with *A Vele Gonfie*, in which collaboration and playfulness are also central (see **17, 79**).

Beyond its playfulness, Almina's painting makes a connection that adds another layer to its interpretation. In addition to Sargent's reference to Ingres, this portrait seems to engage more directly with a lesser-known artwork by Joshua Reynolds: a picture of Mrs. Charles Yorke formerly in the collection of Almina's uncle, the art dealer Charles Wertheimer (**69**).[10] Sargent closely echoed its composition, his sitter's handling of the instrument, her demure smile, and the non-Western effect of the overcoat, made of ermine in Mrs. Yorke's case.[11] The Reynolds portrait and one of Nancy

Parsons by Thomas Gainsborough were stolen from Charles Wertheimer, alongside valuable snuffboxes, in a high-profile robbery in February 1907. The theft was widely reported in the press, and while some of the snuffboxes were soon recovered, the paintings never were and are assumed to have been destroyed. The robbery prompted Roger Fry to write an article about the portraits, and the outstanding aesthetic value of the Reynolds in particular, in the *Burlington Magazine* in 1907.[12] Sargent's motivation for making a pastiche of the stolen Reynolds within a year or so after the theft can only be left to speculation. There were some tensions between Asher and his older brother Charles, who had offered a substantial reward to anyone who would return his cherished pictures to him. Almina's picture may have been a lighthearted settlement of this score. Alternatively, Sargent's choice to make a portrait after Reynolds's, which Fry had described in such celebratory terms, may have been a private joke. Fry's disparaging critique of Sargent's art and his animosity toward the painter, from 1900 onward, is notorious. Then again, Sargent always rose above such criticisms and did not feel the need to engage with Fry, so it may give the critic too much credit to speculate that the artist was making a joke at his expense, private or not.

Sargent's motivations for Almina's portrait, along with those of the Wertheimers, may now be lost to us, but the painting's many layers highlight the distance Sargent traveled from Orientalism and its premises.

70 | *Hylda, Almina, and Conway,*
Children of Asher Wertheimer, 1905

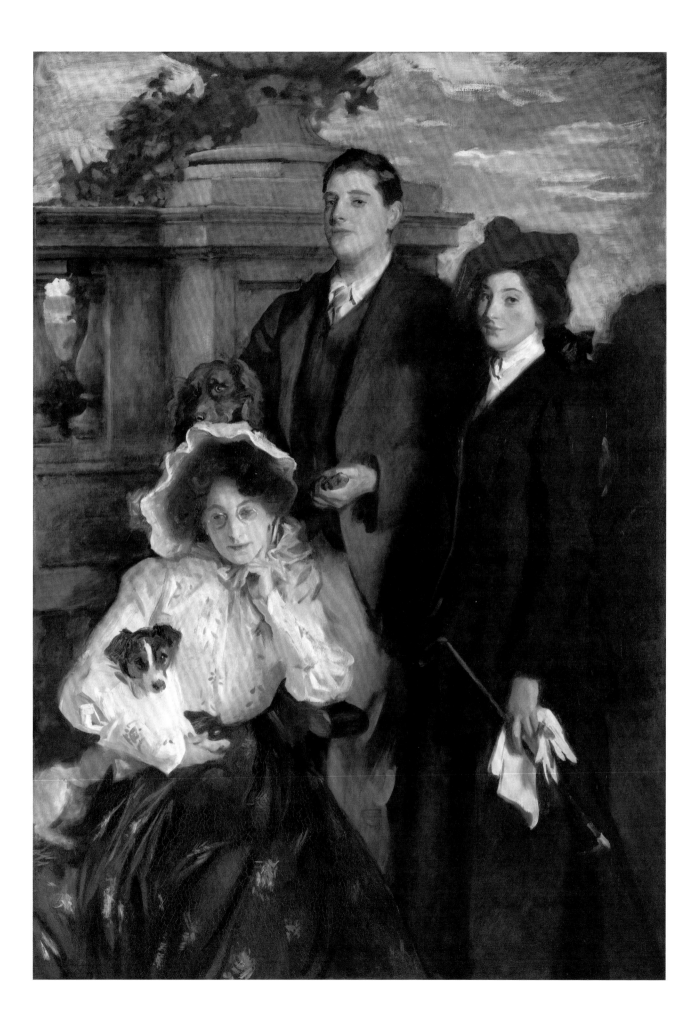

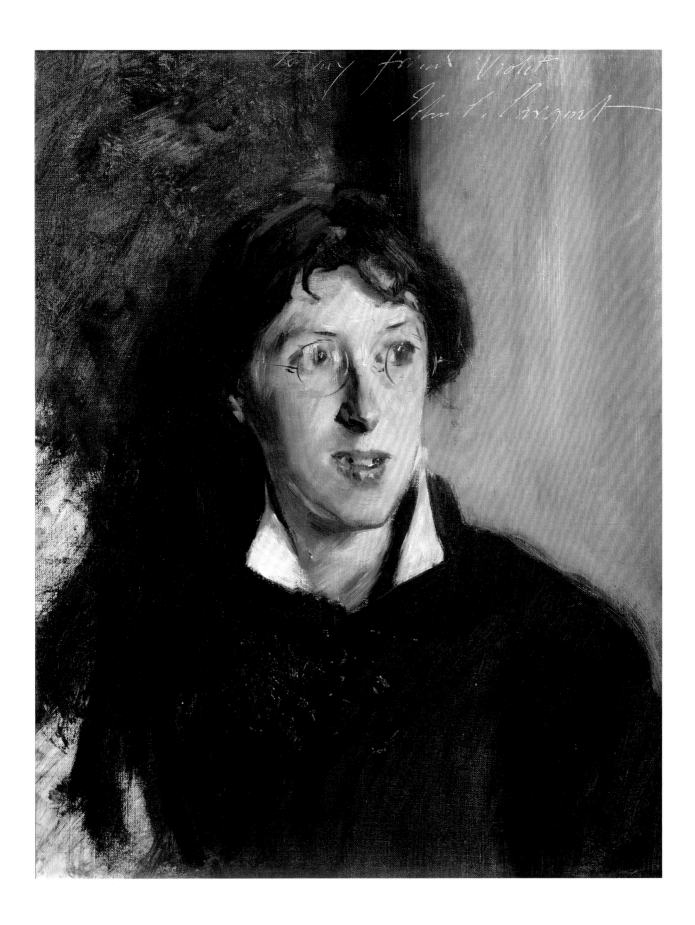

71 | *Vernon Lee,* 1881

Sporting with Gender | PAUL FISHER

*T*N 1885 IN PARIS, SARGENT'S FRIEND VERNON LEE worried about his tendency to amplify his sitters' psychological complexities — and partly through his stagy costume inspirations of the period. "I fear John is getting rather in the way of painting people too *tense*," she wrote. "They look as if they were in a state of crispation des nerfs."[1] *Crispation des nerfs*, an eighteenth-century medical term for nerve-clenching or spasms, here applied to the very modern state of "nerves" or psychological complexity that Sargent, with his up-to-date Paris perspective, often captured in both his male and female sitters, and crucially through the medium of dress.[2]

Sargent's own sexual complexities prompted both his fascination with "nerves" and his preoccupation with dress.[3] Also, for him and for other modern-minded artists, the era's recasting of sex and gender underpinned what the French Symbolist writer Maurice Barrès described in 1889 as the "maladie du siècle" (disease of the century): he and others saw an era rife with gendered social deviations understood as nervous diseases.[4] Doctors often diagnosed "neurasthenia" (what we might call depression) in men and women perceived as enervated by modern urban life, specifically in ways that undermined their conventional gender roles. "Hysteria" (something like anxiety) was a diagnosis often applied to women deemed overstimulated by their burgeoning new opportunities in education, travel, and professional life. And "inversion" (sometimes labeled "homosexuality" after 1869) applied to people who transgressed traditional gender or sexual norms, who bodily or sartorially inverted or reversed established binary gender roles. ("Inversion" included what we now regard as both gay and trans experiences.) In fact, historians have identified Sargent's era, on both sides of the Atlantic, as a time of erupting "gender crisis."[5]

The Belle Époque transformation of traditional gender roles, especially among women, triggered what one art historian has called "an anxiety

around the collapse of difference" between the sexes.[6] As a sometime avant-garde artist, Sargent confronted such conventions subtly or blatantly. Sporting with gender in dress, he often teased or provoked contemporary critics and audiences, triggering uproars and Salon scandals. Famously, in 1887, Henry James described Sargent's audacious youthful talent as inciting paintings that amounted to an "'uncanny' spectacle"— often fashioned from unconventional dress.[7]

Changing gender roles inspired some of Sargent's most provocative canvases, among them his incisive 1881 rendering of Vernon Lee (Violet Paget) with drawn-back hair and wearing a masculine Gladstone collar and round glasses (**71**). Virtually no other Sargent portraits depict women in spectacles, two exceptions being portraits of Hylda Wertheimer (see **70**).[8] But women's eyewear was becoming more common during the late nineteenth century, and many of Sargent's sitters would have used such vision aids in their daily lives. What's more, a lorgnette could provide a society woman with a fashionable accessory, both an item of jewelry and a gestural prop. In general, Sargent's omission of eyeglasses probably says more about his artistic than his social preferences. In this portrait, Vernon Lee's studious spectacles allow Sargent to embody her "masculine" intellectual ambitions as an aesthetic historian. His brilliant, dashed-off sketch in "dabs and blurs" caricatured her as "rather fierce and cantankerous," she thought.[9]

Sargent's unconventional *jeu d'esprit* captured a woman who tested boundaries both in her "masculine" careerism and in her veiled lesbianism. In comparison to earlier nineteenth-century iconoclasts such as the French novelist George Sand or the American sculptor Harriet Hosmer, Lee's version of "cross-dressing" remained somewhat ambiguous, combining traditional feminine garments — often black silk dresses in this period — with masculine accoutrements such as the Gladstone collar.[10] But both Lee's mode of dress and her signature eyewear impressed contemporaries like Lady Mary Ponsonby, who declared herself "rivet[ed]" by Lee's art-historical books and felt that "she is forcing me to see things through her spectacles, so that she may be clothing fact and person with qualities derived entirely from her imagination"— the verb "clothing" here underscoring the imaginative potential of dress.[11]

Eight years later, Sargent painted a sketch and a large exhibition canvas of Vernon Lee's companion Clementina ("Kit") Anstruther-Thomson wearing a shepherd's hat, fur cape, and skirt and blouse, along with a man's necktie (**72**). Critics found this forthright and aggressive stylization of an outdoorsy, intellectual woman a "shocking eccentricity," even though, by 1889, the "tailor-made" (skirt, jacket, and blouse ensemble), which had been made fashionable by Princess Alexandra in the 1880s, was standard daywear for women; it was the lack of decoration and pose that made Sargent's rendering distinctive.[12] (By 1897, when he painted Edith Minturn Phelps-Stokes in a bowtie and dark jacket, tailored outdoor costumes were definitely modish; see **20**) These edgy fashion statements defined a whole generation of restless young women.

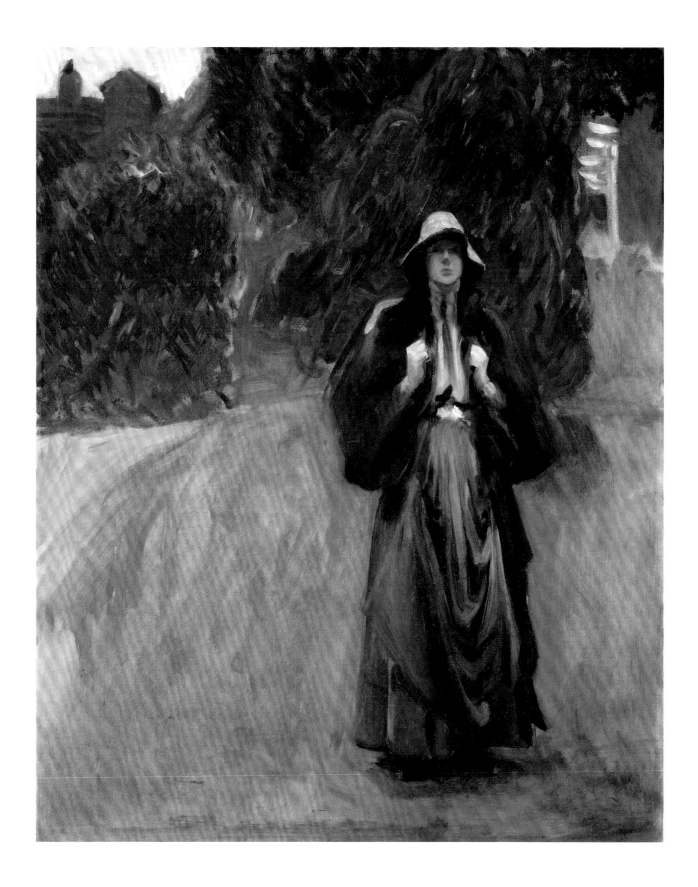

Another such was the artist Alice Brisbane Thursby, whom Sargent painted in about 1898 (see **18**). To portray this unconventional daughter of the American utopian socialist Albert Brisbane, Sargent posed her eagerly craning forward from a bergère armchair in a broad-shouldered fashionable walking dress. With her lavender bow and long silver chain, Mrs. Thursby resembled an "18th century coachman," Kit Anstruther thought — her dashing costume capturing one woman's iconoclastic and restless energies, though not in this case with explicit lesbian implications.[13]

Some of Sargent's portraits of women, such as his 1901 rendition of his young friends Helena ("Ena") and Betty Wertheimer, more subtly sported with gender norms (see **17**). Though Betty's red-velvet evening gown, hair-roses, and fan follow elegant women's conventions of the time, her swagger and direct gaze are provocative, especially in a young Jewish woman, who would have been seen stereotypically in this period as sensuous and exotic. Sargent originally painted Betty's gown with one strap fallen, perilously recalling his infamous Salon scandal, *Madame X*.[14] Sargent treats Ena's cream-colored satin gown as a fascinating drapery that augments her bold and exuberant stance. With one arm hooked around her sister's waist, Ena exudes a confidence, warmth, and energy that typified her unconventionality as a free-spirited artist who followed her own instincts.

In many of his canvases, however, Sargent had to struggle with the entrenched sartorial conventions of his time. As a society portraitist, the painter sometimes had to placate wealthy, conservative patrons in order to further his own ambitions. His portrait of the heiress Pauline Astor depicts her in conventional feminine evening wear: a white silk gown and a fur-trimmed, pale-violet shawl, accented with a fur muff, pearls, and a diamond aigrette on her chignon (see **23**). Such props not only showcased nineteen-year-old Miss Astor's wealth but also advertised her feminine decorum and eligibility. As a premiere portraitist at the turn of the twentieth century among the Anglo-American elite, Sargent attracted queues of relatively conventional, upper-class clients. Yet he remained notorious for his supposed ability to expose the inner life of his subjects with an incisiveness that made some people, especially women, nervous to sit for him. They were "afraid lest he should make them too eccentric," as Vernon Lee had put it in 1885 — a phrase that spoke both of Sargent's sitters' appearance and the psychology that potentially underlay it.[15]

Men also feared deviations from the norm, as Sargent understood from his own unconventional position as a cosmopolitan artist. His 1903 portrait of the Boston banker and philanthropist Henry Lee Higginson carefully rendered him the very embodiment of respectable American masculinity (see **86**). Sargent outfitted him in an unobtrusive brown suit in a somber setting, the dark cavalry cloak spread across his knees to memorialize his Civil War service — a distinct message about public service for the students of the Harvard Union, who had commissioned the painting. That Sargent's portrait of Astor recalled Gainsborough, and his Higginson both Raeburn and Rembrandt, enlivened these canvases with wit and depth. But Sargent's Grand Manner portraiture not only furnished nouveau riches

with faux-historical legitimacy; it also reinforced conventional gender norms, implying that such binary distinctions were equally rooted and immutable. Still, for all the deferential gravitas of Higginson's portrait, the gruff sitter, though he was Sargent's friend and banker, was "none too cheerful" to pose, and he and his wife disliked the result.[16]

Other men provided Sargent with potentially volatile subjects for gender transgression, in an age when effeminacy often signaled dangerous "inversion." In 1894, Sargent went to great lengths to persuade W. Graham Robertson, a young London illustrator and designer, to sit for him (**73**). Rendering the young man as an aesthete-dandy, Sargent arranged him in a theatrical and exaggerated pose with one of his hands grasping a jade-handled walking stick, the other arm akimbo with fingers fanned on his hip.

Fin-de-siècle aesthetes like Robertson stood out as showy male iconoclasts of dress. At the same time, dandies performed a brilliantly self-parodying critique of their society, and Sargent's portrait tapped into such paradoxes, allowing for layers of irony and social commentary.[17] In this portrait, Sargent fetishizes the young man's long black wool Chesterfield, an adept and telling choice among the available overcoat styles of the 1890s.[18] What's more, the sitter remembered that "with the sacrifice of most of my wardrobe I became thinner, much to the satisfaction of the artist, who used to pull and drag the unfortunate coat more and more closely around me until it might have been draping a lamp-post." Sargent himself declared that "the coat is the picture"— especially because, among dandies, clothes made the man.[19]

When he saw Whistler's portrait of the queer French decadent Robert de Montesquiou, exhibited in Paris in 1894, Sargent worried that this study of a waspishly thin, tailored figure swaggering with a walking stick would prompt people to say that he'd "copied it" (**74**).[20] Yet many critics of the time saw Sargent's Robertson portrait as critiquing rather than endorsing the cult of conspicuous and outrageous dandies, thereby disassociating him from dangerous queer culture.[21] Sargent's biographer Evan Charteris likewise dubbed this portrait a "symbol of the nineties," observing, "The picture speaks of the 'Beardsley period,' of the 'Yellow Book.' . . . He has painted an individual, but he has defined a period, a type, an attitude of mind."[22] Especially after the Wilde trials of 1895, Sargent also tried to distance himself from public homosexual stereotypes.[23] But in his Robertson portrait he also channeled what Vernon Lee had earlier understood as his taste for unconventionality, his "love of the exotic," the "*bizarre*," and "rare types of beauty . . . incredible types of elegance."[24] And indeed, the enduring fascination of this portrait owes to its ambiguous and ambivalent richness.

Sargent's portrait of his artist friend Albert de Belleroche from about 1883 embodies a more intimate form of gender and sexual complexity (**75**). A private work painted in Paris during Sargent's sittings for *Madame X*, this moody and evocative portrait in a Velázquez style memorializes an intense "romantic friendship" between the two young artists.[25] Originally a sketch for a contemplated Salon piece depicting a youthful champion leaning on a sword, the portrait features Belleroche clad in a square-necked

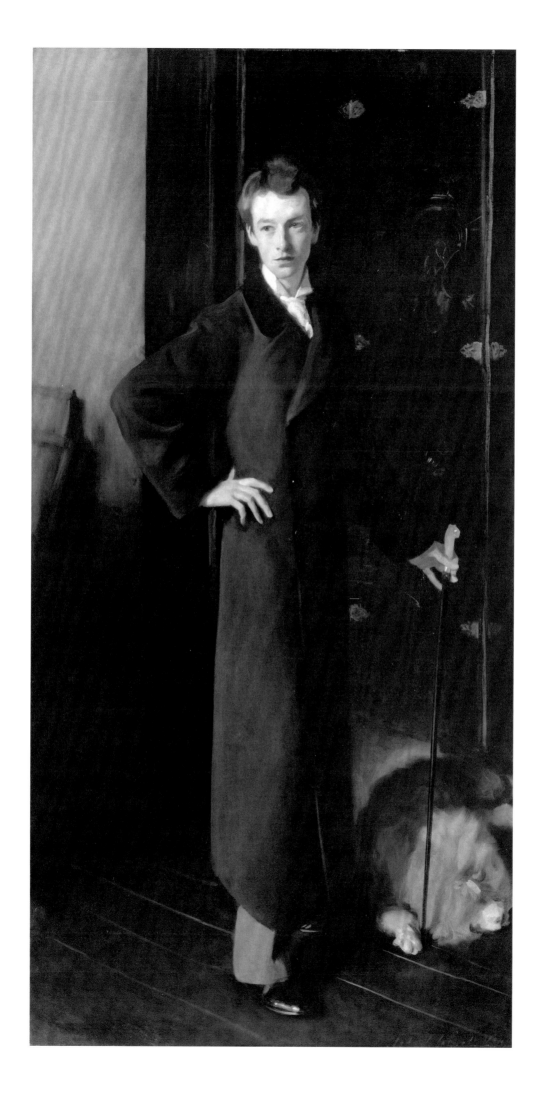

costume that the sitter later recalled as "Florentine" but which dates
from the early sixteenth century.[26] In this case, historical dress prompted
multiple sittings and facilitated a private studio companionship that tran-
scended Sargent's proposed exhibition piece, which never emerged from
these sketches.

In a late portrait of 1923, Sargent faced off with another elegant and
provocative figure, his friend the politician and art collector Philip Sassoon
(**76**). Sassoon was widely known for his exotic and flamboyant tastes. Yet
Sargent didn't portray this scion of two wealthy Jewish dynasties as the
"slim Baghdadian figure . . . dressed in a double-breasted silk-fronted blue
smoking-jacket with slippers of zebra hide," described by the diplomat
Harold Nicholson.[27] Instead Sargent costumed Sassoon in a dark jacket,
white waistcoat, and white cravat that suggest both respectable day dress
and quasi-historical propriety. Only Sassoon's beringed hand, resting on his
hip, hints at his rumored homosexuality.[28]

Sargent represented himself in a similar muted and masculine fash-
ion in his 1906 self-portrait, painted in the Val d'Aosta for the Uffizi (**78**).
Executing this painting "bored him unspeakably," his biographer Charteris

recorded, ostensibly because Sargent had given up portraiture at this point in his career.[29] But also Sargent, infamous for exposing the secret interior lives of others, almost entirely lacked the revelatory instincts of a self-portraitist and disliked turning his gaze on himself. His depiction of himself in a dark jacket, white stand-up collar, and gray silk tie — his Légion d'Honneur ribbon on his lapel rendered through a mere dab of red paint — turned out overwhelmingly conventional, perhaps fitting as this Uffizi commission was painted for a particularly conventional gallery of honor. Still, Sargent resembled a banker more than a painter in the self-portrait, as he also struck people during this period of his life.

In his younger manhood, however, Sargent could occasionally dress playfully and colorfully. When punting on the Thames in 1886, he donned the costume of a gondolier. He presented "a splendid specimen of manly physique," one friend remembered, "clad . . . in a white flannel shirt and trousers, a silk scarf around the waist and a small straw hat with coloured ribbon on his large head."[30] Venetian gondoliers qualified as models of male beauty in the Belle Époque, for heterosexual as well as homosexual observers.[31] Sargent, who often sketched gondoliers and included them in his Venetian compositions, could depict their characteristic costume in lively, kinetic lines (**77**). But in his life as well as in his self-depictions, he habitually screened his own "nervous" modern complications, notably his sexuality, under more conventional and gentlemanly dress. Still, the painter's nervous sensibilities, and his keen sense of gender permutations, rendered him one of the most revealing observers of his era's human complexities.

78 | *Self-Portrait*, 1906

Ena Wertheimer: A Vele Gonfie

ANDREW STEPHENSON

S ARGENT PAINTED THIS DASHING PORTRAIT OF HELENA (Ena) Wertheimer in his Tite Street studio in the summer of 1904 (**79**). Four years earlier, he had completed a double portrait of Ena and her sister Betty (see **17**). Commissioned by her father, Asher Wertheimer, a British-born art dealer of German-Jewish descent, the portrait was a gift to Ena on the occasion of her marriage to the Cologne-born financier Robert Mathias. This very unconventional wedding picture portrays Ena dramatically looking over her left shoulder, with her face, profile, and neck highlighted, and wearing a striking plumed hat.[1] Beneath a piece of black fabric that she clutches with her gloved right hand, draped to look like a voluminous cavalier's cloak, Ena holds a broomstick imitating a ceremonial sword, its tip just visible on the right-hand side of the canvas. Underneath the "cloak," Ena wears a formal jacket, probably of dark wool, with glistening gold metallic embroidery in the style of eighteenth-century court wear.[2] The jacket bears similarities to the Duke of Marlborough's Garter robes, then in Sargent's studio as he painted the ninth duke alongside his wife Consuelo (née Vanderbilt) and their two sons (**80**.).[3] Rather than appropriating the elegant dark-blue silk velvet cloak of the Order of the Garter for Ena, Sargent prefers to underscore the improvised and playful nature of his sitter's cross-dressing through a daring mix of a ceremonial court coat and makeshift cavalier accessories.

Sargent's theatrical composition and dramatic chiaroscuro give the sense of Ena being caught in mid-action, gaining the painting its Italian title, *A Vele Gonfie*, meaning "with full sails," or with gusto and flair. According to contemporary accounts, Ena had a lively, outgoing personality, with a marked sense of humor, and she was striking in appearance, as her 1905 wedding photograph by Cavendish Morton shows (**81**). As an expatriate, Sargent was attracted to those whose outsider status and cosmopolitan experience freed them from the need to conform to

79 | *Ena Wertheimer:*
A Vele Gonfie, 1905

147

conventional British aristocratic codes of public behavior and standards of deportment. Ena, whose Jewish background consigned her to a degree of outsider status by British antisemitism, was liked by Sargent for her extrovert personality, assured confidence, and pronounced enthusiasm — liberated traits that the artist applauded in opposition to what he saw as the cool reserve and conventionalism of some of his titled English sitters. When the painting was exhibited at the Royal Academy in 1905, its critical reception was mixed, with many English critics commenting on Ena's socially confident manner.[4] Supportive writers such as John Collier praised its "extraordinary animation of expression. . . . Its vitality is astounding."[5] Detractors like A. C. R. Carter thought it inelegant and unsophisticated, complaining that Ena "has the elusive grace of the hoyden in full sail."[6] "Hoyden," meaning rude, ill-bred, boisterous, and colloquially tomboyish, suggests a perceived failure on Ena's part to uphold conventional English codes of dignified feminine comportment, or to conform to restrained Anglo gender expectations. This reproach subscribed to contemporary antisemitic criticism of Jewish women's demonstrative social manner and unreserved spontaneity as excessive and unrefined.[7]

Many British critics employing antisemitic stereotyping found Sargent's portraits of wealthy Jewish women overly energetic and excessively vivacious — social mannerisms that they attributed to the arriviste Jew's disregard for upper- and middle-class English codes of decency, and that they saw as signs of a lack of feminine modesty.[8] For example, when Sargent's double portrait of Ena and Betty was exhibited, some British commentators interpreted the sisters' confident manner and intense physicality, displayed in an elegant drawing room adorned with luxurious accessories, as the markers of their nouveau-riche aspirations and as demonstrating social mannerisms that disregarded English codes of propriety (see **17**). D. S. MacColl pronounced in the *Saturday Review* that Ena "is there with a vitality hardly matched since Rubens, the race, the social type, the person." Marion Spielmann in the *Magazine of Art* complained that "the vivacity — especially of the two young ladies — is almost painful." And G. K. Chesterton lamented "a lack of modesty" in the pose.[9] Set in the stylish drawing room of the Wertheimers' Connaught Place mansion, Sargent's double portrait highlights the resplendent colors, rich textures, and opulent materials of the two evening outfits, with Betty's dark crimson velvet décolleté gown contrasting with Ena's sumptuous cream satin silk robe. Against the lightness and smoothness of the sisters' pale complexions, their bright red lips, pronounced eye makeup, rouged cheeks, and red flower hair accessories contribute to two resplendent and daring evening ensembles that would not have been seen as demure or reserved by English standards.

Changes in the etymology of the word "costume" provide clues to how Sargent's sitters' dress came to be viewed as excessive and immodest by certain British critics. Originally meaning a style of dress adopted through custom or usage, with respect to place and time (derived from Latin and then Italian), by the early twentieth century "costume" carried three

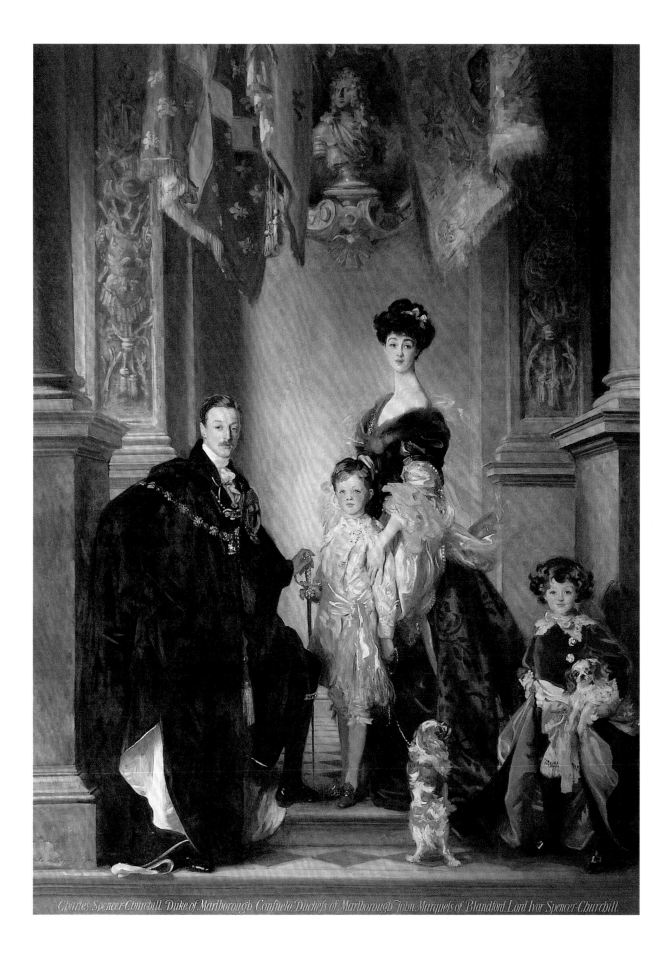

Charles Spencer-Churchill, Duke of Marlborough, Consuelo Duchess of Marlborough, John, Marquess of Blandford, Lord Ivor Spencer-Churchill.

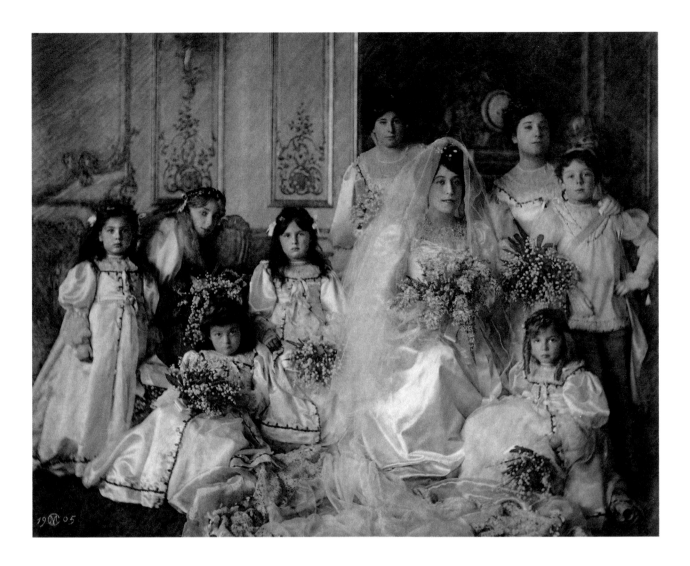

81 | Cavendish Morton (British, 1874–
1939), *The Wedding of Ena Wertheimer
and Robert Mathias*, 1905

additional specific connotations in English. First, it invoked the domain
of the theater, along with theatricality and masquerade (as in fancy-dress
costume). Second, it referred to a performance set in a historical period or
using a historical pageant of dress, incorporating roughly accurate but not
authentic outfits and accessories (as in costume drama). Third, it connoted
something artificial and imitative, which prioritized visual appeal and
spectacular effect over authenticity (as in costume jewelry).

For Ena, an English-born woman of German-Jewish ancestry, not of
noble birth but coming from a cosmopolitan family of meritocratic success,
what would constitute an appropriate costume? How would its sartorial
components be configured? And how might these parts signify to British
art audiences accustomed to the elegant styling of dress in Grand Manner
portraiture? There was no natural costume for Ena, in the sense of one
typical of her country, nationality, culture, or period. Instead, what one
critic called Sargent's "fancy portrait'" makes clear is that costume styling in
the fashion-conscious Edwardian era is a theatrical and playful bricolage.[10]
In *A Vele Gonfie* Sargent deployed a ceremonial court coat and cavalier-
style hat and cloak as female fashion accessories detached from their
privileged class position, proper aristocratic or ancestral signification, and
gender-appropriate use. Acknowledging the contemporary associations of

costume as theatrical style, Sargent prioritized visual appeal and dramatic performance over historical accuracy; it is exactly this audacious approach that makes Ena's portrait so modern and compelling.

Contemporary critics found this subversion of the conventional semiotics of Edwardian female dress disturbing. Encountered outside their proper ceremonial context and out of place on the female Jewish body, the ceremonial uniform and the military accessories become elements in Ena's sexualized cross-gendered, mock-aristocratic performance. Such appropriation characterized Ena as a hoyden: as rude, ill-bred, tomboyish, and decidedly unfeminine.

Nevertheless, as the critic C. J. Holmes recognized at the time, Sargent was a virtuoso portraitist with exceptional pictorial intelligence. His paintings not only captured the physical appearance of his sitters, they also communicated revealing psychological insights. Sargent, Holmes applauded, "produces amazingly clever pieces of work . . . turning an amazing sitter into a fine picture by accepting and insisting upon awkward facts."[11] Appropriated for their dramatic effect and visual impact, the plumed hat, ceremonial court coat, dark cloak, leather glove, and ceremonial sword were, indeed, "awkward facts" in a wedding painting. The portrait commands attention precisely because Sargent does not portray Ena as a respectably modest and demurely feminine young woman but instead captures Ena's confident corporeal swagger. The appropriation of male patrician dress replaces the conventions of Anglo society portraiture with the playful erotics of modern cross-dressing. As the French writer Colette would observe a few decades later, "the seduction emanating from a person of uncertain or dissimulated sex is powerful."[12] Sargent's painting of Ena, by mischievously enlisting male military dress uniform and deploying aristocratic accessories as part of an audacious, sexually powerful, if playful, cross-gender masquerade, challenges the rules of society portraiture and the traditional expectations of a wedding picture. Foregrounded in Sargent's portrait are Ena's refusal to act or dress gender-appropriately and her rejection, as an outsider of German-Jewish ancestry, of the demure ladylike poise and manner demanded by aristocratic English social and sexual conventions.

The Culture of Dress | PAMELA A. PARMAL

\mathcal{J}OHN SINGER SARGENT ONCE REFERRED TO HIMSELF AS A "painter and dressmaker." He made this remark after three weeks of work on Lady Helen Vincent's portrait (**82**). Dissatisfied by the white dress worn by the sitter, he scraped the painting and re-created a new garment in black.[1] His quip reveals the lengths he went to to make sure that the sitter's clothing, in color, texture, and style, furthered his artistic vision. That Lady Vincent's dress doesn't correspond to any current fashion also suggests that he may literally have created it, by draping her with fabric, restyling one of her garments, or simply by imagining it. Although it's unlikely that Sargent actually put his hand to scissors and cloth, his comparison of himself to a dressmaker also emphasizes the centrality of that profession to women's clothing in the nineteenth and early twentieth centuries, when dressmakers created most women's garments, while tailors did the same for men.

At the turn of the nineteenth century, clothing, whether acquired through a dressmaker or tailor, or made at home, was custom fit and usually made of fabric that the wearers supplied themselves. Most people owned few garments, as having clothing custom-made was a time-consuming process entailing multiple visits to the dressmaker or tailor. Textiles were also expensive, and fine materials were out of reach for all but the well-off. Toward the end of the century, this system began to change dramatically, especially for women; by the 1920s, the couturier became the driving creative force behind fashion, and ready-to-wear fashion for men and women was common and more widely affordable.

At the time Sargent began his career in Paris during the 1870s, dressmakers and tailors were plentiful and the couture — where the couturier created several collections a year from which women would choose to have something custom-made in their size — was in its infancy. Paris was the center of the women's fashion industry, as it had been since the eighteenth century, and London had developed a reputation for fine men's tailoring. American and European women of means flocked to Paris

82 | *Lady Helen Vincent, Viscountess d'Abernon (Helen Duncombe),* 1904

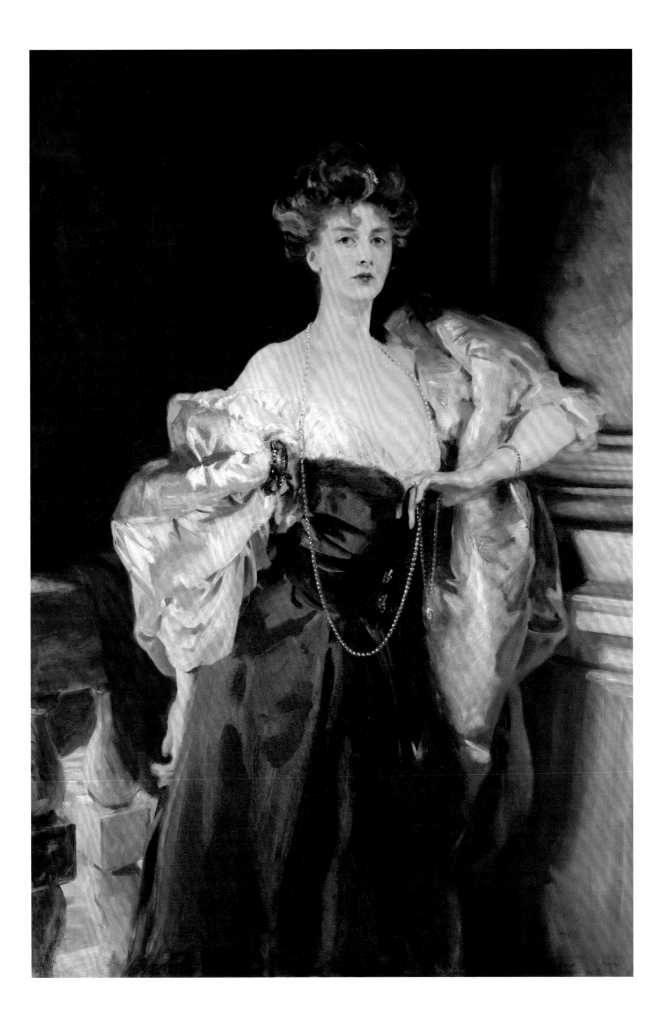

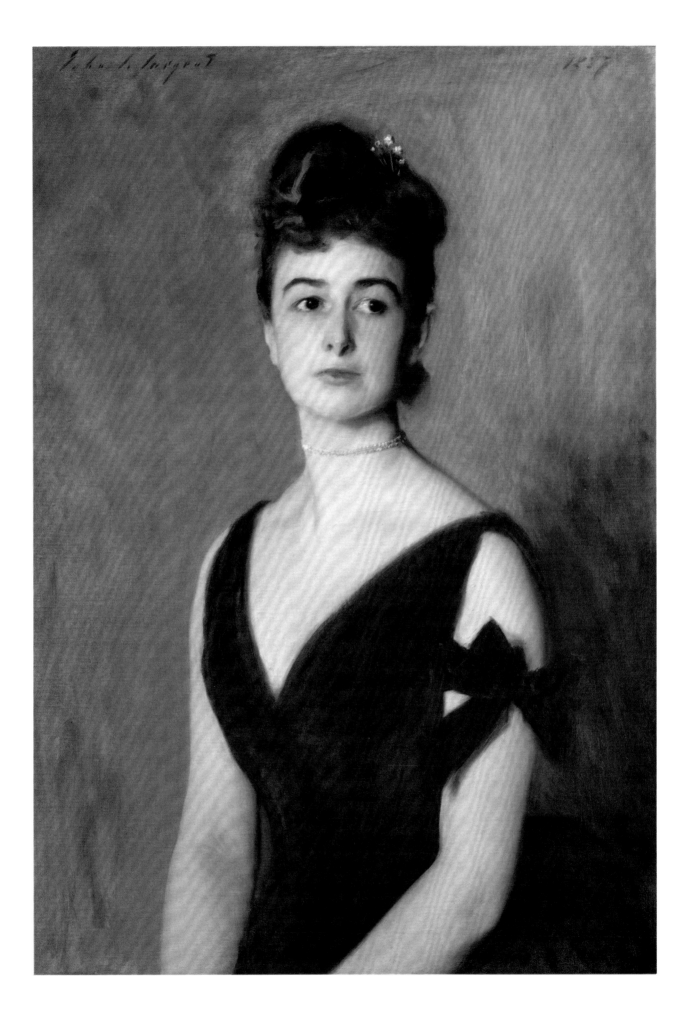

to have their clothing made by fashionable dressmakers and the newly established couturiers, while London became a destination for men, who often stopped by on their travels to visit the city's tailors. Many of Sargent's sitters frequented the best tailors, dressmakers, and couturiers in London and Paris, who created the fashions that often appear in their portraits — although always filtered through the artist's sensibility.

Traditionally a client arrived at the dressmaker or tailor with the fabric in hand and an idea of the garments to make from it. The style of the final garment was decided in collaboration, often using fashion plates as inspiration. The fashion press came to play an important role in the dissemination of contemporary styles of men's and women's dress throughout the nineteenth century, as cheaper printing methods made magazines more widely available. The majority of the designs published in the women's magazines originated in Paris, created by fashion artists and later by the couturiers. They were distributed around the globe by publications such as the British *Ladies Gazette of Fashion* (1842–94), the American periodical *Godey's Lady's Book* (1830–78), and the German *Die Modenwelt* (1865–1942). Men's tailoring journals in the second half of the nineteenth century included the French *Journal de Tailleur* and *Journal l'Homme du Monde* and the English *Gazette of Fashion and Cutting Room Companion: Evening Wear and Hunting Dress* (1850–99).

Along with making new fashions, another important aspect of the dressmaker's and tailor's job was to repair and restyle clothing. Restyling garments was especially common for women during the nineteenth century, as a way to reuse expensive cloth. It was also fairly easily achieved, as the basic silhouette evolved slowly and the dressmaker could update a garment by altering the size of the sleeves or the drape of the skirt. The dress worn by Mrs. Charles E. Inches in her portrait by Sargent is an example (**83**). The original red velvet dress from 1887 would have had a skirt with a large bustle at the back, the top of which is obscured by dark shadows in Sargent's portrait. The dress was restyled around 1892 by the Boston dressmakers Auringer & Lewis, who recut the skirt to give it a more fashionable silhouette by flattening it at the back and adding a short train (**84**). A new bodice was made with a longer torso, indicating that the dress may have been restyled for a different wearer. The high value of fine clothing made it a measure of economy to restyle or repair. Those who could afford to hired lady's maids or valets, to help their employers dress and stay properly groomed while also taking on some of the tasks of the dressmaker or tailor for their employer's wardrobe. Lady's maids and valets traveled with their employers, partly to ensure that their needle skills were always at hand. For instance, the Bostonians Sarah Choate Sears and her husband, Joshua Montgomery Sears, were regular travelers to Europe; according to the New York Arriving Passenger and Crew lists, their lady's maid and valet always accompanied them. In 1892, the family visited Europe with their two children; Ada Mancher, a companion; Kathleen Donohue, Mrs. Sears's lady's maid; George Farley, Mr. Sears's valet; and Marie Amere, their three-year-old daughter Helen's governess.[2]

83 | *Mrs. Charles Inches (Louise Pomeroy)*, 1887

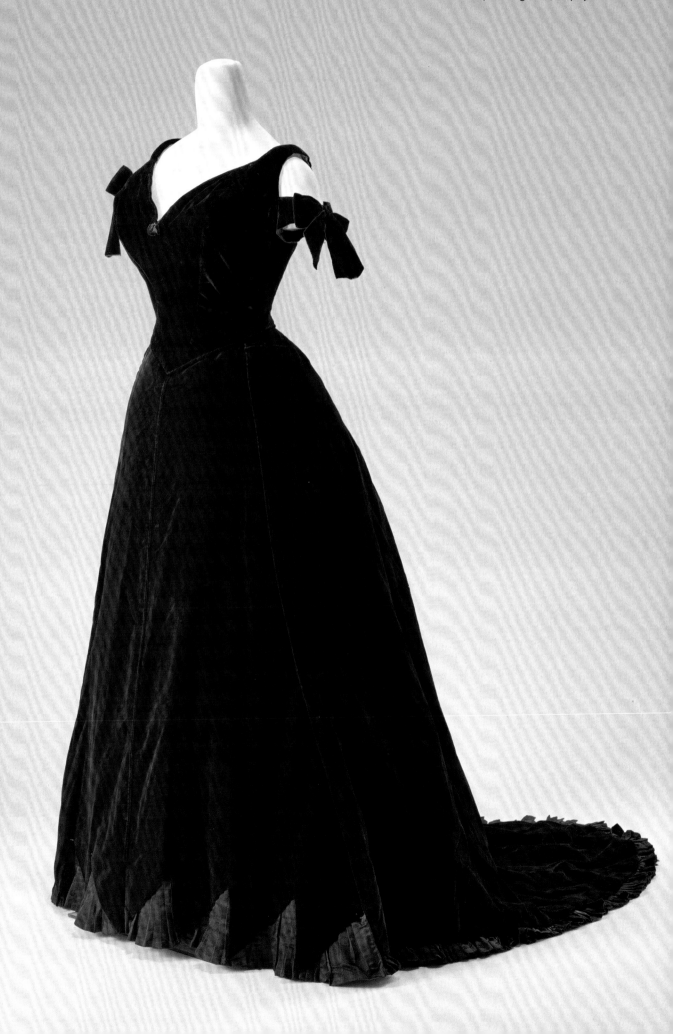

Men such as Joshua Montgomery Sears, who was among the wealthiest men in Boston, would have had multiple outfits appropriate for specific times of the day and various activities including day suits, formal morning wear, country attire for shooting and hunting, evening suits, and white tie and tails. Overall, fashion was less notable in menswear than in women's, as the wool two- or three-piece suit with trousers had become ubiquitous by the later nineteenth century among men of all social classes. Subtle differences in the cut of the garment and the type of fabric distinguished one type of suit from another, while the quality of the fabric and fit established the economic and social standing of the wearer. Bespoke clothing remained essential for any well-dressed man, but others adopted ready-to-wear suits that became increasingly available by the end of the century. One reason that men's clothing production industrialized more quickly than women's was the nineteenth century's many wars, which fostered the mass production of uniforms and the need for standard sizes. The measurements of large numbers of men serving in the military helped to facilitate the standardizing of sizes, and innovations in the production of men's military uniforms were quickly adapted for men's ready-to-wear. Nonetheless, military uniforms worn by men of the class and rank of Sargent's sitters, such as Colonel Ian Hamilton, would still have been custom-made (see **27**).

Another change in menswear that precipitated the transition to ready-to-wear was the introduction of a more loosely fitted day suit. During the early half of the nineteenth century, men's suits consisted of a frock coat with a vest and trousers. The top part of the frock coat was tailored to the body of the wearer with seaming at the waist and up the side backs. The jacket for the day suit, by contrast, had its back panels cut in one piece and fell loosely from the shoulders, similar to men's suit and sport jackets of today. This looser fit made it easier to make and fit ready-to-wear suits for customers in a range of sizes. The French painter Carolus-Duran wears an early version of the day suit in Sargent's portrait of 1879, and portraits of Henry Lee Higginson (1903) and Philip Sassoon (1923) display later examples (**86**; see **25, 76**). Carolus-Duran and Sassoon each wear a cravat, now often referred to as an ascot, which was day wear from the mid-nineteenth century to the early twentieth, while Higginson wears a four-in-hand tie, which became popular around 1850. The day suit could also be made of lightweight white linen and worn during the summer months, or in tropical climates. Sargent painted the Chicago businessman Charles Deering in such a suit while visiting him at his summer home in Miami in 1917 (see **114**).

The more formal frock coat is distinguishable in a few of Sargent's portraits, including that of President Theodore Roosevelt, who wears a black wool example in his likeness of 1903 (**85**). His right arm extends away from his body to rest on a newel post of the stairs in the entrance hall in the White House, revealing the close cut of the top portion of his coat and the skirt that falls gently from the seam at the waist. Roosevelt also wears a white shirt, with a turned-down collar and a black four-in-hand

86 | *Henry Lee Higginson, 1903* **87** | *Jane Evans, 1898*

tie. In many of Sargent's portraits, especially in reproduction, it can be difficult to distinguish what kind of suit his sitters wear, as most are made of the ubiquitous black wool and the pose of the arms obscures the waist. The popularity of black for men's wear developed early in the nineteenth century and quickly spread across the social classes, serving to differentiate it from women's dress as it became more elaborate and colorful.[3] The adoption of black could also mark a rejection of the ornate, multicolored fashions of the eighteenth-century male aristocracy and a desire for democracy.[4] Color did remain in some men's wardrobes. Multihued patterned vests were worn at times, but only a hint was visible underneath the severe cloth of the suit. Men also wore colorful textiles indoors, for instance in dressing gowns; Dr. Pozzi, in Sargent's 1881 portrait, wears a brilliant red gown (see **33**).

While the color of Dr. Pozzi's dressing gown may subtly refer to the red robes of his profession, many of Sargent's sitters wear garments that more directly identify their roles, whether professional, military, or social. Colonel Ian Hamilton, who at the time of his 1898 portrait was Commander of the Third Infantry Brigade of the Tirah Expeditionary Force, is depicted in full dress uniform with his campaign medals and an overcoat, while Sir Frank Swettenham in his 1904 portrait wears a lightweight white linen uniform consistent with his role as High Commissioner for the Malay States and Governor of the Straits Settlements (see **27, 57**). Some sitters were depicted in clothing that proclaimed their high social status, such as Charles Stewart, Sixth Marquess of Londonderry, who was painted in the court dress he wore for the coronation of King Edward VII, when he served as one of the bearers of the king's regalia (see **28**). Other less exalted sitters were painted in professional clothing such as judicial or academic robes. One of Sargent's female sitters, Jane Evans, wears a black wool suit reminiscent of menswear, but with the large leg-of-mutton sleeves in style around the time the portrait was painted, in 1898 (**87**). Jane Evans ran a lodging house at Eton College and earned the respect of the boys who stayed there, several of whom commissioned her portrait.

Jane Evans's severely tailored black wool suit stands out among the more feminine clothing worn by most of Sargent's female sitters. Like menswear, women's wear was occasion and time specific, and included day dresses, walking dresses, tea gowns, visiting dresses, hostess dresses, reception dresses, dining dresses, and ball dresses. Daywear was characterized by high necklines and covered arms, as can be seen in Sarah Choate Sears's portrait (see **102**). When going outdoors, women wore walking suits like those seen in the 1890 portrait of Maria Louisa Robbins Davis or the 1898 portrait of Mrs. Charles Thursby (see **18, 19**). By the turn of the century, women engaged in more energetic pursuits adopted separates, including skirts, shirtwaists, and tailored jackets; Edith Minturn Stokes wears such an ensemble in her portrait of 1897 (see **20**). Visiting dresses were donned when making calls, while hostesses might receive guests in a tea gown, an informal style of dress worn without the full-boned corsets common at the time. All of these styles had relatively modest necklines and sleeves. For more

88 | *Mrs. Henry White (Margaret Stuyvesant Rutherfurd)*, 1883

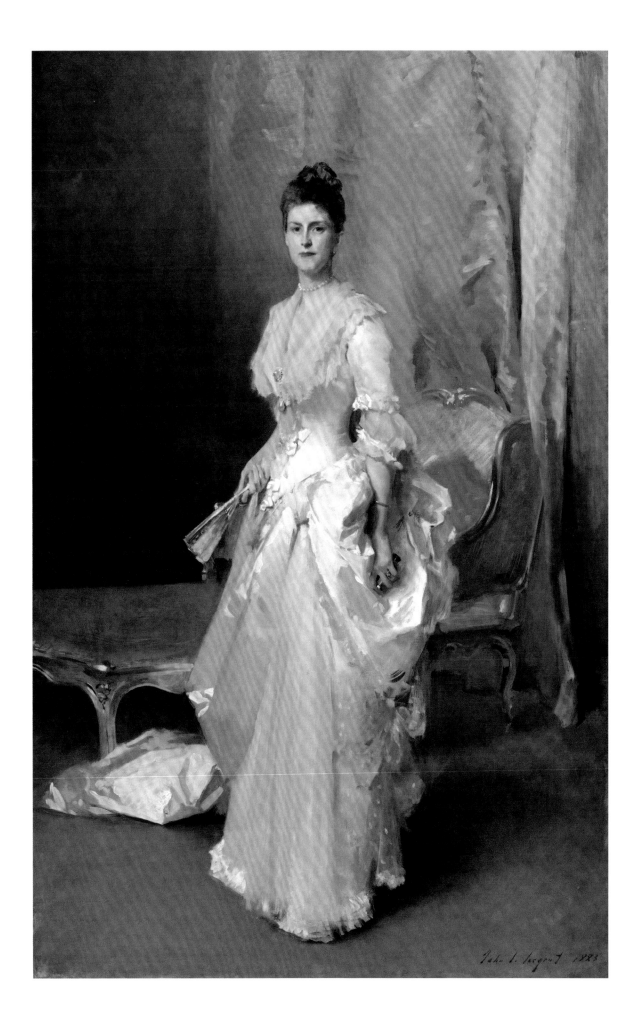

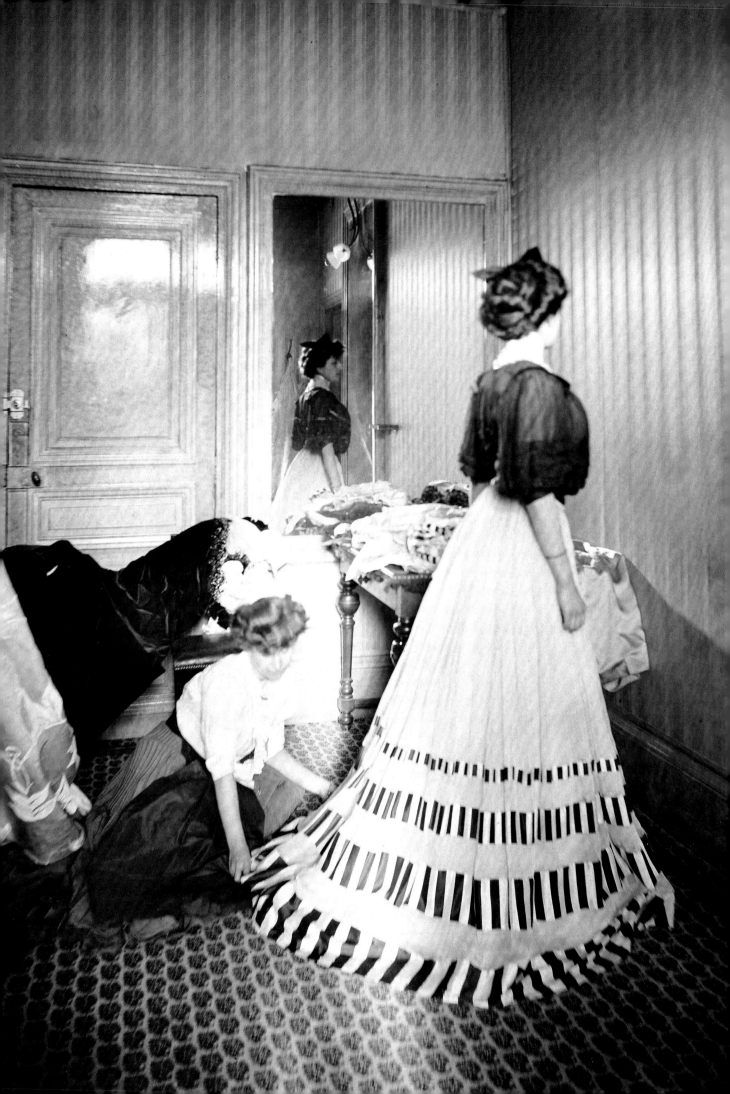

formal occasions such as dinner or a reception, women uncovered more skin. Margaret Stuyvesant Rutherfurd White in her portrait of 1883 wears a dinner or reception dress with an open neckline (**88**), although not as revealing as that of the formal ballgowns seen in *Madame X* or the double portrait of Ena and Betty Wertheimer (see **13, 17**).

Most of Sargent's subjects would have been able to navigate this complex sartorial landscape with ease. Women not born into the upper classes turned to fashion magazines and French fashion plates, along with their dressmakers, for help. By the mid-nineteenth century, if they could afford it, they traveled to Paris to visit fashionable dressmakers such as Madame Vignon and Madame Palmire, who furnished clothing for a number of European royals.[5] Customers would visit the dressmaker with fabric in hand, acquired from a dry-goods merchant or, in Paris, from one of the *magasins des nouveautés* (novelty shops), which purveyed fabrics along with accessories such as gloves and shawls, and even ready-to-wear capes, mantles, and lingerie. Some *magasins* set up their own dressmaking shops, offering one-stop shopping to customers visiting the city, and also hired fashion illustrators to create designs for sale to dressmakers outside Paris. At the same time, some Parisian dressmakers began to sell fabric directly to their customers. Madame Roger advertised in the 1850 Paris city directory that she stocked not only fabric, but also "ready-made wear for ladies and children."[6] This blurring of the line between merchant and craftsperson paved the way for the development of couture in Paris as well as the international ready-to-wear industry.

Charles Frederick Worth is often credited with being the first couturier. An Englishman with experience in the London dry-goods trade, he arrived in Paris in the early 1840s and found work at one of the most fashionable *magasins* in Paris, Gagelin-Opigez. Gagelin also operated a dressmaking studio and supplied court dresses, ballgowns, and wedding trousseaus to customers outside Paris. The shop offered new designs or models twice a year and advertised them in the press. Worth became a partner in the firm, and furthered the development of women's ready-to-wear, which at the time included unfitted garments like mantles and capes. He had also been designing dresses worn by the women who modeled accessories for his clients; one of these models, Marie-Augustine Vernet, became his wife in 1851. Worth left the firm in 1858 and went into partnership with a young Swede, Otto Gustav Bobergh, to "sell silks, lace, cashmere and furs and to make ladies' dresses and mantles."[7]

Worth & Bobergh's business model anticipated the couture, presenting several collections designed during the year and custom-making garments for clients. The firm continued the practice of the *magasins* of selling designs to dressmakers and department stores in large cities such as New York and London, whose dressmaking studios could make up dresses for their customers. Worth's business prospered, and he was soon making clothes for Empress Eugénie and the women of most other European courts, along with the social elites of Paris and less reputable women such as actresses and courtesans. Many foreigners living in or visiting

89 | Fitting room at the House of Worth, Paris, 1907

Paris flocked to the house as well, and by 1863 the company occupied four floors at 7 rue de la Paix and employed 700 workers. Worth & Bobergh set up their workshops so that individuals specialized in specific tasks, such as seaming dresses or applying trims. This "industrialization" of the craft of dressmaking allowed the house to turn out a dress in a single day if necessary. In 1870, the Worth & Bobergh partnership came to an end and Bobergh's name was dropped from the label. A New York client, Mrs. Sherwood, remarked that "it was no wonder that American women sent to Paris and Worth for their clothes as they received stylish clothing of good materials, good fit and at half the cost of New York dressmakers."[8] Mrs. Sherwood was probably a repeat customer, whose measurements were kept by the house; this allowed her to place orders without having to travel to Paris for fittings. At the time of the founder's death in 1895, the firm occupied the entire building in rue de la Paix. It was passed on to his sons Jean-Phillippe, who took on the role of designer, and Gaston-Lucien, who managed the business (**89, 91**).

Among other couture firms founded in the mid-nineteenth century were the houses of Félix, Pingat, Doucet, and Laferrière. Maison Félix, established in 1840, served many of the same clients as Worth. The house was known for dressing women of slender stature in garments with simple, elegant lines. The dress worn by Madame X in her Sargent portrait is often attributed to Félix, as Virginie Amélie Gautreau was one of the house's clients (see **13**). Émile Pingat, like Worth, may have had his start in a *magasin des nouveautés*; a listing in the 1860 Paris city directory for the firm Pingat, Hudson et Cie mentions fancy goods, readymade clothing for women, plain and patterned silks for day dresses, ball dresses, court mantles, and lace and trims.[9] Jacques Doucet's family had been involved in the fashion trades since the early nineteenth century, branching out from linen goods into ready-to-wear and dressmaking. By the late nineteenth century, Doucet occupied premises near Worth on the rue de la Paix. Jacques, grandson of the founder of the firm, took over when his father died in 1898, becoming one of the most fashionable couturiers in Paris. One of

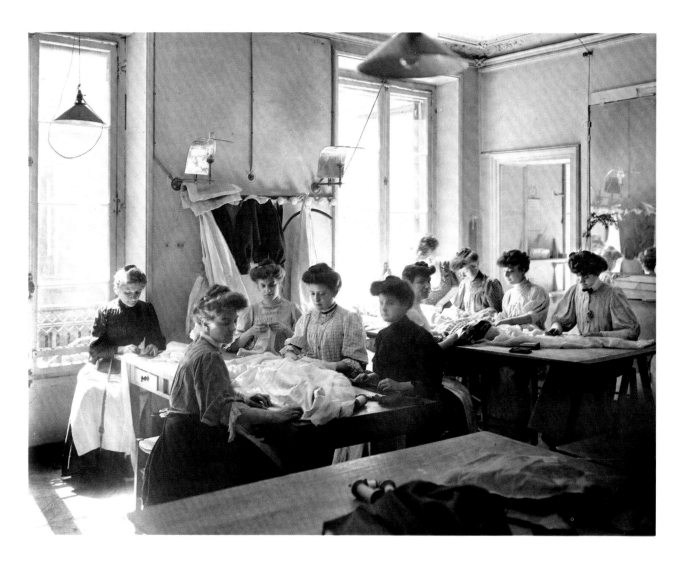

91 | Workshop at the House
of Worth, Paris, 1907

the few female couturiers was Madeleine Laferrière. The house may have
been established in 1847 and may have supplied early ready-to-wear. Maison
Laferrière achieved great fame by the end of the century, making cloth-
ing for royalty such as the Princess of Wales, Alexandra of Denmark, and
American and European socialites like Mrs. Caroline Schermerhorn Astor.
While Sargent's sitters probably frequented all of these couture houses,
Worth appears to have been the most popular — at least going by the cloth-
ing related to his portraits that has survived in museum collections.[10]

Like Worth, all of these couture houses originated in the French cloth-
ing trade in the earlier part of the nineteenth century and evolved with
the times, consolidating retail, dressmaking, and even hairdressing into
fashionable and successful businesses. The couturiers themselves became
leaders in the fashion industry, introducing new collections and setting
styles. The houses all welcomed clients from around the globe, becoming
so international that they employed saleswomen, or *vendeuses*, who spoke
a range of languages to make clients feel welcome (**90**). Worth had the
advantage of being able to converse in his native language with American
and British clients.

By donning a dress by Worth or Félix, a woman knew that she was
wearing the latest fashion, and couture houses profited from their ability

to create a flattering image for clients. Charles Frederick Worth cultivated his role as not just a fashion advisor but an artist at work, often dressing the part in a velvet smock and artist's cap. His work habits also resembled those of an artist. An account of a visit to the salon of Worth from 1863 describes Worth's behavior in artistic terms: "At last, when he has handled the taffety like clay, and arranged it according to his beau ideal, he goes and takes his place, with his head thrown back, on a sofa at the further end of the room, whence he commands the manoeuvre with a wand of office."[11] Worth's draping of taffeta on the body of his client and then stepping back to assess his work is reminiscent of accounts of Sargent's putting paint to canvas and then stepping back to assess the effect.

Worth not only cultivated the habits of an artist but also described himself as one: "I have Delacroix's sense of color and I compose. A *toilette* is as good as a painting."[12] He was not the first to make this comparison. The French writer Charles Baudelaire in *The Painter of Modern Life* (1863) asserted that in order for a painting to be modern, it must accurately capture the women's fashions of its day, and went on to compare a well-dressed woman to a work of art: "Everything that adorns woman, everything that serves to show off her beauty, is part of herself. . . . She is a general harmony, not only in her bearing and the way in which she moves and walks, but also in the muslins, the gauzes, the vast iridescent cloud of stuff in which she envelops herself." This idea that art and fashion were linked came to define the work of some painters: Sargent's teacher Carolus-Duran was sought after as a portraitist by the most fashionable women of the era, such as the Countess de Greffulhe and Caroline Schermerhorn Astor. Clothing themselves elegantly and properly was essential to the artistry of these women, and they wanted their portraits to accurately reflect their taste. That might be why these two women chose Carolus-Duran, who was known for his ability to accurately depict the fashions of the day, rather than an artist like Sargent, who might pursue his own aesthetic aims for a portrait at the expense of the details of dress.

By the time that Sargent passed away in 1925, the dressmaker culture of the nineteenth century had almost completely disappeared. The simple lines of 1920s fashion did not require a custom fit, making ready-to-wear more feasible, aided by the development of standard sizes. As ready-to-wear proliferated, however, French couture still led the way, setting the fashions and selling model designs to manufacturers. Women continued to frequent couture salons until the 1960s, when the postwar generation began to prefer buying ready-to-wear to the time-consuming process of having clothing custom-made, with multiple fittings and visits to the designer. In response, many of the houses began their own ready-to-wear lines. They still maintained the couture side of the business, which served as the creative heart of the industry and the place where the art of fashion continues to be celebrated.

Walking dress (**104**), detail

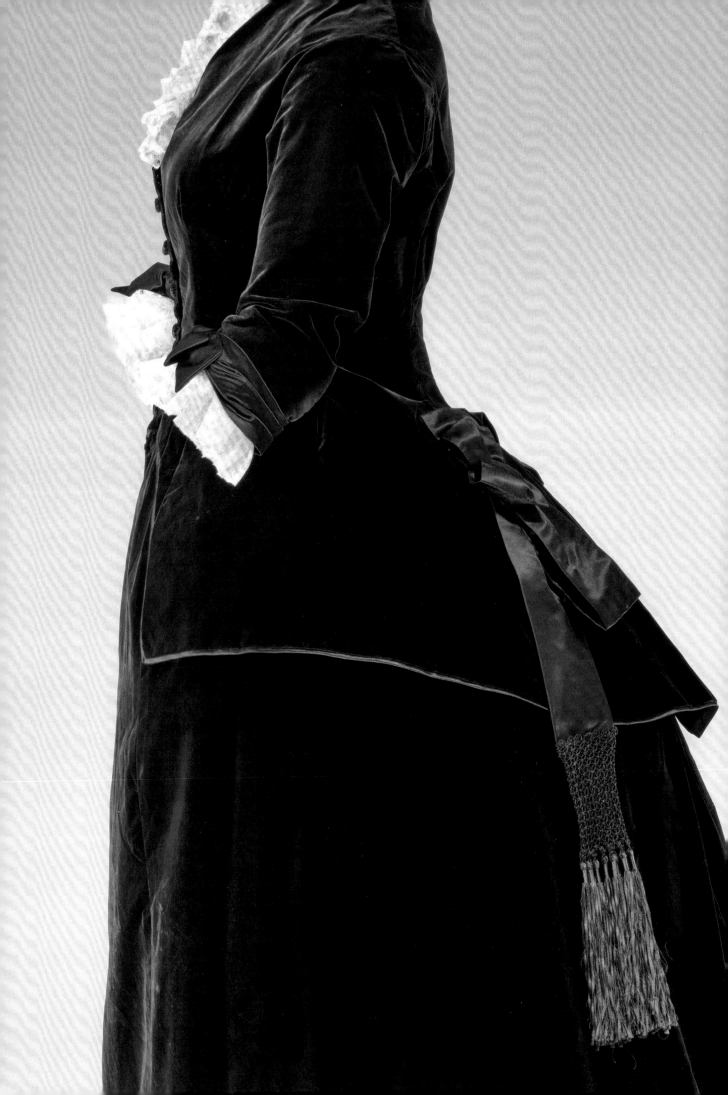

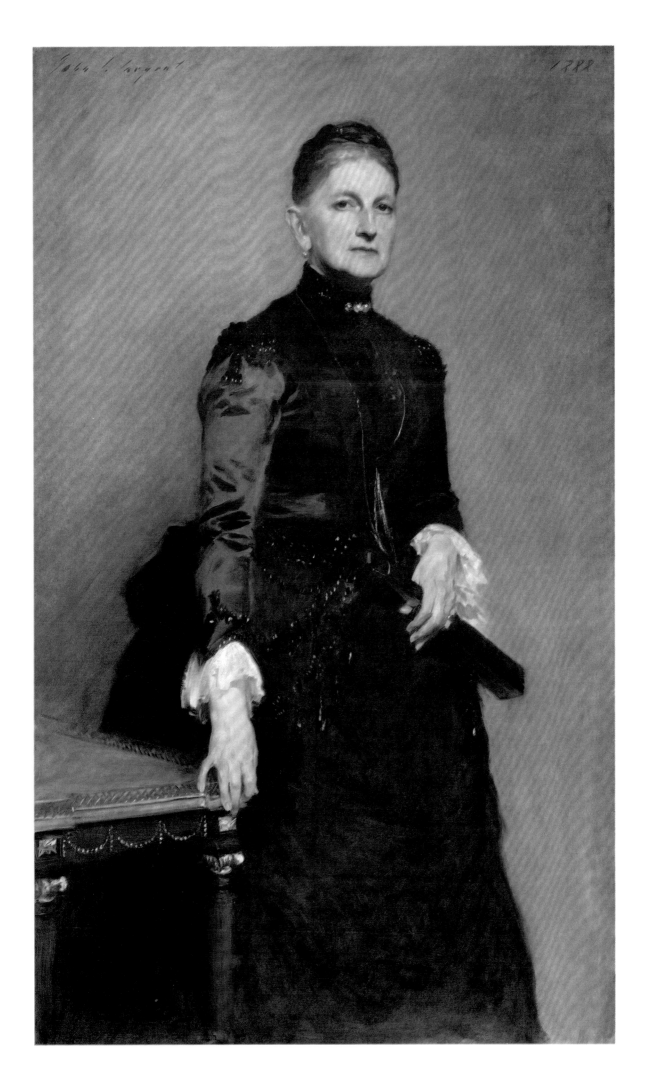

From Dress to Paint | ANNA REYNOLDS

*T*HE OFT-QUOTED REMARK ATTRIBUTED TO SARGENT, "I can paint only what I see," suggests pure objectivity and often is taken to imply his allegiance to the philosophies of Impressionism.[1] Sargent, however, did not paint only what he saw. Henry James, who was to become an early champion of Sargent, described the Impressionists' approach after visiting their second exhibition, in 1876, at the Paris gallery of the art dealer Paul Durand-Ruel. James acknowledges the experience of seeing their work as "decidedly interesting" but does not yet seem convinced by the approach of the "young contributors," describing them as "partisans of unadorned reality and absolute foes to arrangement, embellishment, selection."[2] That practice — of arrangement, embellishment, and selection — lies at the very heart of Sargent's ability to represent dress. Comparing his portraits with the rare surviving examples of items of dress that he depicted makes it clear that Sargent paints what he *wants* to see, adjusting where necessary for effect.

The artist's method for transforming three-dimensional clothing into brushstrokes and pigment begins with selection, that is, identifying which garments, accessories, colors, and fabrics will best suit the sitter and fit with Sargent's vision. Second comes arrangement — the combination of items, the fluffing and pinning of folds, and the addition of jewels. Finally is embellishment, most evident in modifications to the decorative features of the garment's surface, by changing their number, scale, position, or orientation.

Sargent often assumed entire responsibility for selecting the clothing worn by his sitters, even definitively rejecting expensive outfits acquired specifically for the occasion. In the case of his portrait of Eleanora O'Donnell Iselin, the sitter had initially offered Sargent a range of Parisian gowns from which to make a selection.[3] Instead the artist, with character-istic immediacy, made the decision to paint her in the outfit she happened

92 | *Mrs. Adrian Iselin*
(Eleanora O'Donnell), 1888

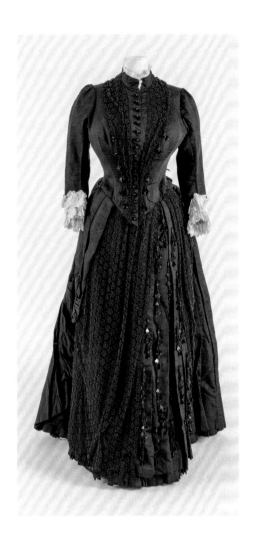

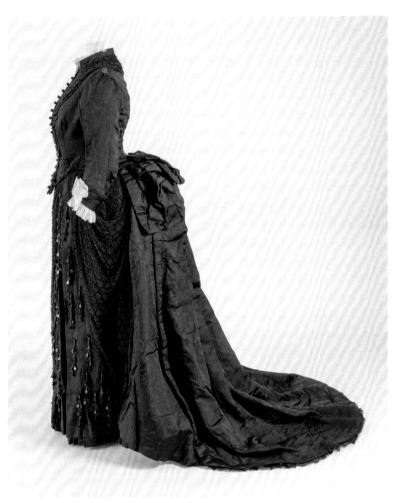

93 | Day dress, 1887–89

to be wearing, a black day dress suitable for receiving visitors in her New York townhouse overlooking Madison Square Park (**92**). One account indicates that Mrs. Iselin was unhappy with the severity of the costume, although presumably Sargent felt it contributed to a deeper understanding of her determined character, serious in demeanor and dedicated to the smooth running of her household, with no time for ostentatious frivolities.[4] While the portrait is restrained in its use of color, small details reveal more about the materiality of the dress itself. The manner in which the sleeve has been painted, for example, with brushstrokes of deep black to indicate slight folds, over a grayish undertone, gives a sheen suggestive of silk satin. Tiny dots of pure white pigment on the bodice, for example at the shoulder and cuff, represent reflections on subtle appliquéd ornaments — perhaps black sequins or polished jet beads similar to those on a strikingly similar dress from exactly the same date (**93**). Such understated decoration was considered appropriate for daywear, and it is unlikely that Sargent has departed too far from the dress's actual appearance, although he downplays the embellishment further by articulating only those beads that catch the light. Mrs. Iselin's white linen cuffs, painted by Sargent as slightly translucent, provide a contrast to the opaque black, softening its impact against the skin. The surviving garment indicates that these were likely attached inside the sleeves and were not part of a separate underlayer.

LE MONITEUR DE LA MODE

Sargent's selection of the clothing for his sitters often seems to have been influenced by its color. Almost two-thirds of his male sitters wear a plain dark suit, while in women's dress, his overriding preference is for monochromatic black or white gowns, perhaps in recognition of the ability — noted by the influential French critic Théophile Gautier in 1858 — of such neutral tones to give "plenty of emphasis to the head, the seat of intelligence, and the hands, the tools of thought or a sign of breeding."[5] Black dresses became fashionable for women of all ages during the last decades of the nineteenth century and are worn by many of Sargent's subjects, from the sixty-seven-year-old Mrs. Iselin to the youthful Louise Burckhardt, painted at the age of twenty in *Lady with the Rose* (see **10**). The introduction of aniline dyes, most often associated with startlingly bright hues, also included an intense pure black, patented in 1863, that enabled a rich depth of color that had previously been hard to achieve. Black clothing retained its association with mourning throughout the period, with crinkled matte black crape the iconic textile of choice during the deepest stage of mourning. However, the strict codes of etiquette that had dictated what fabrics and colors could be worn (depending on the relationship to the deceased and stage of mourning) gradually relaxed toward the end of the century, while descriptions in fashion periodicals make it clear that the wearing of black clothing was not limited to those

in mourning. For example, a fashion plate from *Le Moniteur de la Mode* of 1881 shows two women in evening wear, one dressed entirely in black and the other in white (**94**). The black gown incorporates a patterned silk in a striking checkerboard design, and is trimmed with sparkling silver fringe and bright red flowers, decoration that would not have been appropriate during mourning. Mrs. Iselin was not in mourning in 1888, when her portrait was painted, despite the austere appearance of her dress. Sargent's depictions of women in black — particularly in the 1880s, when it is worn by nearly half of his female sitters — are a testament to his love of the aesthetic impact of the color, as well as to its widespread fashionability for day and evening dress, being considered both chic and flattering.[6]

Patterned fabrics are rare in Sargent's oeuvre, with only eight of his female portraits clearly representing patterned silks.[7] In line with many other contemporary artists of the late nineteenth century, he follows the tradition, stretching back to Anthony van Dyck in the seventeenth century, of artists simplifying surface patterns of textiles when representing them on canvas. The reasons are probably both practical and aesthetic: plain fabrics are quicker to paint and more effective in showing the effects of light across their surface, and patterns have the potential to draw too much attention, overwhelming the sitter and detracting from the overall composition. Sargent makes an exception in his portrait of Mrs. Boit, whose polka-dotted outfit was worn at a party held to introduce her second daughter to society (**95**).[8] Her black bodice is sewn from at least two black fabrics (one opaque, one sheer). With it she wears a pink silk underskirt decorated with large black polka dots and a plain black overskirt, visible toward the left-hand side of the painting. Sargent clearly indicates the fashionably asymmetrical pleats of the skirt, first emphasizing the undulations in the surface with deeper shades of pigment (including deep red and touches of blue), then introducing a single dab of black paint for each spot, some more elliptical than others to indicate the directional folds of the fabric. Similarly spotted fabrics appear in garments of around this date and are also regularly represented in fashion periodicals, although more frequently for walking dresses than evening gowns; in an 1885 fashion plate from the *Journal des Desmoiselles*, one of the figures wears a gown incorporating pink polka-dotted fabric in combination with olive green (**96**).[9]

The deceptive rapidity of the brushstrokes in the portrait of Mrs. Boit belies the thirty sittings required to complete the painting, while the seated pose conceals the distinctive silhouette of the 1880s (clearly shown in the fashion plate), with its shelf-like posterior created initially through the use of a bustle petticoat, and later by integrating a bustle pad and steel half-hoops within the dress itself. It is interesting that one commentator described Mrs. Boit's polka-dotted gown as "high-colored" and the aigrette in her hair as "saucy," while a critic in the *Times* considered the dress "showy."[10] Given that both critics were writing for British publications, it might be conjectured that the sitter's American nationality influenced these descriptions. According to the artist Edwin Blashfield, at around this date

95 | *Mrs. Edward Darley Boit*
(Mary Louisa Cushing), 1887

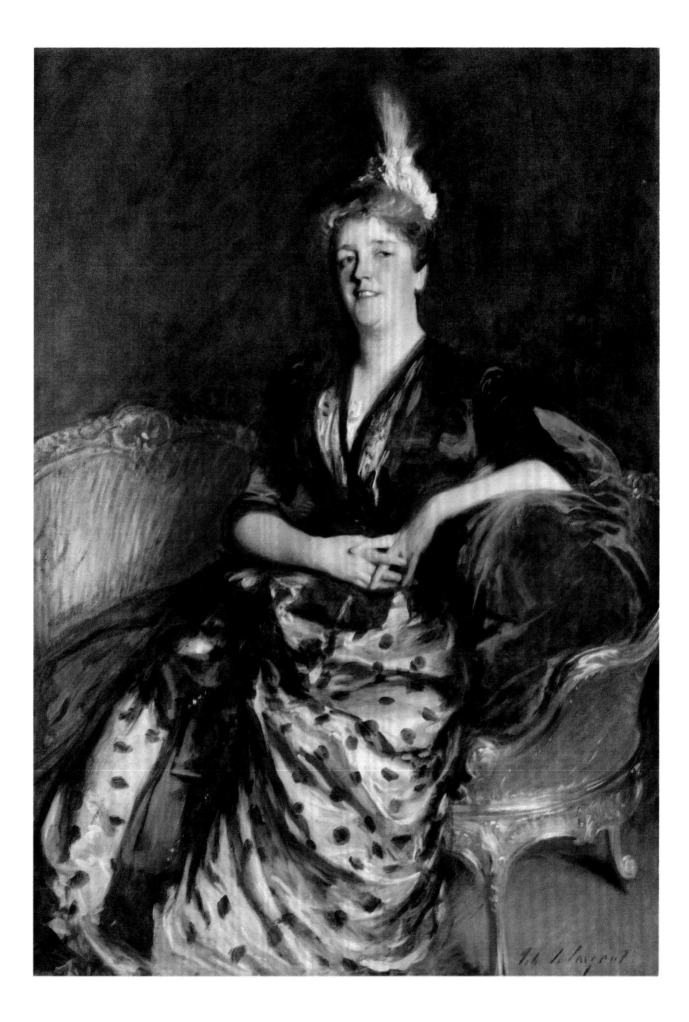

Mrs. Edward Darley Boit (**95**), detail

96 | A. Chaillot, after Monogrammist
BC, *Costumes de Madame Turl*, from
Journal des Demoiselles, 1885

Sargent "seemed to have a predilection for the aniline suggestion in colors," and while the pink of Mrs. Boit's dress is not as bright as the vivid shades made available by the invention of aniline dyes several decades earlier (including "Magenta" and "Solferino," invented in 1856 and 1859 respectively), the pinkish mauve shown here is a slightly paler version of that chromatic zone.[11] Moreover, the contrast with the black makes it particularly eye-catching: the same critic who found the dress "showy" observed that in this painting Sargent was dealing with "more startling effects of colour."[12] Although the choice of color may have been considered relatively bold (at least by the relatively conservative critics of the time), the bodice's lack of puffed shoulders or a standing collar, both new design features of the mid-1880s, suggests that the forty-one-year-old sitter was not necessarily interested in being at the forefront of fashion.[13]

After selecting the garments for his sitters, Sargent next ensured they were arranged to his satisfaction, using pins to keep draperies in his preferred position. The effect is clearly demonstrated in the portrait of Izmé Vickers (1907), whose "boteh" patterned cashmere shawl — a studio prop belonging to Sargent — was held in position with pricking pins.[14] With each sitting usually lasting at least an hour, multiple pins would have been required to maintain the impression of momentary weightlessness, and the arrangement repeated for each sitting. Similarly, Sargent appears to have taken great care to arrange the black silk taffeta evening cloak worn by Lady Sassoon, so that its striking pink silk lining is visible — not just at the broad sleeve opening but also at the front edge, thereby creating a dramatic contrast against the rich black (**97**). Comparing the painting with the actual garment shows that this presentation required twisting the left front opening of the cloak outward and arranging it across the body, most likely pinned into place, to produce a shimmering river of pink running diagonally from the sitter's upper left shoulder to the fingertips of her right hand (**98**). Drying cracks and pentimenti in the painting, especially in the sleeve, indicate that Sargent adjusted the color balance in this area, painting over the pinks and blacks to create an effect he found pleasing. The critic in the *Athenaeum* wrote of the final result that "modern dress is adroitly arranged to afford an ensemble of great magnificence."[15]

The dress worn by Gretchen Warren for her portrait with her daughter (see **4**) was selected by Sargent based on its pink hue, the artist having rejected the green velvet gown she had planned to wear because he considered it unflattering to her rosy complexion. The pink and gray gown with a zigzag pattern belonged to the sitter's sister-in-law; too long for the petite Mrs. Warren, it required artful arrangement around her figure. Similarly, the garment worn by Mrs. Warren's twelve-year-old daughter, Rachel, was said to consist of a "plain piece of pink cloth," wrapped around her body and probably pinned into position.[16] Deliberate manipulation could also take the form of pinning jewelry to gowns in unconventional ways. In the portrait of Ella Widener (see **5**), Sargent instructed the sitter to wear an old blue velvet bodice from which he himself removed the trimmings. He then proceeded to drape a necklace of pearls across the front, blending with the

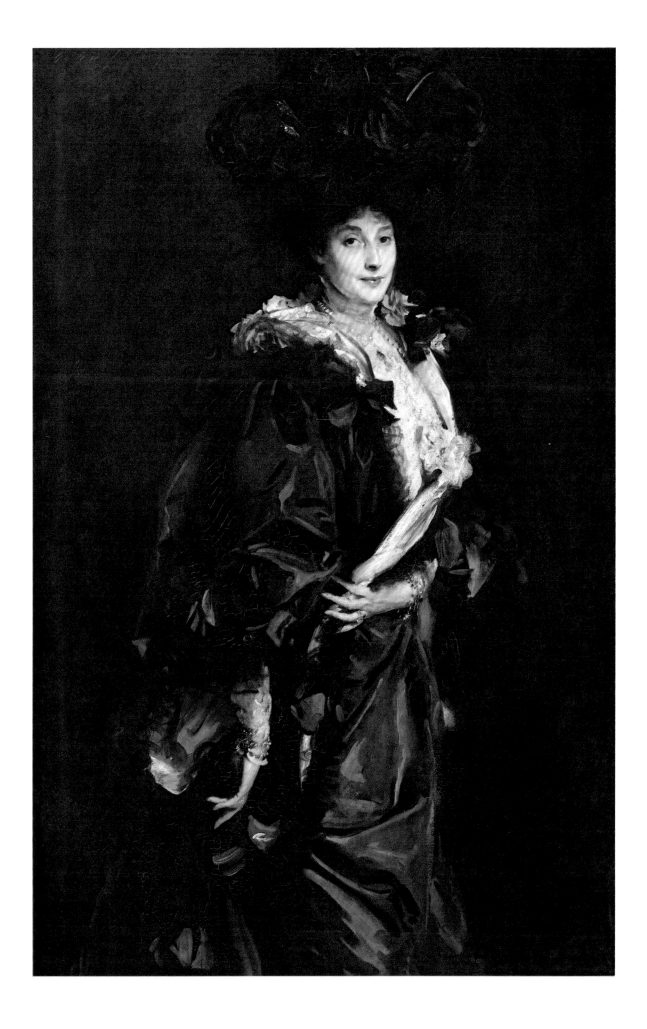

97 | *Lady Sassoon (Aline de Rothschild)*, 1907

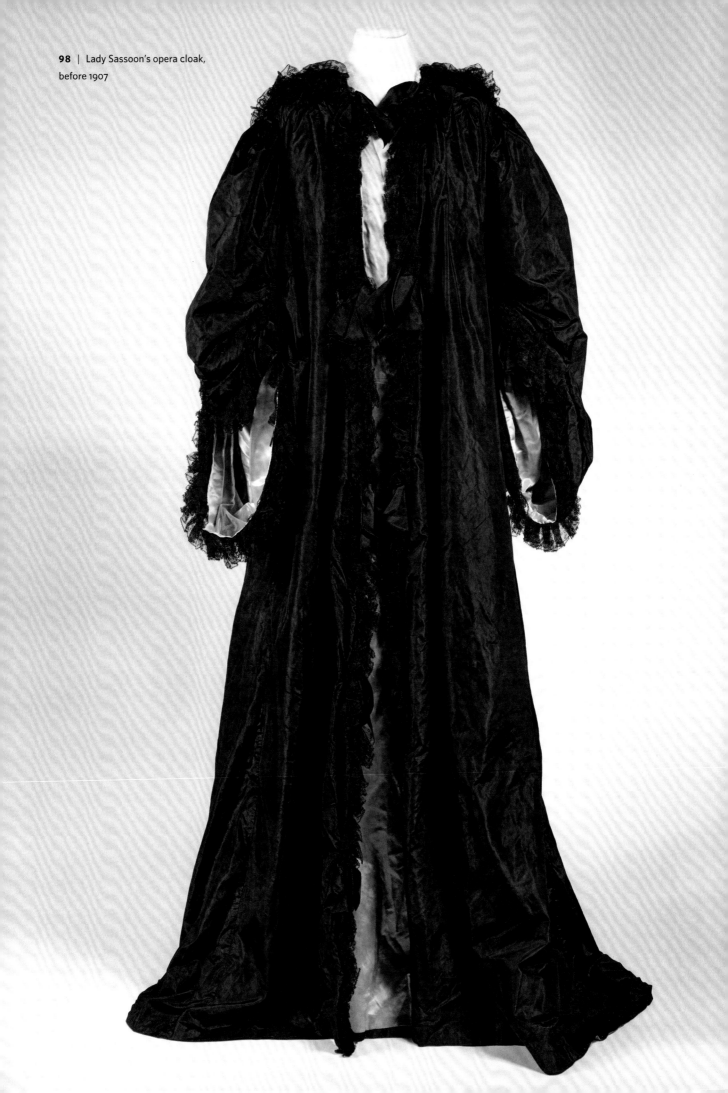

swathes of the fabric, and added a large diamond on one side to act as a light focus.[17]

Whereas James had described the Impressionists as "foes to arrangement," Sargent himself considered it an essential part of the creative process. One of Sargent's few recorded comments to students was that they should "arrange a composition, decoratively, easy, and accidental."[18] In other words, it was important that the active process of arrangement should appear natural and uncontrived in the final painting. This element of the accidental runs through Sargent's depictions of dress, with fabric that looks as if it has fallen into natural folds and wrinkles, rather than been smoothed and tidied, even if in reality the effect has been achieved by pinning the material into place. Such undulations allow Sargent to depict the patterns of light falling across reflective cloth, modifying its tendency to dominate a composition and delivering variety for the viewer's eye as it is led across the surface. When discussing the dress to be worn by Maud Lucia Cazalet for her 1900–1901 portrait, Sargent initially requested that she wear black satin, but added that if she chose white it should be of silk with "some opportunity for folds and arrangements" rather than cotton muslin.[19] At around this date, the sculptural, angular, and intricately tailored styles of dress for women that had been popular during the 1880s and early 1890s were being replaced by garments with a softer, frothier aesthetic, created through lighter-weight silk chiffons and cottons, with flounced layers and a profusion of lace and ribbon bows. Fashionable colors shifted too, from intense deep purples, browns, and chartreuse to pastel shades. Where Sargent represents these pale dresses in his later portraits, they are usually enlivened with the addition of a scarf, either brightly colored fluttering silk or the aforementioned cashmere shawl.

In rare cases the garments worn by Sargent's sitters survive, making possible a direct assessment of the actual clothing alongside its painted version. One of these is the gown worn by Margaret Rotch for her portrait in 1903, made by the French design house Callot Soeurs. It is a characteristic example of the newly fashionable aesthetic of the early twentieth century, and careful comparison of the surviving dress with the portrait enables an understanding of the process of embellishment that Sargent performed, after selecting and arranging to his liking (**99, 100**). The low neckline of the dress's blue silk bodice is trimmed with a flounce of translucent silk chiffon, edged with linen bobbin lace. Sargent reduces the number of scallops, while slightly increasing their size, and also appears to reduce the number of lobes within each scallop (although their lack of definition makes this hard to quantify). He entirely ignores the smocking shaping the hips and neckline, while the ribbon-trimmed rosette at the center front is barely articulated. The painted waist sash is of a slightly different shade from that on the dress itself; this may be a deliberate decision by Sargent, to bring it into better tonal harmony with the greener silk of the bodice, or the surviving sash may be a later replacement. Sargent does not tend to build up layers of paint in the same sequence as the fabrics dress the body, instead painting fabrics on different planes simultaneously or even in reverse, later adding in areas

99 | *Mrs. Abbott Lawrence Rotch
(Margaret Randolph Anderson)*, 1903

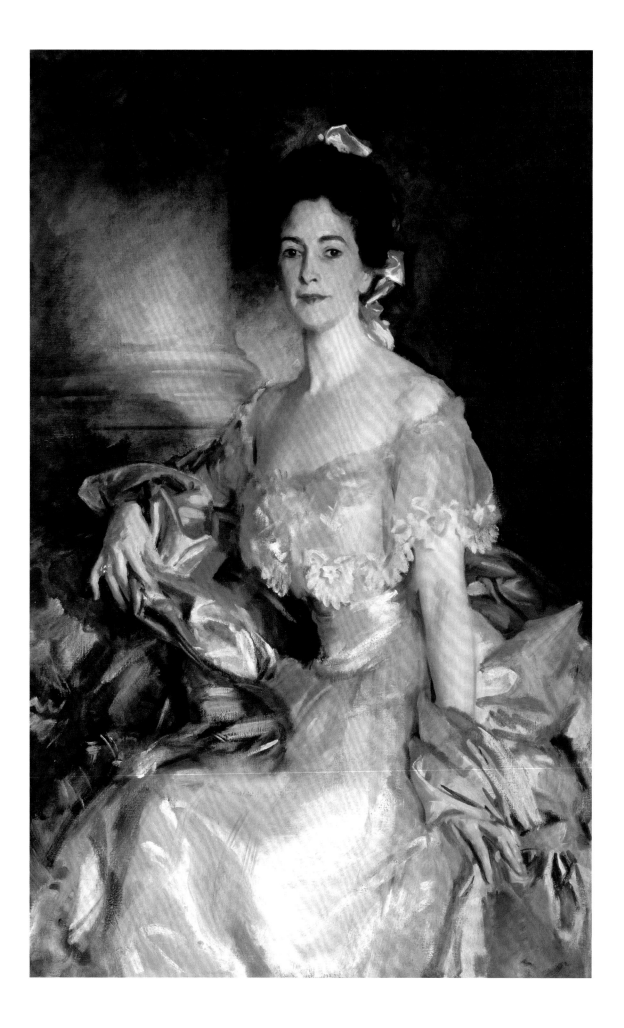

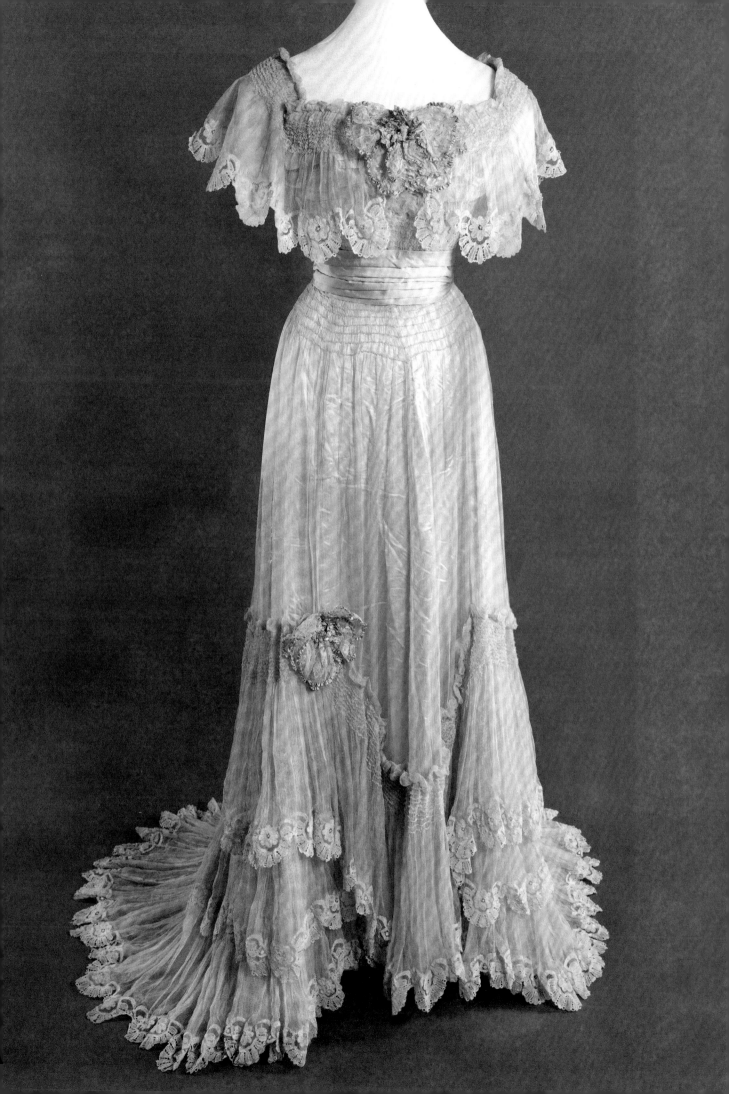

of negative space within the lace, for example, to represent the blue silk or skin beneath. This is a quicker method than painting around the gaps, and fits with Sargent's general recommendation to students: "If you see a thing transparent, paint it transparent; don't get the effect by a thin stain showing the canvas through."[20] Another example of Sargent's ability to paint things transparent is the rendering of Mrs. Rotch's skirt. The dress consists of a shimmering cream silk underskirt, with a pale blue-green silk chiffon overskirt floating above. Sargent paints the folds for these two layers independently, with the underskirt following the position of the knee beneath and the translucent chiffon hanging more vertically, indicated by several long blue and green brushstrokes from waist to hem.

Sargent's evident brushstrokes create vivid representations of fabric, while also serving to highlight the materiality of the painted canvas itself. He creates the illusion of texture and volume within the picture and simultaneously flattens the plane. In his portraits, he is more concerned with evoking the tactility of textiles than in revealing how clothes were actually constructed: the complexity of their assembly is largely hidden, with seams elided and convoluted layers merged. Sargent always required real garments in front of him to create these representations — he never created clothing purely from his imagination, and he took care to select the appropriate attire for a sitter. Yet once chosen and arranged, the clothes were subject to an active process of transformation before being realized in paint, through simplification and omission, but also modification and distortion, to suit his personal aesthetic. The result was — to return to Henry James — "not only a portrait, but a picture."[21]

Sarah Choate Sears and Her Wardrobe

PAMELA A. PARMAL AND ERICA E. HIRSHLER

PHOTOGRAPHER, PAINTER, COLLECTOR, benefactor, and prominent member of Boston society, Sarah Choate Sears was an enthusiastic participant in the city's arts community, with an aesthetic more modern than many. She won prizes for her paintings and watercolors and renown as a Pictorialist photographer and champion of that medium. She amassed an important collection, including paintings by Mary Cassatt, Edgar Degas, Édouard Manet, Claude Monet, and Sargent himself. She sponsored young aspiring painters and artisans by underwriting their travels abroad and encouraging their efforts. Together with her husband, Joshua Montgomery Sears, she hosted musical evenings that featured the city's finest musicians and composers. Their home, according to the local press, was "a natural place of entertainment for all the great artists who visited Boston," and Sargent was predictably among them. With so many interests in common, they would become good friends.[1] He painted her portrait, and some years later, she photographed him at work (**101, 102**).

When Sargent depicted Sears, he chose to show her in white, one of his favorite solutions for women's portraits. Although monochromatic, her white day dress, fashioned from a variety of fabrics, enabled the artist to play with light and texture. But Sears did not always dress in white, and her attire in Sargent's portrait seems at odds with press accounts and her surviving wardrobe, now in the collection of the MFA. Those dresses, vibrant in color and often designed with a touch of drama, hint at Mrs. Sears's personality; she was not afraid to make a statement with her clothing. In 1896, the *Boston Globe* dutifully reported that she had worn "blue satin and lace garniture, also many gems," and later that she been "among the handsomely gowned women at the opera Monday night wearing a black satin, with an ecru lace bodice, with trimmings of turquoise blue velvet, jeweled buttons and diamonds . . . she wore an ornament in her

House of Worth, evening dress (**106**), detail

185

hair." The next month she wore "black and white striped silk, with a green velvet stock and girdle"; in 1897 it was "black, with bodice aglow with cut steel and sequins"; in 1898, black silk, "the bodice of jet and chiffon"; in 1900, "white crepe de chine over white silk"; and in 1903, "dainty pompadour [figured] silk trimmed with white lace and touches of pale blue."[2] In Sargent's portrait, however, she appears modest, thoughtful, and demure, with her white dress and bouquet of roses. Does the portrait tell us more about the sitter's, or the painter's, taste and preferences?

When Sears first arrived at Sargent's London studio for her sitting, she may have brought a selection of the dresses from her wardrobe. This was common practice for Sargent, who would outline it in a letter to J. P. Morgan Jr. about his wife's portrait: "The question to be settled is the one of the dress and that can best be determined in the light of the studio. So that the usual thing is at a first sitting to bring a box with different dresses and actually put one or two on."[3] On several occasions Sargent rejected everything on offer, instead painting the sitter in the clothes they had on, or in some studio confection. He irritated Eleanora Iselin, for example, who had her maid show Sargent a selection of her "best Paris frocks," only to have him insist on depicting her in the black silk day dress she was wearing (see **92**). Similarly, Elliott Fitch Shepard

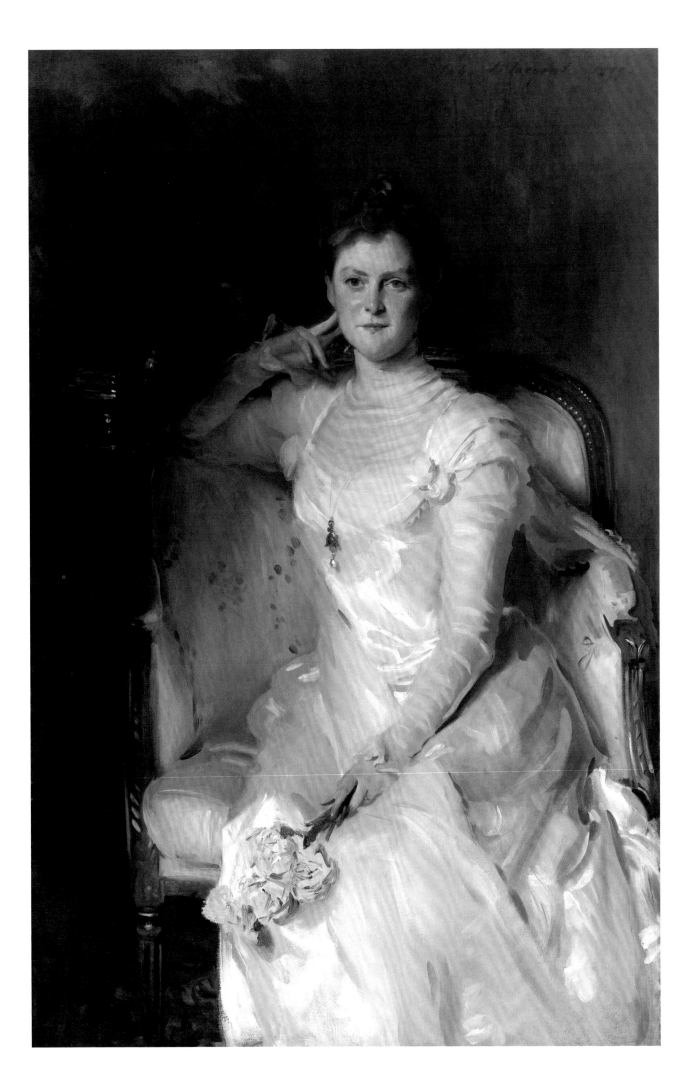

had been disappointed with Sargent's portrait of his wife, Margaret Louise Vanderbilt Shepard, whom Sargent had painted in a bright red dress she never owned and with a hairstyle she never wore.[4] But Sargent and Sears were friends, and they shared an artistic sensibility; it seems likely that they collaborated, perhaps choosing the white palette and floral attribute to harmonize with his earlier portrait of Sarah's daughter Helen, who also wears white and stands next to a tub of hydrangeas (**103**).

Sears, like most well-off women visitors to Paris, frequented the best couture houses and other fashionable emporia. She seems to have preferred Maison Worth, a house that was especially popular with Americans, although it catered to women from many different countries with saleswomen who spoke a range of languages. Of the twelve dresses worn by Mrs. Sears that survive, all but three are from Worth.[5] The earliest Worth dresses in the MFA's collection were probably acquired during the Searses' wedding trip to Paris, when she likely purchased a burgundy and pink floral reception dress, a lavender-gray reception or dinner dress with purple velvet sleeves embroidered with pink silk flowers, and a deep sapphire-blue walking dress (**104**). She probably acquired an ivory silk evening dress embroidered with faux pearls during a trip in 1894; and in 1896, she may have purchased one of her more extraordinary dresses, a gown of chartreuse silk damask with the large puffed sleeves characteristic of the day (**105, 106**).[6] Sears continued to visit the house into the early twentieth century, returning to Worth to have them make her gown and train for her 1900 presentation to the Court of Saint James's in London.[7]

Such fashionable dress was extremely important, especially to American society women seeking to overcome any impression that they were provincial. The writer Edith Wharton understood; she herself was a customer who "makes such a fetish of dressing [that] she considers it an absolute sign of civilization to dress in the evening." She wrote of it in her novel set in the 1870s, *The Age of Innocence* (1920), in a conversation between Newland Archer and his wife, May. On their way to a dinner in London, May replies to Archer's comment that she has made herself too beautiful for the party: "I don't want them to think that we dress like savages," she said. Archer was "struck again by the religious reverence of even the most unworldly American woman for the social advantages of dress. It's their armor," he muses, "their defense against the unknown, and their defiance of it."[8] This veneration for the right dress was understandable for a woman entering worlds whose customs and social habits might not be familiar. By acquiring a Worth dress, she could be assured of wearing the proper clothes for the occasion.

Sargent's lack of reverence for high fashion probably influenced some sitters to look elsewhere for a painter. The choice of the white day dress for Sears's portrait may have been all Sargent's; but Sears, knowing the aesthetic impulses that drive an artist, might have allowed the artist the upper hand. With Sargent, one got a fashionable portrait, but not always a portrait of fashion.

103 | *Helen Sears*, 1895

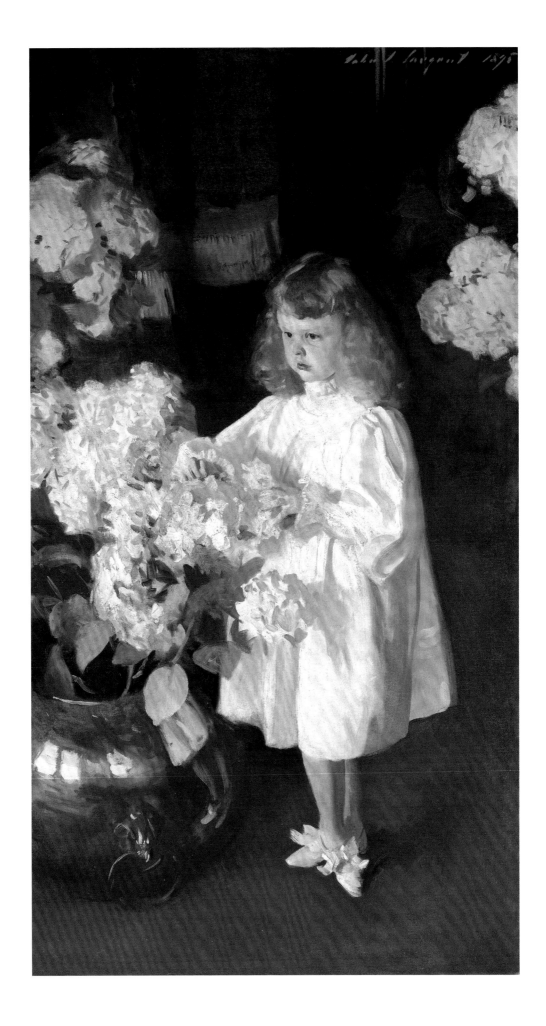

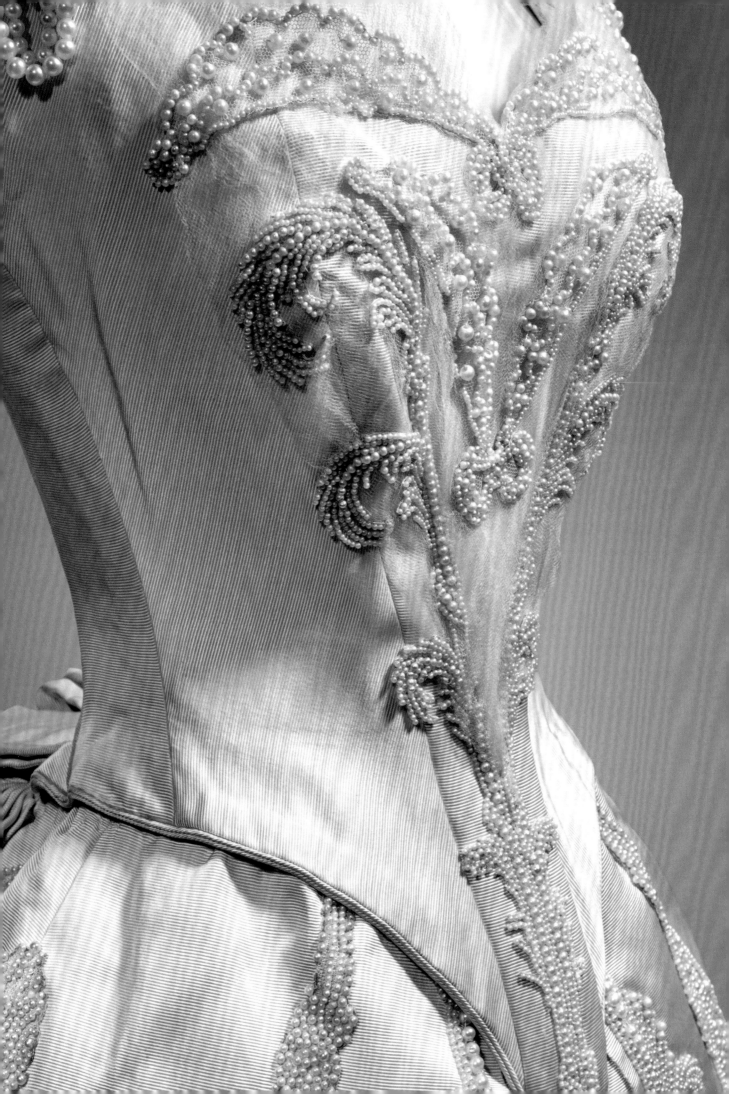

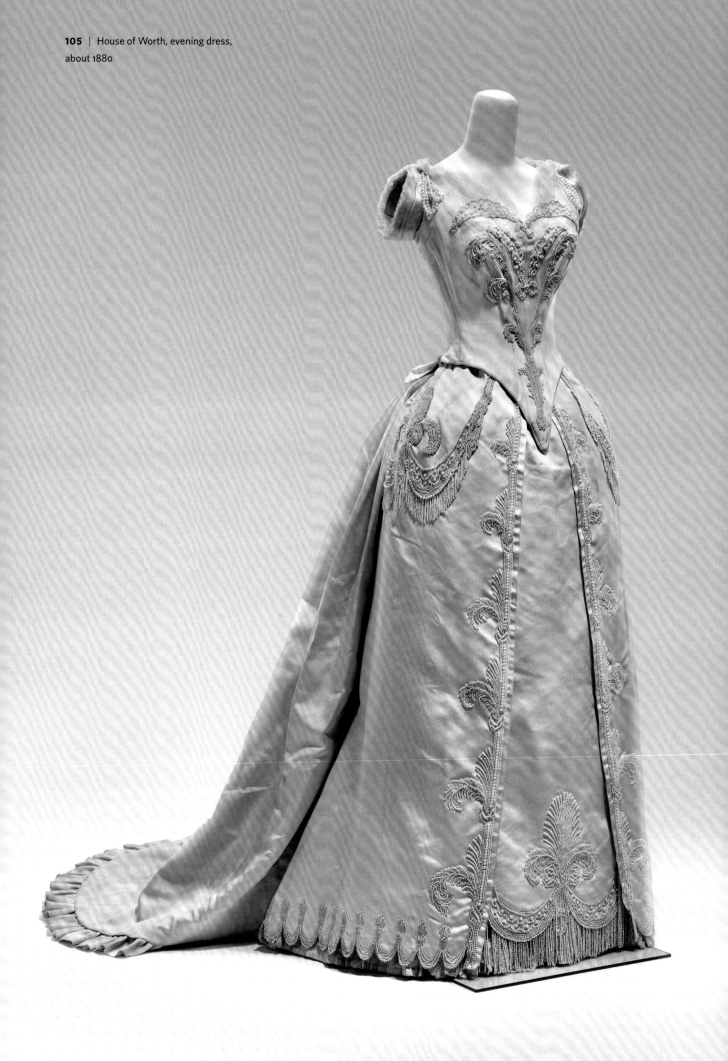

Lord Ribblesdale | DOMINIC GREEN

*S*ARGENT PAINTED *Lord Ribblesdale* IN HIS STUDIO IN TITE Street (**107**). Though by this time Sargent was tiring of portraiture, it was he who spotted his subject and initiated the painting. Thomas Lister, 4th Baron Ribblesdale, forty-eight years old at the time, was known for his style, charm, and looks. Edward VII called him "the Ancestor": the living essence of the hereditary principle and aristocratic style.[1]

The *Times* described Ribblesdale's outfit in the portrait as "a riding costume suggesting the period of George IV." He wears a Chesterfield coat with a velvet collar over a brown jacket, buff waistcoat, white stock, black silk muffler, box-cloth breeches, polished black butcher boots, a black top hat worn at an angle and gray kid gloves.[2] In his left hand he holds a hunting whip. The whip has three parts. The crop, the stiff handle, is for opening and closing gates, and for prodding a horse onward. The lash is for whipping the dogs if they're disobedient. The popper, at the end of the lash, makes the cracking sounds that are the master's last resort. This sort of whip is of no use in Chelsea. It is a souvenir of Ribblesdale's service as Master of the Buckhounds, a royal office he held from 1892 to 1895. Those were also the years of William Gladstone's fourth and final ministry as Liberal prime minster, which Ribblesdale supported from the House of Lords until it foundered on the issue of Home Rule for Ireland. At the apogee of empire, the United Kingdom was beginning to disunite. In a middle-class, commercial democracy, members of the aristocracy were no longer so certain in the saddle.

Ribblesdale's whip is a pun on this political background. In 1896, he became the Liberal Party's chief whip in the House of Lords, a position he would retain until 1907. He was also a celebrated amateur boxer, said to be capable of knocking out any man in the House of Lords, should such necessity arise. The Liberals, in their policies as in their contradictions, were accelerating the rise of the modern British state. Ribblesdale is part of

107 | *Lord Ribblesdale,* 1902

this paradox: an emblem of his class, but also an emblem of class struggle. He was fighting to hold together the unelected faction of a party that was committed to the democratic undoing of his peers, the landowning class. The hunter is becoming the hunted.

Sargent's initial plan was to depict Ribblesdale in the livery of the Master of the Buckhounds: "dark green gala coat, green and gold embroidered shoulder-belt, white leather breeches, and black boots with champagne tops."[3] The hereditary office of Master of the Buckhounds, who originally managed the hounds in the Royal Household, is first mentioned in the reign of Edward III (1327–77). In 1528, Henry VIII created the Master of the Privy Buckhounds, a political appointment. After the two offices were merged in 1706, the position was held by a nobleman who had rendered service to the ruling party. The post was abolished in 1901, shortly before Ribblesdale stood for his portrait. He was among the last of the men to have held this six-hundred-year-old office.

If Sargent had painted Ribblesdale in his Master's uniform, he would have seemed heraldic and historical — archaic, even: a stag at bay before the modern age. Ribblesdale consented, only for Sargent to abandon the plan due, Ribblesdale's daughter recalled, to "the difficulty of the leathers — an unpleasing mass of white for the painter."[4] Sargent was adept in the grand manner of adapting unpleasing masses of material into fields for the demonstration of painterly bravura. The difficulty was that the heavy leather material sagged down and ballooned around Ribblesdale's knees, reducing the opportunities for clever brushwork, and increasing the possibility that Ribblesdale, rather than looking timeless and dignified, would have appeared a bit ridiculous.

Sargent and Ribblesdale instead agreed that Ribblesdale was to be represented in "mufti," his usual riding outfit, in the ubiquitous countryman's style that the Edwardians called "ratcatcher" and in which the Master would be indistinguishable in dress from some of his servants. *Mufti* is an Anglo-Indian military term for civilian clothes, dating to 1816. A *mufti* is a Muslim cleric; the English usage probably referred to the decorated dressing gowns and tasseled caps worn by off-duty officers. Ribblesdale's mufti here is understated, English-style.

Sargent surmounted "the difficulty of the leathers" to create a more expressive and subtle portrait of aristocracy in a time of change. This authoritative figure asserts his authority by granting himself the license not to wear the marks of his hereditary rank — or, rather, to wear alternative markers. Ribblesdale is not so much dressing down, or even dressing up in an antique costume. He is dressing backward to assert his legitimacy at a historical moment when British society is moving forward.

As the *Times* recognized, Ribblesdale looks like a late Georgian, not a late Victorian or a modern Edwardian. His pose and expression, and Sargent's treatment, politely reassert the hereditary authority that the class system will continue to sustain, regardless of land or income. The "Ancestor" is claiming a future. We are encouraged to trust Ribblesdale by the austere, subliminally Classical setting, and by his apparent rejection of heraldic

108 | Leslie Ward ("Spy") (British, 1851-1922), *"Mufti" (Lord Ribblesdale)*, in *Vanity Fair*, 1881

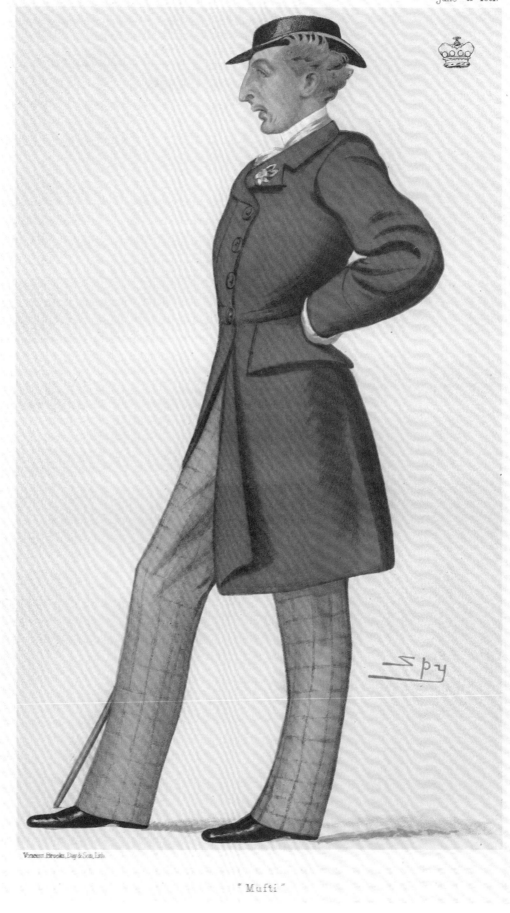

"Mufti"

costume for ordinary field gear. In a democratic age, Ribblesdale the hereditary aristocrat becomes the everyman statesman, and the Master of Buckhounds is more comfortable in the costume of his lordship's ratcatcher. But he still holds, as they say in politics, the whip hand. The Master of Buckhounds uses the whip as last resort, and so does the statesman who whips in the vote. But there's an obvious threat of violence here: this is a man used to power. He holds the right, and he has the height, the strength and, judging from his expression, the will, to crack the whip.

"Mufti," a cartoon by Leslie Ward ("Spy") from some twenty years earlier, suggests that Ribblesdale's apparently serendipitous choice of outfit for his portrait was consistent with a lifelong effort to project a certain public image (**108**). In 1881, Ribblesdale, then a lord-in-waiting to Queen Victoria, was already known for riding out in mufti. He continued to dress casually as Master of the Buckhounds and "always wore mufti when hunting," his daughter recalled.[5] After losing the Master of Buckhounds position, he continued to wear mufti in the saddle. In his book on hunting, *The Queen's Hounds and Stag-Hunting Recollections* (1897), he recalls that he did not object when the Queen's field rode out in "ratcatcher," though he remained a "stickler" for the tall hat, which "looks the best, and in every way is the best for riding of all kinds, which includes falling." But he regrets the aesthetic decline: "We can no longer boast of a d'Orsay, a Brummell, a Beaufort or an Alvaney. Blacking is no longer made of port wine and red currant jelly, or boot-top liquid of champagne and apricot jam. We feel the leveling tendency of the democratic tailor."[6]

In his portrait, Ribblesdale looks down at us from a commanding height: the figure measures about ten heads, well above the traditional seven-and-a-half. But Ribblesdale was indeed exceptionally tall. A photograph from before the turn of the century of Ribblesdale in his Master's costume suggests that Sargent's rendering is rather accurate (**109**). The portrait's effect of towering height in part derives from the slim outline Sargent creates by sharpening his subject's features and pinning back the left side of his jacket, and possibly the coat too. The crop, which is in Ribblesdale's right hand in the photograph, is highlighted by moving it to Ribblesdale's left hand. The lighter material of the breeches in the painting hangs more vertically than the leather breeches do in the photograph. Sargent makes use of Ribblesdale's shorter jacket, and the way Ribblesdale tucks it away with his right arm, to elongate Ribblesdale even further: the gray breeches run straight to the cream waistcoat.

The similarity between the photograph pose and the portrait pose, and Sargent's original choice of Master of the Buckhounds rig, suggest that the painting's composition may have been based on the photograph. In which case, we are looking at Sargent's Edwardian variation on a Victorian photograph whose composition echoes Georgian painting, and whose subject chooses to be represented in Georgian costume. In his portrait, Ribblesdale meets the aesthetic demands of a kind of timeless nobility. Yet Ribblesdale was neither as austere nor consistent as this image suggests. He had succeeded to his title at twenty-two, after his father, a gambler, had

committed suicide, and was prone to depression and outbursts of temper. His eldest son, Thomas, was killed in action in Somaliland in 1904. After Ribblesdale's wife, Charlotte Monckton Tennant, died in 1911, he became a long-term resident of Rosa Lewis's Cavendish Hotel in Jermyn Street. His second son was killed at Gallipoli in 1915. In 1916, Ribblesdale donated the painting to the National Gallery in memory of all three of them.

Within two decades of this portrait, Ribblesdale's Liberal Party had crumbled, his class was on the way to losing the whip hand, and he himself had sunk from a paragon of nobility to a parable of democratic decline. George Bernard Shaw is said to have used Ribblesdale as the model for Professor Henry Higgins in *Pygmalion* (1913). Virginia Woolf encountered Ribblesdale in 1917 and recorded that he was "the very image of his picture — only obviously seedy and dissolute."[7] In 1919, he surprised London society and restored the family fortune by marrying the former Mrs. John Jacob Astor, née Ava Willing of Philadelphia. Shortly before his death in 1925, he was involved in a financial scandal, for trading his name to a business that needed "a lord on the board."[8]

Ribblesdale may be in mufti, but he's wearing the uniform of the ruling class at leisure, and he holds the totem of royal authority. We are asked to salute the uniform, not the man, but Sargent exposes the man in the soft-mouthed arrogance of power. How much in this portrait's subtle psychology suggests repressed anger? Perhaps there's a clue in the only bright accent in the whole painting, the fine red line that highlights the thread of the coiled whip: a line of blood, a bloodline — as if Ribblesdale, the amateur boxer with a temper, has drawn blood with it.

A Riot of White ELAINE KILMURRAY

T N THE MIDDLE OF THE NINETEENTH CENTURY, Charles Baudelaire declared that "color . . . thinks by itself, independently of the object it clothes," that it has its own autonomy.[1] Painting with white, achromatic, a color and yet not a color, presents particular technical challenges that caused it to become associated with the primacy of form over subject, leading the French critic Jules-Antoine Castagnary to ask: "Does a tour-de-force in painting consist of laying white on white?"[2] White and whiteness — as motif, accent, pure pigment — are pervasive and eloquent in Sargent's work, describing and defining form while also reading independently, declaring the individual touch of his brush.

Fumée d'ambre gris (Smoke of Ambergris), which depicts a female figure wrapped in white and off-white robes in a mostly white architectural setting, was exhibited at the Salon in 1880 (**110**). In a letter from Sargent to his friend Vernon Lee, the artist emphasized that he had been motivated by color rather than subject ("the only interest of the thing was the color").[3] In the satirical journal *Le Charivari*, Louis Leroy relayed an imagined conversation in which Édouard Manet — himself a painter of electrifying whites — described the painting as "a complete symphony in white major. White on white, white everywhere."[4] Critics reached back to the Aestheticism of the 1850s and 1860s, during which the idealization of white was at its height, for their points of reference.[5] Several of them related *Fumée d'ambre gris* to the work of the Romantic writer and art critic Théophile Gautier, an advocate of *l'art pour l'art* (art for art's sake), which asserted that art was self-sufficient and ineffable, that it resisted narrative and moral interpretation, and was closely associated with the abstract purity of music.[6] Specific allusions were made to Gautier's "Symphonie en blanc majeur" (Symphony in White Major, 1852), a poem with a Parnassian emphasis on form, restraint, and technical perfection, in which white is the recurrent motif.[7] One critic wrote that Gautier would have given Sargent's

A Morning Walk (**112**), detail

203

painting the same title, and Paul Mantz called it "a melodic fantasy, the very thing for those who love the sublime master, Théophile Gautier."[8] French literature played a significant role in informing Sargent's sensibility and tastes. He spoke the language fluently, having been "brought up to care for French letters and the French style," and the contents of his library confirm his lifelong admiration for French literature.[9]

Sargent was aware of the rapid developments in optics and color theory that excited artists in the second half of the nineteenth century, and of their implications for the Impressionist imperative to capture ethereal light in the materials available to the artist.[10] He almost certainly visited Monet in Giverny in 1885 and corresponded with him later about color and pigment.[11] The experience of working alongside Monet is evident in the work he painted afterward in the English countryside, a high point in his experimentation with painting white. In Broadway, he painted portraits of his friends Alice Barnard and Lily Millet and a lyrical study of the young Teresa Gosse, all dressed in summer white. The two models in *Carnation, Lily, Lily, Rose* wear white dresses made expressly for the picture and are overtopped by huge white lilies (**111**). In *A Morning Walk*, Sargent's younger sister Violet wears a white cotton dress and walks on a riverbank in bright sunlight (**112**). Her figure is not dematerialized in intense light as is Monet's *Woman with a Parasol, Facing Left* (1886, Musée d'Orsay, Paris), but, when light strikes white fabric, it splinters, creating broken color so that her dress, quivering with light, is shot with myriad shades, delicate blue and violet shadows with creamy white highlights. Shadow on the underside of her white umbrella is caught in splashes of blue, green, yellow, and pink. Here, white is not absence of color (in scientific terms, it contains the constituent colors of the spectrum), but an area of latent possibility, expressed in delicate overlaid brushstrokes, being released.

Sargent integrated aspects of his experiments with white into his formal portraiture. His three-quarter-length portrait of Helen Harrison was painted in 1886, at a transitional period for the artist (he was moving back and forth between Paris and England in the wake of the *Madame X* scandal) and at a time of intense scrutiny for the sitter, who was involved in a sensational, high-profile divorce case (see **16**).[12] Her stark red robe is distinctive in design, with echoes of the academic or legal gown and overtones of the penitential, and it reads like a carapace over the luminous whiteness of her dress. The chromatic contrast between the whiteness with its blue and violet shadows and the crimson is austere and dramatic, and the keenly drawn edges of the sash and nervily rendered folds of fabric echo the graceful reticence of the sitter's pose and gesture. Sargent uses the textures of the whites in subtle ways, the skin shimmering through the translucent sleeves creating a sense of physical vulnerability. The Duchess of Portland, also dressed in white and red, might be seen as an oblique pendant to the portrait of Helen Harrison. She is a beautiful woman painted in the grand manner, and the red velvet cloak and the Medici lace collar are patrician both in terms of costume and in art-historical allusion (see **62**). Such costumes were worn in the fancy-dress balls popular among

110 | *Fumée d'ambre gris (Smoke of Ambergris)*, 1880

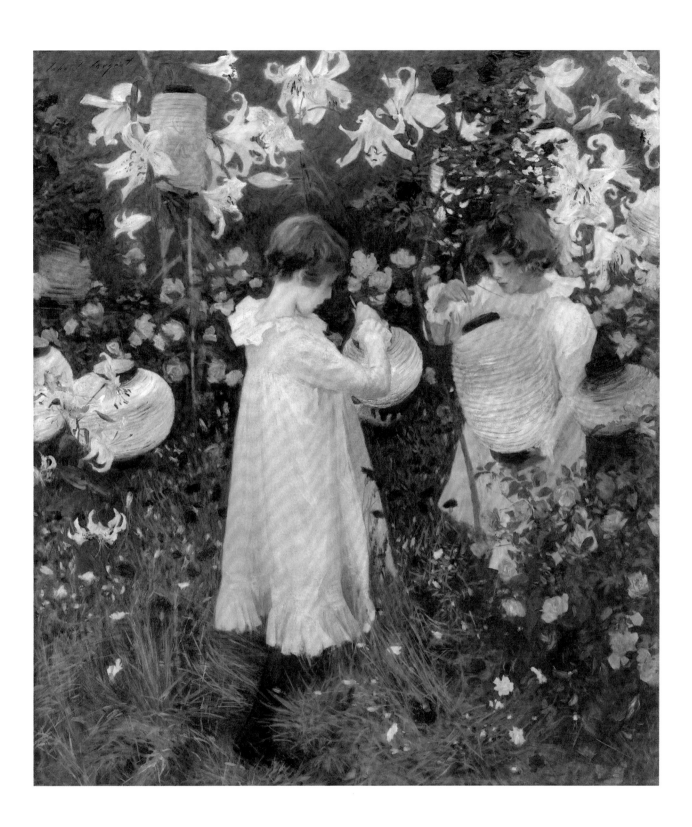

111 | *Carnation, Lily, Lily, Rose*, 1885–86

112 | *A Morning Walk*, 1888

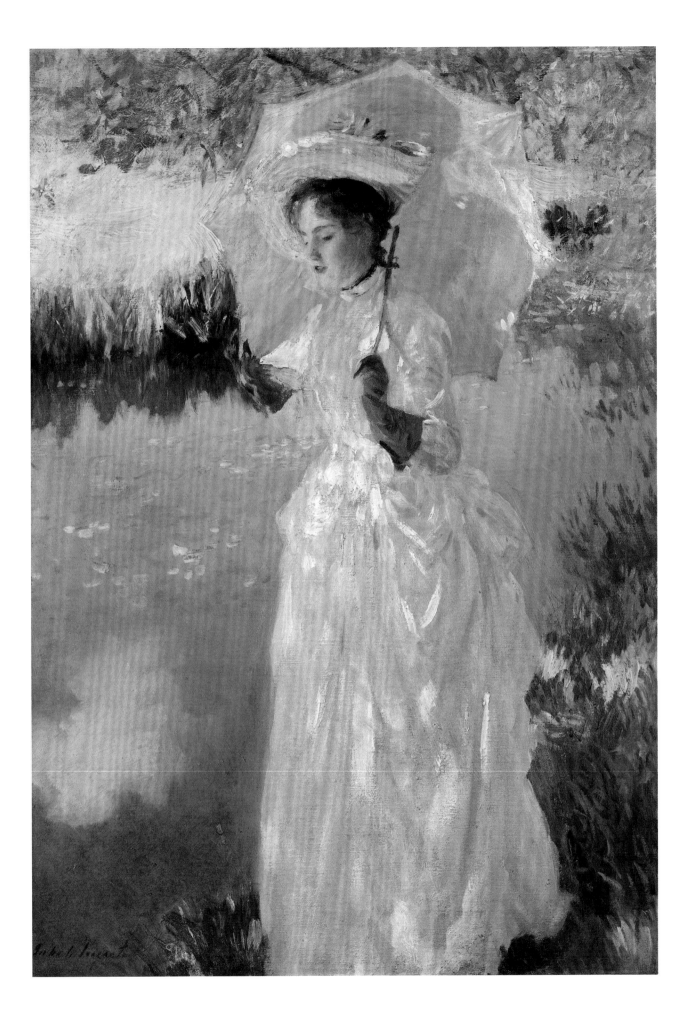

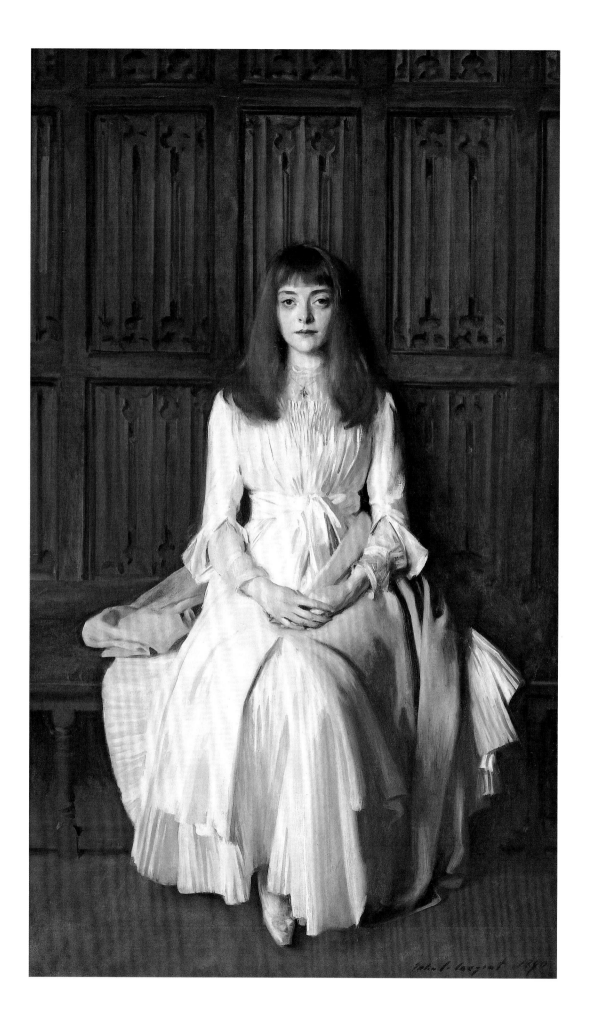

the aristocracy of the time, and the duchess's ensemble might seem anachronistic, the stuff of pastiche rather than reality.[13] The cloak and gown are rendered with extreme softness of line, as if they are fluid and mutable.

Elsie Palmer, a young girl on the brink of womanhood, is painted in a white dress in the Aesthetic style delicately blushed with the palest pink (**113**). She is seated in a fixed frontal pose, looking mesmerized against the linen-fold paneling of a corridor at the medieval manor house Ightham Mote, in Kent. The fine pleating of her dress repeats the lines of the paneling, creating a hypnotic and unsettling image. In *Lady Agnew of Lochnaw*, painted in June 1892, the cool white satin and chiffon tea gown with mauve sash, the pale turquoise hanging behind the sitter, and the floral-covered *bergère* chair create exquisite aerial harmonies (see **12**). Seeing the picture after the first sitting, her husband, Noel Agnew, described it as "a very pretty arrangement," and reviewers responded to the way in which it fused realistic representation with Impressionist impulses and fluidity of facture. It succeeded "as a portrait, a decorative pattern, or a piece of well-engineered impressionist painting."[14]

While the use of white for outerwear dates from the sixteenth century, it became very fashionable in Europe around the 1780s, perhaps stemming from a desire to emulate Neoclassical values after a time of upheaval. It is a "color" deeply embedded in Western culture, frequently (and largely incorrectly) associated with antiquity, and it continues to be aesthetically, culturally, racially, and psychologically charged.[15] In the nineteenth and twentieth centuries it was thought to signify innocence, virtue, and spirituality. It can suggest simplicity and cleanliness, but its essential impracticality for outerwear also carries connotations of luxury, sophistication, and exclusivity. Even in quite simple garments, its simplicity is deceptive. There was an economic cost to white. Cotton was imported to Europe from distant lands, from India and from the New World. It involved the labor of enslaved workers in the United States and poorly paid workers in India and Britain, and every stage of its production and maintenance, bleaching, finishing, garment construction, and laundering, was elaborate and expensive.[16]

Contemporary preoccupation with white cloth is given exuberant expression in the last chapter of *Au bonheur des dames* (The Ladies' Paradise, 1883), Émile Zola's novel set in the world of a Parisian department store. Zola describes a "Great White Sale" of garments and textiles in passages of poetic intensity that create a relentless imagery of super-abundant whiteness, a "chanson du blanc" (song of white). Diverse fabrics are described in terms of the natural world, a wintry landscape which seems to overwhelm the interior of the store: "Then the galleries went on in a dazzling whiteness, a chilly northern vista, an entire landscape of snow, unfolding to infinity in steppes hung with ermine, a mass of glaciers shining under the sun. . . . There was nothing but white . . . a riot of white."[17]

White became a frequent color of choice for costume in Sargent's female portraits, suggesting a timeless distinction for his increasingly aristocratic clientele. Just before the turn of the twentieth century, he paints a

113 | *Miss Elsie Palmer, or A Lady In White, 1889–90*

group portrait of three sisters all dressed in white: *The Wyndham Sisters: Lady Elcho, Mrs. Adeane, and Mrs. Tennant* (1899, Metropolitan Museum of Art, New York). The three seated women are compressed into the lower half of a large canvas with a vast shadowy space above them. The unconventional composition reflects the taste and social confidence of the sitters who, as members of "the Souls," an elite coterie of patrician intellectuals, would have prided themselves on their progressive ideas. In the shadowy space, the whites of their gowns and jewelry act as refined highlights, reading as symbols of luxury but also as discrete patches of brilliant pigment in a way that was recognizably modern. The white accents in an echoing space might refer back to another study of sisters painted seventeen years earlier. In an even more unorthodox canvas, the starched white pinafores of three of the daughters of the artist Edward Darley Boit, the white dress of the youngest, splashes of white gleaming on the large urns, and two diffuse whitish blocks indicating mirror and reflection, are the only relief in a startlingly ambiguous space (see **60**).

At this period, men wore white costume in specific professional and sporting contexts, on certain ceremonial occasions, or in hot climates, where white linen helped them withstand temperature and humidity. The latter two circumstances apply to Sir Frank Swettenham, who is represented in white uniform as Governor of the [Malay] Straits Settlement, in present-day Malaysia (see **57**). Lord Londonderry is represented in procession during the coronation of King Edward VII, the white of his breeches and stockings, and the white lining of his crimson velvet robe trimmed with ermine, highlighted against the shadowed architecture of Westminster Abbey (see **28**). An insouciant Lord Dalhousie is painted in a Van Dyck pose in a studio setting, wearing white flannels, cutting a contemporary dash against the Old Master-ish template (see **59**). Sargent depicts the super-relaxed Charles Deering in the bright sunlight of his Miami estate: in white suit, shoes, and straw hat, he is seated in a rattan chair by the water's edge, shaded by coconut trees and surrounded by fronds and fallen coconuts (**114**).

It is apparent from family photographs that, in their summer excursions in the Alps, Sargent's sisters, nieces, and female friends were dressed for an active life in sensible skirts and stout boots, but Sargent portrays them swathed in mostly white or off-white fabric, transforming them into creatures of elegance and romance. *Two Girls in White Dresses* (**115**) might be an early twentieth-century outdoor counterpart to Jean-Auguste-Dominique Ingres's portrait of Marie-Françoise Beauregard, Madame Rivière, which shows the sitter framed in a contained oval, wearing a simple white Neoclassical dress, a white chiffon scarf, and a pale cream cashmere shawl edged with wide borders woven with a stylized pine-cone motif (**116**).[18] The model posing for both figures in Sargent's painting, with a shawl similar to that worn by Madame Rivière, is almost certainly Rose-Marie Ormond, the elder of his two nieces. The principal figure is swathed in cloth (the "dress" is of indeterminate construction), the shape of her body difficult to discern under the voluminous fabric. In an audaciously

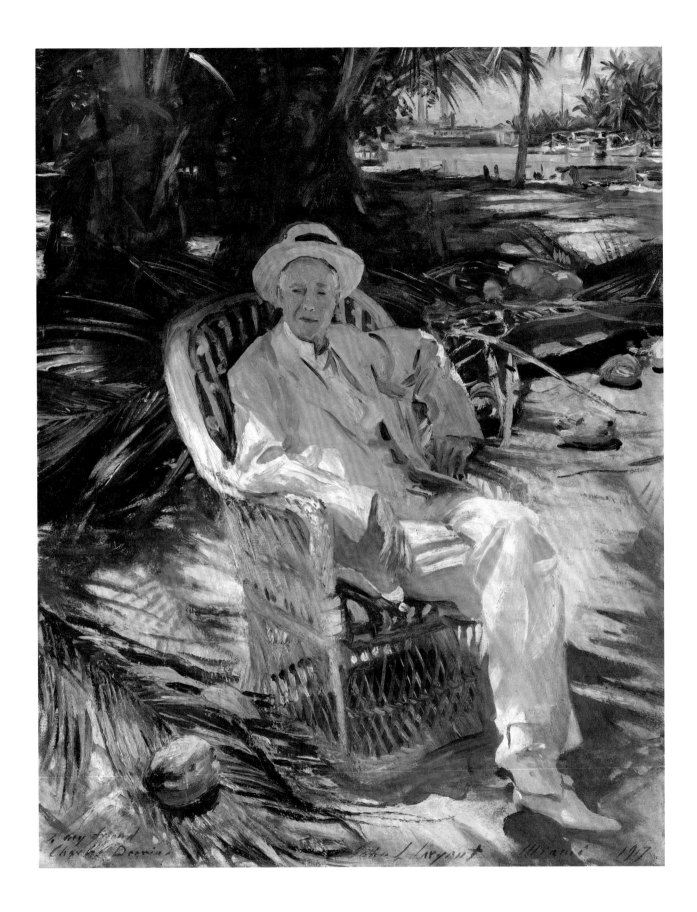

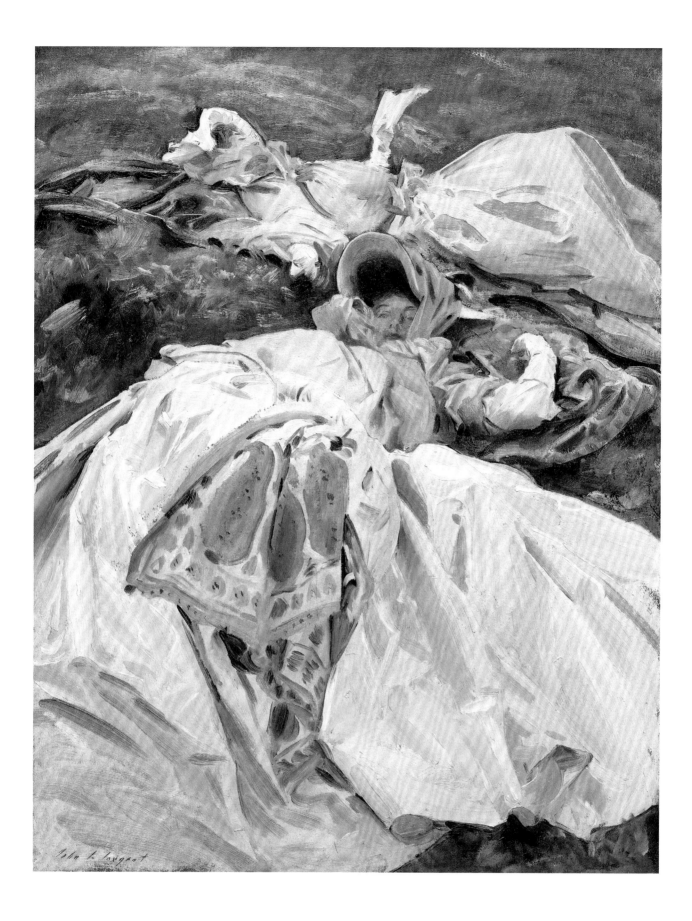

116 | Jean-Auguste-Dominique Ingres
(French, 1780–1867), *Marie-Françoise
Beauregard, Madame Rivière*, 1806

foreshortened composition, the skirt described in thick sweeps of creamy
white pigment fills half the picture space and the mauve-gray pinecone
motif on the border of the cashmere shawl is placed in a prominent posi-
tion, just to the left of center. Whereas Ingres uses the curves of the shawl
encircling the figure to define the female body, Sargent almost treats the
shawl as camouflage. The sensuality is all in the paint. When the picture
was exhibited at the New English Art Club in London in the summer of
1912 as *Falbalas* (French for "flounces" or "frills"), reviewers were struck by
the extreme fluidity of the paint, describing the draperies in liquid terms as
having "the appearance of a flowing mountain stream," or as being "a lique-
faction of clothes" and "a waterfall."[19] This conflation of the fall of cloth
with physical features of the natural world is the painterly counterpart to
Zola's passage fusing the whiteness of cloth with the imagery of landscape.

Sargent's way of painting creates a surface texture that draws attention
away from content and description toward the physical reality of pigment
and process. He worked with freely brushed loads of pigment (he advised a
student, "you want plenty of paint to paint with"), laying down apparently
haphazard brushstrokes and making vigorous use of the palette knife.[20]
In his later work, pigment is applied so thickly as to create surface relief.
Seen close up, objects lose their legibility and become slabs and gashes
of pigment, the active picture surface resolving into readable shapes and
forms only at a distance. Baudelaire declared that color had an essential
independence. In Sargent's work we see the independence of paint.

117 | *Femme en barque (Lady in a Boat)*, about 1885–88

118 | *Mrs. Frank Millet (Elizabeth Merrill)*, 1885–86

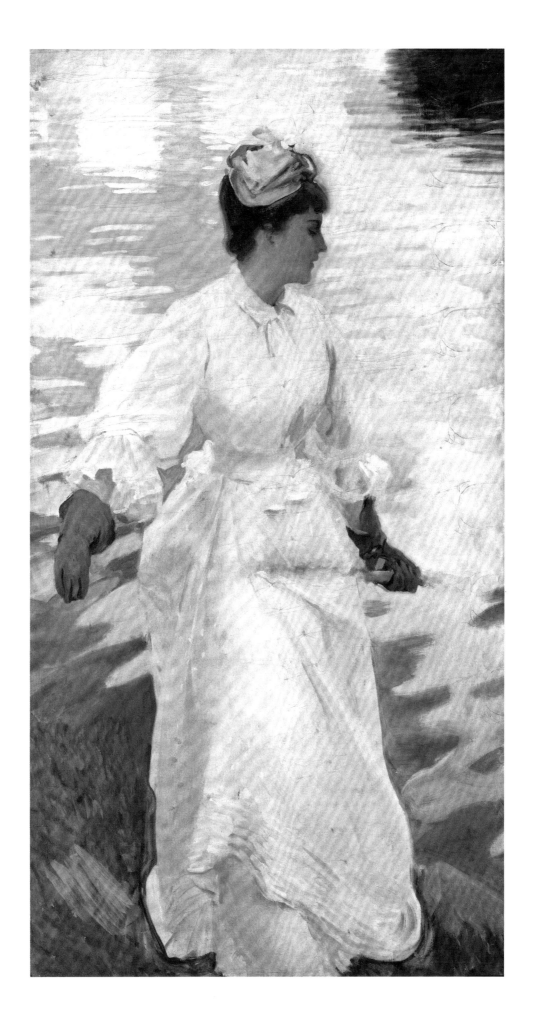

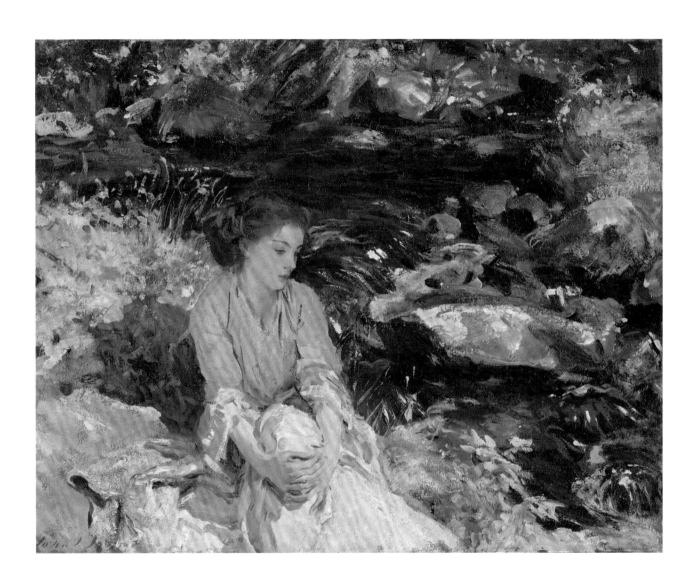

119 | *Lady Fishing, Mrs. Ormond (Violet Sargent),* 1889 **120** | *The Black Brook,* about 1908

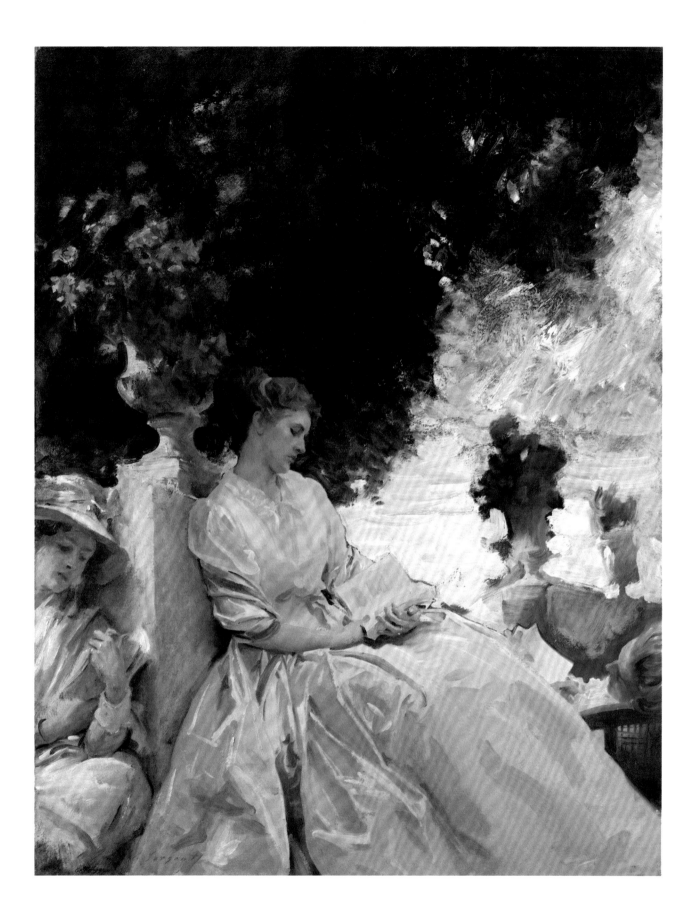

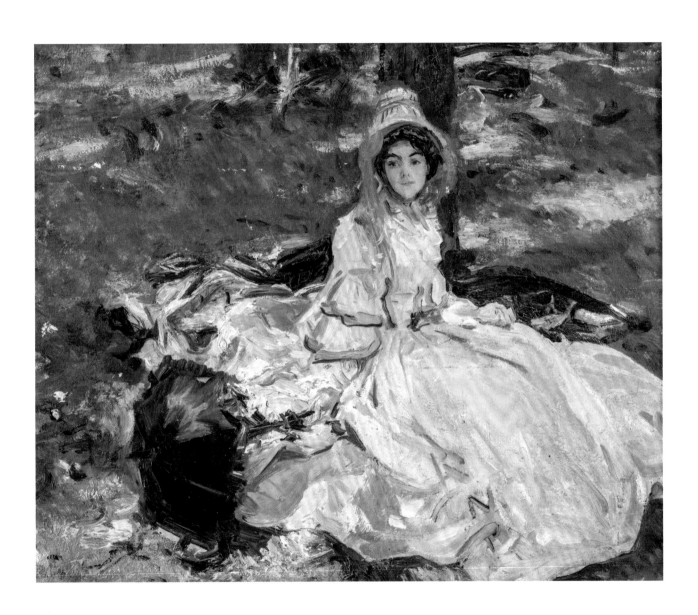

Notes

References to the John Singer Sargent catalogue raisonné of paintings are abbreviated as *"Complete Paintings* [volume]:[page]." All volumes are by Richard Ormond and Elaine Kilmurray, and were published by Yale University Press for the Paul Mellon Centre for British Art between 1998 and 2017:

1. *The Early Portraits*
2. *Portraits of the 1890s*
3. *The Later Portraits*
4. *Figures and Landscapes, 1874–1882*
5. *Figures and Landscapes, 1883–1899*
6. *Venetian Figures and Landscapes, 1898–1913*
7. *Figures and Landscapes, 1900–1907*
8. *Figures and Landscapes, 1908–1913*
9. *Figures and Landscapes, 1914–1925*

CURATORS' PREFACE

1. *The Collected Works of Thomas Carlyle* (London, 1864), vol. 6, p. 177; Lucia Miller, "John Singer Sargent in the Diaries of Lucia Fairchild 1890 and 1891," *Archives of American Art Journal* 26 (1986): 5.
2. Edith Wharton, *The Age of Innocence* (rept., New York: Collier Books, 1968), 198.
3. Katherine Joslin, *Edith Wharton and the Making of Fashion* (Hanover, NH: University Press of New England, 2009), 57.
4. "The Sargent Portraits at the Museum of Fine Arts," *Boston Evening Transcript*, June 12, 1903, p. 9. We are grateful to Rob Leith for his assistance with research into the pricing of Worth gowns.
5. Gail Hamilton [Mary Abigail Dodge], *Women's Worth and Worthlessness* (New York: Harper and Brothers, 1872), 105; Mrs. Carl Meyer [Adèle Levis Meyer] and Clementina Black, *Makers of Our Clothes: A Case for Trade Boards* (London: Duckworth, 1909).
6. *The Contributor's Club* (Feb. 1884): 282.

SITTING FOR SARGENT

1. For "pish-tash" see N. P. Stokes, *Random Recollections of a Happy Life* (New York: privately printed, 1941), 116; for "Spanish oaths," see *Men, Women & Things: Memories of the Duke of Portland* (London: Faber & Faber, 1937), 219.
2. Diary of Lucia Fairchild, October 2, 1890; Dartmouth College Library, Hanover, NH.
3. *Letters of John Hay and Extracts from Diary*, 3 vols. (Washington, DC: privately printed, 1908), vol. 3, p. 267.
4. Marie-Louise Pailleron, *Le paradis perdu* (Paris: Albin Michel, 1947), 159–63.
5. *Men, Women, & Things*, 414.

6. Diary of Lucia Fairchild, October 2, 1890.
7. Cara Burch to David McKibbin, February 21, 1958; McKibbin Papers, Sargent Archive, Museum of Fine Arts, Boston.
8. Memorandum of a conversation with James Lomax, October 4, 1979; Sargent Archive.
9. Undated letter from the artist to J. P. Morgan, Jr.; Mrs. J. P. Morgan Jr.'s scrapbook for 1898–1905, Morgan Library, New York.
10. P. A. B. Widener, *Without Drums* (New York: Putnam, 1940), 67–68.
11. Charles Merrill Mount, *John Singer Sargent: A Biography* (New York: W. W. Norton, 1955), 242.
12. Letter from Lord Rathcreedon to the compilers of the Sargent catalogue raisonné, July 1984; Sargent Archive.
13. Letter to David McKibbin, October 14, 1950; McKibbin Papers, Sargent Archive.
14. W. Graham Robertson, *Life Was Worth Living* (London: Harper, 1931), 238.
15. *Complete Paintings* 2:xxi–xxv; 3:xxvii–xxxi.
16. Letter to David McKibbin, February 21, 1958; McKibbin Papers, Sargent Archive.
17. Undated letter from Sargent to Edwin Austin Abbey, quoted in Evan Charteris, *John Sargent* (New York: Scribner's, 1927), 137.
18. Recorded in Charteris, *John Sargent*, 157.

PORTRAITS AS FASHION

1. Margaret Oliphant, *Dress* (London: Macmillan, 1878), 4.
2. Marc Simpson, "Sargent and His Critics," in *Uncanny Spectacle: The Public Career of the Young John Singer Sargent*, ed. Marc Simpson (Williamstown, MA: Sterling and Francine Clark Art Institute, 1997), 38.
3. "The Salon was a great social occasion; [Sargent's] pictures were seen by people unconcerned by art, but concerned with fashion. The Salon was to painting what the Derby is to horses." Stanley Olson, *John Singer Sargent, His Portraits* (New York: St. Martin's, 1986), 78.
4. See Katherine Joslin, *Edith Wharton and the Making of Fashion* (Hanover, NH: University Press of New England, 2009), 58.
5. "The historical conditions for the rise of the chic Parisienne were a convergence of mass-production, consumption and the spread of a visual culture promoting consumption . . . the chic parisienne's national role was both as a symbolic icon and as a consumer of French goods." Ruth Iskin, *Modern Women and Parisian Consumer Culture in Impressionist Painting* (Cambridge: Cambridge University Press, 2007), 223.
6. See *Complete Paintings* 1:57.

7. "American Art in the Paris Salon," *Art Amateur* 7, no. 3 (Aug. 1882).

8. Paul Leroi [Léon Gauchez], "Salon de 1882," *L'Art* 8, no. 30 (July–Sept. 1882): 139.

9. Quoted in Clair Hughes, *Henry James and the Art of Dress* (Basingstoke: Palgrave Macmillan, 2001), 8.

10. "The rise of haute couture and the distribution of more accessible forms of fashion to a wider social audience were connected with an interest in portraiture among female patrons — not only in terms of commissioning portraits but for the importance of going to view them in exhibitions as a pleasurable pastime." Kimberly Wahl, ed., *Dressed as in a Painting: Women and British Aestheticism in an Age of Reform* (Durham: University of New Hampshire Press, 2013), 67. See also Aileen Ribeiro, "Fashion and Whistler," in *Whistler, Women and Fashion*, ed. Margaret F. MacDonald, Susan Grace Galassi, and Aileen Ribeiro (New Haven: Yale University Press, 2003), 32.

11. George Moore, *Modern Painting* (London: Walter Scott, 1906), 252–53.

12. D. H. Lawrence, *Phoenix: The Posthumous Papers of D. H. Lawrence* (London: Heinemann, 1936), 560.

13. Walter Sickert, *The Complete Writings on Art*, ed. Anna Gruetzner Robin (Oxford: Oxford University Press, 2000), 243.

14. *The Art Journal* (1885): 190.

15. Paul Mantz, "Le Salon: IV," *Le Temps*, May 23, 1884, p. 2.

16. Jules Claretie, "La vie à Paris," *Le Temps*, May 16, 1884, p. 3.

17. Letter from Ralph Curtis to his parents, about May 2, 1884, quoted in Evan Charteris, *John Sargent* (New York: Scribner's, 1927), 61–62.

18. A. B., "*Portrait de Mme ***, par M. John Sargent*," *Le Monde illustré*, May 7, 1884, p. 6.

19. "The Tailor at the Academy," *Huddersfield Chronicle*, June 17, 1895, p. 4. The comparison to a lamppost predates Robertson's description of the portrait using the same term in his memoirs.

20. "*Les Demoiselles Hunters*, Salon de 1903, Société Nationale des Beaux-Arts," *Les Modes* 31 (July 1903).

21. See Michele Majer, "Arte, moda e mercato: La rivista 'Les Modes' e l'Hôtel des Modes," in *Boldini e la moda*, ed. Barbara Guidi (Ferrara: Fondazione Ferrara Arte, 2019).

22. Gabriel Badea-Päun, *The Society Portrait: From David to Warhol* (London: Thames & Hudson, 2007), 102.

23. Maurice de Waleffe, "Autour de la mode," *Les Modes* 204 (May 1921): 2. From spring 1891 onward, there were two salons in Paris: that of the Société des Artistes Français, and the alternative salon of the Société Nationale des Beaux-Arts, founded by a group of established artists to showcase the work of young, upcoming artists.

24. In reinterpretations of the painting, the actress Julianne Moore was photographed by Peter Lindbergh in a sheath dress for *Harper's Bazaar* in 2008, and Steven Meisel shot the actress Nicole Kidman in a simple black dress with a slight A-line cut for the June 1999 issue of *Vogue*.

25. Henry James, *The Painter's Eye: Notes and Essays on the Pictorial Arts* (London: R. Hart-Davis, 1956), 218.

26. Moore, *Modern Painting*, 253.

27. "American Art in the Paris Salon," *Art Amateur* 7, no. 3 (Aug. 1882).

28. Henry James, "John S. Sargent," *Harper's New Monthly Magazine* 75, no. 449 (Oct. 1887): 684, 686.

MADAME X

1. "Nouvelles & échos," *Gil Blas*, January 8, 1882, p. 1.

2. Sargent wrote to Ben del Castillo: "I have a great desire to paint her portrait and have reason to think she would allow it and is waiting for someone to propose this homage to her beauty." Quoted in Evan Charteris, *John Sargent* (New York: Scribner's, 1927), 59.

3. The portrait was exhibited at the Paris Salon in 1884 as *Madame ****. After Gautreau died in 1915, Sargent offered to sell the painting to the Metropolitan Museum in New York. In 1916, he wrote the director Edward Robinson, "I should prefer, on account of the row I had with the lady years ago, that this picture should not be called by her name." In the formal paperwork, she assumed her current title, *Madame X*. For more information on how the painting came to the museum, see Stephanie L. Herdrich, "From the Archives: How *Madame X* Came to The Met," blog post, January 8, 2016, www.metmuseum.org.

4. Perdican, "Courrier de Paris," *L'Illustration*, June 18, 1881, p. 412. It seems likely that Sargent and Gautreau, who were invested in their status in Paris, would have been aware of this mention. (It is tempting to speculate that Perdican's linking of the young artist and beautiful ingenue may have made a collaboration seem like a good idea — though there is no evidence of this.) Perdican's observation was an important foreshadowing of significant anti-American sentiment that would prove highly relevant to the portrait's reception.

5. As opening day of the Salon neared, anticipation around the portrait grew. At a soirée in late March, Perdican noted that "the "beautiful Mme Gauthereau" [*sic*] was greatly admired" and predicted that "She will be even more so at the Salon where the American Painter John Sargent exhibits his portrait." Perdican, "Courrier de Paris," *L'Illustration*, March 22, 1884, p. 182.

6. "La Belle Americaine," *New York Herald*, March 30, 1880. See Elizabeth L. Block, "Virginie Amélie Avegno Gautreau: Living Statue," *Nineteenth-Century Art Worldwide* 17 (Autumn 2018): 103.

7. Gabriel Louis Pringué, in *30 ans de dîners en ville*; see Block, "Virginie," 114.

8. Sargent wrote to Vernon Lee: "Do you object to people who are 'fardées' to the extent of being a uniform lavender or blotting-paper colour all over? If so you would not care for my sitter; but she has the most beautiful lines, and if the lavender or chlorate of potash-lozenge colour be pretty in itself I should be more than pleased." Quoted in Charteris, *John Sargent*, 59. For a discussion of her skin and cosmetics, see Susan Sidlauskas, "Painting Skin: John Singer Sargent's 'Madame X,'" *American Art* 15, no. 3 (Autumn 2001): 9–33.

9. Jules Comte, "Le Salon de 1884: La peinture," *L'Illustration*, May 3, 1884, p. 290.

10. Sargent and Gautreau to Allouard-Jouan, summer 1883, Sargent Archive, Museum of Fine Arts, Boston.

11. Sargent wrote to Ben del Castillo, "Carolus has been to see it and said, 'Vous pouvez l'envoyer au Salon avec confiance.' Encouraging, but false. I have made up my mind to be refused." Quoted in Charteris, *John Sargent*, 59–60.

12. Jules Comte, "Le Salon de 1884: La peinture," *L'Illustration*, May 3, 1884, p. 290. Gautreau was known to have patronized Paris's prestigious couturiers, including, as noted above, Maison Félix. Elizabeth Block has noted that Maison Félix had achieved success for "specializing in a slim silhouette, with the torso shaped like a long and narrow hourglass." See Elizabeth L. Block, "Maison Félix and the Body Types of Its Clients, 1875–1900," *West 86th* 26 (Spring/Summer 2019): 80.

13. "While the style of her dress may have been daring and even shocking to bourgeois Salon goers, the cut was on the forefront of fashion — not beyond it." Justine Renée De Young, "Women in Black: Fashion, Modernity and Modernism in Paris, 1860–1890" (PhD diss., Northwestern University, 2009), 312–13.

14. See *Catalogue illustré du Salon* and *Livret illustré du Salon* (Supplement) (Paris: F.-G. Dumas, 1884). For example, catalogue 322, Bouguereau, *La Jeunesse de Bacchus*; catalogue 491, Chaplin, *Portrait de Mme M.*; and 492, Chaplin, *Portrait*

de Mlle L. In Sargent's oeuvre, see, for example, his portrait of Mrs. Harry Vane Milbank (1883–84) with its plunging décolleté and bare shoulders.

15. By the 1880s, the Parisienne, long associated with infallible taste, had "increasingly become a woman bathed in elegance and expensive fabrics rather than a modern woman on the go." Françoise Tétart-Vittu, "Édouard Manet, *The Parisienne*," in *Impressionism, Fashion, Modernity*, ed. Gloria Groom (Chicago: Art Institute of Chicago, 2012), 83.

16. Joséphin Péladan, "Salon de 1884, IX: La femme — habillé, déshabillé, nue," *L'Artiste* 54 (1884): 441.

17. "Eccentricities of French Art," *Art Amateur* 11 (Aug. 1884): 52.

18. Ralph Curtis, letter to his parents, quoted in Charteris, *John Sargent*, 61–62.

19. Jules Claretie, "La vie à Paris," *Le Temps*, May 16, 1884, p. 3.

20. Louis de Fourcaud, "Le Salon de 1884," *Gazette des Beaux-Arts*, June 1, 1884, pp. 482–84.

21. Arsène Houssaye, "Quelques opinions avancées sur la Parisienne," *L'Artiste*, August 1, 1867, p. 147.

THE NEW WOMAN

1. Sarah Grand, "The New Aspect of the Woman Question," *The North American Review* 158, no. 448 (March 1894): 270–27.

2. For a feminist account of these caricatures, see Ouida, "The New Woman" (1894), reprinted in *The North American Review* 272, no. 3, *Special Heritage Issue: The Woman Question, 1849–1987* (September 1987): 61–65.

3. See Martha Banta, *Imaging American Women: Idea and Ideals in Cultural History* (New York: Columbia University Press, 1987), 113.

4. Karen Halitunen, "The Life and Times of the American Girl," *American Quarterly* 42, no. 1 (March 1989): 190–95; 191.

5. On the New Woman in art, see Ellen Wiley Todd, *The "New Woman" Revised: Painting and Gender Politics on Fourteenth Street* (Berkeley: University of California Press, 1993); and Holly Pyne Connor, ed., *Off the Pedestal: New Women in the Art of Homer, Chase, and Sargent* (Newark, NJ: Newark Museum, 2006). See also Martha H. Patterson, ed., *The American New Woman Revisited: A Reader, 1894–1930* (New Brunswick, NJ: Rutgers University Press, 2008).

6. Patricia Marks, *Bicycles, Bangs and Bloomers: The New Woman in the Popular Press* (Lexington: University Press of Kentucky, 1990), 160.

7. Martha H. Patterson, *Beyond the Gibson Girl: Re-imagining the American New Woman 1895–1915* (Chicago: University of Illinois Press, 2005), 38.

8. Advertisement for Ferris's Good Sense Corset Waist for Bicycle Wear, 1897; americanhistory.si.edu.

9. *Complete Paintings* 2:126.

10. Helen's father was director of the Tyneside firm of T. & W. Smith, as well as an important collector of works by the English Aesthetic movement. Her husband, Robert, was a stockbroker and connoisseur of music. The couple lived at Shiplake Court, a historic manor house at Henley-on-Thames.

11. Review of the Royal Academy exhibition of 1886 in the *Evesham Journal and Four Shires Advertiser*; cited in *Complete Paintings* 1:144.

12. Kali Israel, *Names and Stories: Emilia Dilke and Victorian Culture* (New York: Oxford University Press, 1999), 206; David Nicholls, *The Lost Prime Minister: A Life of Sir Charles Dilke* (London: The Hambledon Press), 1995, 340n2; Mary Jean Corbett, "On Crawford v. Crawford and Dilke, 1886,"*BRANCH: Britain, Representation and Nineteenth-Century History*, ed. Dino Franco Felluga, www.branchcollectionve.org.

13. Roy Jenkins, *Victorian Scandal: A Biography of the Right Honourable Gentleman Sir Charles Dilke* (New York: Chilmark, 1965), 349–50; Kali Israel, "French Vices and British Liberties: Gender, Class and Narrative Competition in a Late Victorian Sex Scandal," *Social History* 22, no. 1 (Jan. 1997): 1–26.

14. The couple lived a cosmopolitan existence, traveling between England and Argentina, where Thursby was involved in various engineering projects. *Complete Paintings* 2:146–47.

15. Isaac Newton Phelps Stokes, *Random Recollections of a Happy Life* (New York: privately printed, 1941), 116.

16. *Pittsburgh Press*, September 16, 1906, [n.p.].

17. *Complete Paintings* 2:122–24; H. Barbara Weinberg, *American Impressionism and Realism: A Landmark Exhibition from the Met* (New York: Metropolitan Museum of Art, 2009), 214.

18. Charles Caffin in *International Studio* (1901); James Montgomery Flagg in *Century* (1899); and *International Studio* (1898), all cited in *Complete Paintings* 2:124.

19. Quoted in Patterson, *Beyond the Gibson Girl*, 34.

MRS. HUGH HAMMERSLEY

1. George Moore, "A Portrait by Mr Sargent," in *Modern Painting* (London: Walter Scott, 1893), 252.

2. Fragment of an article from *Land and Water*, May 27, 1893, Campbell Archive, Metropolitan Museum of Art; *Saturday Review*, June 10, 1893, pp. 627–28.

3. *The Times* (London), May 1, 1893, p. 10.

4. Jessica Regan, "'A Crying Hint of Rose': Fashion in Sargent's *Mrs. Hugh Hammersley*," www.metmuseum.org.

5. Nobuko Shibayama, Dorothy Mahon, Silvia A. Centeno, and Federico Carò, "John Singer Sargent's *Mrs. Hugh Hammersley*: Colorants and Technical Choices to Depict an Evening Gown," *Metropolitan Museum Journal* 53 (2018): 172–79.

6. Sean Robert Willcock, "1893: The French Connection," in *The Royal Academy of Arts Summer Exhibition: A Chronicle, 1769–2018*, edited by Mark Hallett, Sarah Victoria Turner, and Jessica Feather (London: Paul Mellon Centre for Studies in British Art, 2018).

7. *The Times* (London), April 29, 1893, p. 13; *The Illustrated London News*, April 29, 1893, p. 514.

8. *The Times* (London), May 1, 1893, p. 10.

9. In 1899, the critic Royal Cortissoz even identified "restlessness" as the "dominant note" of an American exhibition of Sargent's work in which *Mrs. Hammersley* was shown. R[oyal] [C]ortissoz, "John S. Sargent: The Exhibition in Boston of His Portraits and Studies," *New York Tribune*, February 21, 1899, p. 6.

10. Letter from Kit Anstruther-Thomson to Vernon Lee, spring 1893, Vernon Lee Papers, Miller Library, Colby College, Waterville, Maine.

11. *The Times* (London), May 1, 1893, p. 10. The repaintings are recounted by Sargent's pupil Julie Heyneman in Evan Charteris, *John Sargent* (New York: Scribner's, 1927), 184–85.

12. Diary of Mrs. Watts for June 25, 1893, quoted in *Complete Paintings* 2:63.

13. Moore, "A Portrait," 252.

14. Ibid., 253.

15. *Sunday Times*, January 14, 1894, p. 8.

16. Memorandum by Mrs. Hammersley, March 30, 1893, quoted in *Complete Paintings* 2:61.

TRANSNATIONAL AND TRANSATLANTIC

1. Marc Simpson, *Uncanny Spectacle: The Public Career of the Young John Singer Sargent* (Williamstown, MA: Sterling and Francine Clark Art Institute, 1997), 47–48.

2. Harry Quilter, *The Spectator*, May 1, 1886; quoted in Anne L. Helmreich, "John Singer Sargent, *Carnation, Lily, Lily, Rose* and the Conditions of Modernism in England, 1887," *Victorian Studies* 45, no. 3 (Spring 2003): 436; Mariana van Rensselaer, "Spring Exhibitions and Picture Sales in New York: 1," *American Architect and Building News*, May 1, 1880, p. 190.

3. See Andrew Stephenson, "Locating Cosmopolitanism within a Trans-Atlantic Interpretative Frame: Critical Evaluation of Sargent's Portraits and Figure Studies in Britain and the United States c. 1886–1926," *Tate Papers* 27 (Spring 2017), www.tate.org.uk. See also Diane P. Fischer, ed., *Paris 1900: The "American School" at the Universal Exposition* (Montclair, NJ: Montclair Art Museum, 1999), 1–8, 23–25, 92–93.

4. Simpson, *Uncanny Spectacle*, 19, 54–55.

5. Letter from Manet to Morisot, March 1882, in *Correspondance de Berthe Morisot avec sa famille et ses amis: Manet, Puvis de Chavannes, Degas, Monet, Renoir et Mallarmé* (Paris: Quatre Chemins-Éditart, 1950), 102.

6. Letter from Sargent to Edwin Russell, 10 September 1885, Tate Archive, London.

7. Quoted in Gary A. Reynolds, "Sargent's Late Portraits," in *John Singer Sargent*, ed. Patricia Hills (New York: Whitney Museum of American Art, 1986), 151.

8. "Exhibition of the Royal Academy: Gallery I," *Art Journal* 48, no. 6 (June 1886): 187.

9. See Elizabeth Ann Coleman, *The Opulent Era: Fashions of Worth, Doucet and Pingat* (Brooklyn: Brooklyn Museum, 1989), 86–107.

10. See Véronique Pouillard, *Paris to New York: The Transatlantic Fashion Industry in the Twentieth Century* (Cambridge, MA: Harvard University Press, 2021), 16–17.

11. See Chantal Trubert-Tollu et al., eds., *The House of Worth 1854–1954: The Birth of Haute Couture* (London: Thames & Hudson, 2017), 75, 79.

12. See Valerie Steele, "Painted Beauty: Portraits, Fashion, and Cosmetics in the Gilded Age," in *Beauty's Legacy: Gilded Age Portraits in America*, ed. Barbara Dayer Gallati (New York: New York Historical Society, 2013), 88.

13. "The Royal Academy II," *Saturday Review*, May 16, 1887, p. 685.

14. R. A. M. Stevenson, "J. S. Sargent," *Art Journal* 50 (March 1888): 69.

15. Claude Phillips, "Fine Art: The Royal Academy III," *Academy*, May 28, 1887, p. 383.

16. "The Royal Academy IV," *Saturday Review*, June 4, 1887, p. 800.

17. M. G. van Rensselaer, "Spring Exhibitions and Picture-Sales in New York — I," *American Architect and Building News*, May 1, 1880, 190.

18. "The American Artists: Close of the Exhibition," *New York Times*, April 16, 1880, p. 8.

19. See John Ott, "How New York Stole the Luxury Art Market: Blockbuster Auctions and Bourgeois Identity in Gilded Age America," *Winterthur Portfolio* 42, no. 2–3 (Summer-Autumn 2008): 133–58.

20. See Agnès Penot, "The Perils and Perks of Trading Art Overseas: Goupil's New York Branch," *Nineteenth-Century Art Worldwide* 16, no. 1 (Spring 2017): 1–23, and Musée Goupil, *Gérôme & Goupil: Art and Enterprise* (Paris: Éditions de la Réunion des Musées Nationaux, 2000), 34–43, 11–13.

21. See Jennifer A. Thompson, "Durand-Ruel and America," in *Inventing Impressionism: Durand-Ruel and the Modern Art Market*, ed. Sylvie Patry (London: National Gallery, 2015), 134–51.

22. See Charlotte Vignon, *Duveen Brothers and the Market for Decorative Arts, 1880–1940* (New York: Frick Collection, 2019), 36–40.

23. Other dealers included the Scottish art furnishings dealer Daniel Cottier, who had a showroom in London from 1869 and opened branches in Sydney, Melbourne, and New York from 1873. The London dealer Arthur Tooth and Son also established a New York branch (1900–1924), as did the Paris firm operated by Ernest Gimpel and Nathan Wildenstein (1903–7). Among American dealers who exclusively represented American artists were William Macbeth, who opened his first New York gallery in 1892, and Robert C. Vose's Westminster Gallery, established in 1897 in Boston and Fall River, Mass.

24. "There is no business of any kind in London"; David Croal Thomson to James McNeill Whistler, September 12, 1892, quoted in Patricia de Montfort, "Negotiating a Reputation: J. M. Whistler, D. G. Rossetti and the Art Market 1860–1900," in *The Rise of the Modern Art Market in London, 1850–1939*, ed. Pamela Fletcher and Anne Helmreich (Manchester: Manchester University Press, 2011), 265.

25. David Croal Thomson to James McNeill Whistler, March 21, 1893, ibid., 265.

26. Many American portrait specialists were expatriates like Sargent; among resident artists were William Merritt Chase, Benjamin Curtis Porter, and George C. Munzig. Carolus-Duran and Giovanni Boldini came to the United States in 1898, and by 1904, "New York studios were teaming with foreign portrait painters." See Gallati, "Gilded Age Portraiture: Cultural Capital Personified," in *Beauty's Legacy*, 42–46; 46.

27. *Boston Evening Transcript*, November 22, 1887, quoted in Trevor J. Fairbrother, "Notes on John Singer Sargent in New York, 1888–1890," *Archives of American Art Journal* 22, no. 4 (1982): 29.

28. Sargent to Henry G. Marquand, March 18 (no year), quoted in Trevor J. Fairbrother, *John Singer Sargent and America* (New York: Garland, 1986), 90–91.

29. Greta, "Art in Boston: The Sargent Portrait Exhibition," *The Art Amateur* 18 (April 1888): 110.

30. *Boston Evening Transcript*, January 30, 1888, quoted in Stanley Olson, Warren Adelson, and Richard Ormond, *Sargent at Broadway: The Impressionist Years* (New York: Coe Kerr Gallery, 1986), 41.

31. Erica E. Hirshler, "'A Prince in a Royal Line of Painters': Sargent's Portraits and Posterity," in *Great Expectations: John Singer Sargent Painting Children*, ed. Barbara Dayer Gallati (Brooklyn: Brooklyn Museum, 2004), 164–65.

32. Although Sargent did not sign the formal contract for the Boston Library mural decorations until January 18, 1893, discussions had begun in 1888–89, with support for his appointment from the artists Augustus Saint-Gaudens and Edwin Austin Abbey, the library's chief architect, Charles Follen McKim, and his partner, Stanford White. See Sally M. Promey, *Painting Religion in Public: John Singer Sargent's "Triumph of Religion" at the Boston Public Library* (Princeton N.J.: Princeton University Press, 1999), 12.

33. Sargent's "cracking success" came in 1893 when he exhibited *Mrs. Hugh Hammersley* (1892) and *Mrs. George Lewis* (1892) at the New Gallery, and *Lady Agnew of Lochnaw* (1892) at the Royal Academy to widespread critical acclaim. Elected an associate member of the RA in January 1894 and full member in 1897, by June 1898 Sargent was commanding over one thousand guineas per portrait and had a long waiting list of commissions.

34. See Emily Moore, "John Singer Sargent's British and American Sitters, 1890–1910: Interpreting Cultural Identity within Society Portraits," PhD diss., University of York, 2016.

35. The mother's jacket has been identified as an embroidered Spanish-style bolero or waistcoat; see *Complete Paintings* 2:37. Pamela Parmal has argued that the elaborate embroidery seen on the waistcoat and cuffs is more suggestive of an embroidered eighteenth-century man's vest and part of an eighteenth-century style revival emerging in fashion at this time. Email to author dated October 4, 2021.

36. *New York Evening Times*, July 31, 1893.

37. As Sargent told the Countess of Warwick, "I must have a type to paint. . . . I cannot do a face simply because it belongs to someone who has money to spend"; Frances, Countess of Warwick, *Afterthoughts* (1931), quoted in *Complete Paintings* 2:83n3.

38. By 1915 there were 42 princesses, 17 duchesses, 33 viscountesses, 33 marchionesses, 46 lady wives of knights and baronets, and 136 countesses of American descent. A quarterly entitled *Titled Americans: A List of American Ladies Who Have Married Foreigners of Rank*, compiled by Phillip Frederick Cunliffe-Owen and published in New York from 1890, recorded recent marriages and listed prospective husbands with their age, family seat and estates, and income. See Anne de Courcy, *The Husband Hunters: The American Heiresses Who Married into the British Aristocracy* (New York: Macmillan, 2018).

39. Roger Fry, "Fine Arts: The Royal Academy," *Athenaeum*, May 10, 1902, p. 600.

40. Anna Reynolds, "John Singer Sargent Painting Fashion," *Metropolitan Museum Journal* 54 (2019): 106–24.

41. See Clive Aslet, *An Exuberant Catalogue of Dreams: The Americans Who Revived the Country House in Britain* (London: Aurum Press, 2013), 44–57.

42. The painting, now in the Rothschild Collection at Waddesdon (National Trust), was exhibited at the Grosvenor Gallery in 1885. Sargent also exhibited there in that year.

43. In Pauline Astor's case, her admirer was the Eton-educated and Sandhurst-trained officer Prince Alexander of Teck.

44. "The New Gallery Summer Exhibition," *Art Journal* 38 (1899): 187. See also Andrew Stephenson, "Wonderful Pieces of Stage Management: Reviewing Masculine Fashioning, Race and Imperialism in John Singer Sargent's British Portraits, c. 1897–1914," in *Transculturation in British Art 1770–1930*, ed. Julie Codell (Farnham: Ashgate, 2012), 221–41.

45. "Philadelphia Art Exhibition," *Brush and Pencil* 7 (February 1901): 264.

46. *Complete Paintings* 3:128–30.

47. This criticism was repeated at the time of its acquisition by the MFA in 2003. See Christine Temin, "Perspective," *Boston Globe*, July 2, 2003, p. 82. I am indebted to Erica Hirshler for this source.

48. David Cannadine, *The Decline and Fall of the British Aristocracy* (New Haven: Yale University Press, 1990, rept. New York: Vintage, 1999), 90–91.

49. Rockefeller's son, who commissioned the portrait from Sargent, also expressed concern about the informality of the portrait and its suitability for an institutional setting. John D. Rockefeller Jr. to Sargent, March 13, 1917; quoted in *Complete Paintings* 3:237.

50. "The Royal Academy," *Saturday Review*, May 17, 1919, p. 474.

51. Even Wilson's wife found the finished picture "lacking in virility"; Edith Wilson, *Memoirs of Mrs. Woodrow Wilson* (1939), quoted in *Complete Paintings* 3:245.

52. See Gail Stavitsky, "The Legacy of the 'American School': 1901–1938," in Fischer, *Paris 1900*, 187–89.

PORTRAITS AS PERFORMANCE

I am grateful to Kathleen Adler, Caroline Corbeau-Parsons, David Park Curry, and Pam Parmal for their helpful comments, and to Katherine Fein, Roma Patel, Joseph Semkiu, Francesca Soriano, Allison Taylor, and Astrid Tvetenstrand for research assistance.

1. Edith Wharton, "The Pot-Boiler," *Scribner's Monthly* 36 (Dec. 1904): 699 (I have amended the antisemitic dialect Wharton used for her character of the Jewish art dealer Shepson). For earlier explorations of this essay's themes, see Hirshler, "John Singer Sargent et le Dandy," in *Figures du Dandy: De Van Dyck à Oscar Wilde*, ed. Christophe Leribault (Paris: Paris Tableau, 2016), 63–73; and "Sargent and Theatricality," in *John Singer Sargent*, ed. Per Hedström (Stockholm: Nationalmuseum, 2018), 167–83. For an early and detailed study, see Leigh Culver, "Performing Identities in the Art of John Singer Sargent," PhD diss., University of Pennsylvania, 1999.

2. Joseph Pulitzer, quoted in Don C. Seitz, *Joseph Pulitzer: His Life and Letters* (New York: Simon and Schuster, 1924), 11; the portrait remains in a private collection. Edith Wharton, "The Portrait," in *The Greater Inclination* (New York: Scribner's, 1899), 231. See also Barry Maine, "'The Portrait': Edith Wharton and John Singer Sargent," *Edith Wharton Review* 18, no. 1 (Spring 2002): 7–14, and Michael Pantazzi, "A Face of One's Own: Edith Wharton and the Portrait in Her Short Fiction," *Journal of the Short Story in English* 58 (Spring 2012): 201–14.

3. Roland Barthes, speaking of being photographed, articulated this sensation: "Once I feel myself observed by the lens, everything changes. I constitute myself in the process of 'posing,' I instantaneously make another body for myself, I transform myself in advance into an image. . . . I am neither subject nor object but a subject who feels he is becoming an object." Roland Barthes, *Camera Lucida* (New York: Macmillan, 1981), 10, 14.

4. Writing about naturalism in nineteenth-century French theater, Martin Esslin observes that "art, unlike experimental science, deals with a reality which includes the *emotional* reaction of the observer." "Naturalism in Context," *The Drama Review* 13, no. 2 (Winter 1968): 72.

5. Léon Gozlan, "Ce que c'est qu'une Parisienne," *Les Maitresses de Paris* (Paris: Michel Lévy Frères, 1858), 2; Arsène Houssaye, *Les Parisiennes IV: Les femmes déchues* (Paris: E. Dentu, 1869), 273. For the shift in attitude about foreign-born Parisiennes, see Justine De Young, "Women in Black: Fashion, Modernity, and Modernism in Paris, 1860–1890," PhD diss., Northwestern University, 2009, 310–23.

6. For Pailleron's plays, see Neil Carruthers, "Les Gaîtés de la Jeune Marianne: French Comic Theatre 1870–1900," PhD diss., University of Canterbury, 1986, 135–59. Pailleron's next production, *L'étincelle* (The Spark), which appeared at the Comédie-Française in May 1879, featured the actress Sophie Croizette, Carolus-Duran's sister-in-law and his model for an important 1873 equestrian portrait.

7. Marie-Louise Pailleron, *Le paradis perdu* (Paris: Albin Michel, 1947), 154; Jules Claretie, "Nos gravures: Édouard Pailleron," *L'Illustration*, Dec. 9, 1882, p. 392. A Beaucé portrait meeting that description was on the art market in Paris in 1995 under the title *Caïd aux bottes rouges* (Chief with Red Boots); it is inscribed "à mon ami Edouard."

8. Pailleron, *Paradis perdu*, 155.

9. Philippe de Chennevières, "Le Salon de 1880," *Gazette des Beaux-Arts* 22, no. 1 (July 1880): 62; Martha Bertha Wright, "American Pictures at Paris and London," *Art Amateur* 3, no. 2 (July 1880): 26.

10. Ramón Subercaseaux, *Memorias de ochenta años*, 1 (Santiago, Chile: Editorial Nascimento, 1936), 388; I am grateful to Layla Bermeo for her translation from Subercaseaux's text. Amalia Subercaseaux, diary extracts, typed transcript quoted in *Complete Paintings* 1:57. See also Julie Pierotti, *The Real Beauty: The Artistic World of Eugenia Errázuriz* (Memphis: Dixon Gallery and Gardens, 2018), 12–19.

11. Subercaseaux, *Memorias*, 388; Louis de Fourcaud, "Salon du Gaulois: Portraits," *Le Gaulois*, June 11, 1881, p. 2.

12. See De Young, *Women in Black*, 311–23.

13. Subercaseaux, *Memorias*, 388; "Courrier de Paris," *L'Illustration*, June 18, 1881, p. 412. The editorial in *L'Illustration* is connected most often with Sargent's *Madame X*, as Gautreau is also mentioned, but the writer would have been responding to Sargent's medal at the 1881 Salon.

14. Judith Gautier, "Le Salon," *Le Rappel*, May 1, 1884, p. 1. See Elizabeth L. Block, "Virginie Amélie Avegno Gautreau: Living Statue," *Nineteenth-Century Art Worldwide* 17, no. 2 (Autumn 2018), www.19thc-artworldwide.org.

15. Sargent to Henry James, June 29, 1885, Houghton Library, Harvard University, bMS Am 1094 (396). Caroline Corbeau-Parsons noted the similarity of Pozzi's red robes to those of the medical profession; the unidentified student is quoted in Caroline de Costa and Francesca Miller, *The Diva and Doctor God: Letters from Sarah Bernhardt to Doctor Samuel Pozzi* (Bloomington, IN: Xlibris, 2010), 119.

16. David's portrait, in the collection of the Musée Fabre since 1829, was shown in Paris at the 1878 Universal Exposition. The painting was also described in 1880: "il est vêtu d'une robe de chambre de soie rouge . . . cette vêtement, entre-ouvert, laisse apercevoir la cravate et la chemise blanche" (he wears a red silk dressing gown . . . this garment, half-open, reveals the tie and the white shirt); J. L. Jules David, *Le peintre Jules David: Souvenirs et documents inédits* (Paris, 1880), 635.

17. Léon Lequime, "Première exposition de la Société des XX," *Le Journal de Bruxelles*, Feb. 14, 1884, p. 2; Ralph Curtis to his parents, cited in Evan Charteris, *John Sargent* (New York: Scribner, 1927), 61–62; Louis de Fourcaud, "Le Salon de 1884: Deuxième article," *Gazette des Beaux-Arts* 29, no. 6 (June 1884): 482–84, as translated in Albert Boime, "Sargent in Paris and London," in Patricia Hills et al., *John Singer Sargent* (New York: Whitney Museum of American Art, 1986), 91. For Madame Gautreau's maquillage, see Susan Sidlauskas, "Painting Skin: John Singer Sargent's 'Madame X,'" *American Art* 15, no. 3 (Autumn 2001): 8–33.

18. See Thomas Eakins's *The Concert Singer* (1890–92, Philadelphia Museum of Art), which depicts the same pose. Mrs. Gardner was rumored to have had a romantic attachment to Francis Marion Crawford, and certain Bostonians are said to have remarked that Sargent had shown Gardner's décolleté "all the way down to Crawford's Notch" (a punning reference to a popular tourist site in New Hampshire). See Louise Tharp, *Mrs. Jack* (Boston: Little, Brown, 1965), 134–35.

19. Greta, "The Art Season in Boston," *The Art Amateur* 19, no. 1 (June 1888): 4; Sargent to Isabella Stewart Gardner, January/February [1888]. Isabella Stewart Gardner Museum Archives, Boston, MA; Paul Bourget, *Outre-mer: Impressions of America* (London: T. Fisher Unwin, 1895), 108, 109.

20. See Richard Ormond, Elaine Kilmurray, et al., *Sargent: Portraits of Artists and Friends* (New York: Skira Rizzoli, 2015).

21. Alice Meynell, *The Work of John S. Sargent, R.A.* (London: Heinemann, 1903),

154. Four highly trained young Indonesian women — Seriem, Taminah, Soekia, and Wakiem — created a sensation at the 1889 world's fair with traditional dances, fascinating Sargent and many fellow artists. It has not yet been possible to ascertain precisely which dancer posed for this painting. The women were among hundreds of people from colonized countries who were on display at the fair in simulated "native villages." Dutch-ruled Indonesia sent sixty Javanese craftsmen, musicians, and dancers. See also Leanne Langley, "Art Music: John Singer Sargent as Listener, Practitioner, Performer, and Patron," *Visual Culture in Britain* 19, no.1 (2018): 112–31.

22. Lady Wilson, "Preface," in Thomas Lister, Baron Ribblesdale, *Impressions and Memories* (London, 1927), xxviii, ix; "The Pick of the Pictures," *Punch*, May 7, 1902, p.341; Wilson, "Preface," xvii. The English aristocratic traveler ("milord anglais"), particularly one undertaking the eighteenth-century Grand Tour, was a frequent target of satire in France and elsewhere; see, for example, George Salas, "English Milords," in Charles Dickens's weekly journal *Household Words*, May 21, 1853, pp.270–73.

23. The Suez Canal outfit also included a red underskirt with Egyptian designs and a gold key at the waist, along with an Egyptian headdress; see Aldern Holt, *Fancy Dresses Described; or, What to Wear at Fancy Balls* (London: Debenham and Freebody, 1887), 4. The "Electric Light" dress survives in the collection of the Museum of the City of New York. See also Rebecca N. Mitchell, "The Victorian Fancy Dress Ball, 1870-1900," *Fashion Theory* 21, no. 3 (2017): 291–315, and Elizabeth L. Block, *Dressing Up: The Women Who Influenced French Fashion* (Cambridge, MA: MIT Press, 2021), 143–85.

24. Sargent to Sybil Sassoon, [about 1912], private collection.

25. For the dress, see Charles Merrill Mount, *John Singer Sargent: A Biography* (London: Cresset Press, 1957), 384.

26. *Guardian*, May 3, 1905, p.737; "The Royal Academy — I," *Graphic*, April 29, 1905, p.494; Egan Mew, "Fair Women at the Grafton," *The Bystander*, July 13, 1910, p.76.

27. At the time Sargent painted their portraits, the Stevensons were working on the manuscript that became *Dr. Jekyll and Mr. Hyde*. Louis mentioned his costume in a letter to the painter Will H. Low, Oct. 22, 1885, and Fanny described hers in a letter to her friend Dora N. Williams, August/September 1885; Sargent remarked on his painting to Stevenson, November 1885; all three letters as excerpted in *Complete Paintings* 1:167–68; "At Home with Emile Zola," *New York Times*, April 19, 1885, p.6.

28. Jane de Glehn to her mother, Aug. 13, 1907; Emmet Family Papers, 1792–1989, Archives of American Art, Smithsonian Institution, Washington, DC, box 4, folder 54.

29. A traditional form, the shape of the entari was adapted somewhat during the nineteenth-century Ottoman Empire in response to Western styles. Some urban Turkish women, seeking to signal their modernity, gave it up entirely in favor of European clothing. See Fatma Coç and Emine Koca, "The Clothing Culture of the Turks, and the Entari (Part Two: The Entari)," *Folk Life: Journal of Ethnological Studies* 50, no. 2 (Oct. 2012): 141–68; and Charlotte A. Jirousek, *Ottoman Dress and Design in the West: A Visual History of Cultural Exchange* (Bloomington: Indiana University Press, 2019).

30. See Kathleen Adler, "John Singer Sargent's Portraits of the Wertheimer Family," in *John Singer Sargent: Portraits of the Wertheimer Family*, ed. Norman L. Kleeblatt (New York: Jewish Museum, 1999), 21–33; Linda Nochlin and Tamar Garb, eds., *The Jew in the Text: Modernity and the Construction of Identity* (London: Thames & Hudson, 1995); Mew, "Fair Women at the Grafton."

31. The shawls did not simply fall out of fashion: their production and trade were also affected by imperialist political policies in South Asia. See Michelle Maskiell, "Shawls and Empires, 1500–2000," *Journal of World History* 13, no.1 (Spring 2002): 27–65.

32. Laurence Housman, "The Royal Academy," *Manchester Guardian*, May 1, 1909, p.8.

33. Edwin H. Blashfield, "John Singer Sargent: Recollections," *The North American Review* 221 (June–Aug. 1925): 646, 647.

ELLEN TERRY AS LADY MACBETH

1. *Toronto Daily Mail*, January 3, 1889, p.8. See *Complete Paintings* 1: 189.

2. *Dundee Evening Telegraph*, January 19, 1889.

3. Sargent, letter to Isabella Stewart Gardner, quoted in *Complete Paintings* 1: 188.

4. See Alice Vansittart Strettel Carr, *Mrs J. Comyns Carr's Reminiscences* (London: Hutchinson & Company, 1926), 353, where she reports that a guest "wore a dress at supper one evening which gave me the idea for the Lady Macbeth dress, afterwards painted by Sargent. The bodice of Lady Randolph's gown was trimmed all over with green beetles' wings." *The Daily News* reported that

Ellen Terry's dresses "are the perfection of good taste and beauty, costly enough for a queen and yet graceful and charming enough to satisfy the most critical artist. I believe they were chiefly designed by herself and Mrs Comyns-Carr, whose taste is undoubted. The stuffs were provided in great measure by Helbronner, and are consequently rich and beautiful." *The Daily News*, May 23, 1889, p. 3.

5. See Veronica Tetley Isaac, "Dressing the Part: Ellen Terry (1847–1928): Towards a Methodology for Analysing Historic Theatre Costume" (PhD diss., University of Brighton, 2016), 411n122.

6. *Pall Mall Gazette*, January 11, 1889, p. 1.

7. Carr, *Reminiscences*, 211–12.

8. This surface was understood to be sunken varnish, and then an unvarnished surface. Technical examination at Tate by Senior Conservation Scientist Joyce H. Towsend and Senior Paintings Conservator Rebecca Hellen has clarified the state of this original surface, which has never undergone varnish removal, thus presenting unique evidence of Sargent's finishing of his painting.

9. See Rebecca Hellen and Joyce H. Townsend, "'The Way in Which He Does It': The Making of Sargent's Oils," in *Complete Paintings* 9: 37–39.

10. Ellen Terry, *The Story of My Life* (London, 1908), 305–6.

11. Quoted ibid.

12. Megilp was a commercial medium modifier of linseed oil and mastic varnish that added body or bulk, as well as glossier translucent glazes when brushed out. See Joyce H. Townsend et al., "Nineteenth Century Paint Media Part I: The Formulation of Megilps," in *Painting Techniques: History, Materials and Studio Practice*, ed. Ashok Roy and Perry Smith (London: International Institute for Conservation of Historic & Artistic Works, 1998), 205–10.

13. See Tate Archive, Scientific Report, No2065, *Ellen Terry as Lady Macbeth*, JS Sargent, Rebecca Hellen and Joyce H. Townsend.

14. See Lin Karin Kjernsmo et al., "Iridescence as Camouflage," *Current Biology* 30, no. 3 (February 2020): 551–55, www.sciencedirect.com.

15. "Ellen Terry," in Virginia Woolf, *Complete Collected Essays*, vol. 4 (London: The Hogarth Press, 1967), 67.

THE FASHION IN OLD MASTERS

I would like to thank Charlotte Gere, Charles Martindale, Cordula van Wyhe, and my doctoral students, who have taught me to see Sargent afresh: Liz Renes, Emily Moore, and Anna Bonewitz.

1. Rebecca West, *1900* (London: Viking Press, 1982), 111.

2. See Jonathan Spicer, "The Renaissance Elbow," in *A Cultural History of Gesture from Antiquity to the Present Day*, ed. Jan Bremmer and Herman Roodenburg (Oxford: Polity Press, 1991), 84–128.

3. The version shown here was painted for the sitter himself, after the original full-length portrait commissioned by the Straits Association for the colony of Malaya. For this version, details of the uniform were brought up to date with the latest regulations. See *Complete Paintings* 3:131–33.

4. "Studio Accessories," in *Complete Paintings* 3:xxix.

5. See for example Francis Haskell, *Rediscoveries in Art: Some Aspects of Taste, Fashion and Collecting in England and France* (Oxford: Phaidon, 1976); Elizabeth Prettejohn, *Modern Painters, Old Masters: The Art of Imitation from the Pre-Raphaelites to the First World War* (New Haven: Yale University Press, 2017).

6. Letters to Ben del Castillo (May 23, 1869) and Mrs. Austin, Sargent's cousin (March 2, 1874), reprinted in Evan Charteris, *John Sargent* (London: Heinemann, 1927), 12, 18. See also Stephanie L. Herdrich, "John Singer Sargent and Italian Renaissance Art" in *Sargent and Italy*, ed. Bruce Robertson (Princeton: Princeton University Press, 2003), 98–115.

7. This precept is attributed to Carolus-Duran in Charteris, *John Sargent*, 28.

8. See Gary Tinterow and Geneviève Lacambre, *Manet/Velázquez: The French Taste for Spanish Painting* (New York: Metropolitan Museum of Art, 2003).

9. According to the critic Mariana Griswold van Rensselaer, the dress was one the little girl "was in the habit of wearing" (quoted in *Complete Paintings* 2:25). If so, it may have been a fancy dress based on a historical costume. I am indebted to Lauren Whitley and Pamela Parmal for this observation.

10. Letter to Miss Heyneman, quoted in Charteris, *John Sargent*, 51.

11. Letter from Vernon Lee to her family (June 1884), cited in Richard Ormond, "John Singer Sargent and Vernon Lee," *Colby Library Quarterly* 9, no. 3 (September 1970): 175.

12. As Sargent's artist-friend (and distant cousin) Ralph Curtis remarked in a letter of 1884 to his parents: "He goes to Eng. in 3 weeks. I fear là bas he will fall into Pre-R. influence wh. has got a strange hold of him *since Siena*" (quoted in Charteris, *John Sargent*, 62; italics in original); the wording implies a link between the early Italian and the nineteenth-century English Pre-Raphaelites. Sargent

owned works by Dante Gabriel Rossetti and Ford Madox Brown.

13. See Aileen Ribeiro, "Some Evidence of the Influence of the Dress of the Seventeenth Century on Costume in Eighteenth-Century Female Portraiture," *Burlington Magazine* 119, no. 897 (December 1977): 834–40.

14. See John Collier, *The Art of Portrait Painting* (London: Cassell, 1910), 50–52.

15. My interpretation is much indebted to the subtle and perceptive account of Henry James, "The Guildhall and the Royal Academy," *Harper's Weekly* (June 5, 1897), reprinted in Henry James, *The Painter's Eye: Notes and Essays on the Pictorial Arts*, ed. John L. Sweeney (Madison: University of Wisconsin Press, 1989), 256–67.

16. *Complete Paintings* 2:107–9.

17. For example, Gerald Festus Kelly's portrait of Mrs. Horace Elgin Dodge, with its sumptuous, and historically accurate, depiction of the dress; see Bruce Redford, *John Singer Sargent and the Art of Allusion* (New Haven: Yale University Press, 2016), 106–7.

18. Metropolitan Museum of Art, New York, 49.3.26a,b. I am indebted to Anna Reynolds for this comparison.

19. *The Times* (London), May 1, 1897, p. 16.

20. I am indebted to my doctoral student Anna Merrick Bonewitz for this point. On the conjunction of events see Chris Breward, "1897: Fancy Dressing," in *The Royal Academy Summer Exhibition: A Chronicle, 1769–2018*, ed. Mark Hallett, Sarah Victoria Turner, and Jessica Feather (London: Paul Mellon Centre for Studies in British Art, 2018), https://chronicle250.com/.

21. Elaine Kilmurray, "Portraits 1894–9," in *Complete Paintings* 2:81.

ALMINA WERTHEIMER

1. Evan Charteris, *John Singer Sargent* (New York: Scribner's, 1927), 164.

2. Unlike the majority of the portraits, it was hung not in the dining room of the family's Mayfair townhouse at 8 Connaught Place, but in the morning-room.

3. *Complete Paintings* 3:204.

4. Ingres had read the letters of Lady Montagu, who witnessed life in a harem, an account that did much to shape such fantasies.

5. See Linda Nochlin, "The Imaginary Orient," in *The Politics of Vision: Essays on Nineteenth-Century Art and Society* (New York: Harper & Row, 1989), 33–59; and Antonio Baldassarre, "Being Engaged, Not Informed: French 'Orientalists' Revisited," *Music in Art* 38, nos. 1–2 (2013): 63–87, esp. 74–77.

6. Antonio Baldassarre has argued that the inclusion of a lute-like instrument in Orientalist paintings is in fact a revisit of Western traditions; "Being Engaged," 80–81.

7. Archives of American Art, Smithsonian Institution, Washington, DC, quoted in *Complete Paintings* 3:202. Sargent's collection of Turkish garments does not survive.

8. See Kathleen Adler, "John Singer Sargent's Portraits of the Wertheimer Family," in *John Singer Sargent: Portraits of the Wertheimer Family*, ed. Norman L. Kleeblatt (New York: Jewish Museum, 1999), 21–33. Adler applies Carol Ockman's theory of Ingres's ethnic stereotyping in his portrait *Baronne de Rothschild* (1848) to Almina's portrait.

9. The Wertheimers and probably Sargent himself were dissatisfied with the first portrait of the group, that of Flora Wertheimer, and he painted a second six years later as a result. That ten more portraits ensued is a sign of the Wertheimers' satisfaction with Sargent's approach from that point onward.

10. See David Mannings, *Sir Joshua Reynolds: A Complete Catalogue of His Paintings* (New Haven: Yale University Press, 2000), cat. 1958, p. 488.

11. Rebecca Bouverie, Viscountess Folkestone, also sports the coat in her three-quarter-length portrait by Reynolds (ibid., cat. 225, p. 100). She closely resembles Mrs. Charles Yorke, and wears a very similar dress and pearls in her hair.

12. Roger E. Fry, "The Stolen Portraits," *Burlington Magazine for Connoisseurs* 10, no. 48 (March 1907): 375–79; 375.

SPORTING WITH GENDER

1. Vernon Lee to her mother, June 25 [1885], *Vernon Lee Letters* (London: privately printed, 1937), 171. The work that spurred Lee's remark was Sargent's principal contribution to the Salon of 1885, the double portrait *Mrs. Edward Burckhardt and Her Daughter Louise*. This painting combined fashionable gowns with awkward poses that suggested psychological complexity, yielding "une sorte de parfum exotique qui grise les passants" (a kind of exotic perfume that befuddles passers-by), as one critic put it; Alfred de Lostalot, "Salon de 1886," *Gazette des Beaux-Arts* 33 (June 1886): 460.

2. For *crispation des nerfs*, see, for example, Jean-Baptiste Pressavin, *Nouveau traité des vapeurs, ou Traité des maladies des nerfs* (Lyon, 1771), 189.

3. Many Sargent scholars now acknowledge that Sargent was what we would now call "queer"— a person engaging in unconventional modes of gender and sexuality. Still, Sargent's complexities, as manifested in his life and work, have often been sidelined. For a fuller exploration of Sargent's sexual complications and their impact on his art, see Paul Fisher, *The Grand Affair: John Singer Sargent in His World* (New York: Farrar, Straus & Giroux, 2022).

4. Maurice Barrès, "Complications d'amour," preface to Rachilde, *Monsieur Venus* (Paris: Félix Brossier, 1889), n.p.

5. See Dorothy Moss, "John Singer Sargent, 'Madame X' and 'Baby Millbank,'" *Burlington Magazine* 143, no. 1178 (May 2001): 268; Elaine Showalter, "Syphilis, Sexuality, and the Fiction of the Fin de Siècle," in *Sex, Politics, and Science in the Nineteenth-Century Novel*, ed. Ruth Bernard Yeazell (Baltimore: Johns Hopkins University Press, 1986), 88–115.

6. Tamar Garb, *Bodies of Modernity: Figure and Flesh in Fin-de-Siècle France* (London: Thames & Hudson, 1998), 12.

7. Henry James, "John S. Sargent," in *The Painter's Eye: Notes and Essays on the Pictorial Arts by Henry James* (London: Rupert Hart-Davis, 1956), 218.

8. The two portraits are Sargent's *Hylda, Daughter of Asher and Mrs. Wertheimer* (1901, Tate Britain, London) and *Hylda, Almina and Conway, Children of Asher Wertheimer*, in which he depicts Hylda wearing a pince-nez (see **70**). "I had great difficulty in persuading him to paint me wearing my pince-nez," Hylda later recollected. "He tried hard to induce me to take them off, but I should have felt uncomfortable without them"; quoted in *Exhibition of Works by John Singer Sargent R.A., 1856–1925* (Birmingham, England: City of Birmingham Museum and Art Gallery, 1964), 18.

9. Vernon Lee to her mother, June 25 [1881], *Vernon Lee Letters*, 65.

10. See Peter Gunn, *Vernon Lee: Violet Paget, 1856–1934* (London: Oxford University Press, 1964), 90.

11. Quoted in Vineta Colby, *Vernon Lee: A Literary Biography* (Charlottesville: University of Virginia Press, 2003), 181.

12. Unsigned review, *Magazine of Art* (1890), p. 258.

13. Clementina Anstruther-Thomson to Vernon Lee, undated; Vernon Lee Papers, Miller Library, Colby College, Waterville, ME.

14. See Kathleen Adler, "Sargent's Portraits of the Wertheimer Family," in *The Jew in the Text: Modernity and the Construction of Identity*, ed. Linda Nochlin and Tamar Garb (New York: Thames & Hudson, 1996), 91.

15. Vernon Lee to her mother, June 25 [1885], *Vernon Lee Letters*, 171.

16. Henry Adams to Elizabeth Cameron, March 29, 1903, *The Letters of Henry Adams,* ed. J. C. Levenson, Ernest Samuels, Charles Vandersee, and Viola Hopkins Winner, vol. 5 (Cambridge, MA: Harvard University Press, 1988), 479.

17. See Jonathan Fryer, "Decadence and Dissent: Style and Sensibility among Wilde's Coterie," in *The Wild Years: Oscar Wilde and the Art of His Time*, ed. Tomoko Sato and Lionel Sambourne (London: Barbican Centre and Philip Wilson, 2000), 52–59; 55.

18. Andrew Stephenson has argued that the three-buttoned Chesterfield accentuates the "elongate quality" that characterized queer aesthete-dandies. In the 1890s overcoats delineated "gradations of status and sexuality" for bohemians and aesthetes, and this overcoat was seen by the contemporary critic Claude Phillips to project "nerve force, as distinguished from muscularity"; *Academy*, May 11, 1895, p. 407. See Andrew Stephenson, "'But the Coat Is the Picture: Issues of Masculine Fashioning, Politics, and Sexual Identity in Portraiture in England, c. 1890–1900," in *Fashion in European Art: Dress and Identity, Politics and the Body, 1775–1925*, ed. Justine De Young (London: Tauris, 2017), 178–206; 179–81.

19. W. Graham Robertson, *Life Was Worth Living: The Reminiscences of W. Graham Robertson* (New York: Harper, 1931), 235–37.

20. Ibid., 237–38.

21. One contemporary critic saw in Sargent's complex portrait "the ideal dandy of the present year of grace"—hinting at Sargent's perceived distance from this material as opposed to understanding his complicated relation to it; Agnes Farley Millar, *Independent*, July 9, 1896, p. 931.

22. Evan Charteris, *John Sargent* (New York: Scribner's, 1927), 154.

23. Stephenson describes dandies as "a conspicuous and very public homosexual stereotype" of the era. Stephenson, "But the Coat Is the Picture," 188.

24. Vernon Lee, "J.S.S., In Memoriam," in Charteris, *John Sargent*, 252.

25. For a discussion of nineteenth-century "romantic friendship" as it applies to Sargent, see Fisher, *The Grand Affair*, 177–80.

26. Albert de Belleroche, "The Lithographs of Sargent," *The Print Collector's Quarterly* 13 (Feb. 1926): 34. See also *Complete Paintings* 1:100.

27. Harold Nicholson, *Diaries and Letters*, 3 vols. (New York: Atheneum, 1966), vol. 1, p. 76.

28. Recent biographers of Sassoon have struggled to document his sexuality. See Peter Stansky, *Sassoon: The Worlds of Philip and Sibyl* (New Haven:

Yale University Press, 2003), 35; and Damian Collins, *Charmed Life: The Phenomenal World of Philip Sassoon* (London: Collins, 2016), 28–29. Still, most historians have reasonably assumed that Sassoon was queer, as did many of his contemporaries.

29. Charteris, *John Sargent*, 170.

30. George Henschel, *Musing and Memories of a Musician* (London: Macmillan, 1918), 331–32.

31. See Alan Chong, "Artistic Life in Venice," in *Gondola Days: Isabella Stewart Gardner and the Palazzo Barbaro Circle* (Boston: Isabella Stewart Gardner Museum, 2004), 110.

ENA WERTHEIMER: A VELE GONFIE

1. The hat is possibly a plumed Order of the Garter hat belonging to the Duke of Marlborough, then in Sargent's studio; see *Complete Paintings* 3:142. Kathleen Adler sees it as a cavalier's hat in her "John Singer Sargent's Portraits of the Wertheimer Family," in *John Singer Sargent: Portraits of the Wertheimer Family*, ed. Norman L. Kleeblatt (New York: The Jewish Museum, 1999), 28.

2. I am indebted to Pamela A. Parmal for the identification of the jacket as a ceremonial court coat.

3. This account of the appropriation of the Marlborough robes in Sargent's portrait is derived from the sitter's husband, Robert Mathias, quoted in *Complete Paintings* 3:142.

4. The portrait was exhibited at the Royal Academy Summer Exhibition in 1905, followed by the Pennsylvania Academy of the Fine Arts Annual Exhibition in Philadelphia (January–March 1906), the Akademie der Kunst in Berlin (1907–8), and at the International Society of Sculptors, Painters and Gravers' "Exhibition of Fair Women" at the Grafton Galleries, London (May–July 1910).

5. John Collier, *The Art of Portrait Painting* (London: Cassell, 1905), 75.

6. A. C. R. Carter, "The Royal Academy," *Art Journal* (1905): 166–67.

7. Kathleen Adler notes that this sense of the deviance of the "Jewess" from expected English middle-class norms of restrained behavior and propriety was incorporated into the antisemitic stereotype of Jewish women as "daring to the point of excess"; Adler, "John Singer Sargent's Portraits of the Wertheimer Family," 29. By contrast, dynamic locomotion and the sense of physical action caught momentarily were features of late nineteenth-century male portraiture, commended by avant-garde writers as a conspicuously modern reflection

of the accelerated pace of modern life and the thrill of its engagement. See Andrew Stephenson, "Precarious Poses: The Problem of Artistic Visibility and Its Homosocial Performances in Late Nineteenth-Century London," *Visual Culture in Britain* 8, no. 1 (2007): 83–95.

8. See Adler, "John Singer Sargent's Portraits of the Wertheimer Family," 27–28.

9. D. S. MacColl, "The Academy, II: The Rape of Painting," *Saturday Review*, May 18, 1901, p. 632; Marion Spielmann, "At the Royal Academy Exhibition, 1901, II: The Portraits," *Magazine of Art* 25 (May 1901): 388; G. K. Chesterton, "The Royal Academy," *Art Journal* (June 1908): 161.

10. 'The Royal Academy, I," *Graphic*, April 29, 1905, p. 494. The concept of style as bricolage is derived from Dick Hebdige, *Subculture and the Meaning of Style* (London: Methuen, 1979; rept., 1984), 102–4.

11. C. J. Holmes, "Notes on Some Recently Exhibited Pictures of the British School," *Burlington Magazine* 7 (April–September 1905): 324.

12. Quoted in Marjorie Garber, *Vested Interests: Cross-Dressing and Cultural Anxiety* (New York: Routledge, 1992), 160.

THE CULTURE OF DRESS

1. *Complete Paintings* 3:122.

2. Ancestry.com. New York, U.S., Arriving Passenger and Crew Lists (including Castle Garden and Ellis Island), 1820–1957 [database on-line]. Lehi, UT, USA: Ancestry.com Operations, Inc., 2010. Year: 1892; Arrival: New York, New York, USA; Microfilm Serial: M237, 1820–1897, line 19, page 23.

3. "Clearly black served for gender-coding." John Harvey, *Men in Black* (Chicago: University of Chicago Press, 1995), 23.

4. See Philippe Perrot, *Fashioning the Bourgeoisie: A History of Clothing in the Nineteenth Century* (Princeton: Princeton University Press, 1994), 30; and Claudia Brush Kidwell and Margaret C. Christman, *Suiting Everyone: The Democratization of Clothing in America* (Washington, DC: Smithsonian Institution Press, 1974).

5. The colophon of a surviving bill of 1854 advertises the fact that the couturiers worked for several courts. Invoice from Mmes Palmire Chartier & Legrand, Couturières en Robes, April 4, 1854; https://www.diktats.com.

6. Jean Philippe Worth, *A Century of Fashion* (Boston: Little, Brown, 1928), 12.

7. Chantal Trubert-Tollu et al., *The House of Worth 1858–1954* (London: Thames & Hudson, 2017), 24.

8. Elizabeth Ann Coleman, *The Opulent Era: Fashions of Worth, Pingat, and Doucet* (New York: Brooklyn Museum, 1989), 89.

9. Ibid., 177.

10. A 2003 gift to the MFA (2003.287.1-2–2002.292) included three Worth dresses and a jacket worn by Mrs. J. P. Morgan, Jr. One of the dresses (2003.288.1-2) was worn in Sargent's portrait of Mrs. Morgan, now in the collection of the Morgan Library in New York (AZ165).

11. Abigail Joseph, "'A Wizard of Silks and Tulle': Charles Worth and the Queer Origins of Couture," *Victorian Studies* 56, no. 2 (Winter 2014): 260.

12. Quoted in Marie Simon, *Fashion in Art: The Second Empire and Impressionism* (Paris: Éditions Hazan, 1995), 128.

FROM DRESS TO PAINT

1. See Kenyon Cox, "Sargent," *Old Masters and New: Essays in Art Criticism* (New York, 1905), 264.

2. Henry James, *The Painter's Eye: Notes and Essays on the Pictorial Arts*, ed. John L. Sweeney (London, 1956), 114. It is not certain whether Sargent visited this exhibition, nor is there agreement as to what degree Sargent might be considered an Impressionist. See *Complete Paintings* 1:xiii; Liz Renes, "The Velazquez Aesthetic: John Singer Sargent, Impressionism and Victorian Modernism," in *Beyond the Victorian/Modernist Divide*, ed. Anne-Florence Gillard-Estrada and Anne Besnault-Levita (New York: Routledge, 2018).

3. Ernest Iselin to William Campbell, February 22, 1965; National Gallery of Art Archives, Washington, DC.

4. Frederick Sweet, ed., *Sargent, Whistler, and Mary Cassatt* (Chicago: Art Institute of Chicago, 1954), 57.

5. "Théophile Gautier, *On Fashion*," trans. Richard George Elliott, *Art in Translation* 7, no. 2 (2015): 208. Of male subjects in single-figure portraits, 149 of 237 wear dark suits.

6. Black dresses are worn in 52 out of 109 single-figure portraits of female subjects painted during the 1880s.

7. Of 290 single-figure portraits showing women in fashionable dress.

8. David McKibbin, *Sargent's Boston* (Boston: Museum of Fine Arts, 1956), 33.

9. For another example, see a dinner dress by the House of Worth (1880–90), Metropolitan Museum of Art, New York, 2009.300.2994a, b.

10. *Art Amateur*, April 1888, p. 110; *The Times* (London), May 16, 1888.

11. Edwin Blashfield, "John Singer Sargent — Recollections," *The North American Review* 221 (Jun.-Aug. 1925): 648.

12. *The Times* (London), May 16, 1888.

13. Janet Arnold, "The Cut and Construction of Women's Dresses c. 1860–1890," *Costume* 2 (1968): 29.

14. Quoted in *Complete Paintings* 3:189.

15. "Fine Arts: The Royal Academy (First Notice)," *Athenaeum*, May 4, 1907, p. 547.

16. Charles Merrill Mount, *John Singer Sargent: A Biography* (London: Cresset Press, 1957), 241–43.

17. Peter Widener, *Without Drums* (New York: Putnam, 1940), 67–68.

18. Evan Charteris, *John Sargent* (London: Heinemann, 1927), 188.

19. Quoted in *Complete Paintings* 3:47.

20. Quoted in Lance Mayer and Gay Myers, *American Painters on Technique 1860–1945* (Los Angeles: J. Paul Getty Museum, 2013), 177.

21. Henry James, "John S Sargent," *Harper's New Monthly Magazine* 75 (Oct. 1887): 685.

SARAH CHOATE SEARS AND HER WARDROBE

1. *Boston Evening Transcript*, June 2, 1905, p. 5. For an overview of Sears's involvement in the arts, see Erica E. Hirshler, "The Fine Art of Sarah Choate Sears," *The Magazine Antiques* 160, no. 3 (Sept. 2001): 320–29. Sarah Choate, the daughter of an important and wealthy New England family, married Sears — Boston's richest landowner — in 1877; she also held significant real estate herself.

2. *Boston Globe*, January 26, 1896, p. 21; February 9, 1896, p. 21; March 8, 1896, p. 21; February 7, 1897, p. 21; March 13, 1898, p. 31; November 25, 1900, p. 40; March 10, 1903, p. 4. None of the garments described in the *Globe* seems to have survived.

3. As quoted in *Complete Paintings* 3:163. Mrs. Morgan's 1906 portrait is in the collection of the Morgan Library and Museum.

4. *Complete Paintings* 1:211–12, 216–17. When he heard of Shepard's comments, Sargent arrogantly commented that Shepard might "pay extra to be shown how the good lady could most becomingly array herself" (Henry Harper, as quoted in *Complete Paintings* 1:212). Sargent's 1888 portrait of Mrs. Shepard is in the San Antonio Museum of Art. Even when Sargent chose one of the client's treasured Parisian frocks, as was the case with Mrs. Morgan, it appears that he did not faithfully render the dress. Mrs. Morgan's Worth gown survives in the collection of the Museum of Fine Arts, Boston (2003.288.1-2); it is made of cream-colored damask with bows down the center front. In the portrait, the dress has a pinker tinge and Sargent repositioned the bows somewhat to the side, breaking the central axis.

5. Her wedding dress (MFA 51.3133a-b) was made by the Boston dressmaker T. E. Moseley, and two evening dresses from later in her life were made by the New York dressmaker Farquharson & Wheelock (MFA 50.3146 and 53.2895).

6. In the mid-1890s, she also bought a cream silk evening dress trimmed with lace, inspired by seventeenth-century clothing (MFA 50.3142a-b) and a deep purple velvet reception dress inspired by men's doublets of the sixteenth century (50.3403a-b), although this garment may have been altered at a later date. We are grateful to Joel Thompson, MFA textile conservator, for her assessment.

7. The burgundy and pink floral reception dress is MFA 50.3402a-b; the lavender reception or dinner dress is MFA 50.3405a-b; the white court dress is MFA 50.3143a-b and 50.3401. Sarah Sears was presented at court soon after her uncle Joseph Choate was appointed U.S. Ambassador to Britain in 1899.

8. Elisina Taylor, as quoted in Katherine Joslin, *Edith Wharton and the Making of Fashion* (Lebanon, NH: University Press of New England, 2009), 6; Edith Wharton, *The Age of Innocence* (rept. New York: Collier Books, 1968), 198.

LORD RIBBLESDALE

1. *The Times* (London), October 22, 1925.
2. See *Complete Paintings* 2:76.
3. Ibid.
4. Thomas Lister, Baron Ribblesdale, *Impressions and Memories* (London: Cassell, 1927), xxviii.
5. Ibid.
6. Thomas Lister, Baron Ribblesdale, *The Queen's Hounds and Stag-Hunting Recollections, with an Introduction on the Hereditary Mastership by Edward Burrows* (London: Longmans, Green, 1897), 156–57.
7. Woolf to Duncan Grant, March 6, 1917; *The Letters of Virginia Woolf, Volume 2: 1912–1922*, ed. Nigel Nicolson (London: Hogarth Press, 1976), 144.
8. See Martin van der Weyer, "The Lord on the Board and the Gilded Rogue," *The Spectator*, December, 15, 2007.

A RIOT OF WHITE

1. Charles Baudelaire, "Exposition Universelle, 1855," *Oeuvres complètes*, ed. Charles Pichois (Paris: Gallimard, 1975–76), 2: 595. Baudelaire is discussing the work of Eugène Delacroix. Unless otherwise stated, translations from the French are the author's.
2. Jules-Antoine Castagnary, *Salons (1857–1879)* (Paris, 1892), 1: 179. Castagnary was reviewing Whistler's *The White Girl*

at the Salon des Refusés in 1863. He went on to dismiss the concept of "pure painting" and propose a narrative interpretation of Whistler's picture.
3. Sargent to Vernon Lee, July 9, 1880, Sargent Archive, Museum of Fine Arts, Boston.
4. Louis Leroy, "Le congrès artistique," *Le Charivari*, May 13, 1880, 94.
5. Nicholas Daly has noted that "the early 1860s are white years," in "The Woman in White: Whistler, Hiffernan, Courbet, Du Maurier," *Modernism/modernity* 12, no.1 (Jan. 2005): 1.
6. For Gautier's version of "l'art pour l'art," see Preface to *Mademoiselle de Maupin* in Gautier, *Oeuvres: Choix de romans et de contes*, ed. Paolo Tortonese (Paris: Robert Laffont, 1995), 203. Vernon Lee notes that, in the early part of his career, Sargent was "extremely serious, a great maker of theories; he goes in for art for art's own sake, says that the subject of a picture is something not always in the way etc." Vernon Lee to her mother, June 20, 1881, in *Vernon Lee's Letters*, ed. I. Cooper Willis (privately printed, 1937), 63.
7. *Revue Alsacienne* (Paris) 4 (1880–81): 298. The poem was published in the volume *Émaux et camées* (1852), a copy of which was in Sargent's personal library. See Claudine Gothot-Mersch, ed., *Émaux et camées* (Paris: Gallimard, 1981), 42–44. See also A. Genevay, "Salon de 1880 (Huitième article)," *Le Musée Artistique et Littéraire* 4 (1880): 14–15; Marc Simpson, *Uncanny Spectacle: The Public Career of the Young John Singer Sargent* (Williamstown, MA: Sterling and Francine Clark Art Institute, 1997), 93–94.
8. Paul Mantz, "Le Salon: VII," *Le Temps*, June 20, 1880, 1. Gautier was interested in fashion and its representation in art and wrote an article on fashion, "De la mode," in 1858. See Aileen Ribeiro, "Concerning Fashion: Théophile Gautier's 'De la mode,' 1858," *Costume* 24, no.1 (1990): 62.
9. Eliza Wedgwood, "Memoir" in the form of a letter to Sargent's biographer, Evan Charteris, November 22, 1925, p.10; Sargent Archive, Museum of Fine Arts, Boston. A selection of Sargent's library was sold at Christie's London on July 29, 1925. His personal library, now in private collections, leaned distinctly toward the work of French writers: Balzac, De Musset, De Vigny, Flaubert, Anatole France, Gautier, Goncourt, Montaigne, Stendhal, Huysmans, and Voltaire, and the poetry of Leconte de Lisle, Baudelaire, and Verlaine.
10. See Sargent's letters to the art critic D. S. MacColl, a Mr. Jameson, and the

Duke of Alba, discussing optics and Impressionism; Evan Charteris, *John Sargent* (London: Heinemann, 1927), 123–25, 195–96.
11. For Sargent and Monet, see *Complete Paintings* 5:51–73.
12. Roy Jenkins, *Dilke: A Victorian Tragedy*, revised ed.1965 (rept. London: Bloomsbury Reader, 2012), 393–425.
13. See Aileen Ribeiro, *Clothing Art: The Visual Culture of Fashion* (New Haven: Yale University Press, 2017), 466–67.
14. Andrew Noel Agnew's diaries, 1888–1925 (reference: GD 154/859-75), Scottish Record Office, Edinburgh; quoted in *The Portrait of a Lady: Sargent and Lady Agnew* (Edinburgh: National Gallery of Scotland, 1997), 22. R.A.M. Stevenson, "General Impressions of the Royal Academy of 1893," *Art Journal*, 1893, p.242.
15. For the myth of the whiteness of antiquity, see Denise Eileen McCoskey, *Race, Antiquity and Its Legacy* (Oxford: Oxford University Press, 2012).
16. For the history of cotton, see Sven Beckert, *Empire of Cotton: A Global History* (New York: Knopf, 2014). For an account of the complex industrial processes of bleaching and finishing fabric to achieve the desired degree of whiteness, see Caroline Arscott, "Whistler and Whiteness," in *The Colours of the Past in Victorian England*, ed. Charlotte Ribeyrol (Bern: Peter Lang, 2016), 50–52.
17. Émile Zola, *Au bonheur des dames* (Paris,1883) in *Les Rougon-Macquart*, ed. Henri Mitterand (Paris: Gallimard, 1964), 3: 768.
18. The portrait of Madame Rivière was exhibited at the Paris Salon in 1806 and given to the Musée du Louvre by the sitter's daughter-in-law in 1870.
19. "New English Art Club," *Morning Post*, May 25, 1912; "Art Notes," *Illustrated London News*, June 8, 1912; "New English Art Club," *Newcastle Journal*, May 29, 1912.
20. Sargent's advice to Julie Heyneman is quoted in Charteris, *John Sargent*, 181.

List of Illustrations

Artworks are by John Singer Sargent (American, 1856–1925), unless stated otherwise. Images were provided by the holding institution or collection, unless another source is credited. Objects marked with an asterisk were shown in the exhibition.

1
Max Beerbohm (English, 1872–1956)
Sargent at Work, 1907
Offset lithograph, sheet 20.3 x 15.6 cm
(8 x 6⅛ in.)
Museum of Fine Arts, Boston
The John Singer Sargent Archive —
Gift of Jan and Warren Adelson, 2014

2
John Singer Sargent's studio at 31 Tite Street, Chelsea, London, England, about 1920
Photographic print, 17 x 22 cm (6¾ x 8⅝ in.)
Archives of American Art, Smithsonian Institution

3
John Templeman Coolidge (American, 1856–1945)
John Singer Sargent Painting Mrs. Fiske Warren and Her Daughter Rachel in the Gothic Room at Fenway Court, 1903
Platinum print, 16.2 x 13.7 cm (6⅜ x 5⅜ in.)
Isabella Stewart Gardner Museum, Boston

4*
Mrs. Fiske Warren (Gretchen Osgood) and Her Daughter Rachel, 1903
Oil on canvas, 152.4 x 102.6 cm
(60 x 40⅜ in.)
Museum of Fine Arts, Boston
Gift of Mrs. Rachel Warren Barton and Emily L. Ainsley Fund, 1964, 64.693

5
Mrs. Joseph E. Widener (Ella Holmes Pancoast), 1903
Oil on canvas, 152.4 x 97.8 cm (60 x 38½ in.)
Private collection
Image courtesy John Singer Sargent catalogue raisonné

6*
Madame Ramón Subercaseaux (Amalia Errázuriz), 1880–81
Oil on canvas, 165.1 x 109.9 cm (65 x 43¼ in.)
Sarofim Foundation
Photograph © The Museum of Fine Arts, Houston

7
Frances Sherborne Ridley Watts, 1877
Oil on canvas, 105.9 x 81.3 cm (41⅝ x 32 in.)
Philadelphia Museum of Art
Gift of Mr. and Mrs. Wharton Sinkler, 1962, 1962-193-1

8
Carolus-Duran (Charles-Émile-Auguste Durand) (French, 1837–1917)
La Dame au gant (Lady with the Glove), 1869
Oil on canvas, 228 x 164 cm (89¾ x 64½ in.)
Musée d'Orsay, Paris
Photograph © RMN-Grand Palais/Art Resource, NY

9
"Salon de Paris," *La Caricature*, May 27, 1882

10
Lady with the Rose (Charlotte Louise Burckhardt), 1882
Oil on canvas, 213.4 x 113.7 cm (84 x 44¾ in.)
The Metropolitan Museum of Art, New York
Bequest of Valerie B. Hadden, 1932, 32.154
Image copyright © The Metropolitan Museum of Art. Image source: Art Resource, NY

11*
Edith, Lady Playfair (Edith Russell), 1884
Oil on canvas, 152.1 x 98.4 cm
(59⅞ x 38¾ in.)
Museum of Fine Arts, Boston
Bequest of Edith, Lady Playfair, 1933, 33.530

12*
Lady Agnew of Lochnaw (Gertrude Vernon), 1892
Oil on canvas, 127.7 x 100.3 cm
(49½ x 39½ in.)
National Galleries of Scotland
Purchased with the aid of the Cowan Smith Bequest Fund, 1925, NG 1656

13*
Madame X (Madame Pierre Gautreau [Virginie Amélie Avegno]), 1883–84
Oil on canvas, 208.6 x 109.9 cm
(82⅛ x 43¼ in.)
The Metropolitan Museum of Art, New York
Arthur Hoppock Hearn Fund, 1916, 16.53
Image copyright © The Metropolitan Museum of Art. Image source: Art Resource, NY

14
Édouard Manet (French, 1832–1883)
La Parisienne, 1883
Oil on canvas, 192 x 125 cm (75⅔ x 49¼ in.)
Nationalmuseum, Stockholm NM, 2068
Photograph: Erik Cornelius/Nationalmuseum, Stockholm

15
Charles Dana Gibson (American, 1867–1944)
Scribner's for June, 1895
Zinc engraving, sheet 56.2 x 35.7 cm
(22 x 14 in.)
Library of Congress, Washington, DC

16*

Mrs. Robert Harrison (Helen Smith), 1886
Oil on canvas, 157.8 x 80.3 cm
(62⅛ x 31⅝ in.)
Tate Britain
Bequeathed by Miss P. J. M. Harrison, 2000
Photograph: Tate

17*

*Ena and Betty, Daughters of Asher and
Mrs. Wertheimer*, 1901
Oil on canvas, 185.4 x 130.8 cm (73 x 51.5 in.)
Tate Britain
Presented by the widow and family of
Asher Wertheimer in accordance with his
wishes, 1922
Photograph: Tate

18*

Mrs. Charles Thursby (Alice Brisbane),
about 1897–98
Oil on canvas, 198.1 x 101 cm (78¼ x 39½ in.)
The Newark Museum of Art
Purchase by exchange, 1985, Gift of Mr. and
Mrs. J. Duncan Pitney, Emilie Coles (from the
J. Ackerman Coles Collection), Mrs. Lewis
B. Ballantyne, Mrs. Owen Winston and the
Bequest of Louis Bamberger, 85.45

19*

*Mrs. Edward L. Davis (Maria Robbins)
and Her Son, Livingston Davis*, 1890
Oil on canvas, 218.8 x 122.6 cm
(86⅛ x 48¼ in.)
Los Angeles County Museum of Art
Frances and Armand Hammer Purchase
Fund, M.69.18
Image: www.lacma.org

20

*Mr. and Mrs. I. N. Phelps Stokes (Isaac Newton
Phelps Stokes and Edith Minturn)*, 1887
Oil on canvas, 214 x 101 cm (84¼ x 39¾ in.)
The Metropolitan Museum of Art, New York
Bequest of Edith Minturn Phelps Stokes
(Mrs. I. N.), 1938, 38.104
Image copyright © The Metropolitan
Museum of Art. Image source: Art Resource,
NY

21*

Mrs. Hugh Hammersley (Mary Frances Grant),
1892
Oil on canvas, 205.7 x 115.6 cm (81 x 45½ in.)
The Metropolitan Museum of Art, New York
Gift of Mr. and Mrs. Douglass Campbell, in
memory of Mrs. Richard E. Danielson, 1998,
1998.365
Image copyright © The Metropolitan
Museum of Art. Image source: Art Resource,
NY

22*

Fragment of velvet from the dress worn by
Mrs. Hammersley, about 1890, with the note
and ribbon with which it was wrapped
The Metropolitan Museum of Art, New York,
N.A.2021.3.1a-c
Image copyright © The Metropolitan
Museum of Art. Image source: Art Resource,
NY

23*

Pauline Astor, 1898–99
Oil on canvas, 248.9 x 127 cm (98 x 50 in.)
Private collection
Image courtesy John Singer Sargent
catalogue raisonné
Tate only

24

Mrs. William Playfair (Emily Kitson), 1887
Oil on canvas, 153.7 x 99.1 cm (60½ x 39 in.)
The Huntington Library, Art Museum, and
Botanical Gardens
Purchased with funds from the Virginia
Steele Scott Foundation, 98.2
Image courtesy of the Huntington Art
Museum, San Marino, California

25

*Carolus-Duran (Charles-Émile-Auguste
Durand)*, 1879
Oil on canvas, 116.8 x 96 cm (46 x 37¾ in.)
Sterling and Francine Clark Art Institute,
Williamstown, MA, 1955.14
Image courtesy Clark Art Institute.
clarkart.edu

26

"A Prince, 2 Dukes, 2 Girls and $40,000,000,"
New York Journal and Advertiser, October 10,
1897
Library of Congress, Washington, DC

27*

Colonel Ian Hamilton, C.B., D.S.O., 1898
Oil on canvas, 138.4 x 78.7 cm (54½ x 31 in.)
Tate Britain
Presented by General Sir Ian Hamilton, 1940
Photograph: Tate

28*

*Charles Stewart, Sixth Marquess of
Londonderry, Carrying the Great Sword of State
at the Coronation of Edward VII, August 1902,
and Mr. W. C. Beaumont, His Page on That
Occasion*, 1904
Oil on canvas, 287 x 195.6 cm (113 x 77 in.)
Museum of Fine Arts, Boston
Gift of an American Private Collector and
Museum purchase with the generous
assistance of a friend of the Museum, and
the Juliana Cheney Edwards Collection,
M. and M. Karolik Fund, Harry Wallace
Anderson Fund, General Funds, Francis
Welch Fund, Susan Cornelia Warren
Fund, Ellen Kelleran Gardner Fund, Abbott

Lawrence Fund, and funds by exchange
from a Gift of John Richardson Hall,
Bequest of Ernest Wadsworth Longfellow,
Gift of Alexander Cochrane, The Hayden
Collection — Charles Henry Hayden Fund,
Anonymous gift, and Bequest of Maxim
Karolik, 2003, 2003.274

29*

John D. Rockefeller, 1917
Oil on canvas, 147.3 x 116.8 cm (58 x 46 in.)
Kykuit, National Trust for Historic
Preservation, Pocantico Hills, NY
Bequest of John D. Rockefeller 3rd, Nelson
A. Rockefeller, Laurance S. Rockefeller, David
Rockefeller, NT 2005.3.0020
Photograph: Ben Asen
MFA only

30*

President Woodrow Wilson, 1917
Oil on canvas, 153 x 109 cm (60¼ x 42⅞ in.)
National Gallery of Ireland
Commissioned, the Board of Governors and
Guardians, in memory of Sir Hugh Lane, 1917,
NGI.817
Tate only

31*

Édouard Pailleron, 1879
Oil on canvas, 138.5 x 96 cm (54.5 x 37¾ in.)
Musée d'Orsay, Paris
Photograph © RMN-Grand Palais/Art
Resource, NY

32

*Marie Buloz Pailleron (Madame Édouard
Pailleron)*, 1879
Oil on canvas, 211.2 x 104.4 cm
(83⅛ x 41⅛ in.)
National Gallery of Art, Washington, DC,
Corcoran Collection
Museum Purchase and gifts of Katherine
McCook Knox, John A. Nevius and Mr. and
Mrs. Lansdell K. Christie, 2014.79.53
Image courtesy National Gallery of Art,
Washington, DC

33*

Dr. Pozzi at Home, 1881
Oil on canvas, 201.6 x 102.2 cm
(79⅜ x 40¼ in.)
Hammer Museum, Los Angeles
The Armand Hammer Collection, Gift of the
Armand Hammer Foundation

34

Isabella Stewart Gardner, 1888
Oil on canvas, 190 x 80 cm (74¾ x 31½ in.)
Isabella Stewart Gardner Museum, Boston

35*
Costume for Carmen Dauset Moreno
(Carmencita), about 1890
Silk satin and net, trimmed with silver gilt
thread, spangles, and beads
Center front (bodice): about 9 cm (3½ in.)
Center front (skirt): 84 cm (33⅛ in.)
Shawl: 33.5 x 178.5 cm (13¼ x 70¼ in.)
Private collection
Photograph © Houghton Hall/Pete Huggins

36*
La Carmencita (Carmen Dauset Moreno), 1890
Oil on canvas, 229 x 140 cm (94 x 55⅛ in.)
Musée d'Orsay, Paris
Purchased from the artist for the State,
for the Luxembourg, 1892
Photograph © RMN-Grand Palais/Art
Resource, New York

37*
Javanese Dancer, 1889
Oil on canvas, 175.9 x 78.1 cm
(69¼ x 30¾ in.)
Private collection
Photograph: Museum of Fine Arts, Boston

38*
Sybil Sassoon, Countess of Rocksavage, 1922
Oil on canvas, 161.3 x 89.8 cm
(63½ x 35⅝ in.)
Private collection
Photograph © Houghton Hall/Pete Huggins

39
Bartolomé González (Spanish, 1564–1627),
after Anthonis Mor (Dutch, about 1512–1577)
Queen Anne of Austria, Fourth Wife of Philip II,
about 1616
Oil on canvas, 108.5 x 87 cm (42¾ x 34¼ in.)
Museo del Prado
Photograph © Photographic Archive Museo
Nacional del Prado

40*
Jean-Philippe Worth (French, 1856–1926)
For House of Worth (French, 1858–1956)
Fancy-dress costume for Sybil Sassoon,
Countess of Rocksavage, about 1922
Silk velvet, silk satin, metal thread lace
Center front: about 140 cm (55⅛ in.)
Private collection
Photograph © Houghton Hall/Pete Huggins

41*
*Robert Louis Stevenson and His Wife (Frances
Van de Grift Osbourne)*, 1885
Oil on canvas, 51.43 x 61.6 cm
(20¼ x 24¼ in.)
Crystal Bridges Museum of American Art,
Bentonville, Arkansas, 2005.3
Photograph: Dwight Primiano

42*
Coat (*entari*), Turkish, early 19th century
Silk brocade, metallic lace
Center front: 150 cm (59 in.)
Museum of Fine Arts, Boston
John W. Elliot Fund, 44.758

43
Rose-Marie Ormond, Sargent's niece, in
Turkish dress, Peuterey, about 1907
Photographic print, 8.9 x 6.4 cm
(3½ x 2½ in.)
Museum of Fine Arts, Boston
The John Singer Sargent Archive—
Gift of Richard and Leonee Ormond, 2015,
SC.Sargent Archive.22.1

44
Hiking party in the Simplon Pass, about 1911
Photographic print, 7 x 6.4 cm (2¾ x 2½ in.)
Museum of Fine Arts, Boston
The John Singer Sargent Archive—
Gift of Richard and Leonee Ormond, 2015,
SC.Sargent Archive.22.9

45*
The Chess Game, 1907
Oil on canvas, 69.9 x 55.3 cm (27½ x 21¾ in.)
Allen Family Collection

46*
Shawl, Indian (Kashmiri), about 1830
Goat hair (pashmina) twill tapestry
133 x 280 cm (52⅜ x 110¼ in.)
Private collection
Photograph © Houghton Hall/Pete Huggins

47*
Cashmere, 1908
Oil on canvas, 71.1 x 109.2 cm (28 x 43 in.)
Private collection
Prudence Cuming Associates Ltd., London/
Courtesy Adelson Galleries, New York

48*
Nonchaloir (Repose), 1911
Oil on canvas, 63.8 x 76.2 cm (25⅛ x 30 in.)
National Gallery of Art, Washington, DC
Gift of Curt H. Reisinger, 1948.16.1
Image courtesy National Gallery of Art,
Washington, DC

49*
Group with Parasols (Siesta), 1904–5
Oil on canvas, 55.3 x 70.8 cm (21¾ x 27⅞ in.)
The Middleton Family Collection

50*
Ellen Terry as Lady Macbeth, 1889
Oil on canvas, 221 x 114.3 cm (87 x 45 in.)
Tate Britain
Presented by Sir Joseph Duveen (the elder),
1906
Photograph: Tate

51*

Alice Laura Comyns-Carr (British, 1850–1927)
Cloak for the "Beetle Wing Dress" for Lady Macbeth, 1888
Velvet, silk damask, cotton, metal, glass
Length: about 225 cm (88⅝ in.)
National Trust, UK (Smallhythe Place, Kent)
Photograph © National Trust Images/Andrew Fetherston

52*

Alice Laura Comyns-Carr (British, 1850–1927)
"Beetle Wing Dress" for Lady Macbeth, 1888
Cotton, silk, lace, beetle-wing cases, glass, metal
Length: about 225 cm (88⅝ in.)
National Trust, UK (Smallhythe Place, Kent)
Photograph © National Trust Images/David Brunetti

53

Illustration from Eugène-Emmanuel Viollet-le-Duc, Dictionnaire raisonné du mobilier français, vol. 2 (1871)
Digital image courtesy The New York Public Library, Art & Architecture Collection

54

Possibly William Henry Grove (British, 1847–1906)
Ellen Terry as Lady Macbeth, 1888
Photograph
Image: Smith Archive/Alamy Stock Photo

55

Ellen Terry as Lady Macbeth under ultraviolet light
Photograph: Tate (conservation image)

56

Detail of sleeve, showing fabric with applied beetle wings and border
Photograph: Erica E. Hirshler

57*

Sir Frank (Athelstane) Swettenham, 1904
Oil on canvas, 170.8 x 110.5 cm (67¼ x 43½ in.)
National Portrait Gallery, London
Bequeathed by Sir Frank (Athelstane) Swettenham, 1971
Photograph © National Portrait Gallery, London

58

Anthony van Dyck (Dutch, 1599–1641)
Lord John Stuart and His Brother, Lord Bernard Stuart, about 1638
Oil on canvas, 237.5 x 146.1 cm (93⅓ x 57½ in.)
National Gallery, London, NG6518
© National Gallery, London/Art Resource, New York

59

The Earl of Dalhousie, 1900
Oil on canvas, 154 x 111 cm (60 x 40 in.)
Private collection
Photograph © Christie's Images/Bridgeman Images

60

The Daughters of Edward Darley Boit, 1882
Oil on canvas, 221.9 x 222.6 cm (87⅜ x 87⅝ in.)
Museum of Fine Arts, Boston
Gift of Mary Louisa Boit, Julia Overing Boit, Jane Hubbard Boit, and Florence D. Boit in memory of their father, Edward Darley Boit, 19.124

61*

Sybil Sassoon, Countess of Rocksavage, 1913
Oil on canvas, 86.4 x 67.3 cm (34 x 26½ in.)
Private collection
Photograph © Houghton Hall/Pete Huggins

62*

The Duchess of Portland (Winifred Anna Cavendish-Bentinck, née Dallas-Yorke), 1902
Oil on canvas, 228.6 x 113 cm (90 x 44 in.)
The Portland Collection
Photograph: The Portland Collection/Bridgeman Images
Tate only

63

Thomas Gainsborough (British, 1727–1788)
The Honourable Mrs. Graham, 1775–77
Oil on canvas, 237 x 154 cm (93⅓ x 60⅝ in.)
Scottish National Gallery, Edinburgh
Photograph © National Galleries of Scotland/Bridgeman Images

64*

Mrs. Leopold Hirsch (Frances Mathilde Seligman), 1902
Oil on canvas, 144.8 x 92.7 cm (57 x 36½ in.)
Private collection, on loan to Tate Britain
Photograph: Tate

65*

Mrs. Carl Meyer (Adèle Levis) and Her Children, Frank Cecil and Elsie Charlotte, 1896
Oil on canvas, 201.4 x 134 cm (79¼ x 52¾ in.)
Tate Britain
Bequeathed by Adele, Lady Meyer 1930, with a life interest for her son and grandson and presented in 2005 in celebration of the lives of Sir Anthony and Lady Barbadee Meyer, accessioned 2009
Photograph: Tate

66

François Boucher (French, 1703–1770)
The Marquise de Pompadour, 1756
Oil on canvas, 201 x 157 cm (79⅛ x 61⅞ in.)
Alte Pinakothek, Munich, Inv. HUW 18
Photograph: Collection HypoVereinsbank, Member of UniCredit
bpk Bildagentur/Alte Pinakothek, Munich/Art Resource, NY

67*

Almina, Daughter of Asher Wertheimer, 1908
Oil on canvas, 134 x 101 cm (52¾ x 39¾ in.)
Tate Britain
Presented by the widow and family of Asher Wertheimer in accordance with his wishes, 1922
Photograph: Tate

68

Jean-Auguste-Dominique Ingres (French, 1780–1867)
Odalisque, Slave, Eunuch, 1839–40
Oil on canvas, 72.1 x 100.3 cm (28⅜ x 39½ in.)
Harvard Art Museums/Fogg Museum, Bequest of Grenville L. Winthrop, 1943.251
Photograph © President and Fellows of Harvard College

69

Joshua Reynolds (British, 1723–1792)
Mrs. Charles Yorke, about 1763
Oil on canvas, 92.7 x 71.8 cm
Presumed destroyed
Reproduced from Burlington Magazine for Connoisseurs 10, no. 48 (March 1907): 379

70

Hylda, Almina, and Conway, Children of Asher Wertheimer, 1905
Oil on canvas, 188 x 133.3 cm (74 x 52⅞ in.)
Tate Britain
Presented by the widow and family of Asher Wertheimer in accordance with his wishes, 1922
Photograph: Tate

71*

Vernon Lee, 1881
Oil on canvas, 53.7 x 43.2 cm (21⅛ x 17 in.)
Tate Britain
Bequeathed by Miss Vernon Lee through Miss Cooper Willis, 1935
Photograph: Tate

72

Clementina Anstruther-Thomson, 1889
Oil on canvas 81.3 x 66 cm (32 x 26 in.)
Private collection
Image courtesy of Godel & Co., Inc.

73*
W. Graham Robertson, 1894
Oil on canvas, 230.5 x 118.7 cm
(90¾ x 64¾ in.)
Tate Britain
Presented by W. Graham Robertson, 1940
Photograph: Tate

74
James McNeill Whistler (American,
1834–1903)
*Arrangement in Black and Gold: Comte Robert
de Montesquiou-Fezensac*, 1891–92
Oil on canvas, 208.6 x 91.8 cm
(82⅛ x 36⅛ in.)
The Frick Collection, Henry Clay Frick
Bequest, 1914.1.131
Photograph © The Frick Collection

75*
Albert de Belleroche, about 1883
Oil on canvas, 63.5 x 41.9 cm (25 x 16½ in.)
Stevenson Scott Kaminer
Photograph: Mark Gulezian, QuickSilver
Photographers LLC

76*
Sir Philip Sassoon, 1923
Oil on canvas, 95.2 x 57.8 cm
(29½ x 22¾ in.)
Tate Britain
Bequeathed by Sir Philip Sassoon Bt, 1939
Photograph: Tate

77
Gondolier, 1880–1900
Graphite on light-buff wove paper,
27.1 x 19.8 cm (10⅝ x 7¾ in.)
The Metropolitan Museum of Art, New York
Gift of Mrs. Francis Ormond, 1950, 50.130.111
(recto)
Image copyright © The Metropolitan
Museum of Art. Image source: Art Resource,
NY

78
Self-Portrait, 1906
Oil on canvas, 70 x 53 cm (27½ x 20⅞ in.)
Galleria degli Uffizi, Collezione degli
Autoritratti, Florence
Photograph: Cameraphoto Arte, Venice/
Art Resource, NY

79*
Ena Wertheimer: A Vele Gonfie, 1905
Oil on canvas, 163 x 108 cm (64⅛ x 42.5 in.)
Tate Britain
Bequeathed by Robert Mathias, 1996
Photograph: Tate

80
The Marlborough Family, 1904–5
Oil on canvas, 287 x 238.7 cm (113 x 94 in.)
His Grace the Duke of Marlborough,
Blenheim Palace, Oxfordshire
Photograph: Bridgeman Images

81
Cavendish Morton (British, 1874–1939)
*The Wedding of Ena Wertheimer and
Robert Mathias*, 1905
Platinum print on photographer's paper
mount, 22.5 x 28.8 cm (8⅞ x 11⅜ in.)
National Portrait Gallery, London,
Given by the photographer's son,
Cavendish Morton, 1994
Photograph © National Portrait Gallery,
London/Art Resource, NY

82*
*Lady Helen Vincent, Viscountess d'Abernon
(Helen Duncombe)*, 1904
Oil on canvas, 158.8 x 108 cm
(62½ x 42½ in.)
Birmingham Museum of Art
Museum purchase with funds provided by
John Bohorfoush, the 1984 Museum Dinner
and Ball, and the Museum Store, 1984.121
Photograph: Sean Pathasema

83*
Mrs. Charles Inches (Louise Pomeroy), 1887
Oil on canvas, 86.4 x 60.6 cm (34 x 23⅞ in.)
Museum of Fine Arts, Boston
Anonymous gift in memory of Mrs. Charles
Inches' daughter, Louise Brimmer Inches
Seton, 1991.926

84*
Evening dress, 1887–1902
Silk velvet with silk plain weave lining
Center front (bodice): 26.7 cm (10½ in.)
Center front (skirt): 101.6 cm (40 in.)
Museum of Fine Arts, Boston
Anonymous gift in honor of Louise B. Seton,
2013.1653.1-3

85
President Theodore Roosevelt, 1903
Oil on canvas, 147.6 x 101.6 cm (58⅛ x 40 in.)
White House Collection
Photograph © 2023 White House Historical
Association

86*
Henry Lee Higginson, 1903
Oil on canvas, 246.1 x 153.7 cm
(96⅞ x 60½ in.)
Harvard Art Museums, Harvard University
Portrait Collection
Gift by student subscription to the Harvard
Union, 1903
Photograph © President and Fellows of
Harvard College

87*
Jane Evans, 1898
Oil on canvas, 144 x 93 cm (56¾ x 36½ in.)
Provost and Fellows of Eton College,
Berkshire, England
Reproduced by permission of the Provost
and Fellows of Eton College

88
Mrs. Henry White (Margaret Stuyvesant Rutherfurd), 1883
Oil on canvas, 225.1 x 143.8 cm (88⅝ x 56⅝ in.)
National Gallery of Art, Washington, DC
Corcoran Collection (Gift of John Campbell White), 2014.136.68
Image courtesy National Gallery of Art, Washington, DC

89
Fitting room at the House of Worth, Paris, 1907
Photograph © Jacques Boyer/Roger-Viollet

90
Charles Dana Gibson (American, 1867–1944)
From *The Education of Mr. Pipp* (New York: R.H. Russell, 1899)
Museum of Fine Arts, Boston

91
Workshop at the House of Worth, Paris, 1907
Photograph © Jacques Boyer/Roger-Viollet

92*
Mrs. Adrian Iselin (Eleanora O'Donnell), 1888
Oil on canvas, 153.7 x 93 cm (60½ x 36⅝ in.)
National Gallery of Art, Washington, DC
Gift of Ernest Iselin, 1964.13.1
Image courtesy National Gallery of Art, Washington, DC

93
Day dress, 1887–89
Black corded silk, embroidered net, jet tassels
Center front (bodice): 48 cm (18⅞ in.)
Center back (skirt): 147 cm (57⅞ in.)
Fashion Museum, Bath, FMB7302130
Photograph: Bridgeman Images

94
Illustration from *Le Moniteur de la Mode*, 1881
Digital image courtesy The Metropolitan Museum of Art, New York, Costume Institute

95*
Mrs. Edward Darley Boit (Mary Louisa Cushing), 1887
Oil on canvas, 152.4 x 108.6 cm (60 x 42¾ in.)
Museum of Fine Arts, Boston
Gift of Miss Julia Overing Boit, 1963, 63.2688

96
A. Chaillot, after Monogrammist BC
Costumes de Madame Turl
From *Journal des Demoiselles*, September 1, 1885
Image courtesy Rijksmuseum, Amsterdam

97*
Lady Sassoon (Aline de Rothschild), 1907
Oil on canvas, 157.5 x 104.1 cm (62 x 41 in.)
Private collection
Photograph © Houghton Hall/Pete Huggins

98*
Possibly by House of Worth
(French, 1858–1956)
Opera cloak, before 1907
Silk taffeta and satin, net, ribbons, and lace
Center back: 161 cm (63⅜ in.)
Private collection
Photograph © Houghton Hall/Pete Huggins

99
Mrs. Abbott Lawrence Rotch (Margaret Randolph Anderson), 1903
Oil on canvas, framed: 144.2 x 92.1 cm (56¾ x 36¼ in.)
Private collection, on loan to Joslyn Art Museum, Omaha, Nebraska

100
Callot Soeurs (French, active 1895–1937)
Evening dress, about 1900
Silk, chiffon, and linen lace
Center back (bodice): 28 cm (11 in.)
Length (skirt): about 120 cm (47½ in.)
Lawrence Greenough, London

101
Sarah Choate Sears (American, 1858–1935)
John Singer Sargent Drawing Ethel Barrymore, 1903
Platinum print, 22.5 x 14.5 cm (8⅞ x 5¾ in.)
Isabella Stewart Gardner Museum, Boston, ARC.003948

102*
Mrs. Joshua Montgomery Sears (Sarah Choate Sears), 1899
Oil on canvas, 147.6 x 96.8 cm (58⅛ x 38⅛ in.)
The Museum of Fine Arts, Houston
Museum purchase funded by George R. Brown in honor of his wife, Alice Pratt Brown, 80.144
Photograph © The Museum of Fine Arts, Houston/Thomas R. DuBrock

103*
Helen Sears, 1895
Oil on canvas, 167.3 x 91.4 cm (65⅞ x 36 in.)
Museum of Fine Arts, Boston
Gift of Mrs. J. D. Cameron Bradley, 1955, 55.1116

104*
Possibly by House of Worth
(French, 1858–1956)
Walking dress, 1877
Silk velvet with silk satin trim, knotted fringe
Center front (bodice): 27.9 cm (11 in.)
Center front (skirt): 106.7 cm (42 in.)
Museum of Fine Arts, Boston
Gift of Mrs. J. D. Cameron Bradley, 50.3404a-b
MFA only

105*
House of Worth (French, 1858–1956)
Evening dress, about 1880
Pearl-embroidered bengaline
Center front (bodice): 41.4 cm (16¼ in.)
Center front (skirt): 104.9 cm (41¼ in.)
Museum of Fine Arts, Boston
Gift of Mrs. J. D. Cameron Bradley, 50.3406a-b

106*
Jean-Philippe Worth (French, 1856–1926), for House of Worth (French, 1858–1956)
Evening dress, about 1895
Silk damask
Center front: 132.7 cm (52¼ in.)
Center back: 154.9 cm (61 in.)
Museum of Fine Arts, Boston
Gift of Mrs. J. D. Cameron Bradley, 50.3145

107*
Lord Ribblesdale, 1902
Oil on canvas, 258.4 x 143.5 cm (101¾ x 56½ in.)
The National Gallery, London
Presented by Lord Ribblesdale in memory of Lady Ribblesdale and his sons, Captain the Hon. Thomas Lister and Lieutenant the Hon. Charles Lister, 1916, NG3044
Photograph © The National Gallery, London

108
Leslie Ward ("Spy") (British, 1851–1922)
"Mufti" (Lord Ribblesdale)
Vanity Fair, June 11, 1881
Image: Artokoloro/Alamy Stock Photo

109
Lord Ribblesdale, from *The Queen's Hounds and Stag-Hunting Recollections* (London: Longmans, Green, 1897)

110
Fumée d'ambre gris (Smoke of Ambergris), 1880
Oil on canvas, 139.1 x 90.6 cm (54¾ x 35⅝ in.)
Sterling and Francine Clark Art Institute, Williamstown, MA, 1955.15
Image courtesy Clark Art Institute, clarkart.edu

111*
Carnation, Lily, Lily, Rose, 1885–86
Oil on canvas, 174 x 153.7 cm
(68½ x 60½ in.)
Tate Britain
Presented by the Trustees of the Chantrey
Bequest, 1887
Photograph: Tate
Tate only

112*
A Morning Walk, 1888
Oil on canvas, 67.3 x 50.2 cm (26½ x 19¾ in.)
Private collection
MFA only

113*
Miss Elsie Palmer, or A Lady In White, 1889–90
Oil on canvas, 190.8 x 114.6 cm
(75⅛ x 45⅛ in.)
Colorado Springs Fine Arts Center at
Colorado College
Museum Purchase Fund Acquired through
Public Subscription and Debutante Ball
Purchase Fund, FA 1969.3.1

114*
Charles Deering, 1917
Oil on canvas, 72.4 x 53.3 cm (28½ x 21 in.)
Art Institute of Chicago, Anonymous loan
Photograph: The Art Institute of Chicago/
Art Resource, NY
MFA only

115*
Two Girls in White Dresses, about 1911
Oil on canvas, 69.8 x 54.5 cm
(27½ x 21½ in.)
Private collection
Photograph © Houghton Hall/Pete Huggins

116
Jean-Auguste-Dominique Ingres (French,
1780–1867)
Marie-Françoise Beauregard, Madame Rivière,
1806
Musée du Louvre, Paris
Photo © Photo Josse/Bridgeman Images

117*
Femme en barque (Lady in a Boat),
about 1885–88
Oil on canvas, 50.8 x 68.6 cm (20 x 27 in.)
The Middleton Family Collection

118*
Mrs. Frank Millet (Elizabeth Merrill), 1885–86
Oil on canvas, 87.3 x 67.3 cm
(34⅜ x 26½ in.)
Private collection
Photograph: HIP/Art Resource, NY

119*
Lady Fishing, Mrs. Ormond (Violet Sargent),
1889
Oil on canvas, 184.8 x 97.8 cm
(72¾ x 38½ in.)
Tate Britain
Presented by Miss Emily Sargent in memory
of her brother through the Art Fund, 1929
Photograph: Tate

120*
The Black Brook, about 1908
Oil on canvas, 55.2 x 69.8 cm (21¾ x 27½ in.)
Tate Britain
Purchased 1935
Photograph: Tate

121*
In a Garden, Corfu, 1909
Oil on canvas, 91.4 x 71.4 cm (36 x 28⅛ in.)
The Middleton Family Collection

122*
The Pink Dress, about 1912
Oil on canvas, 54.6 x 66 cm (21½ x 26 in.)
Private collection
Prudence Cuming Associates Ltd., London/
Courtesy Adelson Galleries, New York

DETAILS

p. 1: fig. 107
pp. 2–3: fig. 65
pp. 4–5: fig. 79
pp. 220–21: dress shown in fig. 35

Contributors

CAROLINE CORBEAU-PARSONS is Curator
of Drawings at the Musée d'Orsay.

JAMES FINCH is Assistant Curator,
19th Century British Art, Tate Britain.

PAUL FISHER is Professor and Chair of
American Studies, Wellesley College.

FRANCES FOWLE is Personal Chair of
Nineteenth-Century Art, University of
Edinburgh, and Senior Curator, National
Galleries of Scotland.

DOMINIC GREEN is a critic, historian,
and columnist.

REBECCA HELLEN is Senior National
Conservator, Paintings, National Trust (UK).

STEPHANIE L. HERDRICH is Associate Curator
of American Painting and Sculpture,
The Metropolitan Museum of Art.

ERICA E. HIRSHLER is Croll Senior Curator
of American Paintings, Museum of Fine Arts,
Boston.

ELAINE KILMURRAY is coauthor of the
John Singer Sargent catalogue raisonné.

RICHARD ORMOND is Director and coauthor
of the John Singer Sargent catalogue
raisonné.

PAMELA A. PARMAL is Chair and David and
Roberta Logie Curator of Textile and Fashion
Arts Emerita, Museum of Fine Arts, Boston.

ELIZABETH PRETTEJOHN is Professor of
History of Art, The University of York (UK).

ANNA REYNOLDS is Deputy Surveyor of
The King's Pictures, Royal Collection Trust.

ANDREW STEPHENSON is an independent
scholar.

Acknowledgments

This book, and the exhibition it accompanies, have been long in the making — much more time than it took Sargent to paint even his most obstreperous sitter. Designed in 2017, the fabric of this exhibition was cut and its seams sewn — and then it was laid aside with the outbreak of the pandemic in 2020. Our two-year hiatus allowed time to rethink, to consult, and to revise, but it was never in doubt that the project would reach completion. For that, we are all deeply grateful to Matthew Teitelbaum, Ann and Graham Gund Director of the Museum of Fine Arts, Boston, and to Alex Farquharson, Director, Tate Britain, for their commitment and continued encouragement.

This exhibition began as a curatorial partnership with Pamela A. Parmal, at the time Chair and David and Roberta Logie Curator of Textile and Fashion Arts at the MFA, now Emerita; and Caroline Corbeau-Parsons, formerly Curator, British Art, 1850–1915, at Tate Britain (now at the Musée d'Orsay). The three of us shaped this show together, and I can only begin to express my enormous appreciation to them for their enthusiasm about the topic and for sharing their ideas, expertise, and creativity. By bringing together historians of painting and of fashion, we recognized the synergy of our disciplines and reinforced our understanding that neither simply illustrates the other. Even as the pandemic brought significant changes, both Pam and Caroline have remained active advisors and have contributed their wisdom to this publication. James Finch, Assistant Curator, 19th Century British Art, at Tate Britain, already an important thought partner on this project, took over the curatorial lead in London, together with Chiedza Mhondoro, Assistant Curator, British Art. I am supremely grateful to them both for their important contributions to every aspect of our show. Upon her arrival at the MFA, theo tyson, Penny Vinik Curator of Fashion Arts, helped to ensure that the threads of fashion were consistent throughout our presentation and that our narrative would be clear, enticing, and equitable.

Our team benefited from two international convenings funded by the Terra Foundation for American Art, in London in 2018 and in Boston in 2019, where historians of art, fashion, and culture explored the appearance and meanings of dress in Sargent's work. In addition to the curators, the participants included Kathleen Adler; Layla Bermeo, Kristin and Roger Servison Curator of Paintings, Art of the Americas, MFA; Lynn Courtney, Justine De Young, Michelle Finamore, Paul Fisher, Frances Fowle, Charlotte Gere, Dominic Green, Katie Hanson, Rebecca Hellen, Stephanie L. Herdrich, Elaine Kilmurray, Richard Ormond, Kristin Parker, Elizabeth Prettejohn, Anna Reynolds, Nathaniel Silver,

Jennifer Snodgrass, Andrew Stephenson, Adam Tessier, former Barbara and Theodore Alfond Director of Interpretation, MFA; Françoise Tétart-Vittu, Lydia Vagts, and Lauren Whitley. The discussions helped to shape our show and this book, and thus reflect the great generosity and intellectual stimulation such gatherings provide. Our authors have generously (and patiently) offered their expertise in Sargent's art and life, in fashion and dress, and in the cultural context in which these paintings and clothes were created. Their insights into the world of Sargent and his sitters and how they crafted their identities through dress — or had their public appearances crafted for them — are revelatory. We learn from them that portraits do not always tell the truth about dress, that they are seamed together just as deliberately as the garments, and that the artist was always in charge.

For sharing their deep knowledge of materials and technique, for their passion for making old things look their best, and for their expertise in caring for objects, we offer special thanks to conservators Kate Clive-Powell, Rebecca Hellen, Claudia Iannuccilli, Rhona MacBeth, Director of Conservation and Scientific Research, Eijk and Rose-Marie van Otterloo Conservator of Paintings and Head of Paintings Conservation, MFA; Meredith Montague, Deborah Phipps, Gregg Porter, Joel Thompson, Lydia Vagts, and the talented colleagues of all our lending institutions. The MFA's Jill Kennedy-Kernohan, Mattie Kelley, and Tate's Marisa Perrucci have ensured that these works have traveled safely, while the institutional logistics of our partnership have been eased by the work of Kat Bossi, Patrick McMahon, Angie Morrow, and Christina YuYu, Matsutaro Shoriki Chair, Art of Asia and Chief of Curatorial Affairs and Conservation at the MFA, and by Carolyn Kerr, Andrea Schlieker, and Wendy Lothian at Tate.

On behalf of my co-curators, I would also like to thank the friends, colleagues, scholars, interns, and supporters both inside and outside our institutions who have helped with so many things: Warren Adelson, Kathleen Adler, Michael Altman, Julie Aronson, Larry Berger, Layla Bermeo, Carly Bieterman, Sarah Cash, Esther da Costa Meyer, Jordan Cromwell, David Park Curry, Fiona Dang, Jessica Eber, Katherine Fein, Nonie Gadsden, Katharine Lane Weems Senior Curator of American Decorative Arts and Sculpture, MFA; Pascal Gorguet-Ballesteros, Katie Hanson, Stephanie L. Herdrich, Matigan Holloway, Catherine Johnson-Roehr, Elaine Kilmurray, Deb LaKind, Ethan Lasser, John Moors Cabot Chair, Art of the Americas, MFA; Dalia Habib Linssen, Mary Lublin, Susan Marsh, Terry McAweeney, Ashley Matias Matos, Dorothy Moss, Claudia Nahson, Richard Ormond,

Roma Patel, Luisa Respondek, David Rocksavage, Herman Saksono, George T.M. Shackelford, Joseph Semkiu, Diana Sibbald, Alison Smith, Jennifer Snodgrass, Francesca Soriano, Jean Strouse, Allison Taylor, Astrid Tventenstrand, Jennifer Varekamp, and Sylvia Yount. We are so grateful to our loved ones for offering us patience and support: Matt Parsons, Kate Slipper, and William C. Van Siclen. And we honor the memory of two of our most steadfast champions among our family and friends, Harry Clark and Carol Wall, who started down this path with us, cheered us on, and left us much too soon.

We owe the most profound thanks to our lenders for allowing us to present their works of art in this book and to visitors during the run of the exhibition. Both public institutions and private collectors have given up their treasures to make this project a reality — objects frequently requested and seldom lent. Among the exceptional treasures are the loans from Houghton Hall, not only Sargent paintings but also the garments depicted within them, cherished and carefully preserved. Other objects have not been together since they were in Sargent's Tite Street studio in London, among them the portrait of the great British actress Ellen Terry, from Tate Britain, alongside her original costume embellished with beetle wings, from the National Trust. The writer Oscar Wilde, a neighbor of Sargent's, remarked that a "street that on a wet and dreary morning has vouchsafed the vision of Lady Macbeth in full regalia magnificently seated in a four-wheeler can never again be as other streets: it must always be full of wonderful possibilities." May this project offer others many wonderful possibilities as well.

ERICA E. HIRSHLER
Croll Senior Curator of American Paintings
Museum of Fine Arts, Boston

Index

Page numbers in *italics* denote illustrations. Works are by John Singer Sargent unless otherwise indicated.

MFA Boston

MFA Publications
Museum of Fine Arts, Boston
465 Huntington Avenue
Boston, Massachusetts 02115
www.mfa.org/publications

Published in conjunction with an exhibition
co-organized by the Museum of Fine Arts,
Boston, and Tate Britain:

Fashioned by Sargent
Museum of Fine Arts, Boston,
October 8, 2023–January 15, 2024

Sargent and Fashion
Tate Britain, London, February 21–July 7, 2024

Exhibition at the Museum of Fine Arts,
Boston, sponsored by

BANK OF AMERICA

Additional support from the Barbara M.
Eagle Exhibition Fund, the MFA Associates /
MFA Senior Associates Exhibition
Endowment Fund, the Dr. Lawrence H. and
Roberta Cohn Fund for Exhibitions, and the
Alexander M. Levine and Dr. Rosemarie D.
Bria-Levine Exhibition Fund

Exhibitions at the Museum of Fine Arts,
Boston, and Tate Britain generously
supported by

TERRA
FOUNDATION FOR AMERICAN ART

Generous support for this publication pro-
vided by the Vance Wall Foundation and the
Andrew W. Mellon Publications Fund

© 2023 by Museum of Fine Arts, Boston

ISBN: 978-0-87846-894-2
Library of Congress Control Number:
2023937231

The Museum of Fine Arts, Boston, is a non-
profit institution devoted to the promotion
and appreciation of the creative arts.
The Museum endeavors to respect the copy-
rights of all authors and creators in a manner
consistent with its nonprofit educational
mission. If you feel any material has been
included in this publication improperly,
please contact the Department of Rights and
Licensing at 617 267 9300, or by mail at the
above address.

The Museum is proud to be a leader within
the American museum community in sharing
the objects in its collection via its website.
Currently, information about approximately
400,000 objects is available to the public
worldwide. To learn more about the MFA's
collections, including provenance, publica-
tion, and exhibition history, kindly visit www.
mfa.org/collections.

For a complete listing of MFA publications,
please contact the publisher at the above
address, or call 617 369 4233.

Illustrations in this book were photographed
by the Imaging Studios, Museum of Fine
Arts, Boston, except where otherwise noted.

Grateful acknowledgment is made to the
copyright holders for permission to repro-
duce the works listed on pp. 234–40.

Edited by Jennifer Snodgrass
Proofread by Fronia W. Simpson
Designed by Susan Marsh
Production by Terry McAweeney
Production assistance by Diana Sibbald
Image research and permissions
 by Jessica Altholz Eber
Typeset in Miller Text and Whitney,
 with Gotham Condensed, Snell
 Roundhand, and Zapfino display,
 by Matt Mayerchak
Printed on 150 gsm Perigord
Printed and bound at Graphicom,
 Verona, Italy

Distributed by
ARTBOOK | D.A.P.
75 Broad Street, Suite 630
New York, New York 10004
www.artbook.com

SECOND PRINTING

Printed and bound in Italy
This book was printed on acid-free paper.